"Deresiewicz astutely examines the state of the arts in contemporary culture . . . [painting] a vivid picture of the challenges involved in making art, finding an audience, and being self-supporting as an artist. . . . A savvy assessment of how artists can, and should, function in the market-place."
　　　　　　　　　　　　　　　　　　　　　　　　　　—*Kirkus Reviews*

"From one of our bravest, fiercest critics, *The Death of the Artist* is a devastating anatomization of the creative life in the age of digital repro-duction. Through a moving portrait of artists pushed to penury and humiliation by an economic system engineered to exploit them, William Deresiewicz shows that the cultural life of a nation can be only as healthy as the condition of its democracy. To any working (or begging) artist, the plights described will be as familiar as a recurring nightmare."

　　　　　　　　—**Nathaniel Rich, author of *Losing Earth: A Recent History***

"For some time now, rising inequality and declining living standards for all but the wealthiest Americans have been political and economic con-cerns. In *The Death of the Artist*, Deresiewicz, long one of the nation's foremost literary critics, makes a compelling case that these trends have led to an artistic crisis as well, one that is easy to miss because its most dire consequence may be an absence. It's rare for a critic to turn such a sympathetic and penetrating eye not only to art that is being created—but to that which isn't. But Deresiewicz demonstrates the way our cur-rent system, while it enriches tech giants, impoverishes all but a handful of artists. When the vast majority of artists are unable to support them-selves and focus on their work, we lose what they might have created. It's art itself that is in peril. This is a wise, sensitive, and shrewd book from an author who has proved himself to be essential, not only as a critic of art but of the society that produces it."

　　　　　　—**Adelle Waldman, author of *The Love Affairs of Nathaniel P.***

"In *The Death of the Artist*, cultural critic Bill Deresiewicz pulls no punches. Through intimate portrayals of the lives of working artists, he lays bare how gentrification, Big Tech, and unbridled capitalism are sucking artists dry. He then doubles back on the historically flawed relationship between art and money, mounting a convincing moral argument that it is unacceptable to reap huge profits from artists' works while paying next to nothing for them. Incisive, revealing, insistent, and inspiring, *The Death of the Artist* is a love letter to the beauty and new truths which enrich us—art itself—and a rallying cry for those who produce art in order to stay alive."

—**Julie Lythcott-Haims,** *New York Times* **bestselling author of** ***How to Raise an Adult*** **and** ***Real American***

"Deresiewicz is a provocateur who challenges the status quo and myths surrounding the relationship of artists to work and money. He is an excellent and curious guide, leading readers with both an empathic gaze and a kind of fearlessness that should leave anyone interested in the subject wide awake and a bit shaken."

—**Liz Lerman, MacArthur Award–winning choreographer**

"William Deresiewicz's excellent new book, *The Death of the Artist*, offers a lively, candid, and sobering account of what it's like to be any kind of artist in America today. The fact is that they are starving: revenues that once went to creators now go to tech companies, and creators can barely survive. Their future may depend on collectives like the Authors Guild, who have supported writers on a national level for over a century. Bravo to Deresiewicz for showing us the extent of this crisis in the arts."

—**Roxana Robinson, author of** ***Dawson's Fall*****, and former president of the Authors Guild**

"*The Death of the Artist* is the most important assessment of the state of the arts economy in over fifty years and a masterful handling of the artist's central role in that economy as it has evolved over time. The narrative style is honest, direct, reader friendly, and personally engaged. With his many interviews and individual case studies, Deresiewicz does a terrific job of giving voice to artists. The results are daunting, inspiring, and, dare I say, loving. His empathy and respect for artists will be a

comfort as he leads them to the few hopeful pathways of survival left. I applaud his call for diversity, arresting appraisal of the consequences of gentrification, and devastating exposure of the lie that tech is a panacea for the arts. That he not only indicts the culture that 'kills' artists but also helps artists understand the options available to them makes this book an indispensable beacon."

—Susan Solt, former movie producer (*Doc Hollywood, Presumed Innocent*), former dean of theater at CalArts, and distinguished professor and former dean of the arts at UC Santa Cruz

THE DEATH OF
THE ARTIST

THE DEATH OF THE ARTIST

HOW CREATORS ARE STRUGGLING TO SURVIVE IN THE AGE OF BILLIONAIRES AND BIG TECH

WILLIAM DERESIEWICZ

A HOLT PAPERBACK

HENRY HOLT AND COMPANY

NEW YORK

Holt Paperbacks
Henry Holt and Company
Publishers since 1866
120 Broadway
New York, New York 10271
www.henryholt.com

The Library of Congress has cataloged the hardcover edition as follows:

Names: Deresiewicz, William, 1964– author.
Title: The death of the artist : how creators are struggling to survive in
 the age of billionaires and big tech / William Deresiewicz.
Description: First edition. | New York, New York : Henry Holt and Company,
 2020. | Includes bibliographical references and index.
Identifiers: LCCN 2020002961 (print) | LCCN 2020002962 (ebook) |
 ISBN 9781250125514 (hardcover) | ISBN 9781250125521 (ebook)
Subjects: LCSH: Artists—Economic conditions—21st century. |
 Arts—Economic aspects. | Creation (Literary, artistic, etc.) |
 Entrepreneurship. | Art and business. | Art and the Internet.
Classification: LCC N8353 .D47 2020 (print) | LCC N8353 (ebook) |
 DDC 700.1/03—dc23
LC record available at https://lccn.loc.gov/2020002961
LC ebook record available at https://lccn.loc.gov/2020002962

ISBN: 9781250798794

Our books may be purchased in bulk for promotional, educational, or business
use. Please contact your local bookseller or the Macmillan Corporate and
Premium Sales Department at (800) 221-7945, extension 5442, or by e-mail
at MacmillanSpecialMarkets@macmillan.com.

Originally published in hardcover in 2020 by Henry Holt and Company

First Holt Paperbacks Edition 2022

Designed by Meryl Sussman Levavi

Printed in the United States of America

1 3 5 7 9 10 8 6 4 2

To Jill

CONTENTS

PART I

THE BASIC ISSUES

INTRODUCTION

This is a book about art and money and the relationship between the two and how that relationship is changing and in turn changing art. It is a book about how artists—musicians, writers, visual artists, creators of film and television—are making a living, or struggling to, in the twenty-first-century economy.

A few vignettes:

Matthue Roth is a Hasidic Jewish memoirist, young adult novelist, children's book author, short story writer, slam poet, video game designer, blogger, zinester, columnist, and screenwriter who once dated a non-Jewish sex worker, performed on Broadway with *Def Poetry Jam*, and became the only male member of Sister Spit, a feminist spoken-word collective in San Francisco, where he'd make Shabbos dinner for the riot grrrls. His books carry titles like *Yom Kippur a Go-Go*, *Never Mind the Goldbergs*, and *My First Kafka* (one of the children's books). A sweet, almost childlike man, Roth composes in little notebooks during his hour-long commute between Manhattan and Brooklyn, where he lives with his wife and four children. If he gets an idea on the Sabbath (and he gets ideas all the time), he has to wait until dark to write it down.

Most of what Roth does earns little or no money. When he sold his first novel for $10,000 in 2004, the sum was roughly twice as much as he had made the year before. In 2016, after working for a Jewish website producing video content, an EdTech company creating video games, and Sesame Workshop writing science-related sketches, Roth responded to

a blind posting on the Facebook page of a small New York–area game-writers group. It turned out to be for a job at Google. As a creative writer. His first position there was as a member of the "personality team" for Google Assistant, writing lines of dialogue and devising "Easter eggs"—surprise bonuses and jokes.

"Once I got the Google job, a lot of my friends were like, 'Oh, you've hit easy street,'" Roth told me, "and I thought I had for about a week and a half." But the job turned out to be contract work, with no benefits: good money for his young, single coworkers, less so for someone whose family spends about $30,000 a year on health insurance. His position was renewable for three to six months at a time, limited by state law to a total of two years. When we spoke, he was up to a year and a half. He was also facing down another benchmark. "Almost thirty-nine and a half," he replied when I asked for his age. "I'm getting less young every day." Roth went on to compare himself to the "Ocean of Notions," the storyteller in Salman Rushdie's children's novel *Haroun and the Sea of Stories*, whose "idea spigot runs dry" one day. "I'm scared shitless that my brain's going to turn off or that I'm going to get too afraid to constantly come up with new and exciting ideas," he said—and thus that, on the brink of midlife, he will become unemployable as a creative person.

Lily Kolodny (not her real name) is, by any reasonable standard, a successful young illustrator. Her charmingly childlike style has won her commissions from Penguin Random House, HarperCollins, the *New York Times*, the *New Yorker*, and many other well-known publishers and publications. "My friends would always say to me, 'You're so lucky, you've found the thing that you're supposed to be doing,'" she told me. "And when I do feel talented, and I feel like I'm in the flow, I'm like, I know how to do this. I *should* be doing this."

At the same time, Kolodny is consumed by financial anxiety. "I've always just survived," she said. "I don't have any savings, really." When I asked her what her "nut" was—the number, in dollars, that she felt that she needed to get to each year—she said, "I don't have a number, but that's because I've been postponing the idea of having a number. It's been hard for me to visualize the future." Things had actually been looking up for her a bit around the time we spoke. In recent months, she had engaged in "conscience-free eating out" on several occasions, and had "bought a few things," and was no longer constantly checking her bank

account to see if the rent would clear. She was also working with an agent on a project that she hoped would bring her career to the next level, an "impressionistic semi-fictional illustrated memoir," as she described it. "I've thought of it as my get-rich-quick scheme," she said. "But it's not very quick," she laughed, "it's very slow.

"For me, that's the golden egg," Kolodny explained. "If that crashes and burns, then I have to assess everything." And what would that assessment look like? What else could she do instead? Plan B would be teaching, ideally art but anything, if necessary. Plan C would be any job at all. "Everyone I know," she said, "if they're not in a nine-to-five job, or they're not a trustafarian, they're a yoga teacher, or an Uber driver, or a nanny." It would be hard for her, after all these years, "to turn to something like that, that's so disconnected from my trade." But Kolodny, who was thirty-four at the time we spoke, also knew that she was reaching a decision point. "It's not sustainable," she said about her situation, "especially if I want to have a kid. Well, actually, if I want to have a kid—I *do* want to have a kid."

Martin Bradstreet was twenty-nine when he got to live out his musical dreams. Bradstreet, who grew up in Australia and lives in Montréal, was the founder of the rock band Alexei Martov. (Their music can best be described as loud.) The band built a following around Montréal with shows that they promoted on Facebook. Then, in 2015, Bradstreet decided to put together a tour. For a musician like him, he told me, that's what success *is*: "touring around in a van, playing songs you worked on with your friends," expressing something meaningful to total strangers.

So Bradstreet got online, searched for bands that were similar to his, and looked at tour schedules, hundreds of them, to identify the venues where those bands had played. Then he went on Indie on the Move, a database of venues, for contact information. Places are more likely to book you, he said, if you approach them with a full program already lined up—meaning you plus a couple of local acts—so he'd look up, say, eighty bands in Louisville and listen to their music to find the most compatible ones to reach out to. Then, he said, "you've got to work out how to promote a show in a city you've never been to, at a venue you've never played at, with bands you don't know," which he did, in part, by getting the venues to give him their media contacts so he could approach the latter directly.

Yes, Bradstreet agreed, it's a lot of work, but thanks to the Internet, all you need to tour is work. You're going to lose money at first, he explained, but money wasn't the point for him. (Bradstreet was supporting himself on his savings from online poker and, as he put it, "other investments.") He would have liked to get to the next level—a publicist, a booking agent, a record deal—but, he said, "there are a lot of really talented me's out there." By the time we spoke, Bradstreet had moved on to other pursuits. "It does seem like playing music for a living would be a nice thing to have done," he said, growing wistful, "but it's tough to fit everything together especially in modern life as you get older." Still, he had no regrets. Of the tour's roughly fifty shows, he said, "half are amongst the best hundred nights of my life."

Micah Van Hove is a self-taught independent filmmaker from Ojai, California. Van Hove did not go to film school or even college. His work, he told me, has been "entirely enabled by the Internet" and what he's been able to learn there. For him, if television is like fiction, film is like poetry. "It's about communicating as much as possible in the least amount of time," he said. "There are just certain moments in life that seem to be all-encompassing, or the smallness of something hints at the infinite sprawl of the human experience, and I've always been interested in those moments, because they happen at the weirdest, most random times."

He learned, he told me, by doing, by "falling face first into it." On the first day of shooting his first short, he brought his camera but forgot the lens. His first feature, which he financed on Kickstarter, the crowd-funding site, and made for about $40,000, a "micro-budget" sum, took five years. Van Hove, who grew up poor, had been crashing with friends for most of the previous decade and often still found himself sleeping on floors. He would have been happy to live with his mother, but she was worse off than he was. "It depends on what you can sacrifice," he said. "I can sacrifice having a roof over my head. Most people can't give that up, and it cripples them."

When we spoke, Van Hove was just completing his second feature, having been up doing edits until 5:00 a.m. the night before. He was planning to submit the film to as many festivals as he could afford the entrance fees for, maybe ten to twenty. "I'm on the precipice of seeing if everything I've learned is going to work," he said. Yet he felt ready to take the next

step—writing a solid script and piecing together some real financing, on the order of $500,000—"and people can sense when you're ready." What keeps him going? I asked. "I'm about to be thirty," he said. "I made a decision nine years ago that I was going to be doing this for the rest of my life. I went all in, and I'm all in." Now it was about discovering what he had to contribute. "Because I do see it as a lineage," he said. "We observe the art that came before us, and we secrete it in our own way as a way to talk about the world and shape the world."

* * *

There are two stories you hear about making a living as an artist in the digital age, and they are diametrically opposed. One comes from Silicon Valley and its boosters in the media. There's never been a better time to be an artist, it goes. If you've got a laptop, you've got a recording studio. If you've got an iPhone, you've got a movie camera. GarageBand, Final Cut Pro: all the tools are at your fingertips. And if production is cheap, distribution is free. It's called the Internet: YouTube, Spotify, Instagram, Kindle Direct Publishing. Everyone's an artist; just tap your creativity and put your stuff out there. Soon, you too can make a living doing what you love, just like all those viral stars you read about.

The other story comes from artists themselves, especially musicians but also writers, filmmakers, people who do comedy. Sure, it goes, you can put your stuff out there, but who is going to pay you for it? Digital content has been demonetized: music is free, writing is free, video is free, even images you put up on Facebook or Instagram are free, because people can (and do) just take them. Everyone is *not* an artist. Making art takes years of dedication, and that requires a means of support. If things don't change, a lot of art will cease to be sustainable.

I'm inclined to believe the artists. For one thing, I don't trust Silicon Valley. They have billions of reasons to promote their particular narrative, and it's clear by now they're not the model corporate citizens they like to claim. For another, the data support the artists, who are also, after all, in the best position to know about their own experience.

Still, people *are* still making art. More people than ever, in fact, as the techies like to point out. So how are they managing to do it? Are the new conditions tolerable? Are they sustainable? Are they more democratic—that "even playing field" the Internet was meant to give us? How are

artists adjusting? How are they resisting? How are they thriving, those of them who are? What does it mean, in specific practical terms, to function as an artist in the twenty-first-century economy?

The twenty-first-century economy: that means the Internet and all it's wrought, for good and ill, but it also means rental costs, for housing and studio space, that are galloping ahead of inflation. It means soaring tuitions for college and art school and, with them, soaring student debt. It means the growth of the gig economy, coupled with the long-term stagnation of wages, especially for the kind of low-end day-job service work that younger artists, in particular, have long resorted to. It means globalization: globalized competition, globalized capital flows. Many of us who are not artists, maybe most of us, are also facing these facts or soon will. Artists were among the first, and they've been hit among the worst.

* * *

Being an artist, people might argue, has always been hard. Sort of—that "always" goes back only so far—but for whom, exactly, has it been hard? For younger artists, who are still trying to establish themselves; for artists who aren't very good, of whom there is never a shortage; for those who are good but who never manage to find an audience, to find success. The difference now is that it's hard even if you *do* find success: reach listeners or readers, win the respect of critics and peers, work steadily and full-time in the field. I spoke about these matters with Ian MacKaye, frontman of the hardcore bands Fugazi and Minor Threat and a leading figure in the indie music scene since the early 1980s. "I know plenty of filmmakers," he said, "who poured their heart and soul and all their money into projects long before the Internet who lost their fucking ass, because not enough people wanted to see their movie." And that is as it should be. The problem now is that you often lose your fucking ass even if enough people do want to see your movie, read your novel, listen to your music.

Being an artist has always been hard, but there is hard and hard. *How* hard matters. How hard affects how much you get to do your art, as opposed to grinding at your day job, and therefore how good you become, as well as how much you are able to make. How hard affects who gets to do it in the first place. The less you can earn from your art, the more you must rely on other sources of support, like Mommy and

Daddy. The less money there is in the arts overall, the more they become a rich kid's game. And wealth correlates with race and gender. If you care about diversity, you need to care about economics. The idea that "people will do it anyway"—that if you're a real artist you'll make art no matter what—can be the product only of naïveté or ignorance or privilege.

If many of us are oblivious to the plight of artists in the contemporary economy, there is an obvious reason for that. Not only is there a lot of art being made, there is much, much more of it, at lower cost, than ever. For consumers of art, there really hasn't ever been a better time—at least, not if you equate quantity with quality, or do not worry overmuch about the workers at the other end of the supply chain. First we had fast food, then we had fast fashion (low-cost, disposable clothing made by poorly paid workers in places like Vietnam and Bangladesh), now we have fast art: fast music, fast writing, fast video, photography, design, and illustration, made cheaply and consumed in haste. We can gorge ourselves to our heart's content. How nourishing these products are and how sustainable the systems that create them are questions that we need to ask ourselves.

* * *

How artists get paid (and how much) affects the art they make: the art we get to experience, the art that marks our age and shapes our consciousness. This has always been the case. Art may be timeless, in the sense that it transcends its time, but art, like every other human thing, is also made in time, conditioned by the circumstances under which it is brought into being. People prefer to deny this, but every artist understands it. We get more of what we support, less of what we don't. Art that is truly original—experimental, revolutionary, new—has always been a marginal affair. In good times for the arts, more of it gets dragged across the line of viability, where it is able to survive—where the artist can stick around and keep doing it—until it can be recognized. In bad times, more of it gets dragged the other way. What kind of art are we giving ourselves in the twenty-first century?

The people who pay for art are the ones who determine, directly or otherwise, what is produced: Renaissance patrons, nineteenth-century bourgeois theatergoers, the mass audiences of the twentieth century, public and private funding bodies, sponsors, collectors, and so forth. The twenty-first-century economy not only has sucked a lot of money out of

the arts, it has also moved it around in ways that are unpredictable and not by any means all bad. New financial sources have arisen, most notably crowdfunding sites; old ones are making a comeback, like direct private patronage; existing ones are getting variously stronger, like branded art and other forms of corporate sponsorship, or weaker, like academic employment. All this is also changing what gets made.

My largest interest in this book is to delineate those changes. The Internet allows unmediated access to the audience—and to the artist. If it starves professional production, it fosters the amateur kind. It favors speed, brevity, and repetition; novelty but also recognizability. It puts a premium on flexibility, versatility, and extroversion. All of this (and a great deal more) is changing what we *think* of art, as well: changing what we think is good, changing what we think is art.

Will art itself survive? I don't mean creativity, or making stuff—playing music, drawing pictures, telling stories. We have always done those things and always will. I mean a particular notion of art—Art with a capital A—that has existed only since the eighteenth century: art as an autonomous realm of meaning making, not subordinate to the old powers of church and king or the new powers of politics and the market, beholden to no authority, no ideology, and no master. I mean the notion that the artist's job is not to entertain the audience or flatter its beliefs, not to praise the Lord, the group, or the sports drink, but to speak a new truth. Will *that* survive?

I talked with the musician Kim Deal, another longtime icon of the indie music scene. (Her bands include the Pixies and the Breeders.) Deal was raised in Dayton, Ohio, and lives there, in her fifties, once again. With no self-pity, she compared herself to the kinds of workers she grew up among in the industrial Midwest—increasingly, the postindustrial Midwest. "I'm an autoworker," she told me. "I'm a steel man. I'm just another person in the history of the world where their industry has become archaic, and it's gone." Except that music isn't like coal mining, or buggy-whip manufacture. We can live without buggy whips; we've found alternatives to coal. Music cannot be replaced. How much time during an average day do you spend consuming art? Not just visual-art art; not just high-art art; *all* art: narratives in books, narratives on television, jazz on the stereo, songs in your earphones, paintings, sculptures,

photographs, concerts, ballet, movies, poetry, plays. Several hours a day, no doubt. Given the way that people listen to music at this point, possibly every waking minute.

Can we live without artists, professional ones? The tech evangelists would have us think so. We've returned, they insist, to the golden age of the amateur. Folk production, just like in the good old days. So of all that art that you consume, how much is actually created by amateurs? Other than your roommate's band, probably not very much. Have you seen your cousin's improv troupe? Is *that* the only kind of art you want to have available, not only for the rest of your life but for the rest of foreseeable history? Yes, you'll have access to everything, but what will you have access *to*? Someone else's roommate's band? Great art, even good art, relies on the existence of individuals who are able to devote the lion's share of their energy to producing it—in other words, professionals. Amateur creativity is no doubt a wonderful thing for those who engage in it. It should not be confused with the genuine article.

* * *

One of the more egregious examples of the techno-Pollyannaish line (and, among musicians, one of the most notorious) was published by Steven Johnson, a prominent writer on science and media theory, in the *New York Times Magazine* in 2015. The article, "The Creative Apocalypse That Wasn't," rested on some very general (and poorly interpreted) data sets to argue that, guess what, there's never been a better time to be an artist. In a response, "The Data Journalism That Wasn't," Kevin Erickson, director of the Future of Music Coalition, a research and advocacy group, dismantled Johnson's argument brick by brick and then went on to say this: "If you want to know how musicians are faring, you have to ask musicians, preferably a whole lot of them. You'll get different answers from different musicians, and they'll all be correct in terms of their own experiences. But your overall understanding will better reflect the complexity of the landscape."

So that's what I did. I asked musicians, a whole lot of them—and novelists and memoirists and poets and playwrights, people who make documentaries and fiction films and television shows, painters and illustrators and cartoonists and conceptual artists. This book is based on roughly 140

lengthy formal interviews, and many informal conversations, with teachers, journalists, and activists; producers, editors, and dealers; consultants, administrators, and deans—but mostly with artists.

Stories of individual artists tend to take one of two forms. There are those tales of viral success that serve as propaganda for Silicon Valley: people like Chance the Rapper, who won a trio of Grammys without a record deal, or E. L. James, who spun her *Twilight* fanfic into *Fifty Shades of Grey*. Then there are, as there long have been, biographies and profiles of, or interviews with, successful artists of every variety. The latter are perfectly unobjectionable; we want to know more about these extraordinary individuals, including their ordinary origins and early struggles. But between the two genres, every story we hear about artists is a success story, and in every one, success appears to be inevitable, because it has already happened. Our ideas about the lives that artists live are distorted by a huge selection bias. The vast majority of artists, even of lifelong working ones—already a small percentage of the total—do not become rich or famous. It is those kinds of people I sought out to talk to: not the unicorns who've made it big, but artists like the writer Matthue Roth, the illustrator Lily Kolodny, the musician Martin Bradstreet, and the film-maker Micah Van Hove. The bulk of my interview subjects, moreover, were younger practitioners, between the ages of about twenty-five and forty: people who are making their careers in the contemporary economy, and whose stories therefore have the most to say about the challenges of doing so.

A word about those interviews, which were the most rewarding and certainly the most moving part of writing this book. I decided to conduct them by phone rather than in person, because I sensed that the former arrangement—which would relieve my subjects of the self-consciousness of a face-to-face encounter—would make for more candid, more honest, less guarded interactions. And so it proved to be. I asked my subjects for an hour of their time. Invariably, the conversations ran long. Often, we'd stay on for an hour and a half, even two hours, as these individuals unfolded the most sensitive details of their financial lives. And at the end, it was often *they* who thanked *me*. People want to be heard. They want to tell their stories. I was humbled by the trust these strangers placed in me, and I can only hope, in the pages that follow, to have proven to be worthy of it.

* * *

I come to this project as both an outsider and an insider. I'm a writer, but I'm not an artist. (I like to describe the kind of work I do as noncreative nonfiction, if only because I believe that it's important that there be at least one person in the world today, when "creativity" is the word on everybody's lips, who stands up proudly and declares, "I am not creative.") But for the last twelve years, I have also been a full-time freelance. In broad practical terms, my situation resembles my subjects'.

My life not in but near the arts began one day in 1987 when I walked into Tobi Tobias's dance criticism class at Barnard College. (I was doing a master's in journalism across the street at Columbia.) For the first assignment, Tobi didn't send us to the theater. She sent us into the world, to simply look at people move. Look, and describe. That course changed my life. I learned that I had never seen the world before, because I'd never bothered to, and I also learned that that is what art and loving art are about: not being a snob, not distracting yourself, but seeing what's in front of you. Finding out the truth.

That course really did change my life. It was the reason I decided, later that year, to go back to graduate school to study English literature, as I had always wanted to do (I had been a science major), and it was also the reason I became a critic: a dance critic in New York for ten years, then a book critic for about the last twenty. For the first ten of those twenty, I was also an English professor. I've been thinking about art my entire adult life.

Only once I was well into working on this book did I recognize its continuities with my previous one, about elite college education and the system leading students up to it. Both are about what our brutally unequal economy is forcing young people to do and be. Both are about the survival of the human spirit under the regime of that economy. Yet there is one big difference between the two projects. In my book about college, I largely avoided the question of money, because I wanted my readers to think about what else an education might be for. But money is the only thing that people want to think about when it comes to college these days. This book faces the opposite problem. It is all about money, and money is the last thing people want to think about when it comes to art. Why that is is where we need to start.

ART AND MONEY

According to the common way of thinking, a chapter with the title this one carries should be very short. One sentence, really: art has nothing to do with money, must have nothing to do with money, is defiled by contact with money, is degraded by the very thought of money.

These articles of faith are actually of relatively recent birth. In the Renaissance, when artists were still regarded as artisans, no one thought twice about exchanging art for cash. Artists worked to contract, with terms that specified, as the sociologist Alison Gerber puts it in *The Work of Art*, the particulars of "subject matter, size, pigment, time to delivery, and framing." It was only in modernity, with the emergence of capital-A Art—art as an autonomous realm of expression—that the notion arose that art and commerce were mutually exclusive. As traditional beliefs were broken down across the eighteenth and nineteenth centuries—by modern science, by the skeptical critique of the Enlightenment—art inherited the role of faith, becoming a kind of secular religion for the progressive classes, the place where people went to meet their spiritual needs: for meaning, for guidance, for transcendence. Like religion before it, art was regarded as superior to worldly things. You cannot serve both God and mammon.

As with art, so with artists, the new priests and prophets. It was modernity that gave us the bohemian, the starving artist, and the solitary genius—images, respectively, of blissful unconventionality, monkish

devotion, and spiritual election. Artistic poverty was seen as glamorous, an outward sign of inner purity.

To these ideas, the twentieth century added an overtly political and specifically anti-capitalist dimension. Art did not just stand outside the market; it was meant to oppose it: to join, if not to lead, the social revolution, which first of all would be a revolution of consciousness. And "the master's tools," as Audre Lorde famously wrote, "will never dismantle the master's house." To seek acceptance in the market was to be "co-opted"; to chase material rewards, to be a "sellout."

So the case remains today. Words like "career" and "professional," to say nothing of "property" (as in "intellectual property"), are widely seen as suspect in the arts. In music, people speak about the "indie code," which includes disdain for money and success; if you make it as a band, I was told by Martin Bradstreet, you are, by definition, no longer indie. Serious visual art—the art of the "art world"—regards itself as a form of anti-hegemonic critical discourse. In his preface to an anthology of recent writing from the *Paris Review*, the nation's flagship literary journal, Lorin Stein, then the publication's editor in chief, deplored the idea that fledgling writers might be encouraged to think of themselves as professionals; the collection's title, in fact, is *The Unprofessionals*. In his study *The Gift*, Lewis Hyde insists that the work of art belongs within a "gift economy," not a system of commodity exchange. The book, a modern classic, remains a touchstone for artists nearly forty years after publication.

Such ideas are as fervently held among laypeople as they are among artists—if anything, more so. We don't want the musicians we love to think about money, as one of my interview subjects remarked, and we don't want to think about them thinking about it. Works of art do indeed exist in the realm of the spirit. In their purity and immateriality, their intensity of being, they give us a taste of the Garden, that unfallen state in which we believe our souls to have their proper home. And so we want our artists to be as pure as the art they create. We want them to behave as if the market, with its entanglements, does not exist. Or perhaps it is more precise today to say, as if it no longer exists: as if we had reached the condition, after the end of capitalism, of which so many now dream.

* * *

These are beautiful ideals, but they are, precisely, ideals, which must inevitably compromise when entering the world. Art may exist in the realm of the spirit, but artists do not. They have bodies as well as souls, and bodies make their gross demands. In plainer language, artists have to eat. *The Gift* is inspiring—to stay for a moment with that book, which has shaped so many people's thinking on the subject—but it is telling that Hyde's examples come exclusively from folktale, anthropology, poetry, and myth, with scarcely a word about the actual history of the relationship between art and money.

Hyde's book hides the truth: gift economies are always sustained by underlying systems of support that ultimately depend, at least in modern societies, upon the market. That includes the one of which Hyde is, and I was, a member: academia. Hyde believes that science is a gift economy (as is, by extension, scholarship in general) because scientists do not receive payment for publishing their work. But of course they do: indirectly, from their universities, in the form of the jobs they get to keep, or the raises and promotions they receive, for being academically productive. Prestige is negotiated, under the table, for cold coin: the more prominent a scholar is, the more he or she tends to get paid. Universities, in turn, are funded by tuition, grants, taxes, and other monies, all of which are ultimately generated by the market.

I saw this kind of mystification all the time in academia, especially when graduate students at my institution sought to form a union (because, like artists, they were getting screwed). One tenured professor—he owned a very fancy house, and a very fancy second house—would practically clutch his pearls at any talk of money in relation to the work that academics do. Money: what money? Money: how vulgar! We work for the love of it, the idea was, and the university rewards us out of its own high-minded generosity. Nothing to do with the market at all.

So it is in the arts, another realm replete with left-leaning professionals and the nonprofit institutions through which they earn their livings. Status, accumulated through a system of credentialing, is convertible, at one remove, to cash. A writer may earn nothing from her poetry collection, likely published by a nonprofit press, but it will help her win a faculty position. A museum show pays nothing to the sculptor, but it raises the prices his dealer can charge. Grants, awards, residencies, lectures, commissions: all are ways that institutions launder money—often

received from very rich donors, who didn't make it playing patty-cake—for artists. You aren't paid for *selling* anything, God forbid, just for being who you are and doing what you do.

False consciousness, also known as denial, shades over into hypocrisy. Katrina Frye is a young photographer who became a consultant—in effect, a career and life coach—for artists of all kinds in the Los Angeles area. "Stop BS-ing yourself," she tells her clients. "Don't pretend you're selling your soul by trying to make something commercial. Guess what, you already are" making something commercial. The film director Mitchell Johnston (not his real name) told me this about the leading venue where Hollywood scouts for new talent: "Most people at Sundance are independent looking to become dependent." Such posturing is endemic to the art world, where questions of money are particularly fraught, given the close adjacency of revolutionary rhetoric to small mountains of cash. "It is important to create the illusion that it's not a business," says one anonymous contributor in *I Like Your Work: Art and Etiquette* (a pamphlet published by the indie art press Paper Monument), "and that your relationships do not exist to serve your career." Artists like Andy Warhol and Jeff Koons, in naughtily flaunting their interest in money, writes the Dutch economist Hans Abbing in *Why Are Artists Poor?*, exemplify a common refinement: "By being ironic about what lies at the core of the arts, the art world playfully consolidates the denial of the economy."

You can also just lie. If artists don't talk about money, that's often because they'd rather not discuss their own, especially if it has come to them from parents or spouses. There's a great deal of privilege, financial and otherwise, across the arts, as well as a strong desire to conceal it. The writer Sarah Nicole Prickett, who grew up middle class in London, Ontario, has talked about the kinds of lives she discovered upon entering the New York literary world, individuals with "secret money" and "calm cool expectations." In her essay "'Sponsored' by My Husband: Why It's a Problem That Writers Never Talk about Where Their Money Comes From," the novelist Ann Bauer mentions two acclaimed authors, one "the heir to a mammoth fortune," one who was raised in the lap of the literary establishment. Both lied by omission—in front of large audiences, and in response to young, impressionable questioners—about the advantages that had helped them achieve their success. Talking about your trust fund or your sweet connections, the feeling seems to be—or about the way you

had to hustle, network, and throw a few elbows—would undermine the impression that you earned it all through your own awesome specialness.

In the ultimate form of disingenuousness, images of artistic purity are themselves deployed as marketing strategies. The dodge has been common in music since at least the 1960s. Poverty is authenticity, and authenticity is everything. Bands will take limos to photo shoots where they dress up as bohemian vagabonds. As for the art world, Hans Abbing writes, "It is often commercial to be a-commercial. Expressing anti-market values can add to one's success in the market." Money isn't absent in the arts; it is dissembled.

* * *

The principal victims of this conspiracy of pious make-believe are the artists, typically young ones, who are too ingenuous to spot the double game. If artists are often naïve about money, that's because they've been told not to think about it. If they are often helpless when it comes to managing their careers, that's because they've been instructed to regard "career" as a dirty word. The major thing, Katrina Frye told me, that she needs to teach her clients—who often come to her, still in their twenties, already jaded and burnt out from being shafted for so long—is to lower the psychological barriers to earning their living as artists, to silence the inner voices. "All this judgment about money and art," she tells them, "it's all fake. It's made up."

I cannot think of another field in which people feel guilty about being paid for their work—and even guiltier for wanting to be. The writer Adelle Waldman, who had a surprise hit with her debut novel, *The Love Affairs of Nathaniel P.*, told me that she felt lazy about living, for the moment, off the proceeds, even though she wasn't paid a penny for all the years it took her to write the book (and even though she was continuing to write). Sammus is an Afro-futurist MC and rapper in her early thirties. She told me that the first time one of her CDs received any traction (it sold about three hundred copies on the online music platform Bandcamp), she had so much anxiety about asking for money for it that she put it up for free on SoundCloud a week later. Lucy Bellwood took a gap year at the age of sixteen, during which she went to sea on a full-scale replica of a Revolutionary Era sailing vessel; later, she launched her career as a professional cartoonist by documenting the experience in a charming

book-length comic called *Baggywrinkles: A Lubber's Guide to Life at Sea*. Bellwood has delivered an entire talk about her tormented relationship with money: her fear of lifelong poverty; her shame about having taken food stamps; her hard-won realization—she pronounces the words as if the notion were taboo—that "you're allowed to want" "the stability of a reasonable income." You can't win as an artist, she suggested: either you're a fraud because you aren't making enough from your work or you're greedy because you are making too much. "Too fat, too thin; too tall, too short": whichever way you turn, the world will bombard you with judgments.

The effects are not just psychological. Bellwood talked about her shame about negotiating for higher fees, and she is hardly alone. The illustrator Andy J. Miller (who goes professionally by Andy J. Pizza) has devoted himself—through his podcast, *Creative Pep Talk*, as well as through classes, talks, and books—to educating artists about the realities of career. In his own industry, he told me, he sees "all these artists who have all this baggage with money, underselling themselves, while the people that are smart with money are profiting from them." The indie code in music appears to include being okay with being ripped off—not being paid for a gig, or not as much as you were promised. (Hey, you didn't do it for the money, right?) Because writers and other artists *do* create for nonmaterial reasons, I was told by Mark Coker, the founder of the e-book distribution platform Smashwords, "these people are ripe for being exploited." That exploitation can take many forms: from outright theft; to self-sabotage like Bellwood's; to the monetization of digital content without appropriate compensation; to the underpayment by arts organizations, including nonprofits, of the artists who work for them. But at its root is the perception that artists shouldn't ask for money in the first place—that, as another of my subjects put it, "art should just be art."

* * *

Art is work. The fact that people do it out of love, or self-expression, or political commitment doesn't make it any less so. Nor does the fact that it isn't a job, a matter of formal employment. Chefs often do what they do out of love, but no one expects to eat for free. Organizers do it from political commitment, but they are compensated for their time. Self-employment is still employment. Even if you do not have a boss, it's work.

If art is work, then artists are workers. No one likes to hear this. Nonartists don't, because it shatters their romantic ideas about the creative life. Artists don't either, as people who have tried to organize them as workers have told me. They also buy into the myths; they also want to think they're special. To be a worker is to be like everybody else. Yet to accept that art is work—in the specific sense that it deserves remuneration—can be a crucial act of self-empowerment, as well as self-definition. In "With Compliments," her contribution to the volume *Scratch: Writers, Money, and the Art of Making a Living*, the journalist-turned-carpenter-turned-memoirist Nina MacLaughlin speaks of learning to reject the idea that praise, opportunity, and exposure are adequate forms of compensation for writing, any more than they would be for building a house. "People wonder when you're allowed to call yourself a writer," she concludes. "I think maybe the answer is when you recognize that it is work."

Art is hard. It never just comes to you. The idea of effortless inspiration is another romantic myth. For amateurs, making art may be a form of recreation, but no one, amateur or professional, who has tried to do it with any degree of seriousness is under the illusion that it's easy. "A writer," said Thomas Mann, "is someone for whom writing is more difficult than it is for other people." More difficult, because there is more for you to do, more that you know how to do, and because you hold yourself to higher standards. It would be very easy for me to draw you a picture, because I don't know how to draw. It also wouldn't be any good, and I wouldn't expect you to pay me for it. Sammus, the Afro-futurist rapper, changed her mind about charging for her music as she put more and more into it. "The idea of valuing my art—that became real," she told me: "putting a price on the things that I've created," finding a monetary equivalent for "sleepless nights and anxiety and all of the relationships that working on music for that amount of time had cost me. Now I absolutely feel comfortable putting a dollar amount on my work."

Art has value. It ought to have financial value. No, people don't deserve to get paid for doing something they love—an argument you often hear in connection with issues like piracy—but they do deserve to get paid for doing something *you* love, something other people love. That's how markets work, by putting a price on other forms of value. Wanting to get paid does not mean that you're a capitalist. It doesn't

even mean that you assent to capitalism. It only means that you live in a capitalist society. No one could be a better leftist than Lise Soskolne, the head of W.A.G.E. (Working Artists in the Greater Economy), which organizes for the fair compensation of artists, studio assistants, and other workers in the art world, but the group's manifesto calls for "the remuneration of cultural value in capital value." The writer and visual artist Molly Crabapple, another exemplary leftist, puts it like this in her essay "Filthy Lucre": "Not talking about money is a tool of class war." Being a leftist is not about pretending that the market does not exist; it's about working within it, as long as it exists, for economic justice—for people to be paid, not as little as their bosses or their audience can get away with, but as much as their work is worth.

Artists are not in it to get rich. (And if they were, so what? Since when are someone's motives a reason to decide how much to pay them?) The only artists who fantasize about getting rich are newbies and wannabes. The rest know the truth: becoming an artist is usually a choice to make *less* than you otherwise could. Artists persevere, despite financial hardship, because autonomy and fulfillment are worth more to them than wealth. (Which is also not a reason not to pay them.) Even within their careers, they often make decisions not to maximize their income—to forgo opportunities that might be lucrative, at least compared to others, but don't seem very interesting. When artists assert that they ought to get paid, and paid fairly, it's because they want to make a living, not a killing. They want enough to keep doing it. Artists are like other professionals who work from a sense of commitment—teachers, social workers—and who opt for satisfaction over wealth. They still have bills to pay. You don't have to be doing something for the money to want to get money for doing it. You just have to be alive.

* * *

But artists, or some of them, are wrong about one thing. A number of the people I spoke with said that artists (that is, all of them) should be supported by the public: as a practical matter, to address the economic crisis in the arts, and because they deserve it. But they don't deserve it— not just for being artists. Monica Byrne is an award-winning dramatist and science fiction writer whose works include *What Every Girl Should Know*, a play about the fight for legal birth control, and *The Girl in the*

Road, a near-future novel set in India, Africa, and the Arabian Sea. "We just take it for granted," she told me, that "nobody makes a living writing short stories. Why not? It's a full-time job." But it's not a job, not in the sense that anybody asked you to do it. People should get paid for writing stories others want to read, not just for writing them at all. Artists work on spec. You write a story, and then you hope that someone will pay you to publish it. Or you publish it yourself, today, and hope that your readers will pay you directly. You are satisfying a demand that you can't be sure exists, and if it doesn't exist, you're out of luck. Nobody deserves support, public or otherwise, for making something no one wants. Artists, in that respect, are not any different from people who open restaurants or shops, many of which also fail. Being an artist is not a job. In economic terms, it is a business.

With a job, you are paid for your time: daily or weekly or monthly, as the case may be, according to a rate that's calculated by the hour or the year. Your expenses relative to work, with the probable exception of commuting costs, are typically modest. And if you work on commission, or as an independent contractor, you do so under terms that are agreed to in advance, and payment is guaranteed assuming successful performance.

Making art is different. It begins with an investment—often large, often borne entirely by the artist. It is, first of all, an investment of time: a month to complete a painting; two or three years to write and produce an album; three, four, five years to finish a novel. Time, of course, is money—the money it takes to support yourself (and maybe your family) during that time. The investment is also usually financial in a stricter sense, as well. Remember that even a "micro-budget" movie might cost on the order of $40,000 (and often, in fact, a great deal more). Recording an album in any serious way means paying for studio time and personnel, session players, the cost of mastering; one of the musicians I spoke with put her typical total at $20,000. In the visual arts, you pay for tools and materials, which cost a lot, as well as for studio space, which costs even more. And all of this before you know if your investment will produce returns.

Where does that money—that capital—come from? That is always the question. Furnishing an answer, by acting as a source of outside investment, is the most important thing the culture industry does. Publishers offer advances in exchange for a share of future profits, as do

record labels. Film and television studios sign development deals. All of them also defray production costs—editors and book designers; recording studios and engineers; actors, cameras, crew—as well as paying for marketing and publicity. Yes, the culture industry has problems, the main one being that it shuts so many people out. The major labels can sign only a very small percentage of all the musical acts that are out there. Throw in the indies, where advances are tiny in any case, and you still exclude the vast majority of musicians. Before the Internet, such people had nowhere to go. Now we have crowdfunding sites, especially Kickstarter, which focuses exclusively on creative projects and is designed to provide the seed money, the venture capital, that would otherwise arrive as an advance.

But there is one more crucial source of start-up funds for art: art. Working artists float their current projects, at least in part, with the money they made from their previous ones. In music, they call this the album cycle: write, record, release, tour; rest, rinse, repeat. Each album finances the next: the next two or three years of living, including the time where you get to explore and experiment, reflect and grow, take the next step in your journey of development as a songwriter and instrumentalist. Successful musicians aren't "sitting back and collecting royalties," as the anti-copyright cliché would have it. They are working on new material. If they really are getting rich, they are also likely engaged in various forms of pro bono work: playing benefits, engaging in activism, providing mentorship to younger artists, even funding other people's work.

Except that if music is free, or indie films get pirated to death, or book advances shrivel up because of Amazon, the funding cycle breaks. If a project makes nothing, or next to nothing, it isn't going to finance anything. When you buy a CD, you aren't "paying for plastic"—another anti-copyright cliché, one that implies that with digital music there's nothing to pay for. You are paying for the *next* CD, the next download, the next album—the one that doesn't exist yet. Amy Whitaker is a writer and educator who works at the intersection of art and business. "When I teach business to artists," she says in *Art Thinking*, "I often tell them that they are asked to be generous, to put something out there before they get something back." As members of the audience in the age of free content, we are asked to be generous, too. If you give an artist money, they will turn it into art.

* * *

Putting something out there before you get something back: that is not a description of a gift economy. (The whole idea of a gift is that you don't get something back.) It is a description of a market economy. It is what all restaurant owners do when they buy food in the morning and prepare it in the afternoon before they know how many people will arrive to eat it in the evening. It's what the farmer did, when he grew the food. Yes, art is part of the market economy, the cycle of investment and return. We need to stop being childish about this. We need to stop recoiling in horror at the mention, in connection with art, of the terms "promotion," "cash flow," "business model," "lawyer." I have had to learn this lesson myself. I was also a purist, when I started this project. I was also in denial. But how else do we think that art gets made in a society where that's how nearly everything gets made? Do we think the stork just brings it? It's time for us to lose our innocence.

Markets are not evil. They are one of the ways we get our needs met. They are also not synonymous with capitalism, which they predate by several millennia. (Neither is money, ditto.) But you probably aren't against capitalism, either, even if you think you are. (Another lesson I have had to learn about myself.) If you are a Berniecrat, or a New Dealer, or what people usually mean today by a socialist, you are not against capitalism. (That is what Elizabeth Warren had in mind when she called herself "a capitalist to my bones.") You are against unbridled capitalism. You're against greed, and obscene inequality, and piglike profits and incomes, and the control of government by billionaires and corporations, and the reduction of all values to the money value. You think the market needs to be contained and controlled: through legislation, regulation, litigation; by activists and unions and the generous provision of public services. Me too. But you cannot tame the market if you don't acknowledge its existence.

None of what I'm saying here is intended to imply that the relationship between art and money is anything less than fraught, or ever could be. Hyde was not wrong to suggest, in *The Gift*, that the two are fundamentally incongruous—metaphysically, as it were, incommensurate. It isn't so much that they shouldn't touch as that they can't. Works of art can never be commodities, even if we sometimes must treat them as

such. They are vessels of spirit; we can buy the vessel, but the spirit we can never buy. To say that art belongs to the market is not to say that it should, only that, given the world as it is, it must.

And even Hyde at last acknowledges as much. "It has been the implication of much of this book," he writes in his conclusion, "that there is an irreconcilable conflict between gift exchange and the market." But in the course of working out his ideas, he continues, "my position has changed." He has come to see that the two "need not be wholly separate spheres. There are ways in which they may be reconciled, and . . . it is the reconciliation we must seek." Art must enter the market, Hyde says, but it cannot begin in the market—that is, with an eye to the market, an eye to what sells. Artists must realize their gifts according to their gifts; then and only then can they exchange the fruits of their creative labor for the money that enables them to keep creating.

That is my position, as well. Art and artists must be *in* the market but not *of* it. And in that consists a tension that cannot be resolved; it can only be endured. Ambivalence about the market is not a temporary or remediable condition. It is the way we *function* in the market. Or, at least, it is the way we should. Purity is not an option, and the only other choice is purity's antithesis, the cynicism—typically garnished, these days, with a wink of self-reflexive irony—that counsels a happy surrender. Down that road lies Jeff Koons putting images of the *Mona Lisa* on tote bags for Louis Vuitton. Yet the challenge today—as content is demonetized; as rent and student debt explode; as the institutions of culture, nonprofit and for-profit alike, decline and fall—is that it grows increasingly untenable for artists to maintain that necessary tension: to be "in" but not "of," to not have an eye on what sells, to not capitulate. The documentarian Lisanne Pajot put the matter to me like this: "I think what you're exploring in this book is really the center of this whole dilemma—can you make works that are *just* from you, *just* from your soul, *just* something that you need to make," and survive as an artist today?

* * *

It is no coincidence that artists, more and more, are recognizing the importance of talking about money, especially with one another. A number of my subjects spoke of having suffered, early on, because they had swallowed the myths about starving artists who never think about money

and would rather die than compromise their vision for the suits. Many more were willing to reveal the intimate details of their financial lives, they explained, because they believe that it's vital for younger artists, in particular, to hear the truth.

More broadly, the financial crisis of 2008 appears to have become a watershed in discussions about, and activism around, the question of money in the arts. W.A.G.E., Lise Soskolne's group, was founded that year. The Occupy moment in 2011 gave rise to Occupy Museums, which organizes around student debt and other economic issues in the art world. In 2012, John McCrea, frontman of the alternative rock band Cake, founded the Content Creators Coalition (now the Artist Rights Alliance), a musicians' advocacy group. In 2013, the author and editor Manjula Martin founded the website Scratch, from which the anthology of the same name was later drawn, as a place for conversations about writing and money, and the artist and educator Sharon Louden published *Living and Sustaining a Creative Life*, the first in an ongoing series of volumes of personal essays by visual artists. In 2014, a coalition of media companies, labor groups, and individual artists launched CreativeFuture as an advocacy group for the film and television industry (it now includes members from other creative fields). In 2015, the arts journalist Scott Timberg published *Culture Crash: The Killing of the Creative Class*, a book that documents the cataclysmic effect of the digital economy on musicians, journalists, bookstores, record shops, and other individuals and institutions.

My project here builds on these efforts and others like them. Art may be defined as an attempt to make visible that which is invisible. What this book attempts to make visible are the two things that the arts have long concealed about themselves: work and money. The work that isn't supposed to be work, and the money that isn't supposed to be there.

NEVER-BEEN-A-BETTER-TIME (THE TECHNO-UTOPIAN NARRATIVE)

Before we get into the meat of this—the specifics of the ways that artists really are dealing with money in the twenty-first-century economy—we need to talk about the story that's already out there, the one that's put about by Silicon Valley and its fans and allies. Or stories, because the narrative twists and turns in various directions, as its fallacies and falsehoods are exposed.

First they tell you everything is great. "It has never been easier to start making money from creative work," wrote Steven Johnson in "The Creative Apocalypse That Wasn't," that clueless piece of data journalism in the *New York Times Magazine*, "for your passion to undertake that critical leap from pure hobby to part-time income source." (*Easier*, not easy. *Start* making money, but not necessarily much, minus expenses.) Such talk bleeds into the business-guru boosterism of the "creative entrepreneurship" variety, which dates from the 1990s. "Everyone has a chance to stand out," wrote Tom Peters in "The Brand Called You," his 1997 *Fast Company* article that coined the catchphrase. (Though of course not everyone, by definition, *can*.) Gary Vaynerchuk has told us to *Crush It!: Why NOW Is the Time to Cash In on Your Passion*. Timothy Ferriss has promised *The 4-Hour Workweek*; Chris Guillebeau, *The $100 Startup*. See, it's never been easier.

The argument is typically served with a side of cherry-picked success stories—usually the same ones, because there aren't too many to go around. If the topic is music, Chance the Rapper, the guy who won a trio of

Grammys without a record deal, is sure to arrive before long, no doubt escorted by Amanda Palmer, who raised a million-plus on Kickstarter to produce her album *Theatre Is Evil*, as well as Pomplamoose, an attractive young couple who achieved virality with at-home videos of famous songs. If it's writing, we'll get Andy Weir, author of the mega-selling *The Martian*, originally published on his website, along with E. L. James, who, as noted, rewrote her *Twilight* fanfic into *Fifty Shades of Grey*. Television: Ilana Glazer and Abbi Jacobson of *Broad City*, which started as a crudely produced web series, as well as Lena Dunham of *Girls*, who first attracted notice during college when she posted a film of herself in a bikini brushing her teeth in a fountain.

Journalists also love these kinds of stories for stand-alone pieces. Everybody gets to feel good. Everybody gets to dream a little dream. We read about the humorist who broke on Twitter, the poet who blew up on Instagram, the singer who makes six figures from home. Related are the stories of established artists who pioneer new distribution models, usually involving free content, voluntary payment, or other direct-to-audience transactions. Louis C.K. self-releases a comedy special as a $5 download or stream. The jazz musician Esperanza Spalding records *Exposure* live on Facebook over seventy-seven hours, marketing it as a limited edition of 7,777 physical copies. The celebrated author and cartoonist Neil Gaiman puts his novel *American Gods* online for free for a month. Everyone agrees to forget that these experiments can work only because the artist is already famous.

But facts and logic are not the point. Reading people who write about the economics of culture—issues like piracy, copyright, and free content—from a pro-tech perspective, I am struck, above all, by two things. First (but this is true of the techno-commentariat in general), their fatuous, hectoring smugness. Anyone who disagrees just "doesn't get it," must be a dope or a Luddite, maybe a hand-wringing pessimist. *Don't like what tech is doing to the world? Get used to it. Guess what? That's what people said about the printing press, the Victrola, the VCR. You know who gets it? Kids. Kids get it. Kids are the future.* This is argument by button pushing, the deployment of scare words and buzzwords. "Experts," bad. "Critics," bad. "Middlemen," bad. "Corporations," "property," "professionals" (all of which apparently do not exist in Silicon Valley), bad, bad,

bad. On the other side is the "DIY" "creativity" of "today's kids" that's "bubbling up" "around the world."

The other thing that strikes me, when reading the techno-pundits, is their thoroughgoing ignorance about what culture actually is and how it's made. In *The Wealth of Networks*, Yochai Benkler argues for the superiority of amateur production by analogy with blood drives (where compensation lowers quality), as if making art were as easy as opening a vein. He and other writers on these subjects lionize the amateur, but while they've figured out that "amateur" derives from the Latin for "love," that's pretty much all they've figured out. Clay Shirky, a leading Internet evangelist, believes that love is what separates the amateur artist from the professional, who supposedly does it for money, failing to understand that professional artists put up with everything they have to deal with—including asinine arguments like that one—because love is exactly what motivates them. Shirky also sees Wikipedia and other crowdsourced content as "creative paradigms for a new age"—as if novels or movies were modular constructions no greater than the sum of their parts, capable of being assembled (piecemeal, in odd moments of downtime) by hosts of mutual strangers, not complex, integrated wholes that can be created only through sustained acts of intense imaginative synthesis.

Tech evangelism, in the arts as in everything else, floats a million miles above reality. So sure is it of what *must* be true—still more, of what will be true—that it doesn't bother finding out what actually is. No wonder it's forever issuing supremely confident predictions that turned out to be supremely wrong. In 2014, the blogger and journalist Matthew Yglesias announced that the publishing industry, thanks to Amazon, would soon "be wiped off the face of the earth." In 2010, Nicholas Negroponte, founder of the MIT Media Lab, declared that the physical book would be dead, or at least obsolescent, within five years. Nor are artists, especially those of a futuristic bent, immune from such pronouncements. In 2002, David Bowie said that he was "fully confident that copyright . . . will no longer exist in ten years." "Predictions are for suckers," as Hamilton Nolan, then a senior editor at *Gawker*, remarked in 2015—a sentiment confirmed by the site's collapse the following year.

But the techno-prophets make their biggest blunders when they talk about the biggest question: the impact of Silicon Valley on the health of

culture. In *Free*, published in 2009, Chris Anderson, a longtime editor in chief of *Wired*, suggested that journalism would be saved, after so many reporters had lost their jobs, by legions of part-time amateurs. In *Remix*, from 2008, Lawrence Lessig, a Harvard professor, anti-copyright advocate, and onetime presidential candidate, foresaw that a culture of blogging, by enabling people to express their opinions in writing, would teach millions to think with greater rigor and integrity. "Monopolies aren't what they used to be," said Anderson, allowing that it was "too soon to say" that they were "no longer to be feared online." Amazon, like other tech giants, said Lessig, "might abuse the data it collects," but "it has a huge incentive not to," since "I can take my business elsewhere." Predictions are indeed for suckers: the ones who swallow them. Predictions, in this context, function as a form of propaganda—the tech sector peddling, through its useful idiots in journalism and academia, an empty promise of prosperity and liberation.

Artists know better. When I paraphrased the Silicon Valley narrative to my interview subjects—never-been-a-better-time, just-put-your-stuff-out-there—nearly every one of them called bullshit. "That works out really well," said one. "I can tell you, as I'm driving in my Rolls-Royce, that works out really well." Just put your writing up on Medium, asked another—"and how are you going to make money doing that?" It comes down to budget, remarked a third who works in television: "Everyone has the same tools now," he said, "but that's like saying that anyone can be president." "I just can't see the economic piece," said Ruby Lerner, the founding director of Creative Capital, a leading arts philanthropy. "You can't 3D-print a thousand pairs of earrings and get out of your parents' basement." Most often, though, when I gave them the Silicon Valley line, my interview subjects just laughed.

* * *

Okay, so maybe everything isn't great, the techno-utopian story continues, but trust us, it will be. The market will save us, or maybe the kids will. I think of this as the "don't worry, be happy" argument. Markets adjust, said Lawrence Lessig: the "invisible hand" will see to it that producers of content have ways to make money. For the indie rocker and producer Steve Albini, as for other critics of copyright, it is "the audience that will figure out how to reward" their favorite artists.

"Music can't be stopped," I was told by Ian MacKaye, the indie-music icon. "The future will be great. Trust me," writes Dave Allen, the punk rocker turned tech, advertising, and music industry executive. Such statements remind me of the famous cartoon of a pair of scientists in front of a blackboard. One of them has jotted down a series of formulas, presumably outlining some kind of process, in the midst of which he's written, "THEN A MIRACLE OCCURS." ("I think you should be more explicit here in step two," the other one says.) That seems to be the kind of thinking that's in operation here. Everything sucks—THEN A MIRACLE OCCURS—then everything's great. In the arts, again, so as everywhere within the tech economy. Silicon Valley has been regaling us with stories of utopia for decades now, but the advent of that happy state is always postponed to the out years. Meanwhile, everybody gets to lose their job.

On the individual level, "don't worry, be happy" takes the form of that ubiquitous "just": just make good art, just put your stuff out there, just make your own rules, just ask. Issuing these types of reassuring nuggets has become a cottage industry, especially among artists who have managed to find success amidst the new conditions. "Make good art," as well as "make up your own rules," comes, among elsewhere, from Neil Gaiman, whose 2012 commencement speech at the University of the Arts in Philadelphia, which offered those and other bromides, became a viral phenomenon. "Ask" comes, most recognizably, from Amanda Palmer, who made herself briefly notorious, after her Kickstarter coup, for asking musicians to play on the subsequent tour for free, then much more famous for a TED talk, "The Art of Asking," that she parlayed into a best-selling book. It's easy to think that it's easy, once you've made it. Jo Miller, a onetime graduate student who went on to become the showrunner for Samantha Bee's *Full Frontal*, had this to say on NPR's *Fresh Air*: "All the grad students who are listening . . . try it. Put your stuff out on the Internet. Put out YouTube videos. Put up—just put up your funny writings. Tweet funny things. Someone will find you."

Such statements, however well meant, are grotesquely irresponsible. And some of them are not well meant. There are a lot of people out there who are only too happy to sell you a handful of moonbeams—companies like Author Solutions, currently owned by a hedge fund, whose business model revolves around preying on self-published writers, or MasterClass,

which markets prerecorded lectures by the likes of Steve Martin, all-you-can-watch for the low, low price of $180 a year. "Know that there's room for you" in comedy, Martin says in his promo. Eat shit, Steve. There isn't room for lots of actual *comedians* in comedy.

"Winning does not scale," as Molly Crabapple, the writer and visual artist, remarks in "Filthy Lucre." "It's easy to say that if people are just good enough, work hard enough, ask enough, believe enough," then they will be successful. "But it's a lie." The actor Bradley Whitford has also been more honest. No, he said on *WTF*, the comedian Marc Maron's podcast, talent, hard work, and "wanting it" are not enough for an acting career. You also need luck. In *Uproot: Travels in 21st-Century Music and Digital Culture*, the DJ Jace Clayton remarks that he doesn't trust people who say, "Make your own rules": "Those people probably have a safety net." Clayton adds that "making quality music" (i.e., good art) "has no direct bearing on one's popularity." One of my interview subjects, an independent filmmaker whose work has been shown at Sundance but who still lives hand to mouth, had this to say: "This idea that you can make something and it'll get out to the world is the trap of capitalism on steroids. It's the lie. It's Horatio Alger."

Horatio Alger: the rags-to-riches fables of an earlier Gilded Age. The cruelest thing about the rhetoric of "just," of you-can-make-it-too, is that it plays on myths that people are already all too happy to swallow. Hans Abbing lists a raft of these in *Why Are Artists Poor?*: the myth that dedication leads to success, whereas the actual chance of success in the arts is akin to surviving a leap off a cliff; the myth of late-career success, which enables people to "continue to deceive themselves till they are eighty"; the myth of the self-taught artist, which may have some validity in popular music but rarely, at best, in other forms.

To these long-standing misconceptions, we can add a number that the Internet has put on steroids. The myth of the overnight success (it takes three to five years to become an "overnight" success, I was told by an executive at Kickstarter, and she was only talking about building an audience, not learning to create in the first place). The myth of the undiscovered genius, unusual even in the days of Kafka and van Gogh, essentially extinct in the age of a large, multileveled, and increasingly global culture industry (and educational system) that makes it its business to scour for talent. The myth that if you don't succeed, it's your own fault (you "didn't

want it badly enough"), which is not only a form of victim blaming but makes the classic American mistake of seeing economics in individual rather than systemic terms. The myth that if you don't succeed, it wasn't meant to be, which is, of course, a circular argument ("people who are going to find a way," I was told, "are going to find a way"). Abbing is an economist as well as a visual artist. Artists are poor, he says, because there are too many of them, and there are too many of them because so many of them are delusional.

<p style="text-align:center">* * *</p>

Maybe things aren't great, and maybe they aren't even going to be great— the story continues—but at least they're better than they used to be, back in the bad old days of "middlemen" and "gatekeepers." I think of this as the "evil suits" argument: the evil suits who rip off artists, who neglect original talent, who only care about money. The existence of evil suits has become a ubiquitous matter of faith, one of our foundational beliefs about art and commerce. I believed that the suits were evil, too, until I actually met some. The first time that I made the rounds of New York City publishers, hoping to get a book deal, I expected to encounter lots of philistines with spreadsheets. Instead, I met people (mostly women, by the way) who love books, who read books, who want to publish the best books they can. The idea that the culture industry "neglects geniuses" or "smothers original voices" is wildly misinformed. "Everybody wants to publish original voices," I was told by the editor Peter Ginna, author of *What Editors Do: The Art, Craft, and Business of Book Editing*, who has worked in the field since 1982. Publishing original voices is what people like Ginna live for, and it's also part of how they make their living. Of course, he added, editors make mistakes—he had rejected John Grisham—but that's because they're fallible, not evil. The truth is that neglected geniuses, neglected books (like Herman Melville, in his day, or *Call It Sleep*, Henry Roth's now-classic immigrant novel) are neglected not by publishers, for the most part (*Moby-Dick*, after all, *was* published), but by the public. *We're* the ones who smother original voices, by ignoring them. Meanwhile, every time you "discover" a great new book, that's almost certainly because an editor (and agent, and publisher) discovered it first.

Much of the animus against the suits (especially in music, where it's

at its worst) appears to derive from an inability, or refusal, to recognize that the business of culture is a business. How often have we heard those tales about musicians being forced to "sign away their rights," or discovering, only later, that they had? But I don't get it. Did they not read their contract? Did someone compel them to sign their contract? Turning over distribution rights, in exchange for advances and royalties, is exactly what a record deal entails. What did they think that the money was for?

There's a certain amount of entitlement functioning here. I've heard artists (actors, writers) complain that it's unfair that they should have to "ask permission to work"—to be cast or published. But they aren't just asking to work; they are asking to be paid, and no one is going to pay you unless they think you're worth it (and worth it more than someone else is). What many artists really seem to hate about the suits is that they are ignoring them, the way that teenage boys will hate a pretty girl. Even now, when self-publishing and self-production are genuine options, when no one needs to "ask permission" anymore, artists almost always seek affiliation with the culture industry. Indie bands want bookers, managers, record deals. Indie filmmakers want to get picked up by Hollywood. Even E. L. James and Andy Weir signed on with major publishers after their viral successes. I talked to a number of authors who had managed to publish books without an agent, but I'm not sure that I talked to any who didn't want one.

At bottom, though, what seems to be in operation, when people talk about the suits, is exactly that taboo against the mixing of art and money. I'm reminded of the Jewish moneylenders of pre-modern Europe, figures like Shylock in *The Merchant of Venice*, despised for engaging in the kinds of transactions that their Christian neighbors considered themselves too pure to sully their hands with but relied on nonetheless. The suits—the people who handle the money—have become the scapegoats for the guilt that artists feel about money, symbolically loaded with the evil that money is felt to represent.

I'm not suggesting that the culture industry is perfect. Far from it. It may not smother original voices, but it does shut a lot of them out, if only because it can't afford to take too many chances. It produces tons of crap, since that's what pays the bills. In music, I've learned, evil suits who try to rip off artists really are a thing (although I've also learned that *everyone* in music tries to rip off artists—major labels, indie labels, man-

agers, promoters, club owners, even people who hold house shows—so the problem in music may be the culture, more than the suits).

Nor am I suggesting that the old system represented any kind of golden age—especially not as it had come to exist by the dawn of the Web. The old old system, as it were—small, independent enterprises often deeply committed to finding and nurturing talent, like Ahmet Ertegun's Atlantic Records or the Scribner's of Maxwell Perkins—helped to bring us some of the greatest art of the decades surrounding World War II. But starting in the 1970s, successive waves of consolidation, still ongoing, ushered in a new old system dominated by media-industry conglomerates. There's not the slightest question that the Internet and other digital tools have opened access and lowered costs. That doesn't mean things are better overall today. At best, as I'll explain in the following chapter, the picture is mixed, and certainly much more complicated than the techno-messianists ("old bad, new good") would have us believe.

* * *

Besides, once they've finished telling us about the bad old days, they assure us that we're going back to the good old days. Back to the troubadours, when musicians made their living by performing. Back to the village workshop, with print-on-demand publication, when goods were locally produced. Only in the last century, we are reminded, has it been possible for musicians to make a decent living. For most of history, ideas were free.

First of all, we're not "going back" to anything. History proceeds in one direction only, facile analogies notwithstanding. The troubadours lived in a radically different society. They didn't have to pay income tax, make rent in LA, or put their kids through college. They could rely on a dense social network of communities and extended families. Second, a lot of what was good about the good old days came along, inseparably, with bad old things. Ideas were free, and the pace of innovation was glacial. Ideas were free, so the creators of ideas were beholden to the powers that supported them, principally crown and church, which meant that they didn't dare to challenge them. Those people who effuse about "the village"? I'd like to see them try to live in one. Since when is "that's the way it used to be" an argument for anything? Only in the last century has it been possible for women to vote, but I'm not sure we should give

up that one, either. Famines and epidemics are also the way it used to be. (We're going back to cholera!) So are mass deprivation and the existence of a caste system—two things we may, indeed, be going back to.

Then, to complete the trifecta of mutually contradictory historical arguments, the techno-bullies tell us that, actually, this is how it's always been. Artists have always been taken advantage of. Musicians have always had to hustle. Writers have always complained. You're against technology? Books are a form of technology! Nothing to see here, move along.

What bothers me the most about these arguments is their sheer, hand-waving laziness. They can't be bothered to get off the couch—to make comparisons, to look at specifics, to pay attention, to give a damn. No one is against technology per se, only the uses to which particular technologies are sometimes put (as well as the arrogance of some of those who do the putting). As for "artists have always been taken advantage of," or "writers have always complained," how would those sound if we altered the terms a bit? "Women have always been taken advantage of." "Black people have always complained." Not so great. The fact that things have always sucked is not a reason they should go on sucking—still less, suck harder. And at the very least, if you do acknowledge that they suck, that artists have always had to struggle and still do, then for God's sake don't try to tell them it's easy today.

* * *

And here we begin to approach the final argument, the real argument. The mildest version goes like this. Can't make a living as an artist anymore? You shouldn't want to. Just do it on the side; just do it for love. We're back to the claim that amateurism is superior to professionalism, for artists as well as for art. Yet it's hard to imagine that anyone would take the notion seriously with respect to any other field. Are amateur athletes superior to professionals? Would you go to an amateur doctor? Would athletes and doctors be happier not to get paid? Would anybody have the chutzpah to suggest they shouldn't be?

Since the techno-sages like to cite the etymology of "amateur," they should go the extra inch and look the word up in the *Oxford English Dictionary*, which provides the history of its use. They would discover that the word and its derivatives, which began to enter the language in the

late eighteenth century, carried connotations of inferiority and dilettan-
tism—as in "amateurish" and "amateur hour"—from the very beginning.
(They also connoted the luxury of independent wealth, as in "gentleman
amateur.") No one has *ever* thought that amateurs are better than profes-
sionals, because they're not.

But if people like Yochai Benkler, the author of *The Wealth of Net-
works*, really do believe it, they should have the courage of their convic-
tions. You think it's better to work for free? Go right ahead. Benkler is
a professor at Harvard Law School. I'm sure he'd say that he loves what
he does. Good for him; so why is Harvard paying him? And why is he
depriving his students of the superior teaching he would no doubt pro-
vide, and himself of the superior fulfillment he would no doubt feel, if he
worked exclusively for love? Professional artists, it bears repeating, do
not work for money. They earn money in order to work for love. They
would love to work exclusively for love, but they don't have the money.

There is a more cynical, and more honest, version of "just do it for
love." I will let it be explained by Gillian Welch, who recorded a song, in
response to the advent of Napster, called "Everything Is Free":

> Someone hit the big score.
> They figured it out.
> That we're gonna do it anyway,
> Even if it doesn't pay.

People actually say these kinds of things. Why pay writers if they're
going to write no matter what? To which the only rational rejoinder is:
because fuck you, that's why. Or as Welch explains, remarking that she
can just stay home and sing to herself:

> If there's something that you want to hear,
> You can sing it yourself.

At the last degree of cynicism, we encounter Silicon Valley's true,
unvarnished argument. It's the one that Amazon makes when it strong-
arms publishers, that Google makes when it forces musicians to accept
exploitative terms for participation in YouTube, that Facebook makes

when it charges you to reach your followers. The argument is, just try and stop us. Fuck *us*? No, fuck *you*.

* * *

And that's essentially how many of the artists whom I spoke with understand the current situation. It is what it is. There's nothing you can do about it. You might as well complain about the weather, someone said—a particularly pungent analogy, given that the largest crisis we face as a species, and that we are finally rousing ourselves to address, is, precisely, the weather. Learned helplessness can be, must be, unlearned. Artists, as well as anybody else who cares about the arts, can start by recognizing that the digital economy, as it has evolved, is not inevitable; that markets, far from being naturally occurring phenomena, are structured by laws and regulations; that monopolies can and have been broken up. As we have all begun to understand in recent years, the big technology firms, behind their scrim of funded philosophy and gee-whiz journalism, are not the friendly giants that they've always claimed. These people are nobody's friends but their own.

PART II

THE BIG PICTURE

4

THE NEW CONDITIONS

A re things really harder for artists these days, if they have always been hard? The short answer is yes. Incomes are down; costs are up. If the "starving artist" of yore made little and lived cheaply, that little is now even less, and the living is no longer cheap. Recorded music sales, long the mainstay of musical careers, have plummeted. Book advances and freelance writing fees are sharply down. Budgets have been slashed for all but the biggest films, Hollywood and indie alike. Yes, there are many more ways to make money today—and many more people competing for them. Old opportunities tend to pay less; new ones often pay little. Full-time jobs—at universities, orchestras, publications, television shows—are turning into contract work or worse.

As for costs, production and distribution may now be cheap or free, but those are not the two main costs of making art. The two main costs are staying alive while you are making it and becoming an artist in the first place, and those have both been soaring. Staying alive means, principally, rent, and median rent is up some 42 percent, adjusted for inflation, since 2000. Add to this the fact that artists tend to piece together part-time income sources, none of which arrive with benefits, a circumstance that leaves them even more exposed than other workers to the ever-rising cost of health care. Becoming an artist requires, at a minimum, time—time to learn and hone your craft—and time, again, means staying alive, means rent (and food and clothes and transportation). It means equipment: instruments, art supplies; software also isn't cheap. Above all, except for

musicians (and often for them, as well), becoming a professional artist almost certainly means going to school: college at least, then perhaps an MFA. And tuitions, as everyone knows, have been climbing for years.

The result, in sum, is the ongoing loss of the "middle-class" artist. The vast majority of people who try to become professional artists do not succeed; the vast majority of those who earn any money at all from their art earn tiny amounts. That much has been true for decades if not centuries. What *is* new is that even artists who are otherwise successful—who make art as their principal vocation; who produce on a regular basis; who publish, show, release, perform; who win a modicum of recognition—are unable to support themselves at a middle-class level. To pay for adequate housing, to afford reliable health care, to take a vacation every once in a while—rather than subsisting from check to check, forever on the brink of the financial abyss. That possibility, beyond the biggest winners in the winner-takes-all, is disappearing from the arts.

From 2009 to 2015, according to a survey by the Authors Guild, full-time writers saw their writing-related income decline by an average of 30 percent. From 2001 to 2018, according to the Bureau of Labor Statistics, the number of people employed as musicians dropped by 24 percent. "I've seen hard data for people who are in successful bands, quote unquote, festival headlining bands," said Rebecca Gates, who led a survey of working musicians for the Future of Music Coalition, "who would make more money in a good retail job." Almost everyone I asked, including those who nonetheless believe that now is a terrific time to be an artist, reported that a lot of their peers are suffering, that young artists have it tougher than twenty or thirty years ago, and that the middle tier is falling away. Tammy Kim, a journalist with extensive connections in the New York arts community, sent me a list of twenty possible interview subjects, some as old as their fifties. "Everybody on that list is struggling," she said. Christine Smallwood, another writer with a wide acquaintance, told me that "fear and anxiety are omnipresent" among the creative people she knows.

Older artists, who have lived through the changes of the last twenty years, represent a kind of controlled experiment. In the Authors Guild survey, writing-related income dropped by 47 percent for those with fifteen to twenty-five years' experience, 67 percent for those with twenty-five to forty years'. Authors who, as late as the turn of the century, could

sell a book every couple of years and live off the proceeds, I was told by Mary Rasenberger, executive director of the Guild, have basically lost their jobs. When I asked Kim Deal, the indie rock icon who compared herself to a steelworker, how she makes a living these days, she hemmed and hawed for twenty seconds. "Stuff still comes in," she finally said, meaning royalties from old work. It's one thing to know that your life is going to stink while you're still establishing yourself. It's quite another to know that it will always stink. Kids will still make music, I was told by Ruth Vitale, CEO of CreativeFuture, "they'll just sleep on their parents' sofa for the rest of their fucking lives."

* * *

So what are the larger developments that have given rise to the financial predicament of artists in the twenty-first century? The most obvious, the overwhelming fact across the arts in the digital age, is the demonetization of content. Once music, text, and images could be digitized and transmitted online, the door was open to peer-to-peer file sharing and other forms of piracy. Napster, the original P2P service, debuted in 1999. The music business peaked that year at $39 billion in global revenue. By 2014, that figure had fallen to $15 billion. As download speeds accelerated and file quality improved, piracy spread to film and television. Estimates by academic studies of the loss of film sales due to piracy range from 14 percent to 34 percent. With the advent of e-books, piracy arrived for publishing, as well.

Forced demonetization begat the voluntary kind. Once the distributors of content understood that users were going to steal it anyway, they started to give it away or mark it down so low that people wouldn't bother to. Hence the advent of free or subscription-based streaming services (Spotify, Hulu, etc.), free and low-cost self-published e-books, and the practice by newspapers and magazines of putting their content up without a paywall.

The ubiquity of free digital content has led, in turn, to the expectation of free everything, including physical objects and commissioned work. The singer-songwriter Nina Nastasia told me about people coming up to her at the merchandise table after her shows and asking if they could just "have" a CD, or simply walking off with one. Mark Coker, CEO of Smashwords, mentioned that one of his authors, a fantasy writer who

prices his e-books at $3.99, received a nasty email from a reader swearing that he would stop buying his novels unless he put them up for free (in which case, of course, he wouldn't be buying them anyway). In the age of free, chutzpah has been elevated to an economic principle.

Artists are routinely asked—it is one of the banes of the creative life in the twenty-first century—to work for nothing. Or for "exposure," which is a synonym for nothing. As the writer and cartoonist Tim Kreider has written, "People who would consider it a bizarre breach of conduct to expect anyone to give them a haircut or a can of soda at no cost will ask you, with a straight face and a clear conscience, whether you wouldn't be willing to write an essay or draw an illustration for them for nothing." Younger artists—who have been told to "build an audience," who are even more liable than others to undervalue their work or to feel guilty about asking for payment, and who, in any case, have very little bargaining power—are especially vulnerable to this kind of exploitation. The illustrator Jessica Hische has gone so far as to produce an elaborate flowchart, "Should I Work for Free?," to help creators answer that incessant question. ("Did they promise you 'lots of future work'? > YES > . . . Yippee. The promise of more cheap/free work.")

The very "disruption" of which everyone is so aware—the discarding of old financial guidelines and destruction of existing employment relationships—has opened the way for all kinds of inventive chicanery. With no rules in place, the rule seems to be: get away with as much as you can. Companies plead poverty or try to enlist you in fellow feeling. "The word 'start-up,'" Hische notes, "is used pretty loosely by businesses to get you to charge them less." There is also outright theft. A fair number of websites appear to have built their business model, at least in part, on the recognition that freelancers won't remember about or don't have the energy to chase down the payments they're owed. Several global fashion brands have become notorious for stealing designs that independent artists, following the injunction to build your audience by putting stuff out there, have posted online.

Perhaps the most insidious aspect of free content, as well as the most demoralizing, is the extent to which it devalues art in the eyes of the audience. Price is a signal of worth. We tend to value more what we have paid more for or worked harder to get; what we have gotten for free with a click we tend to value not at all. With Facebook, Instagram, YouTube,

and the like, music, text, and images are now akin to tap water, accessed with a turn of the spigot and supplied in an endless, homogenous stream. In *Uproot*, Jace Clayton tells a story about asking the clerk in an art supply store about the music that was playing on the sound system. "'Oh'—he shrugged—'it's Spotify.'" We used to take pride in the books, albums, and movies that we kept on our shelves, personal touchstones as well as permanent companions. Now that we don't even store anything on our hard drives, art is here one minute, gone the next.

Nor is this devaluation purely psychological. The creation of art cannot be automated, nor can technology make the process more efficient. Quality, therefore, will sink to meet price. Artists who are paid less, all else being equal, will be forced to spend less time on making any given thing. Kim Deal, the indie rocker, remembers how, at a certain point, music came to be "considered not only just free but trash, a bother to have to wade" through. We still put a tremendous amount of value on the arts in general, but less and less on any given work.

* * *

The other major drag on the incomes of artists today, itself enmeshed in the rise of the Internet, is the decline of the culture industry: the institutions, both commercial and nonprofit, that produce and sell so much of the work that artists do. On the commercial side, the major culprit is, again, demonetization, which, by eating holes in corporate profits, has left labels, publishers, studios, and others with fewer resources to invest in talent—hence not only falling advances, but also shrinking "lists" (to use the publishing term), the roster of artists and works that a company is able to support.

Development systems, as a result, are being starved across the arts. Instead of investing in artists, the culture industry increasingly expects them to invest in themselves, then cherry-picks the early winners. Labels surf the metrics, waiting for young musicians to prove their commercial potential with self-produced viral successes—no more talent spotting in smoky Village clubs or Memphis bars. Hollywood plays a comparable game with independent filmmakers, relying on the major festivals to trawl the talent pool. Publishers and publications cut costs by stripping out layers of editors, one of whose essential roles is to mentor fledgling writers. As the art world consolidates around a few global behemoths like

Gagosian and David Zwirner, the mid-level galleries that provide aspiring artists with early exposure and sales are getting throttled.

The culture industry works by spreading risk. Success in the arts is impossible to predict; most books and albums never earn back their advances; most movies fail to recoup production costs. Companies place their bets on a range of properties, hoping to score a *Harry Potter* now and then. Absent such support, as DIY individuals, artists are left to make one very bad bet: on themselves.

There are other reasons to lament the decline of the culture industry, its image as a den of heartless, parasitic middlemen notwithstanding. It does the things that artists either can't do or would rather not, and it does them a lot more effectively than artists ever could. Marketing and promotion are only the most obvious examples. In an increasingly cacophonous environment, the large commercial institutions have the money, and the clout, to get your work attention—your book on NPR and the front tables at Barnes & Noble, your song on the radio stations and Spotify playlists. The fact that marketing channels have fragmented into a million blogs and podcasts makes such muscle more important now, not less.

Books also need copyediting, proofreading, cover design, sometimes legal vetting. Albums need sound engineers, cover art, videos; musicians need licensing, publishing, booking. Movies, of course, require a whole platoon of specialized technicians, as a glance at the credits of even the smallest films will demonstrate. Those middlemen exist for a reason, and in these days of straightened budgets, when lavish expense accounts are long gone, there's not a lot of fat left in the system. Anyone who tries to do it DIY will find themselves assembling an ad hoc culture industry of their own, complete with as many middlemen as they can afford.

There is one great exception, of course, to the general decline of the traditional commercial industries: television. In the last twenty years, the medium has blossomed as never before: more shows, better shows, whole new, bold new kinds of shows. While the segmentation of the audience has put an end to *Seinfeld*-level money, it has also multiplied the ranks of "middle-class" creators and performers, the key to a robust artistic ecosystem.

But if television is the exception, it is the exception that proves the rule. The industry is thriving not despite demonetization, but because it

has largely avoided it. Every time you pay your subscription to Netflix, Hulu, HBO Go, Amazon Prime, ESPN+, and so forth—not to mention your cable bill—you're adding your drops to the mighty river of cash that continues to sluice through the system. Television used to be the "stepchild" of the entertainment industry, writes the veteran producer Lynda Obst in *Sleepless in Hollywood*, with movies bringing in the lion's share of profit. Now it's the reverse. As of 2012, TV generated some $22 billion for the five big media conglomerates (which then included Viacom, Disney, Time Warner, News Corp, and NBCUniversal), about nine times as much as their film divisions. If anybody figures out how to do to television what Napster and Spotify did to music (and it seems inevitable that somebody will), the golden age will disappear like Brigadoon. Maybe then, when their Netflix and their HBO have turned to dust, people will start to wake up to what's been happening across the arts.

* * *

If the more popular arts rely for their financial viability on commercial institutions, the more rarefied ones rely on nonprofits. This is the domain of the so-called SOBs—symphonies, operas, and ballets—as well as of museums and live theater. Here, too, the story is grim. Old-line institutions have been struggling to adapt to new audiences and habits. People want their culture on demand and on their devices, not at 8:00 p.m. on a Thursday night, in a place they have to travel to, sit still at, and dress up for. At the very least, as the urban theorist Richard Florida has pointed out, they want it woven into the "street-level" fabric of the new urban lifestyle—music in a bar, art in a café, readings at the local bookstore—not set apart in marble palaces. They want it in the context of fluid, social experiences, or "experiences"—those ever-multiplying festivals and street fairs and art walks. They want it shareable and Instagramable, not solemn and self-enclosed. And they don't want to have to know a whole lot to enjoy it.

The old pachyderms, not surprisingly, are hurting. From 2003 to 2013, the share of Americans who reported having attended a museum at least once in the previous year dropped by 20 percent; those who reported having attended a live performing arts event, by 29 percent. As of 2013, American symphony orchestras earned more of their money from philanthropic contributions than they did from ticket sales—effectively making

them charities, as the *New York Times* has put it. Since 2010, at least sixteen have been hit by strikes or lockouts. Museums, which carry large fixed costs, have been trying to win back customers with ambitious renovations and expansions, which add still greater costs. Recent years have seen financial troubles across the sector, including at flagship institutions like the Metropolitan Museum of Art, the Museum of Modern Art, the Los Angeles County Museum of Art, the Museum of Contemporary Art in Los Angeles, and the Art Institute of Chicago.

As for philanthropy itself as well as public funding, both continue to decline. Individual donors as well as foundations, I was told repeatedly, have shifted their priorities to other areas of social need, ones that seem to promise greater and more immediate "impact" than the arts. A new generation of philanthropists has arisen who demand the kind of quantifiable results that art cannot provide, and who, in any case, do not possess the feeling for culture that motivated their forebears. Around the country, local philanthropic largesse has also been weakened by corporate consolidation: by sales, mergers, closures, and relocations. The businesses and CEOs that would once have taken the lead in patronizing the arts in places like St. Louis or Baltimore have moved to New York or Seattle.

Meanwhile, as of 2020, the budget of the National Endowment for the Arts came to all of $162.25 million, a figure that represents a decline of 66 percent, adjusting for inflation, since its peak in 1981, pencils out to roughly 49 cents per person, and amounts to less than a third of what the military spends on bands. (Adjusting for population growth, as well, the drop was 77 percent.) As of 2019, total funding for the arts at all levels of government came to $1.38 billion, a decline in real dollars of roughly 23 percent since 2001 (34 percent adjusting for population growth) and approximately 0.0066 percent of GDP—less than two-thirds of one hundredth of 1 percent.

But the most important nonprofit organizations in the arts are not arts organizations at all. They are universities. Since the end of World War II, academic employment has been the principal way that practitioners of the high arts have been supported in the United States. For poets and literary novelists, for visual artists, for classical composers, for playwrights and other theatrical professionals, a teaching job at a college or university has for many decades been the characteristic professional

goal. One of the major reasons that people pursue MFAs—and programs have been multiplying for years—is to credential themselves for academic employment.

Yet the oasis of a tenured position, even simply of a full-time position, is, more and more, a mirage. What is true throughout academia—the long-term trend toward temporary, low-wage instructional employment—is doubly so in art schools and departments. Between adjuncts, postdocs, graduate students, and others, less than 30 percent of people who teach at American colleges and universities now are actual professors, individuals who either have tenure or are on the tenure track. In the visual arts, the number is more like 6 percent. Full-time positions of any kind, even short-term posts, will typically attract some two hundred applicants or more. "Tenured jobs are ridiculously hard to come by," I was told by a poet who was in the middle, once again, of the annual academic ritual of job market roulette (which can start to feel like Russian roulette). One position he tried for drew eight hundred hopefuls. Getting on the tenure track, said Jen Delos Reyes, associate director of the School of Art & Art History at the University of Illinois at Chicago, is, at this point, "like winning the lottery," a "fantasy." A career in the visual arts such as practitioners used to enjoy, one that "unfold[s] through various institutional affiliations," the painter and critic Roger White suggests in *The Contemporaries*, is no longer a realistic expectation.

As for those adjunct positions, they typically pay peanuts, if not peanut shells. "You have one hundred thousand dollars in debt, or fifty thousand dollars in debt," I was told by Coco Fusco, an interdisciplinary artist, writer, and curator who has held professorial appointments at a succession of art schools, "and you're making somewhere between three and six thousand dollars a class, and you don't have benefits, and you're running around to three or four different schools trying to make ends meet. Not really a viable existence." And yet, Delos Reyes told me, people are "banging down the door" to win those jobs, no doubt in part because there aren't a lot of other options. "Over the course of my career," writes Alexander Chee, an award-winning novelist and essayist who makes a living as an itinerant "visiting writer" ("a sort of high-class adjunct," as he puts it), "I've had to watch as both teaching and writing have suffered from twin crises of income destruction." Academic teaching

used to be the answer for financially precarious artists. Now it's just another form of the same problem.

* * *

So that's the bad news, or at least the top headlines. There is also some very good news for artists in the digital age. It starts with the fact that the Internet offers unmediated access to the audience. The gatekeepers aren't quite dead, but they can be circumvented. You really can just put your stuff out there—post your work online for all the world to hear or read or see—and while that isn't by any means the end of the story in terms of developing a sustainable career, it can be the beginning of it. For visual artists, the platform of choice is Instagram. For writers, there is Wattpad (for stories), Medium (for essays and journalism), and a host of e-book sites, including Smashwords, Kobo Writing Life, and Kindle Direct Publishing. Musicians have SoundCloud, Bandcamp, Spotify, and YouTube. Videographers have Vimeo and, of course, again, YouTube. And those are just the leading options.

The idea is indeed to build an audience by posting stuff for free, then to "monetize" it, in the current term of art: sell it other stuff that isn't free. One of the guiding concepts among independent artists on the Web is the idea of "1000 true fans," a phrase coined by Kevin Kelly, the founding editor of *Wired*. Because you are able to sell things directly and keep 100 percent of the proceeds, rather than receiving, say, a publisher's 10 percent royalty, you no longer need a large audience. If you can gather a cadre of "superfans," people who love your work enough to buy whatever you can figure out to sell them, you can make a decent living. And because the Internet is everywhere, those one thousand fans can be anywhere: two in Toledo, one in Bulgaria, five more in Manila.

So what is this other stuff that your fans are going to buy, once you've hooked them on your work? Generally speaking, things that aren't digital, meaning objects or experiences. For musicians, that starts with shows and goes on to "merch" (merchandise), which is best sold at shows: T-shirts, hats, posters, stickers, buttons, as well as physical media like CDs or LPs. For visual artists—painters, illustrators, graphic designers, cartoonists—monetization means classes and workshops, online or in-person; illustrated books of many kinds (children's books, calendars); plus anything that you can fit an image on: cards, mugs, posters, note-

books, key chains, pins. For authors, it means physical books, speaking engagements, writer-in-residence gigs; for those who write nonfiction in particular, it means workshops. And there are also more inventive tactics. Since 2011, the musician Jonathan Coulton has been running an annual weeklong cruise.

The strategy favors artists with a well-defined "brand" or "niche": Celtic metal, young adult chick lit, illustrations of food. Coulton, a former coder, is a self-proclaimed geek, writing songs about technology and science fiction. Because it depends on maintaining an ongoing relationship with your audience—keeping your true fans engaged and your superfans happy—the strategy also necessitates constant output. Finished work is best, but the intervals between new drawings or songs are typically bridged with various forms of informal communication: blog posts, Twitter posts, podcasts. Anything that shows your "process"—a chapter draft, a video of a cartoon being made—is particularly valued. "Fans" are something more than listeners or readers in the older sense. They don't just want to savor the work. They want to feel connected on a personal level. They want to feel like they know you, and they want to feel like they're part of the adventure of creation.

* * *

Building, engaging, and monetizing your audience, consciously and systematically, is exactly the idea behind what is surely the most important financial innovation for artists in the early twenty-first century: crowdfunding. Crowdfunding means direct financial support, through dedicated online platforms, of artists by fans. Crowdfunding has become a lifeline for independent creators; for most of the younger artists I spoke with, it is a crucial part of their financial picture. And while there are many crowdfunding sites, including quite a few, like Indiegogo or GoFundMe, that aren't particularly focused on the arts, the two most important for artists are undoubtedly Kickstarter and Patreon.

Kickstarter, as the name implies, helps to get specific projects off the ground. Campaigns on the platform function, in effect, as advances, replacing the kinds of investments that a studio or label would make and thus solving "the cash-flow problems of creatives," as Richard Nash, a digital media strategist, put it to me—the difficulty, for artists who are living without much of a financial margin, of coming up with that $20,000 to record

an album or $40,000 to produce a micro-budget movie. Campaigns are run on an all-or-nothing basis, with deadlines, lending a certain dramatic tension to the proceedings. If you reach your goal, you get the money; if not, your backers keep what they had pledged. According to Margot Atwell, who runs the platform's publishing section (books, comics, journalism), the total raised has stabilized at roughly $600 million a year. Not all of that goes to projects in the arts or to creators in the United States, but it is still worth noting that this is about four times the budget of the NEA.

Atwell stressed the importance of creating a thoughtful reward structure. When you pledge on the site, you don't just get a fuzzy feeling. You get stuff in return: at the lowest levels, typically some kind of thank-you; in the midrange, tangible objects (usually versions of the finished product); something "experiential," as she put it, for the big spenders. Kickstarter, she said, is "a value-exchange platform"—not, in other words, a charity. For *Derby Life*, Atwell's book about roller derby (the company encourages employees to run their own campaigns), $5 got you a thank-you postcard; $25, a print copy; $100, a chance to read a draft and offer feedback. That level sold out "almost instantly," she said.

If Kickstarter is akin to a media company, Patreon updates (no surprise) the concept of a private patron. Instead of giving once, for a specific project, donors pledge a monthly sum—a kind of subscription model, except that you're subscribing to a person. Which means that artists receive the equivalent not of an advance but of a salary. (Some people choose to receive their donations per creation rather than per month.) Again, there are different levels. Again, they come with rewards. Because the relationship is ongoing, the latter are often more personal: process materials (diaries, sketchbooks, blog posts), audio and video recordings, live Q&As. As of 2018, the platform (which, like Kickstarter, takes a 5 percent commission) raised about $140 million a year.

Crowdfunding is not a panacea. Rewards take time and money to produce. So does creating a campaign or donor page in the first place. (You can end up losing money on Kickstarter, one musician told me.) On Patreon, according to a 2017 analysis, only 2 percent of creators bring in more than the federal minimum wage of $1,160 per month. On Kickstarter, campaigns often fail. At best, crowdfunding makes up a piece, however important, of an artist's financial portfolio. It also doesn't replace the hard work of building an audience. It was Margot Atwell who

told me that it takes three to five years to become an overnight success. When you "see a project blowing up" on Kickstarter, she said, raising ten times its goal, that's because the individual or team behind it already "built up a community and a following that cares about their work."

Crowdfunding may be getting a little stale. Back when Kickstarter was new, I was told by the documentary filmmakers James Swirsky and Lisanne Pajot, who ran a successful campaign in 2010, the year after the platform launched, "the idea of connecting to an artist and watching that artist's journey was novel." Now, they said, because the experience has grown familiar, and because so many artists are trying to replicate it, "people have Kickstarter fatigue. A lot of the Internet has just gotten over it." Which may explain why the platform's annual financial intake has plateaued.

Crowdfunding may also be getting a little crowded. "The thousand true fans theory might have worked earlier," Marian Call, a DIY singer-songwriter, explained, but at this point, she thinks, it's more like ten thousand fans. Fandom, at the level of niche tastes, tends to spread in social networks. "The problem with Kickstarters and Patreons," she said, "is that of my fans, the same couple of hundred people are going to participate most of the time, and they are also the people participating most in all the Kickstarters of all my friends. So that group of people you can't stretch too thin."

Still, the rewards of crowdfunding, and of the audience-engagement model in general, are more than just monetary. Mara Zepeda, who built an online calligraphy business, explained it like this: "You have all these relationships: that's the primary thing. Suddenly people are responding to your work, they're saying, 'Oh, I love this, I want to do this commission, can you do this collaboration with me, can you come to this photo shoot on Lake Como?' So you go from being totally alone [to being] part of a community." Lucy Bellwood, the cartoonist who went to sea at age sixteen, had successfully completed three progressively larger Kickstarter campaigns and was receiving about $2,000 a month through Patreon. "My audience is fucking rad," she told me. "The people I have the good fortune to connect with online tend to be really great humans, and I feel very lucky to have them around." About Patreon in particular, she said, "If I stop to think about it too hard, it just makes me teary, and I don't know how to justify any of it."

* * *

The new model, build-engage-monetize, really *has* helped democratize and diversify the arts, two claims you often hear. When artists are able to appeal directly to audiences, our ideas of both artists and audiences change. Peter Ginna, the editor who scoffed at the idea that publishers are philistines who set out to smother original voices, acknowledged that there certainly are biases, often unconscious ones, at work in the industry. "Publishing is embarrassingly lily-white," he told me, "editorial departments even more than the rest of the business, which is saying something." Nonmale and, even more, nonwhite authors do end up getting shut out, because "white, suburban, Ivy League" editors don't know how to find them or "don't get what they're doing"—even worse, at times, because they judge their work to be "too black, or too Filipino" for a mainstream audience

But who, exactly, is the audience? What does it look like, and what does it want? "Traditional publishing often says, well, we can't sell this," Margot Atwell, who worked in the industry before moving to Kickstarter, told me. "I just think that means they haven't been creative enough." Atwell mentioned *Bingo Love*, a graphic novella about middle-aged black lesbians who meet in a bingo hall, which more than doubled its funding goal. "So many people wanted a story like that," she said, "and there's just nothing out there."

The new model is not for everyone, young or old. For Gina Goldblatt, a fiction writer and poet in her early thirties, Patreon and other crowd-funding platforms are "like, do a song and dance for me ten times and compete with these seventeen other people and then maybe I'll give you some money." But the Internet has opened access to the old model, too. Artists still aspire to get noticed by the culture industry, but now they have a lot more ways to do it. Crowdfunding is often itself a strategy to bootstrap to the next level: you Kickstart your movie, say, then take it to festivals in the hopes of generating interest from an agent or producer. But there are also other routes. Getting discovered with a YouTube video or Twitter post (or, more likely, a series of them) is still an incredibly long shot and should be the whole of nobody's career plan, but it does occur.

People at the center are scouting for talent, to the extent that it is possible to scout a field as vast as social media. The television producer

Jane Espenson, whose credits include *Buffy the Vampire Slayer*, *Gilmore Girls*, and *Battlestar Galactica*, discovered Brad Bell, with whom she created *Husbands*, the first web series to be taken seriously as a television show, because a friend of hers retweeted a link to something Bell had self-produced. "I found Brad because he was putting up funny videos that were just him talking to a webcam on YouTube," Espenson told me. "I was like, this kid can write. This kid's making jokes that sound like my jokes." "People start with what they have the means to create," she went on. "They get the attention of the people creating one level up, they team up to make a thing that gets the attention of the people the next level up," and so forth. Connections still don't hurt, she said, and the old avenues, like writing a spec script, continue to be relevant, but "people are bubbling up through the system in a lot of new and different ways."

There are comparable stories across the arts: painters getting picked up by galleries after attracting attention on Instagram; writers winning notice and, ultimately, publishing contracts for their unique voices on Twitter. Such scenarios are very rare relative to the number of people who are vying for them, and they scarcely put you on easy street. A dealer or a deal is not synonymous with wealth and fame, but only a step on the road that might—might—lead to a sustainable career. "Everybody's buying a lottery ticket," I was told by the music producer Steve Greenberg, a former president of Columbia Records who has discovered a long list of major acts, including Hanson, Baha Men, Joss Stone, the Jonas Brothers, Andy Grammer, and AJR. But "it's easier to be in a situation where your music *might* be heard by the right people to start to spread the word than it ever has been before. Thirty years ago, you literally had to send a tape in to my record company and we just sat on a big pile of tapes and we probably didn't open it."

* * *

And those two broad possibilities—building a niche audience and using digital tools to win a place in the established industries—hardly exhaust the opportunities created for artists by the new economy. Perhaps the largest positive fact about the economics of the arts today is simply that there are so many options now: so many possible paths or, more to the point, so many pieces that can be assembled to create your own individual path.

For one thing, there is more demand than ever in commercial contexts for the things that artists do. With every corporation looking to create its own content—since they are also hoping to "engage" their audience, especially through everybody's medium of choice, video—there is more need for people who know how to handle a camera. As for music, every video needs a score, and so does every ad and video game (and, of course, every song needs a video). Companies are also hiring more writers and editors to spiff up the textual components of their online presentation. And in a world of "creative" urban spaces, retail or otherwise (the hipster coffee shop, the techie workspace), as well as of the "unique" or "artisanal" consumer goods through which the affluent class (and those who seek to emulate it) increasingly defines itself, there is unprecedented demand for visual design in all its forms. We are marinating now in creativity. Did you see that Virgin America safety video? It was practically a Broadway show.

The culture industry itself, feeding always the bottomless maw of the Internet, has multiplied its demand for material: TV shows put "extras" online, newspapers commission videos for their websites, the print editions of magazines now represent no more than the tips of their respective icebergs. Fan conventions like Comic-Con constitute an enormous new venue for monetization of all kinds; Etsy and other online platforms, a huge new market for craft objects. The Internet-driven enthusiasm for amateur creativity—which can be understood, for many of those who engage in it, as more a form of recreation than production—has itself engendered opportunities for professional artists as teachers, consultants, and minor celebrities.

What all these options mean, more than anything else, is the possibility of freedom: freedom from bosses and gatekeepers, freedom to construct your own professional existence. "It's just so intoxicating," Mara Zepeda told me. "I started a calligraphy business in 2009, and I remember the first year I made $40,000, and it was like, I'm never going back. I'm never going back to ever working for someone again. And for this whole group of indie" creators on the Web, she went on, "this whole punk mentality" of DIY, the moment you get to that point, "you've reached the promised land, because you never have to work for the Man again. Once you realize that you can do it, you can throw together an Etsy store or whatever it is, and you can have customers that are all around

the world, and you can feed yourself—I don't know many people who have ever gone back."

* * *

So that's the good news. But there is bad news about the good news. The good news is, you have the freedom to pursue the new opportunities. The bad news is, so does everyone else. The good news is you can do it yourself. The bad news is you have to. Again, it looks easy only in retrospect. It always looks doable, from the perspective of people who have already done it.

What it means to do it yourself, to manage your professional artistic existence in the twenty-first century, I will take up in the following chapter. For now, let's consider that other uncomfortable truth: everybody else is trying to do it, too. Recall that Hans Abbing said that artists are poor because there are too many of them—and he was writing in 2002, before social media. "Maybe the reason why Queen made so much money is that there were so few Queens," a poet friend remarked to me. "But now there are a thousand Queens." If only. Ian Svenonius, the DC punk provocateur, has a song called "600,000 Bands":

> 600,000 bands.
> Each one makes a sound.
> Well everybody wants you listen to theirs,
> But you can't right now 'cause you're listening to this.

Yet even Svenonius's figure is too optimistic by far. As of 2017, Sound-Cloud carried music by ten million artists. In 2016 alone, the Kindle Store added a million books. About fifty thousand films, mostly indies, are shot worldwide each year, of which about ten thousand are submitted to Sundance.

When Greenberg says that it's a lottery, he isn't kidding. Of the books available on Kindle, of which there are now over six million, 68 percent sell fewer than two copies a month. The overwhelming majority of those six million are self-published, and of all the independent authors they represent, fewer than two thousand earn at least $25,000 a year on the site. Sundance accepts a little over one hundred features a year. It's no wonder that less than 3 percent of people who direct a small-budget

film go on to direct at least two more; ditto with the percentage of those who write one. Of the two million artists on Spotify, less than 4 percent account for over 95 percent of streams. Of the roughly fifty million songs available, at last count, on the site, 20 percent have never been streamed, not even once. (Let that one sink in for a moment.) I'm reminded of something that the writer Fran Lebowitz has said: your chances of winning the lottery are the same whether you buy a ticket or not.

Another analogy occurs to me: D-day. If most of us are unaware of the lethally high attrition rate among artists, especially younger ones, in the digital age, that's because for every wave that's cut down as it hits the beach, there's another one right behind it. So there's never a shortage of hopeful young artists around, only they are not the same from one year to the next. Melvin Gibbs, a former president of the Content Creators Coalition and a celebrated bassist who's appeared on nearly two hundred albums, put the matter to me like this: "You're tired of pulling double shifts as a waiter and then going to gigs, and you quit. And then someone else comes along." "Talk about how many people want to be an artist—that feeling is realer for no one more than for artists," I was told by Sarah Nicole Prickett, the writer who moved from Ontario to New York. "I have this constant feeling like I could be replaced at any moment."

The logic of this vast artistic oversupply is not only Darwinian (the struggle for survival) and Hobbesian (the war of all against all), it is also Malthusian: the outstripping of resources by population growth. What has long been true is even worse today: artists refuse to act as if the normal economic rules apply to them. Expansion in a given sector usually responds to increased, or at least anticipated, demand. You wouldn't just triple the size of the auto industry because more people felt like making cars. You'd wait to figure out if anybody wanted to drive them first. But now that everyone can be an artist, everybody wants to. Longtime, accomplished professionals have difficulty getting heard today, but every eager novice, crank, and mediocrity must push themselves forward. Whether or not the pie is getting smaller, it has been pulverized into a million tiny crumbs. We are purchasing universal access at the price of universal impoverishment.

But the cream always rises to the top, people say. Does it? The arts, with respect to issues of access and oversupply, are comparable today to the world of opinion. Everybody can express their views online, so every-

body does. Is the cream rising there? Throwing everything up and letting the Internet sort it out is not a formula for the recognition of excellence in any field. The feeling that your work is being buried underneath an avalanche of amateur garbage, as many of my interviews confirmed, is one of the afflictions of the professional artist's existence today.

So is the presumption behind that phenomenon: the notion, precisely, that anyone can do it. The literary agent Chris Parris-Lamb has had this to say: "Most submissions I see feel like someone checking 'write a novel' off their bucket list." The average person can't try to leave their mark by writing a symphony, he goes on, because they can't read music, but hey, we're all already typing anyway. The very tools that have made it so easy to create have contributed to the confusion of quality with mediocrity. "You could work for a week in your house, and use the right programs, and you'll come out with stuff that sounds professional," Steve Greenberg remarked. But "it's really easy to confuse professional-sounding music with really good and interesting music." The audience, as a result, no longer appreciates the time and effort that it takes to make the good stuff.

And if we value creativity less, if we think that it's as easy for the professionals as it is for the amateurs, if we can't tell a nugget of gold from a highly polished turd, we'll be that much less likely to pay for it. Because remember that artists don't just need you to notice their work, as they wave and shout in the general cacophony, don't just need you to listen to or look at it, since they don't make any money that way anymore. They need you to actively support it. They need you to become a "true fan." They need you to subscribe to them on Patreon, and chip in for their Kickstarter, and follow them on Instagram, and retweet them on Twitter, and sign up for their YouTube channel. Svenonius's song continues:

> 600,000 bands.
> All want you to give them a hand.
> They're struggling to breathe,
> And they need you please.

* * *

And they're not just competing with every other band in the world, every other artist in the world. They're competing with every other entity that has a presence in the "attention economy": every corporation, every

politician, every dog video. Competing, moreover, on a steeply tilted playing field. The Web is governed by network effects—meaning, as the tech investor Yuri Milner has remarked, that "big sucks the traffic out of small." That is why the Internet itself inclines so strongly toward monopoly. Everybody uses Facebook because everybody uses Facebook (and Amazon, and Google, and YouTube, which is owned by Google, and Instagram, which is owned by Facebook). Content follows the identical law, especially because virality is driven by algorithms—employed by those same corporations to create our search results and news feeds and recommendations lists—that multiply the popularity of that which is already popular.

The system is designed for scale. You can actually make a lot of money as a musician from streaming, but only if you generate, say, a hundred million streams. A paltry million streams will only get you between about $700 and $6,000. Anything that doesn't scale is out of luck. In theory, we, the audience, can choose from everything in recorded history, discovering weird movies and exploring obscure bands. In practice, we are apt to sit back and let the algorithms do the work for us. The advent of Amazon, for instance, has actually narrowed the range of "discovery" for the typical reader, because it is so much harder to browse on the platform than it is in an actual bookstore, where you can take in lots of titles at a single glance and move with ease among unrelated categories.

It wasn't supposed to be like this, according to the techno-utopians. One of their most cherished concepts is the "long tail," a term coined by Chris Anderson, the author of *Free*. If you draw a graph that plots the sales of different products of a given type by the number of units sold (sales of different kinds of mustard, say), you wind up with a curve that looks roughly like the bottom left quarter of a circle (to be precise, it's a hyperbola)—a few big sellers on the left, and a tail that thins out to the right as you get into less and less popular items. A brick-and-mortar store does not have the shelf space for most of the latter, things that sell only a small number of units. But the Internet, Anderson observed, is, so to speak, an infinite shelf, which means that it can carry an endless number of different things (six million books and counting on Amazon), which means in turn that the distribution curve can extend to the right without limit. That's the long tail.

As people browsed the infinite shelf, Anderson believed, the tail would

get not only longer but thicker, that "the bigger [would] get smaller and the smaller, bigger," as Astra Taylor paraphrased the concept in *The People's Platform*. Out in the long tail would flourish all those niche artists with their thousand true fans. In fact, the opposite has taken place. The "fat head" has gotten even fatter. Best-selling books have gotten bestier; blockbuster movies have gotten bustier; chart-topping singles just sit there, topping the charts, for longer and longer. In the age of *Thriller*, the great blockbusting album of the early 1980s, 80 percent of revenue in the music business went to the top 20 percent of content. Now it goes to the top 1 percent. The long tail is getting not only longer but thinner, and there are a lot of things out there on the infinite shelf that are pretty much gathering dust. The arrangement is working out fine, but only for the aggregators, the distributors, the Amazons and Googles—the people who own the shelf.

* * *

All of which means that access is not, in practice, equal and universal. Nor is it "disintermediated": direct from artist to audience. You don't have access to the audience if the audience can't find you, and nobody can search for you unless they know that you exist. For artists, the more noise there is in the system, the more valuable become the players who can cut through it, which mean the major corporations, old and new, of the culture industry. For the audience, the more valuable become the players who can filter it, who perform the work of "curation," of selecting and sorting. Whatever we'd prefer to think, the gatekeepers are not dead (a curator is just a gatekeeper that you happen to like), nor is it possible to imagine how they ever could be.

They have, however, multiplied. Every time somebody sets up a new opportunity—a new comedy club, a new reading series, a new podcast about music, a new website for the visual arts—they create a new gate, and they appoint themselves the gatekeeper. And the more of those there are—the more venues, the more platforms, the more entry points—the more important the most prominent ones become: the leading biennials, now that there are hundreds; the major film festivals, now that there are thousands; the most prestigious MFA programs, as they continue to proliferate; the most listened-to Spotify playlists; the landing page on Netflix; the "featured" lists on the crowdfunding sites. Getting into them or onto

them—gaining access, as it were, to access—becomes more important, as well. The gatekeepers keep people out, which is cruel, but now, as Mitchell Johnston, the director, told me, "people believe" they're dead, which, for artists, "may be even more cruel."

In such an environment, unfair advantages help—a lot. One is legacy. The figures who are best positioned to prosper in the new attention economy are those who established themselves before it existed and are able to leverage the fame they already achieved. That's the reason it is so obtuse to hold up U2, say, as an example of why it supposedly pays to give away your music for free. In a gloating piece entitled "Amazon Is Doing the World a Favor by Crushing Book Publishers," Matthew Yglesias, the blogger and journalist, cites George R. R. Martin, author of the series that became *Game of Thrones*, as the kind of writer who is able these days to dispense with the publishing industry. Right—thanks to the publishing industry. The argument would be akin to pointing to a forty-year-old man, who can obviously get along fine on his own, as proof that people don't need parents. In this as in so many other respects, the arts are a microcosm of the economy as a whole, in which the old and middle-aged, having built their wealth (and other forms of capital) in times of greater abundance, have secured a generational incumbency against the young.

Another, related advantage is what the movie industry calls "pre-awareness." It's a whole lot easier to hitch a ride on an existing brand than it is to develop a new one from scratch. That's why Hollywood is dominated by franchises, those endless successions of sequels, especially ones that are built around characters already familiar from comic books. That's why television seems to be remaking every show in history, including the ones they should never have made in the first place. That's why Paris Hilton can release a gold record, Tom Hanks can publish a bestselling book of short stories, Michael Moore can have a one-man Broadway show, Alec Baldwin can do a podcast on public radio, and Lionel Richie can market a line of bedsheets. Ours is the age of the "360-degree revenue model," in which celebrities self-replicate across the available platforms.

Yet another advantage is getting there first. People who are early to a given platform, who are bold enough to try a thing before the rest of us have even heard of it, benefit simply from the lack of competition:

Andrew Sullivan in blogging, for example, or Marc Maron in podcasting. When the model blows up, they blow up. As Jaron Lanier, the tech visionary and tech critic, explains in *Who Owns the Future*, when a new platform is emerging, during "that fleeting magic moment when a network is gaining its network effect," "a small-time player might just score a once-in-a-lifetime spectacular lift." One of Lanier's examples, in fact, is our old friend Amanda Palmer, who launched her Kickstarter campaign, as Lanier puts it, "during that honeymoon year" for the site. Sean Blanda, a former director of 99U, the site and conference for creative professionals, spoke to me about the early 2000s as the time of the "land-grab" in blogging and other online media, when the Web was being divvied up. The phrase is apt because, as he explained, once "we get into our bubbles of content"—settle on our go-to sites or podcasts—we tend to stay there. The land that has been grabbed is our attention.

Being early was one of the themes that came up most consistently in my interviews, especially among the artists who had found the greatest success: early to YouTube or Etsy or web series or selling directly from your own site. Just as consistently, these individuals agreed that it would be much more difficult to do today what they did back then. Lisa Congdon was one of the first illustrators to build her practice exclusively over the Internet, beginning in 2007. Mentioning another, who began even earlier, she said, "If the two of us started today, we'd just be one of a million people with a certain kind of hip aesthetic trying to build a following and sell their work." YouTube launched in 2005. In 2006, the average video got about ten thousand views; in 2016, it got eighty-nine. People start to see successful podcasts, say, and think that podcasting is the new model. No, the model is, the model continues to be, being new. But as the Internet matures, or calcifies—it's not the Wild West it once was, and platforms no longer emerge with the same kind of frequency—it isn't clear how much more "new" we're going to get, how many more land grabs there are going to be, on the closing frontier. "I wonder," Blanda said, "where's the next one? Is there a next one? Will there ever be another one?"

* * *

But the biggest advantage is money. This was, without a doubt, the single most pervasive theme across my interviews. Independent film is "an elite sport," with "a high level of trust-fundism," one director told me. "You

have to know that you have, at the very least, a safety net." It's the same in live theater, according to Clare Barron, an Obie Award–winning playwright and 2019 Pulitzer Prize finalist. "If you look at the most successful young directors, every single one of them comes from a lot of money," she said. "That's a big problem. That changes who is able to actually make work and the type of theater you see. A lot of avant-garde companies have founders who come from money and were able to put on ten plays before they became successful." That students in art school tend to come from affluent backgrounds is more or less taken for granted. "What kind of parent is going to agree to pay $200,000 for a BFA?" Coco Fusco, the longtime art professor, asked. "The majority of middle-class professionals will not support their children to study art. So who's there? It's a very narrow slice of America."

Then there are the sorts of entry-level positions that artists take as a means of getting their foot in the door. Young writers work as junior editors, aspiring film and television directors as production assistants, young visual artists as studio and gallery assistants. Such jobs are ways to make connections, learn the ropes, observe the pros at work, and immerse yourself in the field. The only problem is they tend to pay the kinds of salaries that say, "You don't really need this money, do you?" That is, when they pay at all. Studio assistants can receive as little as $11 an hour; production assistants, $12 to $15 an hour. I had a former student who was in her seventh year as an editor at a major independent press. "What do you make?" I asked her. "About 60?" She snorted: "Almost 40." As of 2017, editorial assistants at the *New Yorker*, a former staffer told me, were earning $35,000 a year, in a city where rent can easily account for half that much. "Privilege doesn't even begin to describe where they're from," he said.

But just as common as the job that scarcely pays a living wage—indeed ubiquitous, at this point, in media and the arts, and often essential for getting a start—is the job that doesn't pay a thing: in other words, the internship. Internships are, pretty much by definition, an affirmative action program for the rich. Gemma Sieff, who left a senior position at *Harper's Magazine,* in part because of the pay, had this to say about the New York culture industry: "It is a de facto class system. And it's something that these liberal organizations will not look at. They can't look at it, because it just makes them look so crummy."

The advantages of wealth are also indirect. Noah Fischer is a visual

artist who composed the manifesto that incited the creation of Occupy Wall Street's Arts and Culture working group, which developed into Occupy Museums. "All these worlds—the world of writing, the world of film, the world of visual arts—still work by who you know," he told me. "It's not like you take a test." The idea of universal access, I was told by Tammy Kim, a journalist who has written for the *New York Times*, the *New Yorker*, and other leading publications, "is complete and utter bullshit. Anybody trying to rise up through those ranks is going to have a hell of a time doing that without personal connections." And since people tend to start to build their networks in college and graduate school, Fischer said, and since elite institutions select preferentially for children of the well-to-do, "there is this huge class filter, privilege filter," in the arts.

Nor do the educational advantages begin at age eighteen. "Only very affluent public [high] schools can fund an art program," Coco Fusco said. "You can't get into a good art school without a portfolio, and you're not going to have a portfolio if you don't take any art classes." People understand that if you aren't doing calculus by twelfth grade, there's not much possibility that you'll become a scientist or engineer, but they don't appreciate the sheer amount of cultural and human capital that you need to accumulate by the time you finish high school and, certainly, by the time you finish college—the skill, the connections, the social fluency, the "literacy," in the widest sense—if you're going to have a decent chance as nearly any kind of artist.

The arts have long skewed rich: because they don't pay very well; because success is so uncertain and, even when achieved, so inconsistent; because it takes so long to establish yourself; because you need to grow up with money just to know what a lot of them are, still more to believe that you have a right to pursue them. But now the skew is getting worse and worse, as incomes fall and costs—especially rent and tuition—go up.

"There's a whole generation of young people in New York," the writer Christine Smallwood said, thinking specifically of housing costs, "that are supported by capital from outside the city." James Lee, who has worked in television since 2000, when he was making $100 a day as a production assistant, noted that people could live in Los Angeles on that kind of money back then. "Rent was a lot cheaper," he said. "Now, if you want to be in TV or film and you're making that kind of money, your career is subsidized by family."

Noah Fischer, who teaches at the Parsons School of Design in New York, told me that the school "attracts the global elite," with "a huge percentage of international students who are paying full tuition. And this is true of all the top art schools in major cities" since 2008, he added, when their domestic customers began to disappear. Student debt, of course, has been exploding, especially for those who do an MFA. It's no longer unusual, Fischer said, for people to be paying $800 to $1,000 a month for thirty years or more. Among his former students, the divide is very clear: between those who are saddled with payments and therefore have trouble finding time to do their work, and the wealthy ones who aren't and don't. Meanwhile, arts funding in K–12 has been declining since the 1970s, a trend exacerbated since 2001 by testing regimes like No Child Left Behind, which squeeze out everything but math and reading—except, of course, in private schools or affluent, might-as-well-be-private public ones.

Salaries in the arts have steadily lost ground against inflation. Hourly wages for studio assistants, for example, haven't budged since 1993—a cut of 44 percent in constant dollars. When staff at the *New Yorker* voted overwhelmingly to unionize in 2018, they did so, in part, because their raises had been far outpaced by increases in the cost of living in New York. Full-time jobs, in the culture industry as elsewhere, are being replaced by "all these sprinkles of employment-*type* relationships," as Tammy Kim, who writes about labor issues, expressed it. The Internet, she said, has contributed "to the denuding of traditional economic relationships that have allowed people to stay afloat in the past. Most people in creative fields are either unlawfully classified as independent contractors or are doing something even worse—something that is so fractured and so temporary that you're literally just doing tiny gigs all the time. So nobody has health insurance, nobody has savings, nobody has any sorts of benefits."

Nor is crowdfunding the magic bullet that many would like to believe. It hasn't solved the problem of access, Margot Atwell told me, because you have to have access to do it. People rarely go on Kickstarter just to look for worthy projects to contribute to, she said. They go on because they were asked. Crowdfunding favors the well connected, people with friends with disposable income, which means it reinforces, rather than mitigates, existing inequalities. "Your success on Kickstarter can depend heavily on your background and network," I was told by Paul Rucker,

a composer, visual artist, and 2017 Guggenheim Fellow, who is African American. "We're more likely to give money to someone who looks like us." Clare Barron needed $12,000 to produce her second play, the kind of money that a kid who was raised on the Upper East Side can dig out of the pocket of their father's swimming trunks. "This is where it really matters where you come from," she said. Barron is from Wenatchee, Washington, not "the type of place where I can go back and say, 'Mr. and Mrs. Smith, can I have a thousand dollars?'" She finally managed to cobble together a tiny grant, contributions from a few donors, and a little bit from Indiegogo. "It was so exhausting, emotionally," she said. "It was horrible."

Favianna Rodriguez is a transnational interdisciplinary artist and co-founder of a range of community and activist groups, including Oakland's EastSide Arts Alliance and Cultural Center; Presente.org, the largest online advocacy group for Latin American immigrants in the United States; and CultureStrike, a national arts social justice network. "We are now in a crisis around the demographics of who's making culture," she told me. Four out of five working artists, Rodriguez said, people who earn the majority of their income from art, are white. "Overall, the state of the arts economy is disgustingly unequal. And it's all the arts: it's literature, film, it's sculpture, dance, it's everything." The Internet has failed to make much of a difference, she added. You still need training. You still need money to do your work. The "systemic institutions that run culture in this country"—the museums, the art schools, the Hollywood studios—have not gone away. The arts, in short, she said, are getting "extremely less equitable."

* * *

So that's the long answer to whether circumstances really are more difficult for artists now. Some things are better; more things are worse. Still, people like Favianna Rodriguez, and Clare Barron, and Paul Rucker, and Noah Fischer, and James Lee, and all the others I talked to persevere. Some are finding ways to thrive, others merely to survive. How they are doing so—what today's conditions look like on the ground—is the subject of the following chapter.

DOING IT YOURSELF

The good news is, you can do it yourself. The bad news is, you have to. Careers, including artistic ones, have a way of mirroring the overall economy. In the decades after World War II, an era that was dominated by big, blocky, stable institutions like General Electric and the Teamsters and the Ford Foundation, artists had careers that were sort of big and blocky, too, and if not static or stable, exactly, then linear. You did one thing, or a few related things, and you did them the same way for a long time: made movies for the same studio, taught painting at the same university, wrote novels for the same publisher and articles for the same magazines. You didn't think about the business end, because you didn't have to—that's what the middlemen were for—and there wasn't anything that you could do about it anyway. But now the economy is fluid, fragmented, and marked by the churn of continuous disruption. So are the arts, and so are careers in the arts. The only constant now for artists is that everything is always shifting. The only rule is: keep your eyes open and stay on your toes.

"A career in creativity requires enormous amounts of creativity," the illustrator Andy J. Miller (Andy J. Pizza) told me, affirming what a lot of people stressed. You need to think of "crafting your career as the ultimate creative project. It's not gonna just be, break into editorial illustration and you're set." The watchwords now are "nimble," "savvy," "scrappy": be agile, be shrewd, and be prepared to do what it takes. Diana Spechler is a novelist, travel writer, and storyteller who also teaches online writing

classes and works as a freelance manuscript consultant. "The people who I see getting depressed," she said, "are people who don't see a path other than the one they aspired to twenty years ago. If you can be flexible, you can do it." There's no such thing anymore as secluding yourself in your study or studio. You have to stay in constant contact with the market. It's not enough to practice your craft every day, said Dan Barrett, an Austin-based musician and producer; you also need to practice "networking, bookkeeping, watching trends." Most of his friends who are managing to have successful careers in music, he added, "are extremely conscious about continuously evolving, changing, adapting, like any person in a technology-laden industry would have to [be]."

The importance of that kind of spirit—innovative, flexible, proactive—is one of the things that people have in mind today when they speak about artists as "creative entrepreneurs." (A more accurate term, in this connection, would be "entrepreneurial creatives.") Another thing they have in mind is that managing your career is like running a small business. That means dealing with the nuts and bolts: planning and running a tour, organizing a film shoot, shipping and invoicing artwork, handling clients, chasing down payments, attending to taxes and legal structures, making budgets and keeping accounts—being, as one painter put it, "a one-man band." But it also means thinking strategically: discerning new openings, conducting market research, diversifying your product lines and income streams, developing and managing your brand—even if you'd never use those terms. "There's no formula," said Katrina Frye, the young Los Angeles photographer who set up shop as an artists' consultant, "and that's really uncomfortable." But necessity, here, is also opportunity. Artists must, but also can, bring to their careers the same open-minded curiosity, the same ability to envision unexpected possibilities, that they bring to their art.

Since you're doing, in essence, two jobs, manager as well as maker, you need to develop a second, very different set of skills on top of your artistic ones. A number of people I talked to had made a point of doing a kind of self-guided business degree. One was Barrett, who had struggled for the first ten years of his career as a musician. "One day I realized it wasn't the music industry. It was me. I needed to adapt and I needed to understand business." So he read "probably three hundred business books and books on personal development and books on networking."

One thing he learned was that, like any other business, "you really do have to create something of objective value," something that other people are going to want to pay for, not just what you personally feel like making. But he also learned that "most people are not entrepreneurs." They tend to launch their business "in an entrepreneurial fit," a spasm of discomfort or passion, but aren't really cut out to run it. "It's alarmingly democratic in that way," he said. "To be a professional musician means that you're a successful entrepreneur, and most businesses fail." In other words, there's no more reason to think that every artist can become a businessperson than there is to think that every businessperson can become an artist.

In any case, we should be clear about the kind of small business we're talking about. It's not a real business, in the sense of something that possesses the potential to expand, add workers, build equity, and generate profit. (Successful film directors who establish production companies or art world stars like Jeff Koons, who employs in excess of a hundred people in his studio, are rare exceptions.) Deriding what she called "this creative entrepreneurship bullshit," Lise Soskolne, who is a painter as well as a founder of W.A.G.E., the activist group, pointed out that what you are investing in, as an independent artist, is basically a nonprofit. "When I think about all the money over the years that I poured into this thing," she said, "the chances of actually making a profit are slim to none." When people say that artists are entrepreneurs, they mainly mean that they are self-employed.

But "self-employment" is itself a sneaky oxymoron. If you don't have a boss, you don't have a job. No salary, no pension, no health care benefits. No sick days, no vacation days, no holidays. No Saturdays or Sundays. No office space, no parking space. No goofing off or chatting by the water cooler. You answer your own phone. You generate your own leads. You learn about something known as self-employment tax, the other half of FICA that would otherwise be paid for by your job. Time for you is money in a very literal sense: every minute that you aren't working is a minute that you aren't earning. In an essay that likens the freelance life to a basketball game, with the shot clock ever ticking down, the great art critic Dave Hickey described that life as "the experience of arising each morning certain that if you don't write today, you

won't eat in eight weeks, that if you don't get a job today, you won't eat in sixteen weeks."

Doing it yourself means doing it all yourself. "It's freaking hard," the cartoonist Len Peralta, who had worked in advertising offices before going freelance, remarked. "When you don't want to do it, and you're the only person doing it, it's like, why doesn't somebody else push for a while?" It can also be lonely. "My work has no camaraderie attached to it, no sense of collectivized effort and celebration," I was told by Lily Kolodny, the illustrator. "It's just like you send it," meaning a finished piece of work, "and you can walk around the room, and that's the beginning and end of your celebration." Kolodny was living in San Diego when she finalized one of her biggest professional triumphs, an animated video that appeared on the home page of the *New York Times* and took her three weeks of round-the-clock effort. She had no one to share the moment with. "I just went to the beach," she said, "and lay down and slept facedown on the beach."

Of course, if you don't have a job, you don't have a boss. You can make your own hours. You can choose your own projects. You can work at home. You can wear what you want. You don't have to go to meetings, or listen to pep talks, or file reports, or make chitchat with customers. You don't have to smile, or ask permission to take a break. You don't have to play office politics, or kiss someone's ass, or pretend that you like it. And if you're an artist, then you get to be an artist. You get to create. But self-employment isn't for the faint of heart.

* * *

Doing it yourself in the digital age—the age of the attention economy—centers on the overlapping trio of self-marketing, self-promotion, and self-branding. That much is true, it should be said, even if you aren't, strictly speaking, doing it yourself. Even if you're still affiliated with the culture industry, you have to do a lot of it. Authors, for example, now effectively function as partners with their publishing companies in the work of marketing and publicity—an expectation, one industry insider told me, that's felt to be included in the advance. In the old days, when you finished a novel, Martin Amis once remarked, you just handed it in and that was it. Amis was lamenting the advent of the book tour—this

was 1995—a complaint that now sounds quaint. As the writer and editor Sam Sacks has itemized the particulars in the *New Republic*, "authors who have had their novels accepted for publication" are expected to:

> Develop an active presence on Facebook and Twitter (and, for the truly motivated, on Tumblr, Instagram, and Pinterest); create an accompanying website, video trailer, and soundtrack; go on a book tour, naturally, but also participate in a variety of reading series in anticipation of and well after the publication date; take part in panels and signings at book expos; give interviews to blogs and podcasts and write personal essays about your background, your development as a writer, and your process of creation; not only review other books but join the great merry-go-round of blurbing; perhaps you'll even personally attend book clubs.

Kate Carroll de Gutes, an essayist who publishes with small independent presses, which typically have no money at all for marketing and promotion, extemporized a different list, one that could apply to self-published authors, as well: "We do all the social media channels—Facebook, Twitter, Goodreads; we do readings; we do classes; we have email lists; we get friends to write endorsements; we shill for reviews on Amazon and Goodreads." The journalist and author Steven Kotler has remarked that writers need to be proficient not just in public speaking, but in different *kinds* of public speaking: the book-tour talk, the teaching video, the podcast interview, the radio interview, the television interview. It should come as no surprise that the amount of time that authors spend on marketing increased by 59 percent from 2009 to 2015, according to a survey by the Authors Guild. Adelle Waldman, who published a best-selling novel in 2013, told me that she spent a solid year promoting it.

But contemporary marketing goes beyond such frontal tactics. The two most effective strategies, I was told by Andy J. Miller, who also teaches, speaks, and does a podcast about career development for creative professionals (he is one of those people who gave himself a business education), are "content marketing" and "influencer marketing." Content marketing is just a fancy term for putting your stuff out there. "Think of a McDonald's commercial versus an Old Spice commercial,"

Miller said. McDonald's commercials are the same as ever: happy people eating burgers, close-ups of glistening fries, up-talky voiceovers praising the food. Old Spice commercials are miniature movies: funny, cheeky, visually clever, with the product mentioned only by the way. "McDonald's is, 'I'm going to steal 30 seconds from you, force you to watch this, take your time to take your money later,'" Miller explained, "whereas Old Spice is 30 seconds of free comedy to trade you for your attention." The latter is content marketing (also known as branded art): offering something of value for free to get people interested in what you have to sell them.

Miller realized at a certain point that all of those "personal projects" or "side projects" that creative professionals typically engage in these days are just another version of the same thing. He mentioned Jessica Hische in this connection (the person who created the "Should I Work for Free?" flowchart), who posted a different drop-cap illustration every day for a year. "You're giving away free, cool art online, for people's attention, to spark word-of-mouth, to get you jobs," he said. "It's just *you're* the brand." But rather than simply pumping out a whole bunch of stuff, he said, as people tend to do, the most effective use of content marketing is when you target it precisely. You identify the kind of work you'd like to get paid for, then you "reverse engineer" it: put up examples for free to demonstrate what you can do. Miller himself was interested in doing book covers at one point, so he created and posted new designs for a series of public-domain titles like *The Wizard of Oz*.

While Miller and Hische, as illustrators, are involved in a field where work most often takes the form of commissions—specific projects, with narrow parameters, for specific clients—the same ideas apply across the arts. Content marketing is exactly what a young filmmaker is doing when she produces shorts that are designed, as they almost always are these days, to serve as calling cards for work in Hollywood or television. It's what a comedian is doing when he tweets out jokes on Twitter, looking to land a spot in a writers' room. It's what musicians do when they put up free tracks, hoping to have one licensed for a movie or commercial, or to get themselves work writing songs. It's what Issa Rae did when she created the web series *The Misadventures of Awkward Black Girl*, a show that eventually evolved into HBO's *Insecure*. And it's the reason,

of course, that people think they can get away with asking artists to work for "exposure"—the difference being that when you put out your own work, it is, precisely, your own work, and no one else is making money off it.

Influencer marketing, Miller went on, is just a fancy name for collaboration. As with content marketing, he said, creative people get offended if you ask them to think about what they're doing in those terms, but that's what it is nonetheless. Miller mentioned his book *Creative Pep Talk*, which includes contributions by fifty well-known creative professionals. He genuinely wanted to do it, he said, but he also knew that a lot of the contributors would publicize it on their social media feeds and across their networks. "That's the most effective exposure I could get," he said, "and the same goes for having people on my podcast." Today, when every independent creator has, or is, their own publicity shop, every public interaction is an opportunity for cross-promotion. And what creator isn't independent now? What interaction isn't public?

The point of all this marketing is not only to sell existing work (your new album or children's book) or to solicit future opportunities from clients and companies (Hallmark or HBO), but also—following the logic of "1,000 true fans"—to build an audience of your own, a durable source of sales and support. Jane Friedman is a publishing consultant with twenty years' experience in the industry, the author of *The Business of Being a Writer* and *The Authors Guild Guide to Self-Publishing*, and the 2019 winner of Digital Book World's Publishing Commentator of the Year. The process of audience building, she told me, because it means developing relationships, has to be "organic and ongoing." You can't start frantically tweeting and blogging when your book comes out, as many authors do, she said; by then it's too late. Hence the popularity of the "one-a" genre (one-a-day, one-a-week), like Hische's drop-cap illustrations, of which I came across many examples: people posting a new drawing every day for a hundred days, or creating a new song every week for a year, or even writing a new short story every weekday for a year. Blogs and podcasts embody the same idea—new free content on a frequent and regular basis—as does much of the material that people furnish their supporters on Patreon. And because the attention economy is also an addiction economy—as demonstrated every time we check our phones, hoping for a fix—you're also hooking your fans on hearing from you.

It takes as much time as it sounds. Friedman blogged for three years before seeing any kind of financial payoff, "and most people are like, I'm not going to *blog* for three years with the *hope* that something might happen," she said. "You almost have to be compelled to do it, to experiment and play." If you're on Instagram or some other platform only because you've been told you have to be, "it is going to poison the whole enterprise from the start." Friedman mentioned the best-selling essayist Roxane Gay, who had "labored for years in obscurity," and whose career-making piece, "Bad Feminist," Friedman published in the *Virginia Quarterly Review* after discovering Gay on Twitter. "Her Twitter feed is like a stream of consciousness," Friedman said.

In other words, to use the inevitable term, Gay comes across as authentic. Lisa Congdon, the illustrator, who began making visual art in her thirties, built a lucrative practice by blogging nearly every day. "So much of my success isn't my artwork," she told me, "it's the fact that I got really good at telling my story." She spoke honestly about her life: about being older, and later, even though it cost her followers, about being gay. The approach was partly instinctive, the feeling that she needed to be her "whole self" if she was going to be online at all, and partly strategic, consciously growing her following by being "a real human being that people felt like they knew." Building an audience, in the age of social media, means being willing to be personal, even intimate, with strangers. You sell your work today by selling your story, your personality—by selling, in essence, yourself.

* * *

All of this is not without its sorrows, as one might imagine. There is the sheer drain on time and energy. Lucy Bellwood, the cartoonist, told me that she is able to devote no more than 10 to 20 percent of her time to actually drawing. And creative time, to be of any use, must be free from interruption. You need the space to sink into your trance. Jeff Tayler (not his real name) was the frontman of, and creative force behind, a rising indie band when he walked away from music altogether, so fed up was he with all the promotional demands that their label was making: to maintain a constant social media presence; to post photos, videos, and musical tracks; to blog about their shows; to reach out as well as respond to music journalists and bloggers. "They don't want a band," he told

me at the time. "They want a reality show." Later he said, "I wanted to write, and I wanted to think, and I wanted to go deep, but I couldn't really because I was constantly being called to the surface." Yet it's not as if he had a choice, whatever the label might have wanted, "because you're barely scraping by professionally. You might be popular, and you have fans, but you need all the help you can get." So you agree to do that seventh interview for a music blog—"it's a fifteen-year-old in the attic, [but he] might have actually a shit-ton of followers"—even though "that will destroy your day." Tayler couldn't make music anymore. He was too busy being a musician.

Then there are the terrors of social media. All those anxieties you feel when you post on Instagram or Facebook—about crafting your persona or your number of likes? Imagine experiencing those in your professional life. Lily Kolodny, the illustrator who wound up facedown on the beach, had thus far stayed away from those and other platforms at the time we spoke, even though she knew that it was hurting her. An artist friend, she said, "begs me every day of my life to be on Instagram. She's like, 'Lily, this is how careers are made in the arts. You are shooting yourself in the foot every single day.'" But Kolodny was afraid of getting sucked into the ego competition that those sites inevitably involve, of becoming obsessive about her popularity and losing, cumulatively, days and weeks of her life. "I am so not in the spirit of my times in that I'm not an aggressive self-brander," she said. "I'm stuck in this transitional, Generation X–into–millennial fear of losing yet another part of my brain to the mindless activity of marketing myself." Yet she also understood that the issue wasn't only ego. Avoiding the maelstrom of social media, she acknowledged, "is absolutely keeping me at a level of business that's not what it could be."

Kolodny couched her resistance to the new imperatives in generational terms, and, needless to say, she was far from alone in such thinking. Jesse Cohen, one half of Tanlines, an indie rock duo, was born in 1980. This whole self-promotion-branding-marketing thing, I told him, sounds like a giant pain in the ass. Cohen paused a beat. "How old are you?" he said. Which was certainly a fair question. Still, we shouldn't assume that everyone below a certain age is seamlessly adapted to the new environment. Far from it. The guitarist and songwriter Jessica Boudreaux, who was born in 1990, has largely avoided the young musician's typical career

strategy of posting songs on YouTube. "I don't love seeing my face in videos," she explained. Marian Call, the singer-songwriter, whose career has been completely DIY, told me that among the reasons she has never tried to find a label is that she isn't interested in being famous. "I've had things occasionally go viral," she said, "and it's fun for a second, but I don't think I enjoy it." Becoming too much better known, she believes, would interrupt her life. "I figure, don't play a lottery you wouldn't want to win." One painter in her forties suggested that "this term, 'millennial,' might not even apply to an age group as much as to a type of person. Certain people, of any age, find it so fun, interesting, and easy to work through these social media networks, and then other people, of younger ages, don't." And maybe, she added, "that's going to separate the wheat from the chaff," the winners from the losers.

Which is not to say you can't be young, adept at social marketing, and nonetheless intensely ambivalent about it. That may, indeed, be more the norm than the exception. Lucy Bellwood, who was born in 1989, maintains a robust presence on multiple platforms and, as I mentioned, has a successful track record on Kickstarter and Patreon. What does it look like "to try and forge an actual, vulnerable human connection with seven thousand people on a Twitter profile?" she wondered. "We are asked to extend the bounds of what would usually be your most intimate friendships to strangers, and that connection is the glue that holds your fiscal life together. And that is both really magical to me and also totally terrifying."

Charlie Faye, who was born in 1981, fronts the neo-Motown girl group Charlie Faye & the Fayettes. The group has raised money on PledgeMusic, a crowdfunding site—a process that, as usual, involved the sharing of copious behind-the-scenes material: lyric sheets with handwritten notes, personalized videos straight from "Charlie's" living room. If you pledged enough, they took you out for an evening in Austin or let you kick it with them in the studio while they made their new record. "I so would never want to do anything like that," I told her. "No," she said, "none of us want to." None of you in the group, or none of you in the world? "None of us in the world."

The writer David Busis did all the self-marketing stuff, including keeping a blog. Even his freelance work, some of it for places like the *New York Times*, was really just "to market the David Busis author brand," he said. "I couldn't stand myself. I felt like such a douchebag." But "all

of my friends who are successful are totally shameless" when it comes to self-promotion, he went on. Then he reconsidered. "'Shameless,' now that I think about it, is exactly the wrong word. Most of the people who are doing a lot of self-promotion are absolutely filled with shame and self-loathing, and they feel compelled to do it anyway." Yet it may be that such feelings reflect no more than a transitional period in social history. In the future, I suggested to Jesse Cohen, self-marketing will simply be a normal part of life, like taking out the garbage. "Absolutely," he said. "We're already there."

* * *

To be clear, the new universe of online self-presentation coexists with a large and continuing set of imperatives that belong to the older elements of the arts economy. Artists still, depending on their field (and this is no more than a partial list), devote considerable time and effort (and anxiety and stress) to: applying for awards, grants, residencies, competitions, workshops, festivals, performance series, group shows, and the like (an activity with an impressively limited rate of success); pitching articles and submitting stories and poems to magazines and websites (ditto); teaching classes, giving lessons, and holding workshops; managing relationships with agents, editors, publishers, managers, dealers, bookers, producers, and so forth; beating the bushes for client work, then managing those relationships, too; and tending their ever-crucial network of personal (not social media) connections by going to parties, openings, readings, screenings, conferences, conventions, and wherever else the people in their industry flock to schmooze and flatter one another. And all of that, don't forget—all of this, plus all the online stuff—is merely the "other" half of what being an artist entails, the primary half being the one where you actually make your art.

Then, of course, there are the day jobs. Here is another partial list, gathered from the people whom I interviewed or read about. This is one of the things that artists do, unrelated to their creative activity, to make ends meet: wait tables (of course), tend bar, babysit, teach yoga, drive for Uber and Lyft, gig on Postmates, gig on TaskRabbit, gig on CrowdSource, gig on Mechanical Turk, tutor high school students for the SATs, edit law school application essays, edit the work of would-be self-published authors, stuff envelopes at the Metropolitan Museum of Art, strip, sling weed, do carpentry, work for an event planning company, work for a

matchmaking company, do tech writing, do public relations writing, work as a file clerk, work as a "glorified custodian" in a lab, run a coffee shop, play online poker, work as an undercover security agent, walk dogs, read tarot cards, deliver mail, work for a caterer, work for a wedding florist, manage parts at a motorcycle shop, produce a local public radio program, recruit for a high-end hotel, work as a janitor at the Seattle Art Museum, pass out flyers by the TKTS booth in Times Square, work for LinkedIn, do copywriting for Nordstrom, write articles on foot deformities to increase the page rank of oddshoefinder.com, work at a nonprofit, a law firm, a library, a youth shelter, a textile plant, work as a nanny, a secretary, a temp, a telemarketer, a real estate agent, sell their used underwear, sell their jewelry. "An American writer fights his way," James Baldwin wrote, "by means of pure bull-headedness and an indescribable series of odd jobs."

There are conflicting views about the day job. In music, it's a badge of honor, a sign of authenticity. If you're making so much money you don't need one, you must be a sellout. In all the other fields I looked at, it's a mark of shame, something to keep to yourself. In Hollywood, it means that you're a failure. In the art world and the literary world, it means that you're not a "real" artist or writer. Day jobs, in that respect, are like family money (which is the only alternative to having one for at least the first few years of your career, if not a great deal longer). Lots of people have them; no one wants to talk about them.

Grants, commissions, freelance fees, commercial work, ticket sales, crowdfunding, royalties, day jobs, teaching: the central fact of economic life, for the great majority of artists, is that you piece your living together from a wide variety of sources. As Jesse Cohen put it, you stack up a bunch of small checks. (The week before we spoke, he had gotten one for 23¢.) It's not unusual for him, one writer told me, to end the year with fifteen 1099s, the tax reporting statement for freelance income. In a post called "The Career of Being Myself," Meredith Graves, best known as the frontwoman of the rock band Perfect Pussy, described herself as "a member of a touring band, a full-time freelance culture writer and columnist, owner-operator of a small record label . . . a food writer and baker . . . a DJ, a moderator or speaker on panels as well as at colleges, a model, a record-shop employee, a radio and television personality, event coordinator—the list goes on."

A lot of time can go to generating work. "This freelance thing kills people," I was told by Lisa Bacon, who works in television. "It's *so* stressful. You have to hustle each time" to find the next job. "It's constant. It's constant." A lot of time can also go to getting paid for work already done. One musician described the process of chasing down royalty payments, which tend to be tiny, as "hunting for sparrows in the woods," trying to find "enough for a meal." But maintaining a diversity of income streams can be important, if only because you never know when one is going to dry up on you. These days, as Steven Kotler, the journalist and author, has remarked, the whole thing can dry up: the whole *type* of thing, on everyone who does it—his example being long-form journalism, a genre he'd spent years perfecting, which has now more or less disappeared.

Piecing it together also often plays to people's strengths, as well as suiting their personalities. Andy J. Miller, the illustrator, who has ADHD—as do, he believes, a lot of people with creative personalities—told me that he has always envisioned his career as "an ecosystem of things," because he "never considered a full-time position as a real option." The writer with the fifteen 1099s (who preferred to remain anonymous) explained that he had been "traumatized by going to school all those years," the "everydayness" of it, so he has always made a point of avoiding a regular job. And the freelance existence, as Meredith Graves remarked, also comes, at its best, with freedom, opportunity, excitement, absorption, and the sense that you're living exactly the life that you should.

* * *

There is a strange idea that persists in the culture that artists are lazy—that making art is a kind of leisure activity for self-indulgent weirdos. I think of a phrase that I sometimes hear from college students, their image of the alternative to the sort of hardheaded practicality that so many of them profess to favor: "sitting under a tree writing poetry." As if writing poetry were a serene and bucolic activity, whereas my impression is that actually writing poetry is the emotional equivalent of removing your own kidney.

In fact, I can't imagine anyone working harder than a lot of the artists I spoke with, for the simple reason that they come across as working all the time. Diana Spechler, the novelist and travel writer, has always put in seven days a week—often twelve hours a day when she was younger,

and sometimes still. ("I love to work," she said.) Jenni Powell, a pioneering web series creator, went years in which she often wouldn't see her house for a week at a time. Now she merely works twelve to fifteen hours a day and tries "to take some weekend time off." Lisa Congdon, the illustrator who started making art in her thirties, would wake up at 7:00 a.m., reach down to grab her computer off the floor where she had left it the night before, have her girlfriend bring her coffee in bed, and go all day—though, she said, "I would definitely stop for dinner." Lucy Bellwood, the cartoonist, only knows when it's a holiday because the traffic gets lighter in front of her house. When she first arrived in New York and was hustling to finish her graphic novel *Imagine Wanting Only This*, Kristen Radtke, who also has a full-time job, was "just ruthless," she said. "I would have been up all night with incredible anxiety if I hadn't worked [that day]." Now that the book was done, she was a little less driven by the time we talked. For example, she wasn't planning to work after dinner that day. Our conversation took place on the Sunday of a three-day weekend.

Artists need "crazy drive," as one of them put it. They need to work "25/8 not 24/7," as another has said. When I asked young writers in New York whether it is true that every young writer in New York uses stimulants like Adderall to handle the workload, I got three sorts of answers: yes; yes, except for me; and yes, including me, but don't tell anyone I said that. Indeed, the incessant, competitive busyness of life in a freelance economy—complete with the kind of guilty anxiety that Kristen Radtke expressed—where existence becomes an unending series of short-term tasks, is something that today's young high achievers (and even not-so-high achievers) have been training for since middle school, if not earlier. There's a bizarre idea at large that millennials are lazy. Millennials may be many things, most of them to do with the kind of economy in which they've been forced to grow up, but lazy isn't one of them. Quite the reverse. When I was told by the film director Hannah Fidell that she spent two years in Austin in her twenties doing nothing but waiting tables and working on a script, with no friends and no boyfriend, I thought, of course, the classic millennial strategy of just not having a life.

The pace takes its toll, even on the young. "There's almost a direct correlation between being an independent artist and having a chronic health condition," said Andy McMillan, cofounder of the XOXO festival

for independent creators. It's hard to find enough time to take care of yourself—time for sleep, exercise, relaxation; for friendships and relationships. Hannah Fidell was far from alone among the people I spoke with in having surrendered her social life for months or years. Kristen Radtke, who works for a publisher, treats her professional events as her social events. Lucy Bellwood told me that she and her partner, who lives a similar kind of life, had been talking about the need to expand their relationship "beyond helping each other with email triage and, like, organizing one another's project Post-it Notes." Burnout, unsurprisingly, was also not uncommon among the people I spoke with. "For a long time I would just say yes to everything because I thought that I wouldn't be asked again," Sarah Nicole Prickett, the writer from Ontario, told me. "I have this constant feeling like the whole house of cards could fall." Among the writers and artists she knows in New York, she remarked, exhaustion is pervasive.

* * *

At least no one thinks that artists are rich—though just how not-rich a lot of even full-time working artists are might surprise people. Not a few of the individuals I spoke with reported annual incomes in the range of $20,000 to $30,000, if not less. Some had gone on food stamps. "I had years in New York when I survived off of $18,000," I was told by Clare Barron, the playwright. The year she turned thirty-one, Monica Byrne, the novelist and playwright, earned about $15,000. Faina Lerman and her husband, Graeme White, visual artists in their forties who live near Detroit with their two small children, have a combined income of around $20,000. "How do you make a living?" I asked her. "We don't," she said. Nancy Blum, who does visual and public art, had lived "pretty hand to mouth" until about six or seven years before we spoke, netting only $25,000 to $30,000 annually from her work. She was fifty-three at the time of our conversation.

Even artists who were doing better—invariably, like Blum, after years or decades of struggle—were typically earning in the $40,000 to $70,000 range, middle-income but no higher. None that I spoke with were rich. In fact, according to a large-scale longitudinal survey by the Bureau of Labor Statistics, artists rank fourth from the bottom in average income among thirty occupational groups, ahead only of workers in childcare

and food preparation and service and behind even janitors and maids. And because they tend to come from relatively affluent families, according to the same survey, their downward economic mobility—the gap between their parents' income and their own—was the largest by far, representing a decline, on average, of 36 percent. The "starving artist" may be a cliché, but it is not a myth.

How do you survive in New York, I asked Clare Barron, on $18,000? "You live in a $500 apartment, and you eat dollar pizza and bagels," she said. "I just didn't really ever go out—that's how I did it." In New York, it turns out, $500 gets you a room in a basement. "You're living where the boiler is," she said. It's also illegal, so you might get evicted. Barron lived in three such situations, one with six Brazilian women from the same little town. When the basement flooded, she didn't pay rent for four months. She also had to share a bed with one of the Brazilians. Paul Rucker, the composer and visual artist who talked about the way that crowdfunding sites reinforce existing racial inequalities, lived in an illegal warehouse in Seattle, where he shared a bathroom with fifteen people, for eighteen years. That year she turned thirty-one, Byrne subsisted on "a lot of carbs and sugar and peanut-butter-filled pretzels. It was a calorie-per-dollar calculation." During her own years in New York, Diana Spechler would put on all her sports bras at the same time, since they were all worn out, and sometimes make up her last $10 of rent with laundry quarters. She'd also worry when the subway fare went up—an added cost, to her, of maybe a dollar a day. "I was always broke," she said. "Always, always broke."

Health insurance is a ubiquitous concern among the people I spoke with. Some pay a fortune; some buy inexpensive plans that cover almost nothing; some stay in jobs they'd rather leave; some go without and keep their fingers crossed. (And this was after the start of Obamacare. In 2013, the year before the law took effect, 43 percent of artists lacked insurance.) "In the bingo card of 'Comfortable Lifestyle,'" Lucy Bellwood said, "a lot of us are sacrificing maybe health care costs, or we're not going to the dentist." If people do get a little more money, she continued, they want, understandably, to fill in a few of those squares. When Byrne got word of her first advance, she told her agent that she could finally afford to buy some produce.

Bellwood's point, however, is that artists can get trapped in a

"subsistence-based mind-set," running on the hamster wheel of freelance work with no opportunity to take a breath and formulate a larger vision of where they want their work or their career to go. A lot of freelancers, she said, if you handed them $50,000, wouldn't know what to do with it, beyond filling out the bingo card—wouldn't have a bigger project to devote it to, because they've never had the chance to dream one up. And no one is handing them $50,000. What artists really need, writes Amy Whitaker in *Art Thinking*, "is not to be paid to make the things they already know how to make, but to somehow find space inside their financials to play and take risks to develop the next thing."

Incomes of artists are not only low, they can fluctuate wildly. The vast majority of revenue sources for artists are temporary: not steady, predictable paychecks, but short-term gigs and one-offs. Incomes can easily vary, from year to year or month to month, by a factor of five or ten. Lump-sum payments might sound big, but they don't come *on top* of your salary; they *are* your salary. A $50,000 grant, already very large as these things go, amounts to barely a middle-class income. A $100,000 advance, for a book that takes three years to write, is the equivalent, after an agent's 15 percent, of $28,333 a year. Clare Barron told me that she's "stressed out about money all the time," having gone down to "$0" on multiple occasions in recent years. She'll get "these little weird windfalls," but then have no idea what will happen three months down the road. "It's very exhausting psychologically to look at a calendar year," she said, "and not know where the money's going to come from." And when you're living on the economic edge, a single crisis can spell disaster: a health emergency, a stolen laptop, a major project falling through.

Artists have to be (and are) incredibly resourceful. Frugal, first of all. The number one key to sustaining a creative life, I was told, is keeping your expenses low. "If you decide to be a writer," Spechler told me, "you're sort of deciding to live a life where you don't want to buy things." They are also inventive. "One of the most challenging things about being an artist is making a $5,000 show with $500," Paul Rucker said. "We do it all the time." And finally, artists are collaborative. So many of the individuals I came in contact with approach their art in a spirit of solidarity, openhandedness, and mutual aid. When people don't have money, they have one another instead.

And whatever the hardships, artists do what they need to do to make

their art. Barron emphasized that her financial difficulties were a choice, something that enabled her to engage in a practice that she described in devotional terms. "I feel like when everything abandons me, when you feel alienated from all your friends, when you feel incredibly alone, at least I can make something," she said. "And that feeling of making something feels to me like salvation." Faina Lerman, the visual artist who lives with her husband on $20,000 a year, told me that she had always imagined she would be a struggling artist. "You're going to be poor, and you're going to work really hard," she said, "but you're going to be doing what you love, and you're going to be spiritually intact." And how's that working out, I asked. "Pretty good," she said. "We live very minimally," she laughed, "but we still have a good life." Jesse Cohen, of Tanlines, put it like this: "You have to figure out whether you're a lifer. If you're a lifer, it's always a struggle, but it's not a question. You know that that's your calling. That's your job."

SPACE AND TIME

In the catalog of costs that artists bear—food, tools and materials, health insurance, even student loan payments—one expense stands out implacably above the rest, shaping the very conditions in which art is made, often even whether it is made at all. That expense is housing, or in plainer language, rent.

I was struck, in speaking with artists, by how consistently they couched their income not in yearly terms, like a salaried professional, not in hourly terms, like a worker with a steady job, but in monthly ones. Eventually I realized it's because they think of their expenses that way. It is a monthly number that they must come up with, first and foremost. And that number, what's more, is highly inelastic—one they're powerless, at least in the short term, to change. You can live on dollar slices or peanut-butter pretzels, wear your sports bras all at once or not go out with friends—eat, drink, socialize, and travel less one month, more the next—but the rent cannot be bargained with. You make up the last $10 with laundry quarters, if you have to, and wash your clothes some other week. Even if you break your lease (and forfeit your deposit), you still have to find a new place, and you still have to move. Besides, if you could've found a cheaper place, you would be living there already.

But you cannot find a cheaper place, let alone a cheap one. Since 2000, as I mentioned in chapter 4, rent is up some 42 percent, adjusted for inflation, nationwide. Prices in creative centers tend to be especially exorbitant. As of May 2019, median rent for a one-bedroom apartment

was $1,540 in Chicago, $1,890 in Seattle, $2,280 in Los Angeles, $2,850 in New York, and $3,700 in San Francisco. When Matthue Roth, the Hasidic Jewish writer, arrived in San Francisco in 2001, he found a place in the Mission District for $400—a sum that now, he said, "wouldn't get you the front door." Paul Rucker, the composer and visual artist, paid $225 in Seattle in the 1990s; more recently, he told me, he's seen places go from $800 to $2,000.

Oakland has experienced a particularly savage rise in costs as money has flooded east across the San Francisco Bay, with rents increasing 19 percent in 2015 alone, making the city, long a largely black and working-class community, the fourth-most-expensive in the country. I spoke with Jonah Strauss, a housing activist, who recalled what things were like back then. When a room became available, he said, you didn't even bother posting it on Facebook, because you already knew five people who needed one. The market had cooled off a bit by the time we spoke, and conditions had improved, but not by much. On Craigslist, rooms were running about $1,100, one-bedroom apartments about $2,300, and people were offering as much as $400 to be allowed to pitch their tent in your backyard. "People will live in anything," he told me. "I have seen rooms in attics that are four feet tall. I have seen rooms that are built into other rooms. I have seen people living in garages with no insulation and no heat. I've seen people living in trailers out back of houses. I've seen people living in trailers on lots that are primarily used for dumping. I've seen people living in shacks in backyards that have no heat and very little insulation and no power and no running water. I've seen people living in tents. I've seen people living in garden sheds. Brother, people are living in anything."

This is what a housing crisis looks like. I didn't come across a single person who was living decently in a market-rate apartment in a major city on their earnings as an artist—a state of affairs that might sound inevitable at this point but is no less appalling for that. Artists can't afford to live where artists live. The people I spoke with either were living indecently, had gotten lucky, were residing in a smaller locale, or were being supported by parents or a partner. Mostly, they had gotten lucky: a connection to a cheap room, a rent-stabilized unit, a spot in artists-only housing, a place that had belonged to their grandmother, a place that belonged to the parents of a friend from college, an apartment someone purchased

twenty years ago or at the bottom of the market in 2009. But luck, in this context, tends to favor the already fortunate—people with connections, in one form or another, to money. People "luck" into advantageous living situations the way they luck into marrying rich, or going to a fancy college.

Many artists also pay a double rent: one for their apartment, a second for their studio. Prices for the latter, needless to say, have been rising as fast as those for the former—often faster, since they are typically subject to fewer restrictions. A private studio in New York will run you some $2,000; a corner of a studio that you share with five other people, about $600. When I spoke with Lise Soskolne, the painter and activist, she was about to lose her longtime space in Brooklyn's Greenpoint neighborhood and wasn't going to bother looking for another one. Institutional residencies, where artists are awarded stays of one or several months (which they often have to pay for) at art centers, colleges, or other places around the country, have been emerging, she told me, as a stopgap: instead of being able to afford a stable work environment, artists now compete for, and must travel to, temporary ones. "[A] formal studio, separate from the place where an artist lives and sleeps," wrote John Chiaverina in the *New York Times* in 2018, "once a given for a serious artist, has now become a luxury."

* * *

This is the sort of economic hardship that can alter artistic production profoundly. I spoke with several visual artists who, in default of a studio, work on their dining room tables, in the midst of domestic arrangements. There's only so much you can do like that. Solvents and other materials need to be properly vented and stored. Kilns, lathes, and other equipment require safe conditions and an adequate power supply. With their high ceilings and tall windows or skylights, studios provide incomparably better illumination than residential rooms, not to mention a great deal more space. "I am entirely dependent," writes the painter David Humphrey, "on having a physical space that can function as both an extension of my body and as a surrogate for the world: a clubhouse, playpen or dream factory." For artists, an empty studio is like an empty canvas: a space that teems with possibility.

Artists think with their hands and their eyes, through direct tactile

and sensory engagement with their tools and media. No studio—no big, wide room of one's own—means much less space to spread out and do that. Imaginations contract. Works get smaller or change their medium altogether. Artists think with their bodies, walking around a sculpture, pacing toward and away from a painting, encountering the emerging object as a physical presence. "We're not making big work anymore," I was told by Roberto Bedoya, Oakland's manager of cultural affairs. "We're making small work, or we're doing relational work. We're doing social practice. I'm not making big gigantic sculptures because I took over an old factory and I can play with steel like nobody's ever played with [it]. Those days are *gone*."

Nor is space an issue only for visual artists. Ian Svenonius, the DC punk provocateur, has argued that gentrification is killing rock 'n' roll, because no one has space anymore for a drum kit. Instead, they're making EDM (electronic dance music) on their laptops. (From 2008 to 2017, sales of electric guitars declined by 23 percent in North America.) Dance and theater companies rarely own their own spaces anymore. Dancers, said Bedoya, are turning to site-specific work. In ensemble theater, he added, "you do your project and you go home," instead of having the luxury of improvising and exploring in your own space on your own time. "You're not like the Wooster Group," he said, the great experimental theater company that has owned a building in the heart of SoHo since 1968.

Nor is space an issue only for creators. Jonah Strauss, the housing activist, is also a recording engineer. Strauss lost the warehouse space where he had been living and working—twelve hundred glorious square feet for $875 a month—in a fire in 2015. When we spoke, he was staying with his partner, after shifting through five places in two years, and renting a studio at almost twice the cost, with scarcely more than half the room, of his old situation. The entire infrastructure of the arts relies on inexpensive space: for music and recording studios, film and photography studios, dance studios, black box theaters, clubs, galleries, bookstores; for spaces to practice, perform, and exhibit, to hang out and collaborate and scheme.

These are being priced out, too, moving somewhere else or disappearing altogether. In New York, the experimental theater scene, once concentrated in the East Village, has been scattered across the boroughs. The

New York Studio Residency Program, which brought art students from around the country to study in the city for a semester, closed in 2017 after twenty-five years. In 2014, after nineteen years, nearly seventy-five hundred programs, and over one million audience admissions, Brooklyn's Galapagos Art Space, a pioneering incubator of the borough's artistic renaissance, pulled up stakes and moved to Detroit. New York City has now appointed a "nightlife mayor," a liaison to its late-night entertainment industry, in part to stem the loss of music venues—20 percent in the last fifteen years, including iconic clubs like CBGB. "The city needs to stop the bleeding of its cultural hubs," said the council member who proposed the move.

A music aficionado I know who lived in San Francisco during the worst of the run-up in rents told me that his characteristic experience there as a music fan was stumbling upon a beautiful old club, listening to great music, then being informed that, sorry, tonight is our last night. In Portland, Oregon, major jazz clubs have shuttered, and the city's all-ages music venues, which don't serve liquor and therefore operate on smaller margins, have been decimated. In Austin, where musicians are getting priced out by the boom in short-term rentals, the mayor has raised the alarm about the displacement of the city's creative middle class. "You can't be the live music capital of the world," he said, "if you lose your live music musicians and your live music venues."

Everywhere in my research, I heard stories of artists' displacement: people fleeing San Francisco for Oakland and Portland; Oakland for Detroit and Pittsburgh; Seattle for Baltimore, Anchorage, and Cedar Rapids; Manhattan for Brooklyn, Brooklyn for Queens, and New York for Philadelphia, Pittsburgh, Denver, Austin, Oakland, Los Angeles, and Berlin. In San Francisco, a 2015 survey found that 70 percent of the city's artists had been or were being evicted from their homes or studios or both. In "How I Get By," from 2016, the *Observer*, a New York–based website, profiled five artists between the ages twenty-seven and forty-nine. All had started their careers in the city. Four had left: one to Newport, Rhode Island; one to Hamtramck, which is next to Detroit; one to Berlin; and one to Los Angeles. The fifth was still in Williamsburg, holding on, as the condos rose around him. "It seems like New York doesn't want artists to live here," he said.

* * *

But do artists really need to live in centers, if they've gotten so expensive? Can't you live anywhere now, because of the Internet? I put those questions to a lot of people, and the answers, by and large, were unequivocal. Yes, they do. No, you can't. People don't make art in isolation, and online interactions are incomparably impoverished relative to those that take place in real life. Artists move to centers to be in the thick of it: for education, motivation, inspiration, for the chance to find their tribe, join the discussion, and make their way where the making is good. Art is a face-to-face business, a matter of intense collaboration and mutual exchange: musicians jamming after hours at a club, painters dropping by each other's studios and kibitzing each other's work, writers swapping stories and ideas at a coffee shop, theater people making drama by playing and sleeping together. None of that can happen over fiber-optic cables.

Even smaller cities, let alone nonurban areas, lack the necessary density of talent, resources, and ambition. Casey Droege is an artist, arts educator, and arts producer who has dedicated herself to building up the Pittsburgh arts community, yet even she acknowledged that "there's not a lot of room to grow" there as an individual artist. "You can continue making stuff, but it's only going to get you so far," she told me. The people who want to win a national reputation or sell their work beyond the local market "leave pretty quickly, because that can't happen here." Jasmine Reid, a spoken-word poet, moved home to Baltimore after college in 2015 but quickly relocated to New York. "Whenever I would visit," she said, "I would get caught up in just the energy of being here, the pace, and I would just feed off that energy." In Baltimore, "the community is smaller, there's less abundance, and there's less opportunity," whereas in New York, she knew, the poetry scene is vibrant. "Since I've been in New York," she said, "I've been around so many amazing and inspiring artists wherever I go, and I've never had that anywhere else." Her roommates now are all aspiring creators: a filmmaker, a fashion journalist, a musician. The filmmaker has his friends over all the time working on stuff. "I'm constantly astounded by the creative force of people I happen to be in the same space as," Reid said.

"Everyone's in Brooklyn," I was told by a novelist who attended the Iowa Writers' Workshop. Before he'd even found a place to live—in fact, the day he started looking—he ran into two different people from his program. "I just joked yesterday that we moved to Little Iowa City," he

remarked. But the camaraderie, he added, was secondary. "I like being in Brooklyn because it makes me try harder. I just feel like I've got to be smarter, and better, and more successful to be here, to earn my place here." Jessica Boudreaux, the guitarist and songwriter, moved to Portland, Oregon, from Baton Rouge for college. Once she started playing there, she said, she found her people. "I was where I was supposed to be," she told me. She also got better, because the people around her were better, but eventually she came to feel that the local music scene was too much of a bubble. "It's the big fish in a small pond mentality," she has said. "It's a lot of patting each other on the back. I like a sense of healthy competition." If she wanted to put herself back in a situation where she would be forced to improve, she has remarked, she would need to move to a place like Los Angeles.

Or if she wanted a career, she has said, as a songwriter. Artists move to the centers for the same reason coders move to Silicon Valley: because that's where their industries are. So where are the centers? In film and television, obviously, Los Angeles, with another center in New York. In music, New York, Los Angeles, and Nashville, with Austin and Atlanta (the "black Nashville") as important secondary locations. In the visual arts, New York, Los Angeles, and Chicago. In theater, including live comedy, also New York, Los Angeles, and Chicago. In the literary world, New York alone. In dance, again New York alone.

This is not to say that great art isn't being made in other places. In music, in particular, because of the importance of live performance as a creative and economic engine, as well as of historic African American and Latino communities, there is an abundance of terrific local scenes, including in Chicago, Detroit, Memphis, Miami, Seattle, and, of course, New Orleans. The question, however, is where are the cultural industries headquartered? Where do young people go when they want to make it big, or at all—when they commit themselves to breaking in and having a career? Artists in other places may not like to hear this, and cultural bureaucrats certainly don't, but the answer, overwhelmingly, is one of the centers—which means, for the most part, New York or Los Angeles.

The centers are the places where you make connections. Jasmine Reid was thinking of applying for a prestigious fellowship for emerging poets when a current fellow walked into her apartment—one of her filmmaker roommate's friends. She could ask her for advice, and generally start to

make herself familiar to the people whom she needs to know. A documentarian who lives in Oakland explained to me that his career would be better served if he lived in New York or Los Angeles, with better access to funders and more opportunities to network. "In LA, if you have an idea you can just walk out your door and have meetings and pitch it all week," he said. "Whereas I need to get on a plane and line them up and blah blah blah. And I'm just not going to have those relationships as easily because I'm not meeting those people at mixers." The essayist and critic Christine Smallwood remarked that "magazine writing does seem to be as much about personal connections as people outside of New York fear that it is. Everybody's like, 'Oh, they all just know each other and go to the same parties,' and it's true."

The centers are the places where you find collaborators. Sean Olson, who had worked in Los Angeles as a film and television editor and director for over fifteen years, got an important break when he was asked to direct the movie *F.R.E.D.I.*, about a teenager who discovers a friendly robot in the forest behind his house. The producer told him that he could do the movie if he could figure out how to get the robot made within the production's modest budget. Olson turned to his neighbor, who worked in special effects. They got the robot built, and the movie produced. "You can't make a film without great actors," another director told me. "Great actors flood to the cities. Great actors flood to the theater. The casting directors know who they are." Some years ago, he was shooting a film in Ohio and figured that it would be generous, as well as cost-effective, to cast local actors in the supporting roles. But "the lack of talent out there was astounding," he explained. He did find a couple of qualified people, but he was forced to fly in the rest, even for some tiny parts, "just to make sure they could pull their lines off."

The centers are the places where you find the jobs that get you a foot in the door. That is why Olson, of course, who came from Phoenix by way of Denver, was already in LA, where he had begun as an editor on *Fashion Police*. The range of places where the people I spoke with had started was a lot broader than the range of places where they'd ended up. We might like to believe that there are talented people everywhere, but the individuals who actually want to get things done cannot afford to be so sentimental. The talented people have converged on a limited number of places, to be with the other talented people.

* * *

There were dissenters from these ideas. Nancy Blum, the visual and pub-
lic artist, thinks that New York is no longer worth it for young people in
her field, naming Philadelphia, Dallas, and Chicago as good alternatives.
Some of those I spoke with loathe the centers and believe that it's best
to stay as far away from them as possible. Micah Van Hove, the indie
director from Ojai, hates LA and has never been able to persuade him-
self to live there. In LA, he said, every other filmmaker "is talking about
how they can get their TV show made." It's a culture, he went on, that
revolves around money, and if he's going to attack it, he wants to do so
from the outside. "There are politicians, and there are terrorists, and I'm
more of a terrorist."

Jessa Crispin, a contrarian author and critic and the founder of *Book-
slut*, one of the earliest literary blog sites, is also a terrorist. She scoffs at
all the writers who are living in New York "because that's what you think
a writer does," and she believes the practice leads to boring, predictable
work. For a lot of people, I was told by the editor and essayist Mark Greif
(one of the founders of the journal *n+1*), the path to great writing is to
"come to New York City once a year, go to one party, loathe everyone,
go home, lock themselves in a room, mull over how much they loathed
everyone at that party for a year, and just work on their writing."

The most compelling reason to eschew the centers, though, is that
you aspire to a different set of rewards. You don't want to "make it";
you just want to do your own thing. "If your ambition is to have a big
career," Blum acknowledged, then you need to be in New York. But that
isn't everyone's ambition. Marian Call, the DIY singer-songwriter, came
from a classical music background and studied composition and theory
at Stanford, where she was taught to aim for, as she put it, "a career
of note." She would get a university position or work in Hollywood or
Nashville. It was only after she moved to Anchorage and, later, Juneau
that she began to understand and value the possibility of a community-
based career, one in which you're making work not for the critics and
tastemakers, not for the millions, not even for your peers, but for—and
with, and from—the people around you.

Faina Lerman, the visual artist who was happy to be "spiritually
intact," lives in Hamtramck, a working-class town. She rejects the kind

of work that's validated by the art world, so "conceptualized and elitist," she said, that you can't relate to it "unless you have a master's degree from Yale." Lerman prefers to make art that "just kind of stumbles on [people]" as they go about their business, like the playful, even antic performance projects that she does with a partner on street corners and in other public places. "It's for whoever catches it, and it makes them so happy, and it makes us so happy. Because they're like, 'Oh my God, what is this? This just made my day.'"

I did speak with several young artists who aspire to wide recognition but nonetheless believe that it's possible for them to avoid the centers, which they are doing for reasons of cost. Sammus, the Afro-futurist rapper, had moved to Philadelphia, where she and her boyfriend were sharing a two-bedroom apartment for $1,500. Monica Byrne, the novelist and playwright, lives in Durham, North Carolina, where she was paying $675 for the second floor of a renovated Victorian. Atiya Jones, a mixed-media artist, had moved from Brooklyn to Pittsburgh, where she and a roommate were splitting the bulk of a three-story house for $1,100. And if you practice one of the more solitary arts, like writing or illustration, it is certainly possible to leave the centers once you begin to establish yourself. That is what Diana Spechler—she of the laundry quarters and the sports bras—did. Spechler had been renting a studio apartment in a basement in Greenpoint, Brooklyn, for $1,300, which everybody thought was a steal, when she moved to Mexico and found a house for $350. Not long afterward, she had some friends for dinner, and when they left, she realized that she had fed ten people for $6. "I had never had quality of life before," she told me. "I hadn't even really known what it meant."

Still, my research offered little reason to believe that the days of the centers are numbered, especially for younger artists. If anything, the need to be in one is even greater than it used to be, as creative industries, like so many others, have consolidated in a few big cities. The same Internet that enables the few who have won success to live wherever they choose has abetted economic forces that decree that those who are still struggling to do so have little choice at all. In "The Career of Being Myself," Meredith Graves of Perfect Pussy, anticipating the accusation that nobody forced her to live in an expensive city, explained that she "didn't have a career to speak of" until she moved to New York. Zach Hurd, another young musician, was determined to avoid the place, going so far as to live in

suburban New Jersey. He had seen people working so hard to make rent that they didn't have time for their music. But within a couple of years, he realized that New York was the place that he needed to be. "That's where real music is happening," he told me.

Which means that artists, at least those with large aspirations, are in a bind. They have to live in New York, or Los Angeles (which used to be relatively cheap but isn't any longer), or somewhere comparable (to the extent that there are any), but they can't afford to. They need to move to a center to do their work, but living in a center can prevent them from doing it. "Not that many people could ever endure this place," Nancy Blum said of New York. "Most people just get eaten alive, and they work their three jobs as a dog walker, and if they're lucky they get to make on the side. And there's a trillion people here for every person that actually makes it."

* * *

The irony of all this is that artists have served as instruments of their own displacement. It's called the gentrification cycle, and everyone knows how it goes. Artists colonize an inexpensive area, often one with empty industrial buildings, which offer lots of room for lofts and studios. They open alternative art spaces and experimental performance venues and throw parties in the warehouses and do street art on the sides of buildings. The area becomes cool, which attracts the hipsters, who may be understood as fake bohemians with an entrepreneurial glint in their eye. The hipsters open coffee shops and farm-to-table restaurants and maker spaces. The area becomes trendy, which attracts the yuppies (to use a dated term that's due for a revival), who these days tend to work in tech. Developers descend, demolish or gut the old industrial buildings, and put in condos. By then the artists, having functioned as the thin side of the wedge, are long departed to the next "undiscovered" area—though some may still come back to work for the hipsters, pulling shots and serving dinner to the yuppies.

But while the artists may be gone, art remains—at least, a certain kind of art. The alternative spaces have given way to tasteful upscale galleries. The experimental performance venue has become an indie bookstore, with readings twice a week, and workshops in creative nonfiction, and cards for sale by "local artists." There's music at the brewpub Thursday

nights, and an art walk once a month, and films outdoors on summer weekends in the newly redeveloped pocket park. The condo building, which is named for the factory that occupied the site, has a mural on the side, depicting what the area used to look like.

In the gentrified neighborhood, art becomes a lifestyle amenity, merging seamlessly into the rest: the bicycle shop, the farmers market, the yoga studio. It becomes another upper-middle-class commodity. Yes, it is a creative commodity, but so are the others. The cocktails are "creative," and the macchiatos are "creative," and the watches and the razors and the lightbulbs are "creative." The work the techie yuppies do is also "creative." Art becomes submerged within the larger category of "creativity," understood as an economic concept and aligned with ones like "innovation" and "disruption."

And "creativity," in that sense, is the central term of twenty-first-century urbanism, and has been since Richard Florida wrote *The Rise of the Creative Class*, which came out in 2002 and is a book about cities and how they prosper and whom they should try to attract. "Human creativity," Florida wrote, "is the ultimate economic resource," and the creative class consists of those people "who add economic value through their creativity": not just artists but also scientists and engineers, technicians and designers, journalists and academics, and, beyond them, doctors, lawyers, managers, financial professionals, and others. Cities prosper, Florida said, when they attract such individuals, and they do so by giving them the things they want: a tolerant environment, good schools, and the full smorgasbord of lifestyle perks.

Artists, in Florida's account—and his book became the bible of urban planners in cities around the country and beyond—are not so much *part* of the creative class (though technically they are that, too) as *for* it. Singers, actors, poets, and the like, after all, do not themselves produce much economic value (if they did, they wouldn't be so poor). But they are the kind of people that those who do—the techies, the entrepreneurs, the young and "disruptive"—like to have around. They provide the entertainment, as well as furnishing a sort of general creative vibe. When a techie sees an artist walking around their neighborhood, it makes them feel cool. Florida literally includes, in his assessment of various cities according to their ability to attract the creative class, not only a "Child-Friendly Score" (Is the city a good place to raise kids?) and a "Gay Index"

(Is it a diverse and tolerant place, as measured by the percentage of gays and lesbians?) but also a "Bohemian Index": "the number of writers, designers, musicians, actors and directors, painters and sculptors, photographers and dancers," included as a measure "of a region's cultural amenities." In Florida's conception, artists are the human equivalent of a nice park or a system of bike lanes.

That is the logic that has led so many cities, over the last couple of decades, to include an arts component in their redevelopment schemes: arts districts, art walks, multiuse performance venues, art fairs and biennials, music and film festivals, high-design structures and spaces (riverwalks, amphitheaters, pedestrian bridges and malls, repurposed railway tracks). Cities have started to do, on a larger scale and in a deliberate (some would say, an artificial) way, what artists have long been doing inadvertently: kickstarting the gentrification cycle by bringing in an arty buzz. The civic fathers who presided over the industrial cities of the late nineteenth and early and middle twentieth centuries—the Rockefellers and Carnegies who built the museums and libraries and concert halls—supported culture as an end in itself: a public good, a social value, a point of local and national pride. Today's planners and plutocrats support it for its ability to prime the economic pump.

Which means that they can also do without it, should they find a better option. Florida hints at the idea that rubbing elbows with all those artists somehow makes the app designers and drug researchers more creative, but he never quite comes out and says so, because the notion isn't really credible. Art and market-oriented "creativity" are finally too different, in their purposes and procedures, for much of any synergy. The truth is that, in that sense, cities are beginning to figure out that they can get along perfectly well without art. There is a sobering moment in *The Shopkeeper*, a documentary about the music producer Mark Hallman, whose recording studio, Austin's oldest, has long been under threat of closure. "If Mark sells the Congress House," someone remarks, "it will mean very little to the city." Places want "creative industries"—they want to be part of the "creative economy"—but those are largely very different from the arts: software, product design, media, advertising, fashion, and perhaps the more capital-intensive arts like architecture and film production, but not the arts per se.

In New York's Chelsea neighborhood, long the epicenter of the art

world, the "preferred tenants" now, crowding out all but the biggest galleries, according to *ARTnews*, "are tech start-ups with venture capital funding." And Chelsea is just the beginning. "All the way out to the nether reaches of New York," I was told by Noah Fischer, as well as across the Bay Area, "you have a new group of people who are competing for the same kind of industrial space": not just fledgling technology firms but also individuals involved in "maker" culture, tech-millionaire second-career hobbyists, people doing stuff for Burning Man—"funded people who are tapped into the veins and arteries of capitalism through Silicon Valley." To which we can add, up and down the West Coast and beyond, the new recreational marijuana industry, looking for acres of indoor space in close proximity to urban markets.

Nor are artists often any longer felt to be essential to the gentrification cycle even at the level of the neighborhood. "It's actually food, food lifestyle," Lise Soskolne told me. "That's what you need to gentrify a neighborhood now. The path of gentrification is so clear, feels so inevitable, that any neighborhood that has decent architecture or a subway train is going to get turned over. So you don't need artists to beat a path, to show developers where the cool, hip neighborhood is. The cool, hip neighborhood is wherever there can be one."

* * *

Artists, however, are typically far from the first or only victims of gentrification, and before they are victims they are often victimizers. It's not just empty warehouse districts that they tend to discover and colonize (the words are all too apt) but, especially in crowded cities like New York, existing communities. Needless to say, these are almost invariably communities of color. The housing is cheap because the people are poor, and the people are poor because of many decades of underinvestment and discrimination and, before that, far worse. Even places that really are substantially empty—like Detroit, that legendary frontier of $500 houses—are empty for the same reasons, their vacant lots and homes the scars of economic and physical violence. The artists may also be poor, but they are poor and white, poor and educated, with all the social capital that these entail. They are poor but poor by choice, and connected to those who are not, with all the access to financial capital that *that* entails. It may be possible in theory for white artists to live side by side with poor

people of color, but in practice it is not a situation that remains in equilibrium for long. Our major housing program for artists in this country is the displacement of black people.

The very language of gentrification is racially coded. First a neighborhood is "gritty"—that means blacks or Latinos. Then it's "edgy"—that means white bohemians. Then, with luck, it makes it all the way to "vibrant"—that means hipsters and yuppies. And the hipsters and yuppies move in—the money moves in—not just because the white bohemians are there, but because the people of color are gone. But that's okay, because "nobody wanted to live there anyway"—nobody who counts, in other words. The people who *lived* there wanted to live there—it was their home, their history, the site of their own art and culture—but never mind, they can go "somewhere else." (Where? Somewhere.) The neighborhood is "better" now, which means that the people are "better."

On the one hand, artists do need to live somewhere. They aren't deliberately pushing out people of color any more than they are deliberately sowing the seeds of their own eventual displacement. They may be well-off relative to other groups, but that hardly means they are well-off. "We are poor people," I was told by Katie Bell, a white artist who moved to West Oakland, a historically black neighborhood, after many years in San Francisco. "I have like five dollars in my purse." Jonah Strauss, the housing activist, was even sympathetic to the kind of people who have been displacing *him*. "The upper-middle-income people that I run into are just trying to survive, they're trying to support their families," he said. "A lot of those folks cannot afford the nice neighborhoods, so they get pushed into looking at lower-income neighborhoods." They are "a by-product of the problem," he said, not the problem itself. The problem is the tidal wave of money that is washing through places like the Bay Area. "Gentrification is much too small a word for this," he said. "You're talking full-on class warfare."

On the other hand, when white artists come in, they compete for resources with artists of color or are offered ones the latter never had a chance for in the first place. Foundation funding starts to come their way, and cultural institutions get interested, and the *New York Times* arrives to declare an artistic renaissance—as if communities of color had no artists of their own, which as far as the white establishment is concerned they don't, since it cannot see them, cannot recognize their work

as art. The situation is particularly galling when the area being gentri-
fied, being whitened, is a historic center of black or Latino culture, like
Harlem or Oakland. "The tone of the fight is changing," I was told by
William Powhida, a visual artist and prominent art-world gadfly. "Artists
aren't getting as much of a pass anymore. We're not necessarily seen as
allies [just] because we're also generally working poor." Communities
of color "are looking at how can five young art students afford to rent
even a cheap commercial space in areas like Boyle Heights"—a Latino
neighborhood east of downtown Los Angeles where local activists have
mounted a concerted resistance, at least in part successful, against the
incursion of white-owned galleries. "It's not just all getting blamed on
the big galleries or developers" anymore.

There is no good answer, but a somewhat decent one, at least, may lie
in trying to be, as Atiya Jones, the mixed-media artist who had recently
moved to Pittsburgh, put it, "a good newcomer." That means at a mini-
mum, from what I heard from activists in Oakland and Detroit, learning
the history of the place that you've come to—of the Black Panthers in
Oakland, say, or the riots in Detroit—recognizing that you've moved into
a community that extends backward through time, not simply a parcel
of land. Even better, it means making work that recognizes that commu-
nity. "What can I do to give voices to people who have been here their
entire lives?" said Jones. "What can I do as a creator to keep people vis-
ible?" Better still, it means working in solidarity with that community to
resist the inertia of gentrification. Powhida mentioned the Artist Studio
Affordability Project, which was founded in New York in 2013 and has
been working with community and tenant groups to pass the Small Busi-
ness Jobs Survival Act, legislation that would give protections to holders
of small commercial leases in the city—helping artists keep their studios,
but also helping local businesses, the lifeblood of poor communities,
keep their workshops and storefronts. Gentrification erases history and
displaces people; being a good newcomer means honoring the first and
standing with the second.

* * *

It wasn't always like this. The bohemian neighborhoods of New York,
San Francisco, and other cities were essentially stable from around the
turn of the twentieth century through the 1970s. Bob Dylan was haunting

the same streets in 1960s Greenwich Village as Eugene O'Neill in the 1910s. Before about 1950, the industrial cities were still expanding and so made room for everyone; after that, the middle classes fled, so there was plenty of space for those who remained. It was only in the 1980s—with a new generation of money, juiced by Reagan-era inequality, that shunned the suburbs for the newly glitzy city of *Vanity Fair* and Studio 54—that gentrification started to kick into gear in New York. Momentum was halting at first—the crime rate spiked with the crack epidemic in the late 1980s—but over the last decade of the century, murders dropped some 70 percent, the population grew by over 9 percent (its largest increase since the 1920s), and shows like *Friends* and *Sex and the City* transformed the city's image into a fun and glamorous playground for young white professionals. Meanwhile, during the same decade, artists had started to migrate to Brooklyn, of all places, setting up shop in a neighborhood—best known at the time for its ultra-Orthodox community—called Williamsburg.

The pace of change accelerated in the new century, and not only in New York. Ever-growing inequality; the titanic profits generated by the tech and finance industries; and the rise of new plutocracies in China, Russia, and elsewhere created a global class of superrich who needed places to park (and in some cases launder) their money, for which metropolitan real estate turned out to be ideal. Richard Florida preached the gospel of the creative class to postindustrial cities desperate for reinvention. A hip new lifestyle paradigm—urban-artisanal-authentic—went forth from Brooklyn to the country and the world, complete with trends in hats and facial hair. Money spread to Queens and Jersey City and the Lower East Side. It rolled east across Los Angeles and up from Silicon Valley to San Francisco and across the Bay. It erupted from California and Seattle, raining down on Portland, Austin, Denver, Salt Lake City, Boise. It erected golden silos for itself in downtown Pittsburgh and Detroit. Cities were in, and artists were out on their ass.

What isn't good for artists isn't good for art. In New York today, Lise Soskolne has written, the old bohemian scenes, which had sprouted in the sixties and seventies like weeds in cracked pavement, have given way to an entire city reconceived as "a cultural district" for "aspiring creatives"—not artists but professionals who staff, precisely, the creative industries. Stratospheric rents have shifted demographics toward the trust

fund set. Mitchell Johnston, the film director, told me that he left New York in 2016, after fifteen years in Williamsburg, because he'd gotten so disgusted with the "endless amusement ride" of northwest Brooklyn, "a fucking Pirates of the Caribbean" for hipster dilettantes. According to Lizzy Goodman, author of *Meet Me in the Bathroom*, an oral history of the city's indie rock scene in the decade after 9/11, New York no longer has a cultural identity. "The identity right now is money," she has said. And "money has a bleaching effect, eventually, on culture . . . New York feels to me burnt out, whited out."

<p align="center">* * *</p>

Great art happens, even plain old interesting art happens, not in trendy cities, not in "vibrant" Richard Florida cities, not in cities that have money flying through the air, but in cheap ones. Artists need space, but most of all they need time. Time, not to be productive, but to be unproductive: unstructured, open-ended time. Time to play; time to take as much time as you need. In *Creativity*, the most celebrated book on its titular subject, Mihaly Csikszentmihalyi quotes the physicist Freeman Dyson: "People who keep themselves busy all of the time are generally not creative." In *The Contemporaries*, Roger White, the painter and critic, describes imagining that art school would be "a utopia of experimental fuckaround-ery"—or not a utopia, he corrects himself (reminding us that the word, etymologically, means "no-place"), but a "uchronia," "a no-time existing apart from the regimented pace of contemporary life."

If the pace of contemporary life is so regimented (even, as White discovered, in art school), if we don't have time for time, that's because contemporary life is so expensive, mainly since the rent is too damn high. Matt Hummel, another Oakland housing activist, described the city before and after the money rolled in. In the old days, he said, "you wouldn't have to necessarily have a job. You and your friends could hustle money enough to pay the rent," which creates "the ability for people to actually have active lives that are inspired." Then the tech money came. "My twenty bucks is different than their twenty bucks," he explained. "My twenty bucks takes me an hour to get. Their twenty bucks takes minutes to get, seconds to get. When they show up with that seconds money, it overwhelms the system. You can't be a full human and follow dreams and get by anymore." Now, he said about the city's postindustrial spaces, where artists used to live and

work but which have now been mainly turned into condos, "to afford to live there, you can't afford to work there. Nothing you could make in that space will make you be able to afford that rent." Which means that you need to go do something else, or somewhere else.

Not only does the quantity of art decrease when everybody has to get a day job; its very nature changes. Hummel lived for half a dozen years in an intentional community of artists and activists that had taken over an old cookie factory (which has since become a condo building). The kind of events they used to hold there, he said, were not music shows or dance parties or art exhibits, but a "gestalt," an organic synthesis, of all three and more—fluid, informal, spontaneous, and without institutional structure or sanction. The arts in Oakland, Jonah Strauss, the housing activist, told me, are not the downtown galleries in permitted commercial storefronts with rich backers, but "punk bands playing in people's basements" and "dance performances in industrial spaces" and people "doing large-scale murals on the sides of buildings" while their friends sit around and watch. Or, he added, that is at least what they used to be.

"The arts always fed back into themselves," Strauss explained. You would hold an event, and your artist friends would come, and that's how you would pay the rent. Just as the boundaries blurred between the different forms, so did they blur between creator and spectator, art and everyday life. They also blurred, as Hummel explained, between art and activism. "People from all around the world would show up and stay there," he said about the former cookie factory. They would make art, and do political organizing, and make art in service of political organizing, like painting signs for the WTO protests in Seattle in 1999, the event that launched the anti-globalization movement.

The word for that kind of scene, where people lead creative and unconventional lives on the social and economic margins, a word both hallowed and hollowed by too much nostalgia and vicarious delectation, is "bohemia." But here we can see what it actually means. Bohemia is less a kind of place than it is a kind of time. Or rather, it is a kind of time made possible by a kind of place, a kind of space. It is a uchronia, a time outside of time, that exists, indeed, within a utopia, a space outside of space—a space that does not appear on the maps of money, the maps of developers, planners, bureaucrats, and brokers, a space that hasn't been commoditized and priced.

Bohemia is an order of time made possible by an order of money—hours money, not seconds money—and it makes possible, in turn, an order of values. Bohemias are breeding grounds, like Hummel's former cookie factory, for new forms of social organization and political imagination, and they are also breeding grounds for new forms of art. In bohemian scenes, as Jonah Strauss would say, art feeds back into itself. It constitutes its own audience. Artists are never freer, never bolder, than when they are creating for each other. That's what made the Village so fertile an incubator of new experiments. I have long been struck by the fact that the three big groups that emerged from CBGB in the 1970s were the Ramones, the Talking Heads, and Blondie: the archetypal three-chord punk quartet, a cerebral art-school act, and a disco-scented dance band fronted by a singer with a cotton-candy voice. They had little in common, except a milieu that gave them permission to push their visions as far as they could. Bohemias are breeding grounds of avant-gardes that change the world, because they do not have to care about the world.

But in Oakland now, said Hummel, "You can't decide to take on a project that won't make you money." You can't make rent by inviting your friends to come to a show, said Strauss, because the rent is too big and your friends have too little. So who are you going to get to come instead? Gina Goldblatt, the fiction writer and poet, started Liminal Gallery, a "feminist and womanist" literary space that she runs in her loft, because the writing community in the Bay Area, she had found, was much too straight-white-male. ("I know so many women who are much better writers than these schmucks that are getting up here all the time," she said.) Now, with rising rents, she was wondering how to keep it open. "The people you want to come are not necessarily the people who can afford to keep you afloat in this environment," she said. She doesn't mind making money off the yuppies, but she also doesn't want to have to offer work that's designed to appeal to them: that's "kind of artsy in a palatable way," that commodifies and objectifies the writers she works with, that isn't threatening to affluent white people, that enables the hipsters to say, "Yay, I came to see that thing." Art, in other words, that's packaged as a form of entertainment, with the art over here and the audience over there, not something "actually expressing experience and community."

But that is the kind of art that gets funded and recognized, that gets the planners excited, that goes into the galleries that go into the

arts districts that go into the redevelopment schemes that create those vibrant neighborhoods that attract the creative class, who drive up rents, which is good for the city: not the people in the city, who probably have to leave, but the city itself—the land, the real estate, the people who own the city. The artists can stay, but only if they convert their production, as it were, to the export market, the tourist market, rather than consuming it themselves, like those Polynesian islanders who once subsisted on their native produce but now must send it overseas and live on processed food. The hipsters and yuppies, in turn, are the tourists, forever in search of authentic experiences and forever destroying the places they find them.

So potent is bohemia as an object of nostalgia that there appears to be a pervasive belief that it no longer exists, that it cannot exist, in this day and age. But that is an optical illusion, a kind of Heisenberg effect, in which the very act of observation alters the thing that is being observed. Once you've heard about a bohemian community, it is, necessarily, already over. I did come across such a place, one that's not only still intact but growing. I would tell you where it is, but I don't want you to ruin it.

THE LIFE CYCLE

I don't remember when I became an artist," the sculptor and photographer Vik Muniz has said, "but I remember when everyone else stopped being one." In charting the cycle of the artist's life, the arc of a career from youth to middle age and beyond, both halves of that pungent remark will be useful.

Most of the people I talked to don't remember becoming an artist, either. They just always were one. Diana Spechler, the novelist and travel writer, told me that she knew that she wanted to write "from the time I was born," and while I'm guessing that that isn't literally true, at least three of my subjects had produced their first "book" by the time they entered grade school. One was reading at two; another was writing at three. Atiya Jones, the mixed-media artist, remembers building bookshelves out of cardboard boxes at age seven, because she got inspired by a home-improvement show, then learning how to sew in junior high school so she could make her own clothes. Around the time that he was twelve, David Hinojosa, a film and television producer, wrote to Ben Affleck (he somehow knew to contact him through CAA, the talent agency); drafted a critique of *Star Wars: Episode I* in the form of a ten-page outline, which he sent to George Lucas; and rewrote the entire script of the *Seinfeld* finale. Brad Bell, the cocreator (with Jane Espenson) of the web series *Husbands*, was a naturally theatrical kid. By the time *he* was twelve, he knew that he was going to move to Los Angeles to work in television, the same way that he knew that he was gay.

A few of my subjects had parents in the arts—a cartoonist mother, a musician father—but only a few. A few more had ones who were artistically inclined or otherwise supportive of their children's aspirations. More common, though, was a *lack* of encouragement, even an active discouragement, either at home or from the larger world or both. Despite what we like to believe about our love of creativity, especially in kids, artistic children are often met with hostility and incomprehension. Julie Goldstein, an animator and experimental filmmaker, was brought to a psychiatrist because her parents thought that she was troubled. She's not troubled, the psychiatrist told them; she's creative. As for adolescents or young adults who express an aspiration toward the arts, the world reserves for them a special scorn.

It was because of what he saw in both his mother and his peers that Andy J. Miller, the illustrator and podcaster, has devoted himself to assisting young artists. His mother, he explained, is a creative person "who has lived the tragic artist's life. She had all this potential, all these paths she could have taken," but the environment in which she was raised never gave her "any real clear idea of what you could do with that type of talent." She also, he thinks, has undiagnosed ADHD (as do a lot of creative people, he believes) and always tried to go in too many directions. As a child, Miller was often told that he was like her—meaning highly creative—but "by the time I was a teenager," he said, "I was watching her life unravel, and it was like a prophetic vision of my future." In high school, Miller's peer group consisted of people like him and his mom, and a lot of them, as well—individuals "more talented than me," he said—"ended up crashing and burning."

Later, though, when Miller started reading about figures like Steve Jobs, preternaturally creative types who are idolized in the business world and who are supposedly one in a million, they reminded him of no one so much as his friends. "I kept thinking, these people are *everywhere*, you just don't have any metrics to recognize their value." The problem lies, he believes, in the educational system, with the way that it identifies and nurtures aptitude. "Creative IQ doesn't correlate with what we traditionally think of as regular intelligence or IQ," he said. "The hyper-creative people are not necessarily showing up on the tests." Miller described his own experience "as being like a penguin in a pigeon's world. All the tests that I was given were, like, flying tests": math, sports, even his first part-

time jobs. "Everybody around me just seemed to be soaring with ease," he said, while he was "bumbling around on the ground." Discovering design and illustration, he explained, "was like finding water for the first time. Penguins can fly, just in the water."

Some of the people I talked with were lucky enough to have received a good early arts education: a local music teacher, a fancy arts boarding school, even just a regular public high school that happened to offer a decent program. For most kids, though, as I noted in chapter 4, such opportunities have been declining since the 1970s as budget cuts and math-and-reading-based assessment regimes have conspired to cull the arts from public school curricula. Absent the right kind of guidance, Miller told me, "it's pretty much just on you to figure it out." And that's clearly what a lot of the people I talked with had done. They were tough and willful and single-minded, or maybe just so bad at school that their families gave up. Of course, my sample had a radical selection bias, since all my subjects had, by definition (as Vik Muniz would put it), *not* stopped being artists. How many budding artists are defeated by the system we will never know.

What a lot of my subjects did have was resources. That usually meant money. Artists, as I've noted, tend to come from relatively affluent families, and many of the individuals I spoke with had grown up in the upper middle class. Their parents had paid for college or graduate school or their first apartment. One person's parents had bought her a house, which not only gave her a place to live but, with the extra rooms to rent, an income stream. Some people's parents were able to offer them part-time work—one made extra money editing her father's scholarly articles—or connect them with people who could. For some, the supporting relative was a spouse: usually a husband, sometimes a wife. These are the kinds of realities that people go out of their way to conceal, but they should hardly arrive as a shock. As one musician put it, "It's a little embarrassing, but I do think it probably is a common story, because how else does anybody dedicate themselves full-time to *developing* a career that isn't making any money?" Which is a pretty good question.

I also found, with surprising consistency, that even those who didn't have the benefit of family money had access to resources of other kinds. For some, that meant cultural capital. One was the child of a religious studies professor; she grew up poor but quoting Latin around the dinner

table. For others, such access meant being raised in proximity to wealth and being able to enjoy, as Micah Van Hove, the independent filmmaker, put it, the "runoff." Van Hove, again, was raised in Ojai, California, a small town of wide economic disparities, and received a full scholarship to a local private high school. Atiya Jones grew up in a poor, black part of Brooklyn, but her mother pushed to get her placed in a better (because whiter) junior high school in a different neighborhood, where she got to take classes in ceramics and photography. In several cases, cultural capital and the runoff effect had intersected, the first enabling the second. Monica Byrne, the Latin quoter, received a full scholarship to Wellesley. Nicole Dieker, a novelist and online columnist whose father is a music professor, received one to Miami of Ohio.

There were a few late bloomers among the artists I interviewed, people who hadn't started making art until they were out of adolescence, but even they were not very "late"—in college or their early twenties at the utmost. Only one, the illustrator Lisa Congdon, who didn't touch an implement until the age of thirty-two, was fully fledged as an adult. While stories like hers are inspiring, they are so rare as to be not merely exceptional but freakish. We love to believe that it's never too late, but it very often is. Life isn't fair. Making art, like any kind of physical or mental training, is best begun when you are young. The resources that we devote to our children and youth, through family and school, overwhelmingly determine who will get to end up doing it. Which means it isn't so much life that isn't fair, as us.

* * *

So you think you want to be an artist. You graduate from college, or don't go or drop out, or you finish your MFA, and you move to a center to make it. The first thing that happens is that you go from hero to zero. In school you were a star—you wouldn't have decided to go for it if you hadn't been—or at the very least, your teachers and peers paid attention to you. Now no one gives a shit, because you are shit. Now you're being compared, not to the rest of the class but to the rest of the world. "You're taken very seriously" in art school, the installation artist Joe Thurston told me, "then you're here as the bartender." Ta-Nehisi Coates discussed this phase on *WTF*, the comedian Marc Maron's podcast. "I often want to write about what happens when people come to New York to

strike it big," he said, "and that first year when New York just runs you over, and you got to get it figured out, and that is a ugly period." Maron agreed, noting that it's the same in Los Angeles: "You don't know what you're looking for, you don't know how it works, and if you're going in blind, really, with one guy's phone number, you don't know what that means, and you're hanging everything on that phone number." During his own brief sojourn in LA, Matthue Roth, the Hasidic Jewish writer, told me he thought that if he walked by Paramount Studios ("it's like a mile long"), "an exec riding by would be like, 'Hey, let's give that boy a TV show!'" Needless to say, that's not how it works.

The one thing you have at that stage is delusions of grandeur. These help to bear you up, at least at first. "I moved to New York with the sole intent of winning Sundance at the age of twenty-five," the indie film director Tim Sutton told me. Adelle Waldman dashed off her first, unpublished novel, all 550 pages of it, in five months. "By the time I was getting near the end, I was thinking it was amazing," she said. "I was envisioning myself on *Fresh Air*, and I was thinking that I would soon be rich and famous and never have to work again." Later on she figured out that while it certainly was a novel, it wasn't actually any good.

The way forward, at that point, is to embrace your awfulness and just get on with it. "You have to be okay with being bad," the musician Lauren Zettler said—bad in public, bad repeatedly and for a long time. Mitchell Johnston, the film director, talked about his first years after college. "It was that period that anyone involved in the creative arts goes through in their early twenties," he said, "where they try to figure out who they are and what their work's actually about and what they want to do." It took a decade, he said, to find a place for himself in the business. "There are not many great films made by twenty-three-year-olds," he remarked. "It takes a long time to develop all the necessary skills involved in the craft of filmmaking, and there are many of them." In fact, he said, "It's very dangerous to get picked up really early. You can be a flash in the pan." He himself rejected a three-script deal from Hollywood when he was twenty-seven, a tough choice financially but the right one, he believed, nonetheless. You need to have time, he explained, "to grind it out creatively, which is really hard, it's really hard to do that, you have to put yourself through a lot of soul-searching and self-hatred and self-loathing, to develop."

Whether young artists still give themselves that time—whether they are able to—is an open question. Tales of viral success, as well as the media's eagerness to seize upon emerging young creators, make patience difficult and seem superfluous. Social media creates a toxic culture of comparison, one young illustrator and designer told me. Everyone seems to be doing better than you, and because you don't know people's ages on Instagram or Twitter, you end up comparing your accomplishments to those of much older individuals. Everybody wants to skip the step of actually learning to do the thing.

At the same time, the financial obstacles to slow development are formidable at this point. As Lewis Hyde, the author of *The Gift*, has said, bohemia, that realm of low rent and endless time, is the place where you're supposed to go to serve your ten-to-fifteen-year apprenticeship before you're making much of any money from your art—and we know what has happened with that. On top of rent is student debt and the pressures it adds. Noah Fischer, the visual artist who initiated Occupy Museums and who teaches at Parsons, mentioned a former student, a dedicated painter who had started to achieve success. "But the debt has been sneaking up on him the whole time," Fischer said, and he finally had his wages garnished. The student was still making art, "but he's not able to break through," Fischer explained, because he doesn't "really have the time to do it right."

Regardless of your financial situation, the question becomes, once reality has punched you in the face and you've figured out that you're not going to be talking to Terry Gross about your Sundance-winning movie anytime in the near future, whether you're going to go on—whether you are going to *commit*. This is a pivotal moment in the life of any artist. One of the dilemmas, in making that decision, is that the early years of a future success can look an awful lot like those of a lifelong failure. Both involve obscurity, frustration, agonizing doubt. How can you tell the difference? One sign is that you're making at least a small amount of professional progress, however slow and incremental. Another is that you feel yourself, with your newly realistic self-assessment, getting better. Nicole Dieker, the novelist and columnist, tried to make it as a musician before becoming a writer. She figured out before too long that other young musicians she had started with were improving exponentially faster. "I wasn't terrible," she said, "but I wasn't good enough to be good." But

maybe the most important kind of sign is the praise of a respected elder. Even just a word of encouragement from an artist you admire—a one-line email, a referral to an editor or gallerist—can be enough to keep you going for a long time.

* * *

Eventually, you get your big break, and then you're set for life. I'm joking; that isn't what happens at all. Usually, you just keep doing your work. Work generates work. People—producers, agents, potential collaborators—are always on the lookout for talent. You make connections; you become better known. You still get a lot of rejections, but maybe someone takes a chance on you. Depending on the kind of art you do, there might be periodic landmarks (a novel, a movie, a solo show, each representing years of work), but while these are creative milestones, they aren't necessarily professional ones, in the sense that they change very much. People take a look, and maybe they like what they see—some good reviews, some decent sales—but then they move on. What seemed so enormous to you, as Jill Soloway, creator of the television show *Transparent*, has suggested, was a minor event, after all, in the life of the world.

Even "big breaks" aren't necessarily that big. I spoke with several people who had movies shown at Sundance. Each one thought their life would be transformed. In one case, they were more or less correct; in the rest, the recognition may have pushed them up a little higher in the field, but there was no peal of trumpets. Waldman's early fantasy was wrong twice over. She did go on to write a well-received bestseller, but it didn't set her up for life. It only gave her the breathing room—and the validation—to go on.

We should also pause over that word, "break," with its frequent modifier, "lucky." We seldom use the term in other fields. Doctors and plumbers don't get "breaks," because they don't need them. But in the arts, success involves a fair amount of serendipity, as a number of my subjects underscored. They happened to be sitting next to someone in a class, or their sister met an agent at a party in New York. Success in the arts, said Monica Byrne—she's the one whose sister met an agent at a party—requires five ingredients, in descending order of importance: "raw talent, hard work, privilege, luck, and connections." But luck, it should be said, can also be bad. The extent to which you can just get

randomly screwed in the arts is heartbreaking. Matthue Roth's third book was published by Soft Skull Press, a significant step up for him. But the company was sold the week the book came out, so no one at Soft Skull was pushing it, so it didn't get any publicity.

With progress as slow, as uncertain, and as frequently unfair as it typically is (not to mention as poorly rewarded financially), staying the course requires great tenacity and self-belief, as well, ideally, as a kind of serenity or acceptance. It's a matter, as Jesse Cohen, the musician, said, of being a lifer, of knowing with instinctive clarity that this is what you should be doing with yourself. That means not only being in it for the long haul, but also knowing that it's going to *be* a long haul. Which is not to say that people go on blindly. Lauren Zettler stressed the importance of flexibility and self-awareness: "I definitely have taken stock in my career multiple times and said, 'Okay, what's working? What's not working? What am I tired of doing? What do I not feel passionate about anymore? What's taking the joy out of this for me? What are other things I can do?'"

Also vital is emotional support: of friends, fellow artists, a partner. This can be more or less formalized. The visual artist Lenka Clayton is married to a ceramicist, with whom she has two children. Every weekend, they give each other "Macdowell Days," named for the artists' colony: one day off apiece from family responsibilities. Wendy Red Star, another visual artist, belongs to an artists' mom group where she lives in Portland, Oregon. One of the most valuable things that the Internet has done for the arts is to enable such community to occur remotely—through message boards, social media, crowdfunding sites. A lot of Lucy Bellwood's Patreon supporters are "other broke artists," she has said, whom she supports in turn, "because we understand what it's like."

But most important in persisting is a sense of dedication to the work itself: for its own sake, rather than for any possible reward. "What I think drives me now," said a novelist in his late thirties, is "the craftsmanship of it, like a carpenter who feels he knows his craft—is polishing and sanding the edges and making sure the joints fit perfectly, is seeing, oh, change this comma here and put this dialogue tag here and it becomes a perfectly subtextual line of dialogue." For Lauren Zettler, "It's not expecting a lot. That's the other thing. I think that a lot of young kids move to New York, and they're hungry, and they really want success, and they want it to look a certain way, and they almost start to feel entitled to it. And in my

experience, sometimes the less you expect from something, the more you get from it." Nancy Blum, the visual and public artist, was in graduate school at the prestigious Cranbrook Academy, and sick of hearing from the deans about how she and her fellow students were "the cream of the crop," when she went to a talk by Elisabeth Kübler-Ross (the psychiatrist best known for formulating the five stages of grief). "If you do what you need to do for yourself," Blum heard her say, "you will be provided for. Not always in the way you might want, but you will be provided for." No entitlement, no arrogance, no piety about a noble calling. "It was like I got hit by a bolt of lightning," Blum said. "The heavens opened up. And I just made a pact to believe that."

* * *

Still, many artists reach a point of no return, where they feel the need to choose definitively whether to go on. I heard about this moment again and again. It typically occurs at some point in your thirties. You've served your apprenticeship; you've done the right things; you've maybe even had a few successes. But you haven't gotten the kind of traction that would make you feel like you're actually getting somewhere. And life is still so goddamn hard. You're still humping your day job—or worse, driving for Uber. You're still living in a crappy apartment. There's so much work, and so little money, and you no longer have the kind of energy you used to, and the whole thing simply doesn't feel sustainable. Maybe you want to start a family. Maybe your college friends are all doing better than you, with jobs and kids and mortgages. Being a struggling artist was glamorous when you were twenty-eight and could still play the ambitious newcomer, as the memoirist and essayist Meline Toumani put it, but not when you are thirty-eight. If you're going to find an off-ramp, if you're going to go to that Plan B that you've been talking about—or start developing one—then now is the time.

"I have watched my friends involved in the arts," Mitchell Johnston remarked, "especially right around their early to mid-thirties, just start dropping like flies." What happens, I asked? "Well, you know," he said, "usually they get pregnant." Johnston meant they or their partner. "Their wife or their husband is like, 'Look, we have to face facts—you're no good at this,' or 'You're not getting anywhere with it,' or whatever. And they move on." When Lily Kolodny, the illustrator, relocated to Los

Angeles several years ago, she started "meeting people in the arts in their late thirties, forties, who are just at that horrible crisis moment of, 'I don't think it's going to happen'—who are confronting failure right in the face," she said. "It takes a certain amount of lunacy to keep doing this past that."

And yet, Kolodny added, "every single narrative in our culture is like, 'Don't give up the dream!'" There can be tremendous shame involved in giving up: a sense of having failed yourself, of surrendering to conventional existence, of looking foolish in the eyes of the world—the eyes of the relatives who never believed in you, who always told you you were making a mistake—for having presumed to try in the first place. There is also the dilemma of sunk costs, as economists call them. If you drop out now, then all those years were wasted.

Yet dropping out is often precisely the right thing to do. Giving yourself permission *not* to be an artist can be as liberating, and as brave, as allowing yourself to try to be one in the first place. On *WTF*, the comedian and actor Kevin Nealon talked about a roommate from his early days in Los Angeles, a fellow comic who eventually went back to Ohio. "Threw the towel in," Nealon said. "Which is commendable. Some people don't know when to throw it in." "That's for fucking sure," Maron agreed. "That's the problem with this biz," Nealon said. "Who's going to fire you?" Maron replied. "You. And after a certain point, it becomes a pride thing."

People's priorities also simply change, often precisely because of children. After he hit his forties and had a kid, I was told by Dan Barrett, the musician and producer, "the thing that drove me when I was seventeen and twenty-six and thirty-three just didn't feel the same." Music, for him, had been "seven days a week, and nights," and after twenty-five years, "an incredible and passion-filled ride," he burned out. Jesse Cohen himself, the person who told me about the need to be a lifer, discovered that he's not a lifer. He wasn't dying to get back into the studio. Cohen was thirty-six when we spoke, and planning to transition to a new career. The puzzle was what it would be; he didn't want to start from zero in an unrelated field. "I'd like to find a way to bottle my experience and turn it into another career," he said. Which is exactly what Barrett had done. He realized that much of what he did as a producer involved creative-project management. So he started a flooring and design business.

The question at this point, however, given the increasingly dreadful state of the arts economy, is whether careers are sustainable for anyone at all beyond the biggest winners, whether that sense of desperation that so many people feel as they move through their thirties isn't just the normal condition of being an artist today. Barrett was, by his own description, among the "upper-middle" class of musicians, someone who was making "very solid money," but unless you're a star, he said, it becomes very hard to continue and have any kind of lifestyle. Jen Delos Reyes, of the University of Illinois at Chicago, who is an organizer as well as an artist and educator, told me that the issue of sustainability is a topic of incessant conversation among the artists she knows—or, to put it more bluntly, the issue of exhaustion. Most people burn out after ten years, she said. The only way the current model works, you often hear, is if you are young, healthy, and childless.

Only the last of those three is a choice, and it's a choice that many of my subjects had made, especially the women. Of the fourteen female artists over forty whom I spoke with, only three had children (21 percent). Of the twenty-eight under forty, only two did (7 percent). Among the men, eight of ten over forty were fathers (80 percent), and only six of nineteen under that age (32 percent). "My career is my baby," Lisa Congdon said. Nancy Blum explained that she could never have raised a child on what she was earning when she was younger; when she decided to get an MFA, she knew that it meant she wouldn't have kids. Diana Spechler told me it's not that she never wanted to have children, but "this is what happens to a lot of women in the arts. We don't want to believe that we're choosing a childless life, but a lot of times, that's what happens." She knows artist couples who have kids, and they are "broke and stressed out." She also knows artist mothers who are managing fine, and she doesn't quite understand how. "Their husbands aren't artists, so they have plenty of money, so that's one way," she said. Marian Call, the DIY singer-songwriter, was thirty-five when we spoke. Of the dozens of artists in her social circle, she said, she could think of only one or two with kids. "I think that's an interesting thing to ponder, whether we're going to have this class of really astounding, scrambling, hustling, brilliant creatives, of whom only 5 percent procreate."

* * *

My sketch of the artist's career thus far can be seen as a series of sieves. First, those without innate ability or inclination—the bulk of us—were filtered out. Next, those who have them but did not receive the right encouragement or training early on. Then, those who didn't survive the apprenticeship years. Then, those who found an exit in their thirties or the vicinity. Of the remainder, many continue to struggle. Finally come those who find success—for of course there are some still—the few who manage to thread the needle and construct a career that carries them through adulthood.

But the way they find it, and the shape it takes, tends to look quite different from what we usually suppose. Our image of success in the arts is the music or movie star: a "breakout" song or role, a rapid ascent to the heavens of wealth and fame. But it's rarely that sudden, that certain, or that glamorous. Nancy Blum was fifty-three when we spoke. Six or seven years before, she said, the investments she had made in her career had begun to pay off. "At a certain point," she said, "all the hundreds of rejections"—situations where she'd had to say, "I wasn't really rejected, I planted a seed"—"it actually started to be that way." There had been a kind of cumulative effect: enough drawings, enough commissions— she achieved some recognition. "I've been in and out of New York for decades now, and New York knows me a little bit. So I get invited to things." It is often just that undramatic.

Success feels good. It's okay to say that. You pulled it off, against the odds. You climbed your way out of the mud pit. All the doubters? They can suck it. But success is also something that you need to manage, something that comes with its own set of problems. Instead of scrounging for opportunities, now they come to you—which means you need to learn to say no. You can afford to slow down and enjoy yourself—which means you must teach yourself how. You can make a living from your art, at last—which means that from now on you have to. That in turn means two other things: you'd still be wise to keep your expenses low, and you need to make sure that your work remains commercially viable.

The latter can be stultifying. People want you to repeat yourself. Art, after all, is a pleasure delivery system. If readers or listeners like what you've done, they tend to want more of the same. So do those for whom you're making money. Dealers get nervous when their artists go in new directions, as do record labels. If you are an illustrator, a designer, or

an architect, clients want a version of that thing you did for the other guy. Sustaining an artistic career is as much a spiritual problem as it is a financial one: finding ways to stay creatively awake, to remain as open to surprise, and therefore to failure, as you were when you were young and hungry.

The most important thing to understand about artistic success, how-ever, is that it always arrives with an expiration date. You have fans—now. Your work is selling—right now. The critics adore you—for now. Artistic work is project-to-project. Your album or your play can make a splash, but then it is back to square one. The artist's life is feast-or-famine. You can find success again, and past successes help generate future ones, but there are no guarantees. (The "engagement" model of contemporary self-marketing, where you feed your fans a steady stream of posts and other content, is in part a way of bridging the gap between projects, to try to ensure that people still remember you by the time the next one appears.) The transient nature of artistic success is especially cruel in fields that put a premium on youth, like music and television, both of which are littered with has-beens and one-hit wonders, some of whom spend decades eking out a living riding the nostalgia circuit, impersonating their former selves for dwindling cadres of fans.

"The nature of being an artist, if you're serious, is that it's not stable," I was told by the indie director Todd Solondz (*Happiness*, *Welcome to the Dollhouse*). "I always assume each movie I make is my last." "For those who are not writers (and many of those who are)," Alexander Chee, the award-winning novelist and essayist, has written, "there is an illusory 'made it' point, the point at which the writer no longer has to worry about money. It doesn't exist." Jack Conte, one half of Pomplamoose, the popular music duo, has put the matter like this: "The phrase 'made it' does not properly describe Pomplamoose. Pomplamoose is 'making it.' And every day, we bust our asses to continue 'making it.'" That is true, he noted, despite the fact that the band had gotten one hundred million views on YouTube, which points to an important reality. Not only is fame different than money—you can't buy food with it, you can't save it, and left alone it tends to shrink, not grow—but Internet fame is especially ephemeral, often nothing more, as Lucy Bellwood, the cartoonist, has said, than the product of your own "hype machine."

Art is not like other professions. Nurses and lawyers get jobs. Professors

teach at universities. The work is steady, and the institution holds you up. There's a modicum of security, as well as the possibility of reaching a satisfactory plateau, where you're making enough and don't need to keep pushing. Nor must you fret about staying in sync with the zeitgeist, or keeping your material fresh. No one says, "That dental mirror is so 2016," or "That lawsuit is derivative." No one complains that you performed that operation last week. Indeed, one of the strategies artists pursue to prolong their career, as they head toward middle age, is to transition to some kind of institutional or ancillary role: an academic position, a job as an administrator, presenter, or the like. Anything to come in from the cold, not to mention get some decent health insurance.

If you do stay in the game, you get to a point at which it really isn't possible to start a new career. Plan B is one thing when you're thirty-seven; it isn't anything at all when you are fifty-one and still have decades to go to the finish line. Being an artist, as Sammus, the rapper, has suggested, does not come with a retirement plan. On *WTF*, where Maron interviews a lot of comedians, actors, and musicians, that is an anxiety you sometimes hear: that the work will dry up, and then what? Maron himself, who didn't break through until his late forties, seems to have felt it intensely and, in a kind of post-traumatic way, still does. It's not like I can do anything else at this point, he often says. "A decade ago," he remarked when he was fifty-five, "I was looking down the barrel of *no* expectations whatsoever, and just hoping to continue to earn a fucking living *somehow*, without compromising myself too much to survive. Either that, or suicide. Those were my options."

All of which explains the most remarkable fact about success in the arts: for most artists, once they've reached a certain point in life, success is defined as just continuing to be an artist. I've heard many artists say that, and many artists whom I interviewed confirmed it. Success means simply having the ability to do your work, full-time and on your own terms. Every additional year is a victory. Think about that: art is so difficult a field that just being *in* the field is considered an achievement. But no one gets to that position right away. When you're young, you want to be Picasso. You want to be Kanye, or Shonda Rhimes, or David Foster Wallace. No one grows up dreaming of just making work. But slowly, painfully, as with any youthful dream, you adjust your way down to reality. And if you are lucky, you get to make work your whole life.

* * *

What kind of person signs up for all of this, and why? Our beliefs about artists are apt to be wildly inaccurate. Artists, we suppose, are weird, indolent, dreamy, inept—delicate and fragile souls. "People are always surprised," Sharon Louden, the visual artist, remarked, "that I don't have paint in my hair, that I speak in complete sentences, that I'm not lazy." (Louden, who was fifty-three when we spoke, also told me that her parents still did not accept her as an artist.) Artists are resented for daring to follow their dreams, for supposedly avoiding adult responsibilities. Who are they not to suffer, like the rest of us? At the same time, the artist's life is glamorized, romanticized, treated as a fantasy or wish fulfillment, a vision of freedom and pleasure and play. As the musician Stephen Brackett has put it, artists live a "dreamed upon lifestyle."

I've already mentioned some of the attributes that artists actually tend (and need) to have (in addition to talent, of course): tenacity; self-reliance; toughness; self-discipline; obsessive, single-minded dedication; resilience in the face of rejection. A stomach for criticism. A tolerance for risk. A prodigious capacity for work. A willingness to do without. ("I don't want to vacation in Fiji, really," Kim Deal, the indie rocker, told me. "It's *hot*.") I was also repeatedly struck, as people related their stories, by their resourcefulness, their ability to adapt to adverse circumstances and improvise new opportunities. In some I registered a kind of arrogance or vanity that could be, frankly, off-putting, but that appeared to be essential—a stay against the world's neglect as well as, perhaps, the challenge of the task. "Most writers I know work in a state of perpetual anxiety and self-disgust," the novelist J. Robert Lennon has written, "and regard the products of their labor as profoundly disappointing." It takes a lot of confidence to doubt yourself that much.

But what impressed me most among my subjects, perhaps because I come from academia, was their universal sense of openness: to ideas, experience, other perspectives. Academics are "no" people. Their impulse is to shoot things down—understandably, since knowledge advances through the rigorous examination of claims (which, formalized, is peer review). But such healthy skepticism easily becomes a morbid rejectionism. With academics, it is always "I don't think that's right" and "you don't have permission to" and "that's been done before." (Wrong!

Five points off.) Academics tend to entrench themselves in their little areas of expertise and fire at anyone who approaches. But artists are "yes" people. In art, there is no right or wrong, no expertise to defend. Artists say "go ahead." They say "what if?" and "why not?" They say, not "prove it," but as Diaghilev famously did to Cocteau, "astonish me." Their identity is fluid; they define themselves in terms, not of their past achievements, but of their current project. Artists are oriented toward the future; they regard the world as full of possibilities. "We speak in vision," said Katrina Frye, the photographer and artists' consultant. When artists look at a blank canvas, she said, they see what could be there.

Another universal attribute of artists is a reluctance to call themselves artists. The title must be conquered, not claimed. The screenwriter James L. Brooks has said that it takes about twenty years before you can call yourself a writer without embarrassment. The individual who runs around proclaiming their status as an artist marks themselves as either a dabbler, a poser, or a mediocrity. So does the one who boasts about their talent. Serious artists are far too conscious of the record of achievement in their field for anything, in that respect, but circumspection. A number of my subjects said that they prefer to see themselves as craftspeople; "artist" had been soiled by all the dilettantes.

As for why these people do it in the first place, I encountered reasons both mundane and profound. The desire for autonomy was one—to avoid a boss or the nine-to-five. In today's economy, that motive has a sharper edge. If you don't have what it takes to be a highly paid professional—a doctor, banker, coder, or the like—then a creative career, for all its drawbacks, looks pretty good compared to most of the alternatives. Ego, needless to say, was another reason: the thirst, if not for fame, then for acclaim or recognition. Dan Barrett, who worked with a lot of young musicians, told me that there's something "adolescent," even "toddler-like," about the impulse to make art: "I need to be heard. I need to say this important thing. And I need to make it so good that everybody wants to hear *me*."

Still, while ego may bring you to art, it's rarely enough on its own to keep you going at it. Some of the people I interviewed spoke of their art as in service to others. They want to make a contribution to society, or change it, or make people happy, or their lives less mundane, or give them a space in which to feel part of humanity. Making art, for some, is

an act of love; for others, it is something more mystical—the creation of an object that takes on a life of its own and becomes meaningful to others in a way the artist can't imagine and will never be aware of. For still others, art is salvific: it saved their life when they were young—books or music rescued them from emotional chaos, loneliness, despair—and now making it does. Creating art enacts a kind of transformation. You can't make a genuine record, Barrett has said, without leaving yourself a different person.

But the most common motivation I heard, the most common one you hear when artists speak about their work, is simply compulsion. Making art is not a lifestyle choice; it's not a "lifestyle," and it's not a choice. Artists do it because they have to. They are "addicted," even "damaged," unsuited for anything else. They can't not do it—it's just who they are. They were born that way.

PART III

ARTS AND ARTISTS

MUSIC

Music, it sometimes seems to me, is going through a nervous breakdown. No art has seen its economics devastated more by digital disruption. Yet many in the field—on blogs and message boards and comment threads, in articles and public talks—have met that existential threat by embracing or denying it. Piracy has made a mockery of copyright? Copyright is bullshit. Musicians can't get paid for their recordings? They don't deserve to. People can't make a living from their music anymore? They shouldn't want to. Besides—contrary to statistics, common sense, musicians' groups, articles, books, documentaries, and the testimony of innumerable individuals—conditions in music have never been better. Anyone who dares to question these assertions is accused of being "against technology" or wanting to "live off their royalties" or being in the pocket of the labels.

The problem here is not the Internet. The problem is that music and musicians have a uniquely screwed-up relationship to money. In no other art is the anti-materialist ethos so strong. Musicians are not supposed to think about making a living. Their poverty, like that of monks, is meant to be a token of their spiritual purity. Musicians—or, at least, the ones who talk the loudest—like to see themselves as rebels, revolutionaries, truth tellers, barefoot troubadours, punks, vagabonds, the righteous adversaries of the Man. If you make it, you're a sellout. If you make it big, you become that unspeakable thing, a "rich rock star."

At the same time, music is the art in which the possibility of instant

wealth—or, at least, instant fame, leading quickly to wealth—is greatest, especially in the digital age. One self-published viral hit, and you're the new beloved global icon (or so, at least, goes the dream). Very few of the musicians who profess their contempt for rich rock stars, I'd venture to say, would refuse the opportunity to be one. And then, of course, that proud disdain for wealth, that mystique of countercultural authenticity, is so often a part of a marketing strategy. All of which means that in no other art is money an object of such concerted bad faith: hated, fantasized about, concealed.

Add to this the enormous complexity of payment systems in the field. When a painter sells a canvas, they're paid once and that's it. When a writer sells a book, they receive an advance and, if they're lucky, some additional royalties and maybe a few small translation deals down the road. But writing, recording, and releasing a song unleash a fantastically intricate array of financial scenarios. To begin with, the composition (the words and music) is treated separately from the recording. The *composition* earns money for the *songwriter* through physical sales (CDs, etc.), digital sales (iTunes, etc.), streaming (Spotify, etc.), and the various categories of "public performance" (live performance; airplay on radio and digital radio; play in clubs, stores, restaurants, doctors' offices, and the like) and of licensing (for ringtones; for sampling in other songs; for use in movies, television shows, video games, and commercials). There are also sheet music sales, jukebox play, and covers of the song by other artists—and we're not done yet. The *recording* earns money for the *performers* through physical and digital sales, streaming, licensing, and public performance on digital radio only (not, in the United States, regular or "terrestrial" radio, a matter of long-standing consternation)—again, to name just the most important categories.

Got it? Entire entities exist to collect these payments and route them to the appropriate recipients. If you have a label, it might handle some or all of this for you. If you don't, there are services that will look after various pieces, but you need to chase a lot of it yourself. "The music industry," said Maggie Vail of CASH Music, a nonprofit that works to educate musicians about the system, "is not built to be user-friendly."

Each kind of revenue stream involves its own set of middlemen, all of whom take a cut. For the musicians who have to navigate this thicket on their own (or with the help of still other middlemen, like managers and

agents), the situation is almost guaranteed to create confusion, distrust, and hostility—especially since the music industry is hardly known as a citadel of rectitude. Labels are notorious for cheating their artists, but at least there's oversight: contracts, lawyers, revenue statements. The real dirty business seems to happen in the clubs, where musicians often work for cash, on the basis of verbal agreements, with characters who may be deeply unreliable or sketchy, in close proximity to booze and drugs. Music, more than any other field, involves a lot of artists who are very young, who have no idea how the business works, who've been told not to think about money, and who have an outside chance of generating large amounts of it. It's no surprise if people get ripped off.

It's also no surprise if there is a lot of free-floating anger that ends up getting vented, often in the form of very shoddy arguments, online. (Given the fact that so many musicians are male as well as young, some of this can also be attributed to the brain-clogging effects of testosterone.) The old system, dominated by the labels, was widely despised. The new one created by the tech industry—gee, those guys seem so friendly and cool—must therefore be superior, or so the thinking seems to go. The reality (Grandma, what big teeth you have!) is very different.

* * *

Everybody knows what happened to the old system. It was killed by Napster and the MP3. CDs were incredibly profitable. In 1999, the music business had its best year ever, with $39 billion in global revenue. After massive waves of consolidation across the previous couple of decades, the industry was also unbearably corporate and stale, playing it safe with legacy rock acts, pop divas, boy bands, and girl groups. The 1990s had experienced a countermovement in the form of alternative rock, a development driven by countless indie labels that, like the ones that were also important in hip-hop, relied on the CD, with its hefty profit margin, just as much as the Big Six did.

Then, that same year of 1999, came Napster, the first important peer-to-peer file-sharing service—in other words, unlimited free music. The impact was immediate. From 2000 to 2002, sales of the top 10 albums dropped by almost half, and total revenues were down by 12 percent. The arrival of iTunes in 2003 was seen as a panacea: people would pay for music again. This proved to be true, at least to a certain extent, but what

exactly were they paying for? "By shifting the standard unit of commerce from the album to single," writes John Seabrook in *The Song Machine: Inside the Hit Factory*, "iTunes disemboweled the labels' profit margin." From 2002 to 2010, revenues fell another 46 percent. The format did have one important benefit, just not for the music industry: by 2014, Apple had sold some four hundred million iPods. It would not be the last time that Silicon Valley used cheap or free content as bait for bigger fish.

And then came streaming, which began to get traction in 2012 and has displaced the digital downloads of iTunes and other services at twice the rate that CDs pushed out vinyl. (Ultimately, it displaced "iTunes" altogether, now that Apple has broken up the service into parts.) As of 2018, streaming accounted for three-quarters of industry revenue, mostly in the form of paid subscriptions to Spotify, Apple Music, and the rest. Streaming has rescued the labels—the services need their catalogs, since no one's going to subscribe if you cannot offer, say, the Rolling Stones—but only following a heavy contraction. The Big Six became the Big Three, and after global music revenue grew in 2018 for the fourth consecutive year, it stood at $19 billion, a drop since the peak of over two-thirds in real terms.

Streaming is basically a protection racket: if the labels didn't make their music available for free, people would just steal it anyway. (Though a lot still do; according to a 2018 study, 38 percent of listeners consume music illegally.) But it's also one the industry has learned to turn to its advantage. The new model is a collaboration, or conspiracy, between the streaming services and the major labels. Not only have the majors received an ownership stake in the leading service, Spotify, they've also negotiated preferential treatment relative to the indies, let alone to DIY artists. Their payment rates (the amounts they receive per stream) are higher. Their songs get better placement on the streaming sites. They coordinate with the services on the rollout of new releases.

Key to streaming are curated playlists like Spotify's New Music Friday. People like to be told what to listen to, like to listen to the same things as everybody else, and are often content to "lean back" and let the playlists play, just as they do with radio stations. And as with radio stations, the major labels target huge amounts of promotional capacity in the direction of the playlists. According to an industry insider, Universal Music Group, one of the Big Three, has thirty people working the

lists: making sure that curators hear the label's new releases, are aware of the marketing that's going on around those releases, and understand the company's priorities.

As for the indies, which often serve the less commercial genres and are more inclined to take artistic chances, they are hurting badly—merging, shuttering, watching their margins, and therefore the advances they are able to offer their artists, shrink toward zero. Digital sales essentially replaced physical ones, I was told by Ian MacKaye, the indie rocker (Fugazi, Minor Threat), who is also cofounder of the celebrated punk label Dischord Records. But with streaming, he said, "it's fractions of pennies where you once had dollars." In that respect, the alt-rock days are over. In a ruthlessly competitive environment—which pretty much describes the whole economy today—the rule is survival not of the fittest so much as of the biggest.

Not only have the labels consolidated, so have broadcasting, ticketing, concert promotion, artist management, venue operation, and music publishing. In 2008, Sirius and XM, the satellite radio duopoly, became Sirius XM. In 2019, the company acquired Pandora, the leading player in digital radio. In 2010, Live Nation, the biggest promoter, merged with Ticketmaster, the biggest ticketing firm; as of 2017, the new entity, Live Nation Entertainment, promoted some thirty thousand shows and sold roughly five hundred million tickets a year. It also operates more than two hundred venues, manages about five hundred artists, and owns the Lollapalooza and Bonnaroo festivals. In terrestrial radio, still crucial for breaking bands and making stars, the goliath is iHeartRadio, the rebranded Clear Channel, which owns more than 850 stations. Instead of payola, now there is "showola," where labels send their biggest acts, for free, to the company's titanically lucrative festivals in places like Las Vegas. For anyone who hoped that the digital revolution would overthrow the music industry, the reality must be deeply disappointing, at least if they are being honest with themselves about what's really going on.

* * *

What does all this mean for individual musicians? First, that you can forget about selling your music as any significant income source. Streaming rates vary per service, per artist, and over time, and are in any case kept secret by the companies, but a good set of estimates, as of March 2018, ran

as follows: Apple Music pays 0.74 cents per stream; Spotify, 0.44 cents; Pandora, 0.13 cents. But by far the biggest player in streaming music is not a streaming music service. It is YouTube, which accounts for nearly half of all listening online, and which pays 0.07 cents per stream. That means if your song is played on YouTube one million times you get $700.

But these are only averages. In practice, the numbers are often mysterious and inexplicable. Zoë Keating, a successful and prolific DIY composer and cellist, reported income of about $2,400, at rates that are pretty much in line with the estimated averages, for 1.44 million streams on Spotify and Pandora. But for fourteen thousand streams of "Weirdo," Sammus, the rapper, earned only $6.35 on Spotify, less than 0.05 cents per stream. Rosanne Cash made all of $104 for six hundred thousand streams, a rate of 0.017 cents. And Rain Perry, a DIY singer-songwriter, logged a little over three hundred thousand streams across the various services, for which she was paid a grand total of $36.28, about 0.012 cents per stream. Plus all of this is if you even get the money. "Our band's only record came out in April 2014," wrote Meredith Graves of Perfect Pussy in 2016, "and I still have not seen royalties or money from streaming. That, by the way, is totally normal."

Streaming is designed for scale. When Spotify released a set of rosy revenue projections for various tiers of artists, from "superstar" to "niche indie," the Future of Music Coalition, the research and advocacy group, reverse-engineered the numbers and discovered that "niche indie" meant an act like Imagine Dragons, a band with many multiplatinum releases. Nowhere is the long tail thinner or the fat head fatter than in music. It doesn't matter whom you actually listen to on Spotify, Seabrook writes in *The Song Machine*; "90 percent of your subscription fee is going to the megastars in the head." As of 2017, according to the economist Alan B. Krueger, the top 0.1 percent of artists were responsible for more than 50 percent of album sales, with similar numbers for downloads and streaming.

Marc Ribot is an esteemed guitarist and composer who has worked with Tom Waits, Elton John, and a long list of other greats. Ribot has reported that his band Ceramic Dog earned $187 on Spotify for the kind of album that would once have brought in between $4,000 and $9,000 in CD sales. "If the type of music I make is no longer sustainable," he wrote, "you can kiss most jazz, classical, folk, experimental, and a whole lot of indie bands goodbye." None of the musicians I spoke with

regarded their streaming revenue as more than negligible, to the point where they wouldn't have even mentioned it if I hadn't asked.

The collapse of recorded music sales has left musicians scrambling for other sources of income. Everybody figures out a mix that works the best for them, but the most common component is live performance or, in other words, touring. As recorded sales have plummeted, ticket sales have soared: from $1 billion in North America in 1996 to over $7 billion in 2016, a year when the average ticket price for the top one hundred tours hit $76.55. More people are going to more shows—in arenas, in theaters, in clubs, in homes, and, above all, at festivals—and paying more each time they do. The Internet has made it incomparably easier to book gigs DIY, and to organize them that way, too (the reason for the surge in house shows). Free music does indeed mean free exposure; mediocre bands that wouldn't sell too many records anyway can now find fans, and go on tour, in far-flung parts of the globe.

Yet touring is hardly "the answer." The rise in live revenue has fallen short, by many billions of dollars, of making up for the decline in recorded music sales. As with streaming, aggregate totals also do not tell you how the pie is divvied up—either between the companies and the musicians or among the musicians. The "fat head" rule applies to touring, too, with the lion's share of income going to the blue-chip names, many of them "heritage acts": rockers in their sixties and seventies whom fans in their fifties and sixties have the wallet to pay the premium prices for. In 1982, according to Krueger, the top 1 percent of artists garnered 26 percent of total concert revenue; by 2017, the number was 60 percent. At a mega-festival of two hundred acts, Ribot has remarked, 80 percent of the money will go to the three or four headliners.

But the biggest drawback with touring, on the income side of the ledger—the main reason that you can't draw optimistic conclusions about the average musician from the overall numbers—is the same one that exists with many "solutions" in the arts today. Everyone has heard the same advice. Everyone is trying to do the same thing. "You see every artist and his dog out on the road now," the folk musician Eliza Gilkyson has said. "To earn a living and connect with fans," the singer-songwriter Suzanne Vega has written, "bands, young and old, are going on tour. They are everywhere. Right now I'm in competition with my heroes, my peers and everyone else coming up. The market is overflooded."

Touring also comes with major costs, in every sense—for the biggest acts, for the youngest band in the oldest van. As prices rise, so do audiences' expectations for production values. Lady Gaga can do an arena tour, I was told by Kevin Erickson, the head of the Future of Music Coalition, and still lose money. For the band in the van, touring is a huge financial risk: outlays on gas, lodging, and more, all for very uncertain returns. At that level, you're often lucky to break even, luckier still if you have a little left over for rent. Touring also carries opportunity costs: you can't hold down a decent job, often even a lousy one, and disappear for months at a time. A hundred shows a year is the minimum, I was told, for an entry-level DIY musician. Once you get a booker, they're going to want you to double that.

Now think of the strain that that puts on your health, physical and mental. On relationships within the band. On your voice (an increasingly common concern). On your ability to create. Recorded music is new music; live music is existing music. For fans, the hidden cost of free music is all the music that never gets made. In the first ten years of their careers, a period when popular musicians are typically the most productive, Queen, David Bowie, and Elvis Costello, acts that all debuted in the sixties or seventies, each released ten or eleven studio albums. Lady Gaga released five; Beyoncé, four; Adele, three. Seabrook writes of artists like Rihanna "recording vocals late at night in mobile studios parked in trash-filled empty stadium parking lots that reek of urine after a show . . . Because the money is in ticket sales . . . nonstop touring is the norm, and record making has to be fit into breaks in the grueling schedule."

The same dynamic applies at all levels of the business. "Touring is artistic death," wrote Hutch Harris of the Thermals in a post called "Why I Won't Tour Anymore." Plus—the reason that sums up all the others—"I'm too old for this shit." Touring is the quintessential example of the notion that the current economic model only works if you are young, healthy, and childless. Harris was forty when he wrote that post. But it isn't like musicians have a choice. The Thermals broke up less than two years later. Vega is sixty; Ribot is sixty-six; Gilkyson is sixty-nine. I'm sure they still love to perform. I'm also sure that they'd rather not *have* to.

Next in the usual list of ways that musicians make money today is merchandise ("merch"): T-shirts, posters, etc. Merch is high-margin, but it costs a lot to make, which means that it is also high-risk. Indeed, one of

the major dilemmas for the touring band is to decide how much merch to bring on the road: too much and you have to eat the extra cost, too little and you're leaving money on the table. But the main point about merch is precisely that sales mostly happen at shows, often directly from artist to fan, with a selfie thrown in, which means that they're inseparable from touring. Merch involves "selling your time and physical contact," Ribot has said, which means, he added, that musicians are returning to the days before copyright, when "the ultimate merch was our bodies."

For many musicians, however, the largest problem with the shift from recording to performance, to ticket sales and merch, is that they aren't performers. Studio musicians don't perform—those legendary "session men" and backup singers who help create the sound on so many recordings—and neither do professional songwriters, who help create so much of the music itself. (The same applies to the producers, sound engineers, and other talented professionals who are essential to the recording process.) From 2000 to 2015, the number of full-time songwriters in Nashville dropped by 80 percent. For artists like those, David Remnick, the editor of the *New Yorker*, has remarked, the business model now is giving music lessons.

Such artists do participate, at least indirectly, in the last of the trio of revenue streams you hear about most: licensing, specifically "synchs"—the licensing of songs for movies, shows, commercials, and video games. These can be lucrative, on the order of thousands or tens of thousands of dollars a pop, and the market is expanding rapidly with the growth of video content in all its forms. As the matter was put to me by Jeffrey Boxer, then executive director of the Content Creators Coalition, music is hanging on to the parts of the entertainment industry that are still doing well. On the other hand, everyone has heard about licensing, too. The competition for synchs is increasingly fierce, which means that fees are falling. One musician told me that he doesn't know a lot of people who are making money from licensing, but he does know a lot who are *talking* about it.

Of course, the other thing about licensing is that it isn't—how to put this?—very rock 'n' roll. Allowing your song to be used in an ad is pretty much the definition of selling out, something that musicians once religiously avoided even the appearance of. But now, as John Flansburgh of They Might Be Giants has put it, "people just think like that's the best

thing that could ever happen to you . . . to be in a Nike commercial." And what goes for licensing goes double, or quadruple, for corporate sponsorships and branding deals—which are also increasingly common and also pay less and less as everybody chases them. In his book *Uproot*, the DJ Jace Clayton—citing deals by Sonic Youth with Starbucks, Run the Jewels with Volcom (a lifestyle brand), and pretty much everyone with Red Bull (the big gorilla in the field)—notes "how far we'd traveled from the proud DIY spirit of the 1990s to the corporate-cuddling relativism of the 2000s."

It is easy to be critical of this, easy to be snarky. At least, if you don't have to do it yourself—if you came up, like Flansburgh, in the age of the LP or the CD, or if you're not a musician at all. Clayton mentions that licensing took off with Moby's album *Play*, which came out the same year as Napster. Ian MacKaye, an icon of indie integrity, who has never signed a contract or hired a lawyer, spoke with dismay about the young punk rockers he meets, who are desperate for agents and managers. *He* never got a manager, or moved to New York, he told me, like everyone was telling him he had to when he was starting out in 1979. I do not doubt MacKaye's sincerity, but he and Flansburgh and people like them remind me of the senior academics I knew in the 1990s and 2000s, who'd come of age when tenured jobs were falling off the trees and couldn't understand why their graduate students were complaining about the job market, which by that point had become a desert. Punks with *agents*? What's wrong with kids these days? I'll tell you what is wrong with them. They're being fucked by history. The Internet was supposed to liberate musicians from the clutches of the suits. Instead, it's left them in the cold to chase the favor of a different set of suits, whose minds are on coffee and cars. If you suck all the money out of art, you don't make artists pure. You make them poor. And the poor do what they need to do to stay afloat.

* * *

The issue isn't whether "the Internet is good for music," as the matter is often framed, which is both a pointless question and impossible to answer. In many ways, it's clearly been terrific. There's more music than ever, and all of it, both new and old, is at your fingertips. "I always think about the fact that if I was sixteen years old," said Jesse Cohen of Tanlines, who was born in 1980, "and you told me, 'Oh, if you just wait nine

years and eleven months, you'd be able to pay nine ninety-five a month and listen to *everything* in the world,' I would set a clock and wake up every day just staring at it waiting for that day to happen." The Internet's infinite library is also, as Ian MacKaye pointed out, "an incredible resource" for musicians. "If I'm reading a book and they talk about an aborted recording session," he said, "there's a good chance someone's posted it, and it's incredible to actually hear the problem." Marian Call, the DIY singer-songwriter, knows a bunch of young musicians who were graduating from high school around the time we spoke, and "their musical tastes," she said, "are so *fantastically* formed. I mean, they've had access to everything. I'm so proud of them. The stuff they're writing just blows my mind." The Internet has enabled old bands to be rediscovered and revived, new genres to emerge, scenes to arise in places where none had existed, musicians from around the globe to get a hearing far beyond their countries of origin, and listeners to find each other as well as the artists whom they build community around.

Music has also been at the forefront of all the developments I talked about in chapters 4 and 5: DIY self-management and self-production, the ability to build an audience and monetize it (including through crowd-funding), the opportunity to learn and earn remotely in a multitude of ways. At the same time, since music is the art where doing it yourself is easiest, musicians are uniquely exposed to new forms of predatory practice. An entire industry has arisen on the promise of selling musicians an edge in the DIY jungle: "playlist plugging" outfits such as Playlist Pump that offer personalized payola; "A&R" companies like Taxi that will take your money to listen to your demos (or pretend to); online classes (i.e., prerecorded videos) that charge you $500 to tell you to build an audience and monetize it.

Then there's the affliction known as "music tech." Everything in music happens through online platforms: social media platforms; streaming platforms; crowdfunding platforms (including music-only ones like PledgeMusic and Sellaband); "artist services" platforms for booking gigs (Sonicbids, ReverbNation), marketing to listeners (BandPage, Topspin), and so forth. As fans or the industry migrate from platform to platform, musicians, having little choice, find themselves chasing the trendy ones. They pour hundreds of hours into creating their pages, interacting with fans, and building their lists. But, as with all of us on platforms like

Facebook and Instagram, it is the companies that own the data, and they don't care about musicians. They are tech companies, not music companies. They are following the logic of tech: amass a user base (with copious amounts of venture capital), then figure out a way to monetize it later. Make a buck by pushing in between musicians and their fans. There's even a platform now for house shows.

The business model works, however, only if you establish a monopoly (like Amazon or Facebook), at which point you can do as you please. Which means the platforms end up either screwing their musicians (by overcharging them, delaying payments, or engaging in other chicanery), or disappearing and taking the musicians' hard-won data with them, or screwing them and then disappearing. BandPage is gone, as are Sellaband and PledgeMusic. Topspin is gone in all but name. Myspace, to which musicians were stampeding circa 2005, has become a punch line. Facebook, having vanquished it, now charges you to reach your fans. Patreon has started to play its own kinds of tricks. The beloved SoundCloud, with its ten million artists, repository of a dozen years of global music culture, has long been teetering on the financial abyss. YouTube is the worst of all, suborning piracy on a colossal scale, coercing musicians into signing exploitative user agreements, and more.

So the issue, for us, is not whether the Internet is good for music, or even whether it is good for musicians, but whether it is good for their ability to earn a living. And here the evidence is unequivocal. As the issue was framed in the title of a post by David Lowery of the rock bands Cracker and Camper Van Beethoven: "Meet the New Boss, Worse than the Old Boss?" (The question is rhetorical—his answer is yes.) It may be that artists were exploited by their labels, but the labels, at least, invested in musicians, if only because their business model depended on them. With tech, the new boss, musicians are forced to invest in the companies, by creating the content that makes those companies so profitable. The labels sell music to listeners; the platforms sell listeners to advertisers (and their data to God knows who). Labels and artists, however contentious their relationship may sometimes be, are necessarily symbiotic. The tech industry is parasitic. It doesn't care if one musician gets a million streams or a million get a single one apiece. It doesn't care how many young musicians come and go, because it knows there will always be more, and it isn't putting money into any of them.

"I'll put it to you like this," said Melvin Gibbs, the celebrated bassist and former president of the Content Creators Coalition. "When I was in my twenties, I had my own apartment. I had a little family. Now musicians in their twenties in New York City live five in an apartment. People are still making music, but they're starving." After Napster, I was told by Kim Deal, the indie rocker, "every couple of years I'd remember how bad I thought it was and how I thought we had gone to the bottom—how can the music industry die even more?" And then it would die even more. Now she's doing one of those things that the Internet is supposed to make profitable: recording her own music and selling it directly from her website. Except it isn't profitable. "I do it because I made money when there *was* an industry," she told me. "My dad calls it a hobby. My *hobby*."

A friend of mine did another one of those things. A talented amateur folk musician, he formed a group and started gigging and releasing original material—to great acclaim, it proved, in the folk community. So he decided to go for it: cut back on his work as a commercial videographer to put in more time on his music. He figured he'd make half his money doing each. As it turned out, the income split was not 50-50 but 0-100. His group did all the things that you're supposed to do: email list, newsletter, Facebook page, YouTube channel, website. They paid their $500 to watch the videos about building your audience and monetizing it. They put out five albums, played over fifty shows a year, and even got meaningful radio play. And they made no money. "I mean really," he told me back before he gave it up, "we don't make any money."

How a few representative musicians, mostly younger ones, are navigating the current environment is something that I sketch in the second half of this chapter. But what's at stake here, in the bigger picture, is the survival of the middle, those professional working musicians who constitute the backbone of the art: the musicians' musicians like Marc Ribot and Melvin Gibbs; the gifted instrumentalists who distill their craft across a lifetime of devotion; the session players and backup singers; the mainstays of local scenes and uncommercial genres; the pioneers like Ian MacKaye and Kim Deal who may not sell a lot of records but who change a lot of lives. "The term 'struggling musician,' when I was young," Bill Maher once remarked to Esperanza Spalding, one of the leading figures in contemporary jazz, "referred to people who didn't have a record out yet. Now it's people who are actually quite well-known, and they sell

records, and they just don't make any money." Yes, Spalding responded, "that's most of us."

SIX MUSICIANS

Marian Call was watching the commentary on an episode of *Firefly*, the science fiction series, when she had what she described as an awakening. It "suddenly snapped into focus in my mind that I was capable of performing all the steps necessary to record an album," she told me. "Where before it had seemed completely impossible, like music just came from this magical place." A television show isn't simply something that you see, she realized; a record isn't simply something that you hear. Each is a series of steps that somebody took. Call knew that she would be able to compose an album, arrange it, get the performances she wanted out of musicians, learn to edit it with music software, design it, release it, and promote it. So that is what she did. This was in 2007, when Call was twenty-five. By 2017, she had put out ten albums, all of them self-produced and all but one of them self-released.

Call's music was inspired by *Firefly* in another sense, as well. As science fiction, the show is part of the larger universe of geek or nerd culture, which is what a lot of her work has been about. In a clear, classically trained voice, Call sings witty, literate songs about topics like space travel, zombies, Shark Week (the Discovery Channel's annual extravaganza), and, indeed, *Firefly*—songs with titles like "Dear Mr. Darcy," "The Liberal Arts Degree Waltz," and "I'll Still Be a Geek After Nobody Thinks It's Chic." The focus gave her a subject—a niche—and with it a potential audience, and she has been tirelessly inventive in devising ways to build, connect with, and monetize that audience. She has recorded custom voicemail carols for the holiday season; held an online "Jukebox Challenge" concert, where people got to bid on the songs she would cover; and conducted a fifty-state tour, over nine months, in which most of the stops were requested, and organized, by fans. Her website includes a list of fifteen things that listeners can do to support her ("write a blog post . . . host a house concert . . . buy a T-shirt or totebag"). In 2009, before Kickstarter and four years before Patreon, she set up a "Donors' Circle" of regular supporters, which has been indispensable, she told me, to everything that she's accomplished since.

Call's parents were working, conservatory-trained musicians in small-town Washington state. In college at Stanford, she studied classical, jazz, and contemporary orchestral theory and composition, but she gave up music after graduation, unable to see a viable career path. She married young and moved to Anchorage—a place, she assumed, that didn't have an arts scene. "That was a very silly, elitist, young idea," she said. "Once I got up here I realized the arts scene here's amazing"—as it can be, she added, in "lots of small towns and second cities." Her ideas about music also changed. She "wound up drinking beer at open mics, and hearing rock-roots bands that made people dance on the bar, and going out to jazz jams that went until two in the morning." In college, she said, she'd composed "the kind of music that's mostly played at universities these days." In Anchorage, she started writing songs: "songs that my grandmother would understand, songs that were fun or infectious." She had "left college thinking that to be an artist I needed a platform," but now she realized that she "needed a community with which to build a platform." She found not one but two: one in Alaska and one on the Internet.

Call's financial life is nonetheless precarious. She refers to herself as "a full-time artist deep in debt." She got divorced in 2009, which was "financially catastrophic," and was "home-free," as she put it—house sitting, couch surfing—for a couple of years (one of the reasons she embarked on her fifty-state tour). In 2015, she did a Kickstarter for her fourth studio album that brought in $65,000, at which point she was free of debt "for this brief, beautiful couple of months." Then her laptop got stolen on tour. Even more expensive than replacing the computer was replacing the software. And since the delay prevented her from using all of her Kickstarter money by the end of the calendar year, she was blindsided a few months later by a tax bill that ate up over a third of the funds. She also lost a lot of merch money, which normally accounts for 15 to 20 percent of her performance revenue, because she was touring with old CDs. But things like that happen to a lot of small creators, she said. "You really live on the margins, and you're really vulnerable. The point is to make sure that it doesn't cause you *not* to deliver."

Still, Call was sanguine about her prospects when we spoke. She was remarried and living in Juneau, another small city with a strong arts scene, where she was building a community-based career that included

teaching in the public schools. She'd already seen five or six shifts in the music business, which seem to come along every couple of years, she said: CDs, downloads, crowdfunding, streaming, licensing. "The nice thing about being an individual," she remarked, as opposed to a giant conglomerate, "is that I can pivot instantly and with very little overhead."

* * *

By twenty-seven, Jessica Boudreaux was pretty much finished with life on the road. Boudreaux, a musician in the riot grrrl mode—high-energy, badass—is the lead singer and guitarist of Summer Cannibals, a Portland, Oregon, hard-core band that's named for the song by Patti Smith. The band had formed in 2012, self-released albums in 2013 and 2015, put out a third in 2016 on the legendary indie label Kill Rock Stars, and toured relentlessly both on their own and with more senior acts.

Boudreaux described what it's like on the road. The bandmates stay in cheap hotels, all four in a single room, and try to buy their food in stores instead of eating out, avoiding fast food and consuming vegetables when possible. Sometimes the venue feeds them. "Sometimes the hotel will have free breakfast," she said. "That's disgusting but good." In the van, people tend to spend a lot of time on their iPhones. Boudreaux plays sudoku, which helps to chill her out (she suffers from anxiety), and has also become better at getting other paid work done—online writing or design—though it's pretty challenging, she said. The group has tried to set up exercise routines, but nobody's managed to stick to them. "Every once in a while it's really good for everybody to sit down and have a good dinner together," she said. "If we have a night off, we like to go see a movie." But they try to have as few nights off as possible—ideally, no more than one or two in a three- or four-week stretch of shows. Basically, it's play, sleep, wake up, drive. No post-performance rock-star partying? "No," she laughed, "not at all."

By 2016, Boudreaux, who also performed on tour with one of the bands the Summer Cannibals sometimes opened for, was earning enough on the road to make ends meet. "But at what cost?" she asked. "You're never home. You're exhausted. You're not really able to think about anything else or do anything else *because* of how exhausted you are." Plus the constant repetition of the interviews, having to explain your story over and over again, plus the creepy guys who message you online. "You

have less and less time to create, and so your job starts being more that you're a personality and a performer."

That year, Boudreaux realized that maybe this wasn't the way that she wanted to do things. Her initial plan was to try to transition to professional songwriting. She had been writing songs since she was a teenager in her bedroom filling notebooks with lyrics. She had also written all the Summer Cannibals' material. Meticulous in her approach to craft as well as a demonic worker—in addition to everything else, she practices guitar a few hours a day—Boudreaux describes herself as "a very all-in kind of person." When I spoke with her at the end of the summer the following year, she was working on her third album since January: one for the band, plus two solo projects. The latter involved something new—pop songs, of all things, designed to advertise her versatility to prospective clients, as well as for the change. "Sometimes you just don't want to be angry," she said. The previous year, a rough one, she had turned to Carly Rae Jepsen, Madonna, Whitney Houston—songs that make you smile and move. "Embracing that part of me felt really empowering in a way that I didn't expect," she said.

Boudreaux had planned to move to Los Angeles, one of the places that you need to go if you want to become a professional songwriter. She went down there for meetings, talked to a guy at BMI who was going to set her up with a writing partner. In the end, however, it didn't feel right. She decided to remain in Portland, near her support system, and explore a different option. Having long been interested in production, Boudreaux had made a point of recording the Summer Cannibals' three albums at three different studios to see how various people go about the process. She learned a lot, including the fact that, in a city full of studios, she didn't find a single female producer or recording engineer. So now her goal was to get into that. "When I see myself in the future," she said, "I go to work in a studio every day, and I'm helping other artists, musicians, find their voice. I see myself wanting to work with young women who have never been in the studio with another woman, have only ever really been bossed around by dudes." But Boudreaux also knew that, as a musician, "you can't just do one thing anymore. You have to be able to be versatile"—play, write, mix, master, do commercial work—"and you have to be *open* to doing different things."

Last time I checked, the Summer Cannibals were scheduled to do

another tour: twenty-six shows in thirty nights, in a huge circular route around the entire West.

* * *

The first time that I Googled Charlie Faye, a young musician whom I'd noticed in *The Shopkeeper*, the documentary about the Austin producer Mark Hallman, I thought I had found the wrong person. The artist I had seen played roots-based music and Americana, introspective leaning toward the mournful, on acoustic guitar. The artist I found was fronting a neo-Motown girl group, complete with coordinated outfits and synchronized dance moves, called Charlie Faye & the Fayettes. If I had to summarize the difference between the two acts, I would say that it involved a shift from "no" to "yes." Charlie Faye sang songs with titles like "Bitterness," "Heartaches and Old Pains," and "Girl Who Cried Love." Charlie Faye & the Fayettes do songs like "See You Again," "Sweet Little Messages," and "Green Light" ("You've got the green light, baby / I'm saying yes, not maybe").

Faye explained the transformation when we spoke. She had come to music late, in college, when she started taking lessons on guitar and mandolin, learning bluegrass and fingerstyle blues. She moved to Austin a few years later, in 2006, supporting herself with babysitting and food-service work. In 2010, she did a "Travels with Charlie" tour—ten residencies in ten cities over ten months, producing ten songs with ten sets of local musicians—but despite completing a Kickstarter for the project, renting out her place while she was on the road, and taking some part-time jobs along the way (like working for a granola company in Boulder), she ended up going into debt. In 2012, she led a fight, unsuccessfully and pretty much alone, to save South Austin's Wilson Street Cottages, a patch of little houses that had long been a haven for artists, where she paid less than $500 a month, from being leveled to make way for condos. She also put out four albums in seven years. But she'd never made a lot of money doing her old kind of music, I asked? "That would be accurate," she said.

Around the time that she released her fourth album, Faye met her husband, a musician and producer who had been based in Los Angeles for many years. As the headquarters of the film and television industry, the city is the center of the music licensing business. Faye's husband convinced her that licensing was a better way to try to make a living

than performing. But first, she'd have to write some different songs. "They don't need a lot of sad, singer-songwriter stuff," she told me. "First of all, there's a ton of that stuff out there if they want it." Also, "nobody wants to put that in a commercial. It might be appropriate for a sad scene in a movie, but mostly they want upbeat stuff." Her new material is perfect. "It's catchy, it's *happy*, it's simple, and it's also not like everything else. Nobody else is making this kind of music right now." (In other words, she's found a niche.) "They could license a Supremes song for a hundred grand, or they can license one of mine for ten grand."

Faye explained how licensing works. Shows, movies, and advertising agencies have music supervisors, who choose or commission tracks for their productions. The supervisors work with licensing companies— there are about twenty big ones—trusting them to filter the talent pool and make recommendations, the same way that television producers work with casting directors or publishers with literary agents. Faye began her licensing push by reaching out to all the major companies. With half of them, she had some names to drop, connections she had made in Austin or LA. She ended up signing with one of her last choices but insisted on a six-month deal instead of a full year, because she had an inkling that her opportunities would open up once the Fayettes released their first album, which they were about to do. A little less than six months later, she went to a panel on licensing at SXSW that included the founder of one of the biggest companies. She approached him afterward, they hit it off, and he actually asked her for a CD (as opposed to her shoving one at him, which is usually what happens in these scenarios). A week later, he called to offer her a deal. When I spoke with her the following year, she had already licensed four songs, including for the TV series *Girlboss* and *Riverdale*, for a total of $14,000.

Like Boudreaux and Call, Faye had moved in a lighter, more accessible direction: from music that was confrontational or highbrow or melancholy, respectively, to songs that are fun or infectious, that make you smile and move. Yes, Faye said, she was into Motown anyway, "but the decision to write more *happy* songs? I definitely had some other things in mind. I am trying really hard to make a living."

* * *

At the time that she released her first EP, Sammus, the Afro-futurist rapper, had completely bought into the techno-utopian myth. "I was feeling that sense," she told me, "Silicon Valley folks saying, 'This is the moment! If you're a musician, you can do your thing!'" In other words, just put your stuff online and you can be a star. Sammus, whose given name is Enongo Lumumba-Kasongo, had been teaching third- and fourth-grade math and science in a public school in Houston through Teach for America. The deprivation she had witnessed—seeing "firsthand how kids are essentially thrown away in this country"—had helped to send her back to music, which she hadn't really touched since high school. She needed to alleviate her sense of powerlessness, and she also wanted to create something that would arouse her students' interest in what she was trying to teach them. Having always loved cartoons and video games, she developed the Sammus persona—a "fly nerd" (i.e., cool geek) whose name derives from a heroic female character in the video game *Metroid*—and started making hip-hop tracks on her computer.

In the end, she was too afraid to play them for her students—tough audience—but her friends were encouraging, had never heard the perspective of a black woman who embraced a geek identity. By the following year, Sammus had quit her job and decided to try to make it as a musician. She produced an EP and put it up on Bandcamp, assuming that the Internet would do the rest. It sold about fifteen copies. "It was a very harebrained scheme," she told me. "And I failed miserably, and I was broke." Her parents, who are both academics, said essentially, that's cute, now go back to school. Which she did, at Cornell (where she had gone to college), to get a PhD in science and technology studies.

Yet the experience, however disastrous, proved useful later, if only in teaching her what not to do. Back in Ithaca, Sammus planned, once again, to put aside music for good. But a friend invited her to perform at a campus beat battle, where she won the praise of a legit producer who'd been brought in as a judge. She was also the only woman at the event. "I thought, okay," she said, "I cannot give up music. This is a sign." By her second semester, she was back to making tracks in her bedroom while taking three classes and trying to maintain her sanity. Gradually, as she worked her way through her degree, her career began to gain some altitude. Her next release was chosen by Bandcamp as one of its albums of the day and briefly became the best-selling rap record on the site. By year

three, she had started to consider herself as much an MC and producer as a student. A later album, *Pieces in Space*, hit the Billboard charts. But by then she understood what you actually need to do to try to break a release: start a few months in advance, drop a single, drop another single, make a video, get your press materials together. You don't just put stuff up and cross your fingers.

Meanwhile, Sammus was still in graduate school, driving four hours each way to do shows in New York and Philadelphia, hitting the college circuit, performing at music and gaming conventions, writing verses for a company called Flocabulary that produces educational hip-hop (not all that far from what she'd been trying to do for her students in Houston). Because *Pieces in Space* was released in the midst of a semester, she had to squeeze her tour dates in on the weekends, around her work as a teaching assistant. Her students would come up to her: "This is going to sound weird, but are you famous?" By then, her income from music, $4,000 to $5,000 a month, was far outstripping her stipend as a TA, so she moved to Philadelphia and made the leap to full-time musician (though she still planned to finish her degree). It had been a learning process, she told me, to discover that you can make a comfortable living in music, something between the viral dream of superstardom and the starving artist she had been in Houston.

But Sammus had also started to feel confined by her "geek rapper" persona. Being niche, she told me, "can be a gift and a curse," however lucrative her particular niche happens to be. "It's been a struggle for me to deal with the politics of niche," she said. People come to things like Comic-Con, the giant geek convention, with very specific expectations. "If I want to speak about my identity as a black woman navigating the academy," she said, that's not going to go over very well in "primarily white-male spaces" where they want you to talk about games and cartoons. She was trying to rebrand herself, she explained, which is why she had started speaking in terms of "Afro-futurism" rather than "nerdcore" and had recently switched to a label better known for punk.

At thirty-one, Sammus was also giving herself no more than four or five years more on the road. When we spoke, she had been ricocheting around the country, and her voice was on its last legs. Mega Ran, she said, an older nerdcore rapper who's been something of a mentor, tours 75 percent of the time—not something she can see herself sustaining. She

hoped to start a family at some point, too. Long term, her plan was to return to academia, but as an artist rather than a scholar. Rap, she jokes with friends, does not come with a pension plan.

* * *

Zach Hurd was thirty-four when he decided to blow up his life.

Hurd had been trying to make it in music since college. He had teamed up with a friend his senior year, and soon, through a lucky coincidence, the duo got connected to the college circuit, performing covers and originals for up to $1,500 a gig. To save money, they rented a place that belonged to his friend's aunt in a condo complex near the Jersey shore, two aspiring musicians in a sea of senior citizens. They tried to work with a producer, but, Hurd told me, "I was so committed to not, quote-unquote, selling out" that the relationship went nowhere.

Before long, Hurd realized two things: he had to go solo and he had to move to New York. He got a room in Williamsburg and started working as a temp. It was "super-humbling," he said. He was finding out, in concrete dollar amounts, exactly what he was worth to other people. He'd finish work, run home to grab his guitar, and head out to an open mic. When a job opened up at the Metropolitan Museum, where he had been temping, he hesitated. "Is this what I'm doing now?" he wondered. "I'm going to do a nine-to-five?" He took it—he needed the money—but in all the time he worked there, he always refused to move up, however tight things got financially. He wanted to keep the focus on his music.

Hurd self-recorded a couple of albums, then resolved to find a producer for the third, somebody who really knew what they were doing. "Learning to be in the studio was a whole new animal," he said. "What works in the studio and what doesn't." He put his stuff on CD Baby, an early online music store. He performed a lot, gaining confidence onstage. The record that he made with the producer won an Independent Music Award.

But by that time Hurd was thirty-four, and he was starting to lose heart. He had broken up with his girlfriend; he was still at the museum after seven years; the city was wearing him down. Things just felt, he said, "like a lot more of the same." He knew that he needed to make a change, in his life and his music, but he didn't know what it would look like. So

he quit his job, moved back to Maine, where he had grown up—it was easy, he had few belongings—and proceeded to take stock.

As a kid, Hurd had written songs with his little sister. Now she lived in Los Angeles, a place that he had always loved, so that was where he went. He tapped his pension plan from the Met, even though his mother warned him that it was supposed to be for his retirement. "That *is* my retirement," he thought, "but if I don't do anything before then, it's going to be worth shit." One day at his sister's, he opened a laptop that a techie friend had loaded with Ableton, the music software, and started fooling around. He recorded samples with his acoustic guitar, then chopped them up and played around with them, making use of the production skills that he had acquired in New York. It was a blast. "It was like learning a new instrument," he said. "It was like when I was twelve and learning Nirvana songs. It was all you want to do." Hurd had no idea where this new obsession was going, and he was still wondering what he was doing with his life, but it felt right, so he decided to ignore the fear. Instead of giving up, he doubled down, quitting the restaurant job he had gotten.

Hurd's grandparents had had a house in Virginia that the family was putting up for sale. He volunteered to drive across the country to get it ready, but before he left LA, he put up one of his tracks on Spotify under the name that he had given the new project, Bay Ledges (a reference to Maine). "This part," he told me, "it is straight-up from a movie." A friend called him in Virginia: you're on Fresh Finds, he said. The song, "Safe"—a catchy, synthy number with a SoCal vibe and glitchy, home-made feel—had been discovered by a Spotify curator and selected for the weekly playlist of emerging artists. Twenty thousand streams later, it was chosen for New Music Friday, where it racked up 1.5 million streams in the company of songs by John Legend and The Weeknd. It hit #9 on Spotify's US Viral 50, then #3 on its Global Viral 50.

Hurd's inbox started blowing up with emails from labels. He ended up signing with S-Curve, a label that was founded by Steve Greenberg, the producer who discovered Hanson, the Jonas Brothers, AJR, and many other big acts. "It was just kind of this surreal experience," Hurd told me. "I really thought the days of record deals were done." The label gave him a big enough advance to allow him to work on his music full-time;

funded a backup band, which included his sister; got him a booking agent and a publishing deal; paid for videos; arranged for publicity photos; and set him up with a company to manage his social media presence. It was as if he had been skateboarding down the sidewalk and someone pulled up in a Ferrari and told him to hop in.

But Hurd wanted to be careful about the way the whole thing would be rolled out, he told me—this was just a few months later—because he knew that acts can come and go very quickly these days. There are bands that he was listening to all the time the previous year whose names he couldn't tell you now. "There's a difference between really making a *brand* and just putting out a viral song," he'd learned. "You can get a few million plays on Spotify, but then another band comes in next week, and *they're* the new band."

* * *

Nina Nastasia is the kind of esteemed veteran musician who used to be able to scratch out a livelihood with a small but devoted following. Nastasia, fifty-four, writes spare, haunting songs that one critic has described as "tiny, dense snowglobes, each displaying a new scene from her own folk mythos" and that listeners describe as having saved their lives. Her videos are adorned online, in multiple languages, with comments like "You're amazing and your voice has carried me through some of the worst times in my life" and "I don't have to eat or drink or be loved anymore . . . I just need her music." With her partner and collaborator Kennan Gudjonsson, who is also a visual artist, Nastasia shares a two-hundred-square-foot rent-stabilized apartment in Manhattan's Chelsea neighborhood (that's the size of a lot of bedrooms). Gudjonsson works in the main room, a space that's stuffed with old clocks, animal heads, Gudjonsson's handmade puppets, and an ancient, sagging twin bed. When he says that "Nina has a studio," he means the toilet.

Nastasia has always resisted commercialization. Early on, in the mid-'90s, she refused to license a song for a Mazda ad for a sum that would have been enough to buy a house. A couple of years later, she passed on the chance to release her first record on a subsidiary of Time Warner, then the biggest player in the music business, because the label guy wanted to write a bridge for the demo, to make it more radio-friendly. Instead, she and Gudjonsson produced the album

themselves—analog recording, physical media—back when that was almost unheard of.

Five more albums followed, on indie labels, over the next ten years. In between, the couple drove on tour from Portugal to Poland, played in Serbia, Siberia, the Russian Far East. They've been planning to return to Siberia, only this time in winter. Nastasia likes tough crowds, she said, the kinds of places where you have to figure out how to win the audience over. At a gig in Limerick, Ireland (a town known as Stab City), they were warned not to walk around the neighborhood. One of her videos was shot, impromptu, in the bathroom of a club in Vienna—just her and her guitar in a graffiti-covered stall. Touring became the couple's social life, the way they'd see their closest friends. The road, Gudjonsson said, "is kind of—home."

But as the years wore on and the music business changed, their experience started to sour. They expected to be ripped off by the industry. Now they were being ripped off by fans. Free music meant free publicity, but it also meant that the labels and promoters and bookers got lazy, expecting you to do their work for them. And "you couldn't just sing your friggin' song" on the video anymore, Nastasia said. You had to have a gimmick. "You had to be playing your music on a trapeze, or a roller coaster." Her first label stopped releasing new music because it was no longer able to make it pay. Her next one, FatCat, wanted her to start a YouTube channel—the kind of thing, as she put it, where she'd record herself going, "Hey! Hi! It's Nina! I woke up this morning, and I had toast, and I started writing this song . . ." In 2009, deep in credit card debt, the couple gave in and licensed a song for a Volvo commercial.

It was Gudjonsson who described the process of chasing down minuscule royalty payments as "hunting for sparrows in the woods"—a complicated and exhausting undertaking if, like him and Nastasia, you have to do it on your own. "It's a whole other obsession besides music, in the digital world, to find out where this revenue is being generated," he said. "Because it's being generated all the time." Gudjonsson estimated that, despite repeated threats of legal action, FatCat, a UK label, still owed them at least £100,000. "It's demoralizing," he added. "You get stuck." The thought of everything associated with doing another record, other than making the music, becomes overwhelming—as does the thought of switching labels, or going back to self-production, or starting another

band. Since 2010, Nastasia had recorded three albums but released none. Music journalists began to speak of her as having disappeared. She tried to change careers altogether, starting a clothing line—in other words, Plan B—but the venture ultimately fell through.

When we spoke, she and Gudjonsson were in the process of reentering a music world that seemed to have become a different place in the years they'd been away. "[We] just don't know how to make it fun in this world," he said, "how to make it exciting." They were trying to learn the new rules, not to follow them, he explained, but to break them, which is much more interesting—trying to figure out a way of being entrepreneurial without "spending the majority of our time sitting on our asses at a computer." For the previous year at least, they had slipped below the poverty line. But they had always prioritized other things than money—had always lived, Gudjonsson said, "like we're going to die tomorrow." And yet, he added, music "kept us going, and it kept us happy." Whether it could do so still they were going to find out.

9

WRITING

To enumerate the entities responsible for the disruption of the music business would require an extensive list: Napster, Apple, Spotify, YouTube, and so forth. For the business of books, it only needs a single name.

When he began in publishing in 1982, I was told by Peter Ginna, the author of *What Editors Do*, who has worked at a succession of mainstream presses, it was "the ultimate mature industry." Nothing substantial had changed since the paperback revolution in the 1950s, and for about the following fifteen years, nothing did. Ginna was speaking from his perspective in the heart of the New York publishing industry. Richard Nash, the digital media strategist, who is also the former head of Soft Skull Press, then a well-respected indie, added some qualifications to that account. For Nash, a major turning point arrived in the late 1980s with the contemporaneous development of desktop publishing and the Barnes & Noble superstore. Before that, he said, you pretty much read what the publishing industry told you to read. Only about 350 literary titles came out each year, and you learned about them from the *New York Times Book Review*. But now it became incomparably easier to produce a book and—since outlets had all that additional shelf space to fill—to get it placed before the public. Independent publishing boomed, and the number of titles released, by indies and majors alike, quickly multiplied. Meanwhile, as both Nash and Ginna pointed out, mainstream publishing continued the consolidation that had started in the 1960s. By the early

1990s, the industry was dominated by a Big Six, all of them owned by media conglomerates.

Then came Amazon. (That's the single name, as I'm sure you knew.) The company was launched in 1995. Not only was it able to offer book buyers an immensely more convenient shopping experience, but because it could run at a loss thanks to Wall Street's endless confidence in its business model (the company did not become profitable for twenty years), it was also able to sell at deep discounts compared to the prices listed by publishers and charged by bookstores. Besides, books were never Amazon's real business. The company has always been happy to lose money on any given copy it sells (a luxury, needless to say, that publishers and bookstores don't enjoy). For Amazon, books were a way of building a customer base of affluent, well-educated consumers (the Whole Foods demographic, we might call them). With a median income 50 percent higher than the national average, book buyers are heavily overrepresented among the top fifth of the income distribution, a segment that's responsible for 60 percent of consumer spending.

By 2010, online sales accounted for 28 percent of the book market—the lion's share, of course, through Amazon. Meanwhile, the company had introduced a major new strategy for taking control of that market: selling e-books. The Kindle e-reader, which had debuted in 2007, initially flopped. Then the company poured some half a billion dollars into the new format, selling e-books now, too, at a loss. From 2008 to 2013, sales of the format exploded. (That was when people started writing essays about the death of print.) E-book sales have since plateaued and indeed declined, though not if you include self-published authors. (Readers, we discovered, really do love physical books, enough to pay a premium for them.) But the format enabled Amazon to engineer another massive shift in market share. E-books can only be purchased online. Once readers go to Amazon to buy their e-books, they'll buy their print books there, as well. By 2017, online sales accounted for 67 percent of the book market, and Amazon controlled about half of the entire pie: over 40 percent of print book sales, over 80 percent of digital.

The company's effect on the business of publishing and selling books was immediate and profound. From 1995 to 2000, 40 percent of independent bookstores in the United States went out of business. From 2000 to 2007, more than another thousand closed their doors. Indies

have recovered somewhat since, as the local bookshop has reinvented itself as an all-purpose cultural community center. From 2009 to 2018, their numbers grew by almost 40 percent, recovering about a quarter of the lost ground. But the brick-and-mortar book business as a whole has continued its rapid contraction. Since 2011, Barnes & Noble has closed about 10 percent of its locations. Borders, which also owned Waldenbooks, went belly up the same year, eliminating over six hundred stores. Smaller chains have also been shuttering: three went out of business in 2017 alone, accounting for another four hundred outlets. From 2007 to 2017, total bookstore sales were down by 39 percent.

The disappearance of bookstores puts financial pressure on the publishing industry by restricting "discovery," the ability of readers to learn about new books—especially problematic for an industry where profit is driven by the sale of new products (unlike, say, packaged goods, where customers tend to keep buying the same kind of toothpaste or soda again and again). Initial orders, especially big ones from places like Barnes & Noble (and, once, the other chains), furnish upfront cash for promotion. It's also a lot easier, as I noted in chapter 4, to browse in the three-dimensional space of a physical bookstore than it is on Amazon, to stumble on a title that you hadn't heard of or hadn't been planning to buy. Even now, if you ask people how they learned about the most recent book they purchased, only 5 percent will cite an online seller.

But the most important thing that bookstores do for publishers is offer them an alternative sales channel—and thus an alternative negotiating partner—to the Amazonian anaconda. Amazon has a monopoly in the bookselling business, which means that it has a *monopsony*, at the wholesale level, in the book-*buying* business. A monopsony exists when a market is dominated by a single purchaser, who can extract concessions, including ever-greater price cuts, from sellers. This is the lesson that Jeff Bezos learned from Walmart, whose business model he copied: undersell competitors by offering the lowest prices; offer the lowest prices by squeezing suppliers. Amazon's ugly public battle with Hachette in 2014—during which it slow-walked the sale of the publisher's books on its site—revolved around exactly that issue: which side would have the power to set the prices of the publisher's e-books. More recently, Amazon has monkeyed around with its buy buttons so that clicking "buy new" no longer necessarily takes you to a title's actual publisher, depriving the

latter of sales. "Amazon has this track record," I was told by Mark Coker, the founder of Smashwords, a pioneering e-book distribution platform. "Once they've got control over you, they force you to stretch out your arm and give up more blood every year."

* * *

So why does this matter for writers? Because with profit margins falling, the large commercial publishers (now reduced, with the merger of Penguin and Random House, to a Big Five) have slashed their "lists," the roster of titles they carry, consolidating their catalogs around the most popular kinds of books: fiction by the genre stars (Ken Follett, Danielle Steel), pop-culture franchises (*Harry Potter*, *Dragon Tattoo*), titles by celebrities, all things Trump. Publishing is not immune from the blockbuster logic that dominates culture in the digital age. Big books sell more than ever; smaller books sell less. Which means that smaller books—and the authors who write them—also receive less from publishers: more parsimonious marketing budgets (which lead in turn to still-smaller sales) and, even more dreadfully, lower advances. This is the realm of the so-called mid-list, which is where most authors live, or try to.

The mid-list is also the dwelling place of nearly all the books that have something more than transient value, the ones that we refer to as literature: literary fiction, serious nonfiction (what little poetry commercial publishers still carry is consigned to the bottom of the list). The Big Five do not publish this sort of writing out of the kindness of their hearts. Editors care about good books, but they also care about their jobs. They're not going to publish a book that they know will lose money. The problem is—and this, again, is true of the culture industry in general—no one knows for sure what will or won't. But with a few exceptions among the more prominent indies, only the bigger publishers have even a fighting chance to turn a profit on serious work, because they alone have the marketing muscle to help it break through to public awareness.

Because they publish so many books, and because they have relatively deep pockets, they also have the ability to spread risk. Publish ten literary novels, and one of them might hit, paying for the other nine. Publish the first book by a promising young writer and, even if it doesn't sell, you can publish a second and third, giving their talent a chance to develop. Kathy Belden, a senior editor at Scribner's, mentioned Anthony Doerr in

this connection, whose 2014 novel, *All the Light We Cannot See*, which won the Pulitzer Prize and became a huge bestseller, was his fifth book with the press. I spoke to a writer in his late thirties who publishes with Simon & Schuster. He received an advance of $20,000 for his first novel, which did not sell many copies; $90,000 for his second, which also didn't sell too many copies; and $175,000 for his third. But he's very talented, and he's won some honors, and he's making an increasingly prominent name for himself as a magazine writer. Simon & Schuster can afford, quite literally, to give him time.

Yet the lighter the publishers' pockets become—because Amazon is picking them—the rarer such scenarios will be. Serious work, Peter Ginna told me, is getting harder and harder for the major publishers to do: history, biography, collections of poems or essays. Many of the kinds of books that used to be the bread-and-butter of commercial presses, he said, are migrating to independent publishers (which are often nonprofit) or academic ones (which necessarily are). With both, advances are typically minuscule (and Amazon is squeezing those publishers, too—in fact, even harder, because they have less negotiating power than the majors). Richard Nash sees literary fiction going the way of poetry: indie presses, indie bookstores, exposure through live events. Which means, with rare exceptions, tiny readerships and no money.

* * *

Book sales and the advances that are based on them were one of the principal ways that writers used to piece together a living. Another way was journalism, broadly speaking: freelance writing of all kinds for newspapers and magazines. Well, we know what has happened to journalism. Craigslist came along and wiped out the classifieds, then Google and Facebook gobbled up most of the rest of the ad base. In between, places like *BuzzFeed* and the *Huffington Post*, which started off primarily as "aggregation sites," learned to hijack online traffic by repackaging the news as clickbait. From 2000 to 2016, advertising revenue for American newspapers fell from $65 billion to $19 billion. From 2004 to 2019, some twenty-one hundred of them went out of business; many others have reduced the number of days they publish or eliminated their print editions altogether. From 2000 to 2016, papers shed more than 240,000 jobs, 57 percent of their workforce. In magazines, it's been essentially the

same. Niche publications, or some of them, have managed to survive, but the general interest stalwarts are staggering around like zombies. *Rolling Stone* was put on the block; *Glamour* stopped publishing in print; *Newsweek* has been sold four times since 2010; *Time*, *Fortune*, and the *Atlantic* (like the *Washington Post*) are now each owned by billionaires.

Less money for publications means less, of course, for writers. Freelance rates have plummeted, sometimes by as much as 80 percent. Magazines that once paid by the word and carried sizable writing staffs now often do neither. Yes, there are a million other outlets to place your work—the myriad of media and literary sites that have proliferated in the new century, including those that belong to established publications—but they tend to pay in kibble, if at all: $300, $100, $50. Meline Toumani stepped away from freelancing from 2008 to 2013 to write a memoir. When she returned, she told me, she had a Rip van Winkle moment. She couldn't understand why anyone would bother writing for the kinds of fees that were now being offered. In *World Without Mind: The Existential Threat of Big Tech*, Franklin Foer reports that as the editor of the *New Republic*, he was paying $150 for online reviews, the same amount the magazine had offered for comparable pieces in the 1930s. Adjusted for inflation, that's a drop of 95 percent. Nor, it's clear by now, are the erstwhile darlings of the new media any better at competing with Google and Facebook than are the old dinosaurs. *Vice*, *Vox*, *BuzzFeed*, and others have all begun to teeter, missing revenue targets and laying off staff. Other than a few legacy flagships that have managed to leverage their brand equity—the *New York Times*, the *Washington Post*, the *New Yorker*, the *Atlantic*—no one has figured out how to make journalism profitable in the Internet age.

So why *does* anybody write for those kinds of fees? More important, how? The second question can be answered in a single word: stimulants. You write a lot, really fast, all the time. As a writer for *Flavorwire*, a cultural site, Jason Diamond was responsible for cranking out two pieces a day, each at least five hundred words. "I thought you could just drink a ton of coffee and type," he has said. The use of Adderall and comparable drugs, as I mentioned in chapter 5, is ubiquitous among young writers in New York. As for the why, why bother in the first place: "I was really raw," Diamond went on, "and really in love with the idea of being a writer." Sean Blanda, the former director of 99U, the site and

conference for creative professionals, told me that the last he heard, *Vice* was paying its staff writers $28,000 a year, "an obscene amount" in New York. How can they get away with that, I asked? "Supply and demand," he said. "There are just so many writers who idolize *Vice* and what *Vice* represents." They think, "'I'll take a flyer with my $28,000 salary, living with nine roommates in Crown Heights, and hope it works out.'"

Does it? Rarely. For online publications, profitability is driven by clicks, which means that writers are valued according to the same metric, and since attention (unlike quality) is a zero-sum game, they are therefore engaged in unceasing Darwinian combat. The current environment, Blanda explained, is a "laissez-faire free-for-all that benefits a certain kind of person": an "outsized personality" who is "totally willing to build their own brand in sometimes extreme and nefarious ways." Writers, Blanda meant, are incentivized to take inflammatory positions about divisive issues, but there are other ways to boost your numbers. Young women, in particular, are rewarded for writing explicit, confessional pieces about their personal lives. That was another thing that Meline Toumani, who was born in 1975, could not understand, and not just because it violated her sense of privacy. "The person who enjoys writing about their sex life for $150 a blog post eight times a week," she said, "is not the same person who dreamed of being a writer and putting ideas gently and carefully out into the world."

But some can make the new arrangements work. You have to be a "natural," I was told by Rachel Rosenfelt, cofounder of the *New Inquiry*, a cultural site, and later the publisher of the *New Republic*—"the sort of person who, it wouldn't even occur to you not to write." You also need the kind of voice that will stand out in the online din by projecting a vivid persona. Rosenfelt mentioned Sarah Nicole Prickett, "a very sought-after writer," whose voice is "perfect for the Internet"—witty and sophisticated, but also, in a subtly elusive way, revealing. And since you are essentially in business for yourself, you're never really writing for the publication. You are writing for the Internet, for Facebook shares and Google ranks. "You write as often as possible," Rosenfelt said, "and you're pretty agnostic about where," because it's you, not the website, that's the brand—you, not the site, that readers are aware of and remember. A writer like Prickett, Rosenfelt said, is "more valuable to the magazines that publish her than the other way around." Indeed, she remarked,

"writers are becoming the brand framework of publishing," with entire websites built around individual personae: Ezra Klein (*Vox*), Nate Silver (*FiveThirtyEight*), Glenn Greenwald (the *Intercept*).

More power to Prickett, Greenwald, and the others, but the system, yet again, rewards the few and leaves the rest to fight for scraps. It's virality or bust, stardom or oblivion. Nor does stardom, under these conditions, feel as good as it looks. Prickett has written about "unspool[ing] myself for cash." She is also the person who told me about experiencing the constant feeling that you can be replaced at any moment. Young writers, she said, are "grist for the mill"—that is, the content mill. "You'll never be edited the way you would've been, you'll never be paid, you'll never get the respect, you'll never get the time you need to work on your pieces." Worst of all—she was thinking about the young women who are inveigled into exposing their most intimate secrets—no one has your back. "It's not just the money," she said. "Yeah, being paid fifty dollars to write is insulting, but to me the real injury, the permanent injury, is that no one cared enough about you to actually be like, 'Oh, do you want to write this? Do you want to send it to me and then a week later we'll talk about how you feel?'" And while Prickett was clear that her own situation was better at this point, she also felt that her career—forever responding, however insightfully, to cultural ephemera—had so far amounted to nothing. She was trying to figure out, she said, "how not to just spend the whole rest of my life reacting for a living."

* * *

So what is a writer to do? Richard Nash is a big proponent of the idea that authors need to "go beyond the book" and figure out ways of engaging with readers that don't involve selling them copies of something. As with other kinds of artists, that means physical objects and face-to-face experiences. "Work with your local restaurant and do four events a year where you converse with ten people who are paying $150 to have a dinner party conversation with you," he has suggested. If you're into wine, have your publisher team up with a winery and pick a bottle for people to drink while they start your next book. "You could get one of those wooden unvarnished boxes, stick the signed hardcover of the book and a little explanatory note . . . in there, and sell each one of them for three hundred dollars, easy." For writers who feel that they don't know how

to do these kinds of things, Nash said, "the answer is 'You gotta fucking figure it out.'" And for those who don't want to, he implies, it is "get over yourself."

"There's a frustrating set of expectations that I think a lot of literary novelists in particular have about what they're going to accomplish through book publication," I was told by Jane Friedman, the author of *The Business of Being a Writer* and *The Authors Guild Guide to Self-Publishing*. "The world doesn't stop when your book hits the shelf." Indeed, it often doesn't even notice. Instead of panic-tweeting after it's already way too late to do any good, she said, writers need to develop an ongoing relationship with their audience that doesn't depend on a publisher and its marketing budget, so they can guarantee that they'll have some sales the next time they release a book. Beyond that, she said, "you have to get creative with what you can create or share that you can charge for in between book launches": online courses; email newsletters; the kinds of things that people put up on Patreon, like early or exclusive access to your work or insights. Various online platforms, she added, including Amazon, offer "affiliate" programs where you get a cut of sales whenever someone clicks through from your site—to purchase anything, not just your book. Other platforms furnish opportunities for branded content. With older authors, Friedman said, "you get kind of this gross reaction" to those sorts of suggestions, "like, 'I cannot write a story that incorporates a car brand.'" Millennials, she said, do not have trouble with them.

Nash has also pointed out that while work for people with editorial or writing skills is drying up in publishing and journalism, it is being created across much of the rest of the economy as "more social and economic actors (consumer-goods companies, white-collar professionals, advocacy groups, cultural institutions) become de facto publishers, producing ever more sophisticated publications online and offline." People who are good with words, he told me, will become—are gradually if messily becoming, with much adjustment to their self-conception—speechwriters, ghostwriters, "content strategists," and so forth. "The happiest poet I knew," he said, "was a pharmaceutical industry advertising copywriter."

Nash is no doubt right about the economic trends, but there's a big difference between a day job in publishing or journalism and one for Merck or Monsanto. The former immerses you in a community of writers

and readers, connects you to the literary world, and provides you with an opportunity to hone your skills. The latter offers not much other than a paycheck (not to mention the contrast in corporate missions). "If my definition of being a creative person is being a writer for Facebook, I can probably make a lot of money," I was told by Tammy Kim, the journalist. "But if we're talking about people who truly want to write things that they believe in and love," that option isn't going to work so well. Corporate writing jobs are also not necessarily as attractive, even in financial terms, as they look from afar. It was Nash who referred me, in this precise connection, to Matthue Roth, the writer who was working for Google—for good pay, as we saw, but under a short-term contract with no benefits.

There is one traditional income source for writers that is more robust than ever: Hollywood—specifically, television. With over five hundred scripted shows, the industry is in desperate need of people who know how to put a story together, and it is seeking them, as the movies once did, among novelists and playwrights. Three of the writers I spoke with were working on projects for the medium: Clare Barron, the playwright, for AMC; Adelle Waldman, the novelist, for a production company; and Gemma Sieff, the editor and essayist, for Amazon. "No one wants you to write films," Barron told me, "because there's no money in films. But everyone wants you to write for TV, because there's jobs." The novelist Sam Lipsyte, who chairs the graduate writing program at Columbia, has told of coming upon his students in the midst of a conversation about contemporary writers and being distressed to discover that he hadn't heard of a single one. It turned out that they all wrote for television. A lot of his students "are realists," he said, "and see that it's not like 1972 right now. It's a different world out there for a literary novelist or a short story writer." Television, they understand, is "a place that they need to look into."

* * *

Whatever e-books may have done to Barnes & Noble and Simon & Schuster, they've also been central to the most revolutionary—and for many the most positive—development in writing in the digital age: self-publishing. Self-publishing used to mean vanity presses, where you'd pay a company to print up copies of your book, copies you would store in your garage and thrust at unsuspecting relatives. Now, with e-books, e-readers (and tablets and smartphones), and e-book publishing and

distribution platforms like Smashwords, Amazon's Kindle Direct Publishing, and many others, it means the ability to make your book available for sale, instantly and without the need to seek the blessing of a publisher, around the world. Some self-publishing services will also print your book, either through print-on-demand (a copy is produced when a purchase is made) or in the traditional way, which you can then put up for sale online.

Since 2008, following the debut of the Kindle, self-publishing has exploded. That year, independent authors (as they prefer to be called) brought out about eighty-five thousand new titles. By 2017, the number was over a million. The same year, books by independent authors represented 38 percent of the US e-book market by number of units sold, more than those of all commercial publishers combined, and 22 percent by dollar amount.

For advocates, self-publishing means freedom from an industry they see as broken. Orna Ross, an Irish writer, published her first novel with Penguin, after fifty-four rejections, in 2003, only to see it marketed as chick lit (it was a murder mystery set at the time of the Irish Civil War) to please the supermarket chain Tesco's, then the UK's biggest bookseller. In 2011, she struck out into self-publishing and loved it so much that the following year she founded the Alliance of Independent Authors (ALLi), an international organization that became the leader in the field. With far more manuscripts than it can even look at, let alone publish, the mainstream industry, she told me, has always been an "ad hoc literary lottery," one that is skewed, moreover, by biases of race and gender. More recently, with consolidation and contraction, even the industry's traditional functions—investing in authors and providing them with rigorous and sympathetic editorial guidance—have become increasingly neglected. "It's a very unforgiving environment, publishing," she said. "People are very harsh on writers. It's almost like you've no right to do it." Self-publishing, she said, makes it okay to fail, which then enables you, in Samuel Beckett's words, to "fail better."

"I stress this is not easy," she said. "Publishing a good book is not easy." You need to become a good publisher as well as a good writer, which means mastering the complexities of marketing, promotion, and distribution, as well as of book design. Joel Friedlander, a prominent self-publishing consultant, concurred. "A lot of people get into book publishing

because it sounds easy, nowadays," he said, "and they really get bummed out, they get burned out, they get ripped off." To have a shot at getting your book into bookstores, and yourself into author events, he said, "the book has to be produced exactly the way a book from Knopf or anybody else would be produced, because all those bookers and book buyers, they know exactly what they're looking at."

Self-publishing, done right, requires not only time but money. "It takes a village to publish a book," Friedlander said. "To run a national campaign," he explained, you "need to hire vendors, consultants, marketing people, a publicist; need people writing press material, booking shows." Friedlander, who charges $350 for a sixty-minute consultation, estimated that a serious independent author can spend anywhere from $2,000 to $50,000 to get a book into print. Still, he insisted, "if you really want to do it properly and turn a profit, it's actually not that hard." But even if that claim is true (and it seemed like a strange assertion coming from the guy who said that people get ripped off because they think it's easy), it neglects to include the cost of labor—that is, your own. If you want to make a few thousand dollars by working for a few hundred hours, I put it to him, you can get a job at Walmart. "Yeah, but what would you have at the end?" he replied. "You'd be a beaten-down, anonymous slot worker." Fair enough, but you also wouldn't be risking your own money, and the income would be guaranteed. Plus, a lot of times there's not much difference between publishing a book and not publishing a book. Since 2008, more than seven million books have been self-published. All but a tiny fraction reach essentially no readers and earn essentially no money.

Still, earning money, at least directly, is often not the purpose of self-publication. A lot of people do it, Friedlander said, to "put themselves out into the culture." Many of the writers he interacts with are "one-book authors," individuals who have a manuscript, typically a memoir, that "they had to write." Surveys show, he said, that 81 percent of Americans want to write a book someday. (He agreed that it would be nice if that many wanted to read a book someday.) Yet if no one is actually reading your book, not even the unsuspecting relatives at whom you thrust it, and you dropped a bunch of money on consultants just to get it published, the situation begins to be hard to distinguish from using a vanity press.

More to the point, in terms of actually making a living, self-publication—like the traditional kind, as Nash and Friedman would have

authors regard it—is often merely one component of a larger business strategy. We are back here to the niche, the long tail, and the thousand true fans. Publishing a book on, say, cornmeal crust pizza (the example comes from Friedlander's website) helps establish you as an expert in the field, a position that can then be monetized in many ways: selling books, giving talks, doing cruises, teaching classes and workshops. And if you publish it yourself, you're creating a relationship with readers. In other words, you are building an audience.

* * *

None of this, however, solves the cultural problem: what to do about the literary author, about supporting serious work. Peter Ginna made a point, several years ago, of reading a few of the top-selling self-published books, and he found them uniformly incompetent at a basic level: dialogue, scene setting, proofreading. Just glancing at their "horrible covers," he said, they "looked off in some way, like a discount brand in the supermarket." Orna Ross would no doubt disagree, but even she acknowledged, as did Joel Friedlander, that self-publication is not really suited to literary fiction. What you see instead, she said, especially among younger readers, is a proliferation of "narrow niche genres" like "LGBT Muslim science fiction."

But if self-publishing cannot replicate commercial publishers' ability to finance literary work, it can impede it, by cutting into the revenues upon which traditional publishing depends. As of 2017, according to Jane Friedman, independent authors were capturing up to a third of the market for adult genre fiction—romance, thrillers, mystery, crime— which is a cash cow for commercial presses. Mainly they were doing so by selling their e-books for a great deal less. It turns out that a lot of people, Ginna said, would rather spend $2 for bad fake-Grisham than $10 for real Grisham. Even more disturbing for the mainstream presses is the possibility that somebody like Grisham will decide to go it alone. In 2012, J. K. Rowling set up Pottermore Publishing to bring out her e-books and audiobooks, albeit in partnership with her original publishers. Five years later—and remember, this is just a single author— Pottermore was capturing 2.4 percent of the entire market for the latter, 0.7 percent for the former.

The same bias toward narrow genre niches is visible on Wattpad, the

leading platform for self-published short fiction. Wattpad is a vast global phenomenon. As of 2019, its eighty million readers were spending over twenty-three billion minutes a month on the site, choosing among 665 million uploads by six million writers in fifty languages. Of its users, 45 percent are thirteen to eighteen; 45 percent are eighteen to thirty; 70 percent are female; and 90 percent are reading on mobile devices. As for the categories and subcategories into which its mammoth archive is divided, the large majority are genre designations: "Billionaire" ("possessive," "badboy," "mafia"), "Werewolf" ("possessive," "rogue," "pack"), "ChickLit" ("possessive," "billionaire," "badboy"). When I first went on the site in 2017, one of those subcategories, out of hundreds, was "literary." By 2019, the rubric had disappeared.

For Ashleigh Gardner, Wattpad's head of content, who helps promote and monetize its most popular writers and stories, because the platform is user-driven, it enables us to see what people really want to read. Unlike traditional editors, she told me, "I'm not picking the stories that *I* like. I'm listening to the audience and advocating for what *they* like. We don't know what most people want when all of the book choices are coming out of New York, and it's a monoculture of a certain type of person who, to be honest, can afford to go into publishing and work for free at internships for a year." That is why self-publishing, she added, is "over-indexing for communities that are underrepresented" by the mainstream presses. In the Philippines, for example, where traditional publishing takes place in English, the language of the educated class, Wattpad Tagalog took off "like wildfire," its first big success, *Diary of an Ugly Girl*, becoming a cultural phenomenon on the order of *Fifty Shades of Grey*.

Gardner launched Wattpad Stars, a program where the platform's biggest writers are offered the chance to earn money, among other ways, by creating branded content. The platform also seeks to connect them with traditional publishing companies as well as film and television studios. Its first big crossover hit was Anna Todd's *After*, alternate universe One Direction fan fiction (the boys go to college instead of starting a band), which was published by Simon & Schuster, became a sensation in Europe, and was optioned by Paramount. Not every eligible writer wants to be in Stars, Gardner told me. Some just want to be Internet-famous; some don't want their families to know they're writing sexy stuff online. But many of the younger ones are more enthusiastic about the brand

campaigns than they are about the book deals, especially because the former often pay a lot better. Even older writers, "who just are more aware of what the writing world is," she said, "have been much more excited to see the opportunities we have" than they are about anything that they can get from a commercial publisher.

<center>* * *</center>

For Nash, Wattpad is hobby writing, the equivalent of posting YouTube videos, and not a form of publishing at all, in the sense of competing with the industry for readers or writers. For Ginna and other mainstream editors I spoke with, self-publishing as a whole is not a serious rival to commercial presses. Gardner clearly takes exception to the first of those opinions, Ross and Friedman to the second. Only time will tell who's right. What seems more certain is that the dominant player in self-publishing will be—since it already is—that same single name with which this chapter started. If anything, because self-publishing is done overwhelmingly through e-books, and because Amazon's share of the e-book market is even larger than its share of print, its power over independent authors—who also, as individuals, have zero negotiating leverage—is even greater than it is over the publishing industry. Our literary culture, top to bottom, is in the grip of one of the largest and most ruthless corporations in history.

In self-publishing, too, the company's strategy is monopoly plus monopsony: lower the cost to consumers, increase market share, drive down price. Kindle Direct Publishing, Amazon's self-publishing platform, debuted with the Kindle in 2007. In 2011, the company established KDP Select, a program that, in exchange for various incentives, including greater visibility—and visibility, of course, is oxygen online—requires independent authors to publish exclusively on the platform. As of 2019, 1.3 million books were locked up on the site. Meanwhile, in 2014, the company launched Kindle Unlimited, a kind of Spotify for books—all you can read for $9.99 a month—and decreed that titles on KDP Select would thenceforth also have to be on Kindle Unlimited. As with Spotify, authors are dividing up a common pot that's based on the total number of subscribers, which means that they're competing with each other. Payment is calculated on a per-page basis (pages read, not pages published). As of October 2018, the rate was about 0.48 cents per page.

As Mark Coker, CEO of Smashwords, put it, Kindle Unlimited devalues writing on two levels. By stripping authors of the ability to price their own books, it forces them to sell them for less. Instead of charging, say, $2.99 for a 200-page e-book, you get only 96 cents at the current rate. More broadly, Coker told me, the program "devalues in the mind of the consumer what a book is worth." Writing, like music, begins to feel free. And authors, unlike manufacturers, cannot cut costs, as Coker pointed out, by outsourcing production to China. That is how a monopsony works: if you can only sell your product to a single entity, it's not your customer; it's your boss. When KDP Select was launched, Coker warned that writers risked becoming tenant farmers. Since then, he said, the program has been slowly boiling the proverbial frog, turning up the heat a little bit at a time. "Authors, artists, writers are born desperate to reach their audience," he said. "There will always be another writer more desperate than you, who's willing to lower their pants even lower than you." Amazon understands, he added, that a lot of authors would be willing, if need be, to write for free. Indeed, he thinks "the day is coming when authors are going to have to pay to be read."

SIX WRITERS

Nicole Dieker is pretty much the ideal person to have tried to self-publish a work of literary fiction. Dieker grew up in small-town Missouri, the older of two daughters of a piano teacher and a music professor. Her upbringing taught her to value the arts, but above all, she told me, it taught her to practice. "The idea that every day you're going to sit down at your instrument and you're going to try to get better at it—that taught me as much about how to be an artist as the actual art itself."

In college and her twenties, Dieker studied music and theater and tried to make it as a musician before realizing, as I mentioned in chapter 7, that she didn't have the talent for an actual career. One day, to earn some extra money, she started writing for CrowdSource—"one of those content sites," she said, that "people slag on" because they pay so badly—taking micro-gigs like writing recipes for Food.com for $5 apiece. She turned out to be really good at it and, more important, really fast. "Writing was the first thing where people kept asking me for more," she said. So she started pitching other sites and hustling for other gigs and

tracking her income to make sure that she was earning more each week. "And five years later, now I'm here," she said—"here" being a flourishing freelance career writing regularly for five sites, including *The Billfold*, a personal-finance blog, and irregularly for many others. In 2013, her first year of full-time writing, Dieker earned about $40,000. Three years later, she was up to more than twice that. Speed was still her secret weapon, along with meticulous organization and a musician's sense of discipline. In 2016, she accepted more than seven hundred assignments for an average of about $125 apiece and published over 527,000 words. That's more than four times the length of this book.

Meanwhile, Dieker had been working on a novel. It was a fictionalized version of her family's story (she added a third sister), a sort of *Little Women* for millennials. She wrote it as a series of discrete vignettes, about three to five pages each, both because she was used to composing at that kind of length and because she had to fit the writing in around her other work. How did she manage it, on top of everything else? "I practiced," she said. The result, *The Biographies of Ordinary People*, in two volumes, is a lovely, unpretentious story, suffused with feeling, that unfolds at the speed of life. When Dieker was ready, she queried agents, all of whom told her that the book was not sufficiently commercial for a mainstream press: no central conflict, no antagonist. You could publish it some other way, one told her, as an "art book." Dieker thought, "You just said I made art. That's everything I ever wanted."

But she also wanted to publish it, which meant, she decided, to publish it herself. As she got the venture going, Dieker started a blog, "This Week in Self-Publishing," to document the process. It reads, in retrospect, like a novel about putting out a novel, complete with plot twists and dramatic ironies and a passage from innocence to experience.

The story begins about four months before volume 1 is released. Dieker hopes to sell five thousand copies (a lot even for a commercially published novelist, especially a debut author), including three hundred to five hundred preorders by publication day. She has already, it is clear, done a ton of groundwork. As her self-publishing platform (there are well over a dozen), she has chosen Pronoun, which she loves. It has enabled her to do comparative cover research, Amazon category research, and price research; will provide her with advance reading copies, which are needed for reviewers; and has given her a great-looking order site. Her

only worry is that if the platform should ever shut down, she'll lose the novel's ISBN, its unique commercial product code, taking her metrics and sales data with it.

Over the next few months, we watch her send the book out for reviews, place articles about it, tap her freelance network for marketing leads, do podcasts, plan a tour, total up her followers on social media (about eighteen thousand across three platforms) and recognize that they're not enough to make the novel the success she wants, defend herself for sounding "calculating" and "strategic," rejoice at a positive and thoughtful review, and remind us that although she wrote the book from love, she can't "just fling words into the sky without any dream of long-term financial stability." A month and a half before the launch, she loses all of the preorders she's received through Amazon (which is most of them) because of a glitch in Pronoun's software.

By publication day, Dieker has sold 109 copies. She puts a brave face on it. Readers are responding well. She's gotten "a couple of lovely Amazon reviews." The launch event was great. And she can actually hold a copy of her very own novel. (She posts a picture of it on her bookshelf between Alison Bechdel and Jane Smiley.) "It's everything a debut author could want," she says. Then she presses on. She applies for awards, pitches to reviewers and bloggers, does promos and discounts and giveaways, and thinks about hiring a publicist. There is something poignant about the way that Dieker can sometimes straddle the line between real authorhood and newbie self-delusion. One of the awards that she submits the novel for is the Pulitzer Prize. She's excited to discover "that you can in fact *just send your book* to *Fresh Air* or to the *New York Times*." She hears from the *New York Review of Books*. It's inviting her to buy an ad.

Gradually it sinks in that the novel will not be the success that Dieker had hoped for. A month and a half after launch, she adjusts her sales target down from three thousand to five hundred, forgetting that it had originally been five thousand. When she finally reaches the revised goal six months later, she doesn't even bother to point the fact out. Four months after that, having started the entire process with an "advance" of $6,909 that she collected over Patreon, she is now about $1,000 in the red. Book sales alone have grossed a total of $1,619. Meanwhile, Pronoun has folded: Macmillan, the Big Five publisher that owned it, couldn't figure out a way to make it pay. Dieker moves the book to Kindle Direct

Publishing. She also learns that Goodreads, which is owned by Amazon, will start charging writers for giveaways, a key marketing tool for independent authors. Self-publishing, she has discovered, does not really give you the kind of control that she had thought, because you're always at the mercy of the platforms.

In the midst of it all, Dieker writes a long, tormented post about the sacrifices she is making for the novel—we have already learned that she will end up spending "nearly every free minute" on it for three years—including being less available to family and friends. "But the truth is that I want it more than anything," she writes. "I have structured my entire life to have this choice. My job is to be good enough to get to keep making this choice for as long as I can."

* * *

Ben Sobieck is a father of two in his mid-thirties who lives in Minnesota, where he went to St. Cloud State, and worked for many years at F+W, a longtime publisher of special-interest magazines like *Sky & Telescope*, *Popular Woodworking*, and *Gun Digest*. He is also a Wattpad Star, one of a couple of hundred writers chosen for the special status out of more than six million on the platform.

What Sobieck has learned about the writing business he learned initially, he told me, about the business of magazines. Content may have lost its price, he explained, but not its value. Content has become a way of getting people in the store. F+W's titles have managed to survive, he said, because they're specialized. The problem with general-interest magazines like *Time*, he explained, is that their audiences are simply too broad for effective monetization. "You have to have a niche somewhere," he said. But once you do, "you can serve the entire niche's needs. You can give them products, events, speakers, content—anything." *Blade*, for instance, a magazine for knife collectors, has a line of books, an annual convention, online classes, and an email newsletter with targeted advertising. "The publishing industry," Sobieck said, has become "a data and direct-to-consumer e-commerce machine."

Sobieck began by writing crime, which led him, through the moral and philosophical questions that the genre raises, to the work of René Girard, the French thinker, especially Girard's meditations on the nature of violence and the role of ritual violence in society. Girard and others

brought Sobieck, in turn, to horror, where those questions, he told me, are even more pronounced. "Once I started writing horror," he said, "things really took off. Ever since then, it's been on turbocharge for me."

But writing is one thing, publishing another, and finding readers still a third. Sobieck tried and failed with three self-published books. After the last, he said, "I started to become a little more skeptical about the things I was hearing about self-publishing being this miracle that was going to solve all of our problems." He was "ready to throw in the towel," he said, but around the same time, his wife gave birth to their first child. For the hell of it, he wrote a horror story about the urban legend of the "black-eyed children," an expression of his anxiety as a new parent, and put it up on Wattpad, which he had only just heard about.

"That was the single best decision that I ever made as a writer," he said. Wattpad gave readers a way to find him, precisely because the platform is divided into niches. "If you're trying to go wide"—like *Time*—"you're screwed," he said. The reader thinks, "Why would I take a chance on something that doesn't match up with my personal preferences?" Whereas "when you know who it is that you're talking to," it is so much easier, as a writer, "to make that relationship work." Which apparently he did. His story blew up, at which point he was plucked for Stars.

The other major thing that Sobieck appreciates about the platform is that its monetization strategies are built around free content, just like those of the specialty magazines. Sobieck outlined four that he's participated in. First, branded content: under a sponsorship from Fox, which was launching a series based on *The Exorcist*, he wrote an ending for the black-eyed children narrative that tied into the show. Second, curated reading lists: the movie *Rings* (part of *The Ring* franchise), like many new releases, was set up with a "profile" on the site, complete with a list of stories that matched the movie's theme. Sobieck was paid for having one of his included. Third, writing contests: when TNT was going to bring back *Tales from the Crypt*, it looked for Wattpad stories to adapt. First prize was $20,000; Sobieck didn't win, but such contests are frequent. Fourth, still in beta when we talked, video ads, embedded in stories, with payment based on "impressions" or views, not click-throughs.

Sobieck, who was also chosen to edit *The Writer's Guide to Wattpad*, stressed how lucky he has been, how difficult his success would be to emulate. His story went viral, in part, because someone at the platform

chose to have it featured. At 1.5 million reads, he wasn't "the big dog" on the site, but he gets a lot of opportunities, he suspected, because he is very reliable and understands how publishing works. Even so, the Wattpad money hasn't been enough to let him quit his job and write full-time. At a certain point, he told me, he realized that he needed to diversify. So he took a page from F+W and created a direct-to-consumer product of his own: a writing glove, which he designed, prototyped, sourced manufacturing for, and now markets directly from his website. And because it's a proprietary product, he controls the pricing—not, say, Amazon. At the time of our conversation, he had sold about a thousand pairs, at $30 each, in the first six weeks.

"The process of writing a book, if you stop looking at it as an art and start looking at it from an entrepreneurial perspective, is almost identical to the process of creating a product from scratch," he told me. "You have an idea, and then eventually you get a product into somebody's hand." And, he said, "that's what it finally will take, in this economy, at this present time in publishing, for writers to turn this into a full-time gig. If you can sell a book, which is the most oversaturated and underpriced product in the world, you can sell anything."

* * *

Several years ago, I received an email from a former student I'll call Peter Gordon. Since college, I knew, Gordon had attended the Iowa Writers' Workshop, where he had studied under Ethan Canin. Now, he told me, he needed to talk. The novelist thing was not working out—he was still in Iowa, writing fashion copy and trying to finish a manuscript—and he was thinking of going to law school. He loved to write, he explained, but he didn't feel that he *had* to. Besides, he was approaching thirty, had gotten engaged, and was planning to start a family. To our mutual surprise, I did the math and told him to go to law school. He had given it his shot, and if he didn't think that writing was something that he couldn't live without—well, that's the litmus test of whether you should try to be an artist. So I wrote him a recommendation and wished him luck.

Two years later, I received another email. Gordon hadn't gone to law school, after all. He had gotten into Yale, had even signed a lease on an apartment in New Haven, but at the moment of truth, he pulled back. The email included a link to a beautiful piece that he had published in

the *New York Times* explaining his decision. The turning point had happened at the wedding of his college roommate, who was doing very well in Silicon Valley—his second wedding (not second marriage), in France. Surrounded by an innful of successful people, Gordon had realized that "they all seemed to have gotten what they wanted by following their passion." By the next morning, there was one less future lawyer in the world.

But wasn't writing not really his passion? No, the email explained, he now understood that that wasn't the problem. "Somehow in Iowa I got the idea that I had to write books like the ones I most admire," he said. But those were not the kind of books, he had realized, that he could or wanted to write. He had started a new project, a young adult mystery about a fascist astrology cult. "I'm so excited about it," he said. "For the first time, I don't feel like a faker." Young adult? Yes, he said. "I'm starting to suspect that a big component of success is just getting over yourself."

Later, Gordon explained that while he had turned to YA because he had come to feel he wasn't good enough for literary fiction, he realized now that that's the kind of writer he had been all along. "I've never thought of myself as an artist," he said. "I've always thought of myself as a craftsman," someone who is good at "rearranging the puzzle pieces." And he was bored by most of the young adult fiction he reads, he said, precisely because "it doesn't have a high enough thread count. It's not a dense weave." His aspiration now was to write "a page-turner," but one with "high literary production values." It also didn't hurt that, as Stephen Colbert once remarked to John Green, the author of the YA mega-seller *The Fault in Our Stars*, "a young adult novel is a regular novel that people actually read." Gordon made no apologies about his commercial ambitions. "I would love to get rich," he said, "and I'm thinking of the movie, and have been the whole time that I've been writing it."

To make ends meet after his swerve away from law school, Gordon worked as a freelance writer, teacher, tutor, and editor. Some of his editing came through Blurb, a self-publishing platform, where at first he was taking on everything: "really bad fiction, erotica," religious tracts—a lot of writers who needed help at the most basic level. He liked the work because he was good at it ("it's basically what I was trained to do at the Workshop"), but also because "it lives in this black box. No one knows what the right price is." He eventually asked for 6 cents a word, which

came to about $200 an hour. Later, Gordon started working for a company that does law school admissions consulting—a gig he secured not because he had made it into the top schools but because of that piece in the *Times*, which ended up opening a lot of doors. When I spoke to him at the time, he was making over $100,000 a year, working mornings only, with the rest of the day for his novel.

Gordon and his wife had also moved to Brooklyn. It could be a little awkward, he said, when he ran into classmates from Iowa, which he did all the time. He still felt sheepish telling them that he was writing young adult fiction. For their part, he said, "I feel like they feel like they need to show me that they're not judging me."

* * *

One day in 2007, Austin Kleon was sitting around his apartment in Cleveland Heights. Kleon was twenty-five, working part-time at a public library. He had planned to do a writing program after college, but a professor had said, if you want to be a writer, get a job, not an MFA. Now, however, he was feeling like he had nothing to write about. So, on a whim, he grabbed some newspapers—he had stacks of them lying around—and started fashioning "poems" by blacking out blocks of text, leaving only isolated words and phrases. Kleon merely hoped that the technique would help him come up with ideas for stories, but his wife convinced him to post the results on his blog, which no one had been reading.

No one read the poems, either. A year later, a business website linked to them in Kleon's archive. Not too many people read them then, but Kleon was inspired to produce some more. Finally, the year after that—Kleon and his wife had moved to Austin, where he was working as a web designer for the University of Texas—the poems started getting passed around the Web. Before he knew it, they were featured in a piece on NPR, one of those half-minute "smile file" fillers on *Morning Edition*. The piece led in turn to a book, *Newspaper Blackout*—which, Kleon told me, wasn't very good, mainly because he'd had to crank out a lot of additional poems way too fast.

The book was also a flop. But it did enable him to get some speaking gigs. One was at a community college. After he had booked the gig, Kleon realized that he couldn't think of anything to say. Once again, his wife came to the rescue, suggesting that he do the talk as a "10 things"

list, which he proceeded to cobble together from old blog posts. This time, everybody noticed. The talk went viral, and within a year—Kleon was working at a digital marketing company by this point, and the couple were expecting their first child—it had turned into another book, *Steal Like an Artist: 10 Things Nobody Told You About Being Creative. Steal* became a huge bestseller. So did a sequel, *Show Your Work!: 10 Ways to Share Your Creativity and Get Discovered.* By the time we spoke, *Steal* had sold about half a million copies; *Show*, about two hundred thousand.

Kleon is a sellout who never wanted to sell out. As a creativity guru, he makes a lot of money speaking to business audiences—people, he told me, "that I've never wanted anything to do with in my life." Art, music, writing, he went on—"that's the stuff that kept me alive when I was younger. To peddle it to people who I hated in high school—it's just a bummer." One of the hardest things, he added, is finding himself among individuals "who are supposed to be my peers," meaning other successful self-help authors. "They're nice people," he said, "but man, that's not who I wanted to hang out with when I was younger." Still, he went on, "when you find yourself part of this machine"—the self-help racket, the bestseller hustle—it takes on a life of its own. "I'll tell you what I've felt," he said. "It's very hard to sell out halfway. If you're going to go down that dark path, you might as well go for it," because "fudging" it, trying to have it both ways, is even worse.

Yet if selling out means doing things that violate your principles, Kleon insisted, he doesn't actually believe the term applies to him. When he'd put together *Steal*, he hadn't been aware of the existence of the creativity genre, the creativity industry. "That sounds absurd," he acknowledged, but "the thing you have to understand about me is that I don't give a shit about 'creativity.' I wanted to know how to be an artist. I'm a Midwestern guy. I was just trying desperately to find out, how do I have a wife and a family and have a job and still make interesting work."

It was *Show* that was the acid test, since now he knew what he was part of. Kleon needed a follow-up book, but he also wanted to continue saying things that felt true to what he believed. That very struggle—between art and commercialism, sincerity and salesmanship—informed the book he decided to write. *Show*, he told me, is "a book about self-promotion for people who hate the very idea of self-promotion." It's also one in which he tried to figure out how to do "something artful in this

spectacularly tacky genre," to find out "how weird can you make a book that's going to sit in a Michael's next to an adult coloring book." *Show* includes a chapter on selling out that urges readers not to let their fear of looking like they're doing so allow them to miss opportunities. But in retrospect, he said, that's the chapter that bothers him the most, because he felt that he was selling out a little when he wrote the book.

Now, Kleon told me, he was grappling with what he was going to do for the next thirty-five years. His ambition was to be the peer of authors whom he actually admires. Two years after we spoke, he published *Keep Going: 10 Ways to Stay Creative in Good Times and Bad.*

* * *

From ages fourteen to twenty-four, Monica Byrne pursued a single goal: to become the first human being on Mars. At that point, she switched it to an equally improbable ambition: to support herself as a creative writer.

As a child, Byrne sang in musicals, took guitar lessons, and wrote stories at the dining room table. She never took art seriously as a vocational option, though, in part because it came so easily to her. ("I feel like such an asshole saying that," she told me, "but I didn't understand how it could be hard, and I still don't.") Instead, she studied biochemistry in college, did internships at NASA, got a pilot's license, and started a master's at MIT. After a couple of years in Cambridge, however, she realized that she enjoyed the things that she was doing in her spare time—writing, improv classes, yoga—a whole lot more than conducting research. "Eventually, I was like, why am I making myself do this?" she said. "I'm clearly meant to be an artist."

The next eleven years became a long tale of odd jobs and financial expedients. Byrne worked as a secretary, a lab tech, a "glorified custodian," a freelance editor, a driver for ride-hailing services. At one place, she finagled a chunk of vacation time to do a residency, then came back and quit. ("I *unabashedly* took advantage of every day job I had," she said, "because there was no other way for me to do my work.") She ate a lot of peanut butter pretzels. She crashed with siblings in Durham, a sister in New York, and at her family's farm in North Carolina. An older man saw a production of her first play and offered to become her patron to the tune of $40,000 a year, payable in quarterly installments. The arrangement got creepy, predictably, fast. Before long, he was pressing her to go on

vacation with him, and when she refused, he reneged on his commitment. "When you're vulnerable and young and talented and a woman," Byrne said, "you make calculations."

Talented she certainly was. A year out of MIT, she started writing science fiction. With her very first stories, she won admission to the Clarion Workshop, the leading training program for writers in the field. She wrote and staged four plays in two years. One, *What Every Girl Should Know*, about the fight for legal birth control, went on to be performed in New York, Washington, Boston, and elsewhere. She won residencies and fellowships. She became the first person to give a TED talk that consisted of the performance of a work of fiction. After one of her stories came out, she got a letter from Ursula K. Le Guin, then the doyenne of the genre. "Science fiction is in good hands," it said.

When I asked her how she makes it look so easy—a question that she gets a lot—Byrne referred me to her "anti-resume," a spreadsheet of submissions, applications, and queries that she compiled over a period of six years. It enumerates eighteen acceptances and 548 rejections, a failure rate of 97 percent. One of the former, after sixty-seven tries on the project alone—this was eight years after MIT, a time when her annual income was about $15,000—was from a literary agent who agreed to represent her first novel, *The Girl in the Road* (the near-future novel set in India, Africa, and the Arabian Sea). The agent sold the book to Crown, a subsidiary of Penguin Random House, for $200,000. "It was like Christmas every morning," Byrne told me. She bought a new laptop, a television, her first smartphone. She replaced her college futon with a new bed. She started buying produce.

Girl came out to great reviews, award nominations (including one win)—and disappointing sales. Undaunted, Byrne embarked on a trilogy about climate change, completing the first installment and producing outlines of the other two, the point at which a publication deal is typically concluded. Despite his confidence, her agent couldn't sell it; editors loved what she had but wanted to wait to see the rest. By this point, the money from *Girl* was almost gone. "There were a few days of really intense darkness," Byrne told me. "But that was when I snapped and said to myself, I can never again rely on corporations for my basic needs."

Byrne was already on Patreon, but now she redoubled her efforts—and, in a single month, more than doubled her donations, precisely by

telling her supporters exactly that. At the time we spoke, she was taking in about $30,000 a year on the site. Most of her supporters were giving $3 a month or less—"a lot of poor people," she said, a lot of fellow working artists. Some were friends from Wellesley (which she had attended on full scholarship), including a lawyer who was giving $250 a month. Half were people she knew. Yes, she told me, everyone on Patreon feels like "we're cheating somehow," and she was "constantly worried" that she wasn't returning enough in rewards, but "it's not free money," she said. "They're paying me for a kind of work that is not valued in our economy, but that *they* value." At this point, even if she got a million-dollar deal, she told me, she would stay on the site, "because I want my basic needs to always come from a relationship with individuals that I trust."

* * *

I first met Kate Carroll de Gutes at a reception for nominees for the Oregon Book Awards. I was skulking in a corner, because I don't know how to talk to strangers. She came up to me because she recognized a fellow fifty-something introvert. Later, she told me her story.

De Gutes grew up near San Francisco, studied professional writing at the University of Puget Sound, and got her start by going to the newsstand at the Pike Place Market in Seattle, looking through the periodicals, and selecting ones to pitch. A couple of years later, she moved to Portland and opened a coffee bar, becoming the first woman in Oregon to receive a loan from the Small Business Administration. She figured she would get the place set up and running, then could just kick back and write all day. That's not, she learned, how retail works. Instead, she found herself clocking sixty-hour weeks. In the end, it didn't matter, because a few years later Starbucks came along and put her out of business.

"Then," she said, "I went to the dark side." The dot-com boom was beginning to gather momentum, and de Gutes had connections through her father to Silicon Valley. She started doing business writing, including content marketing, for tech firms. More than twenty years later, she was still at it. "I have not been an Artist, capital A, like we would all want to be," she told me—meaning full-time with no day job. She talks to young writers who tell her, "But you write all day long; you're a *writer*." She says, "Oh honey, there's such a difference." Art is art, and ghostwriting for tech executives is something else.

Meanwhile, working at nights and on weekends, de Gutes produced and published personal essays. In 1994, she sold a proposal for a book about maintaining your creativity by making art at home (the kind of thing that would be jumping off the shelves a decade later). Her agent hated the finished product and told her that she didn't know anyone who would want to publish it. "Once I picked myself up off the floor," de Gutes told me, she got a directory with all the agents in it, started at A, and found one whom she thought was suitable by the time she reached the Fs. The new agent got de Gutes an offer, convinced her to reject it, and sent the book around to other publishers—who all said no. Then he sent it back to the original house, which said, forget it, we know what you did—at which point he dropped her. De Gutes produced a novel after that, but she didn't even try to get it published.

By now, de Gutes was forty-two. She decided to enroll in the MFA program at Pacific Lutheran University—not to work on her writing, but because she'd realized that she needed to make some connections. She did, including with the founder of the program, Judith Kitchen, who ran a little press called Ovenbird and who became a mentor. Ovenbird published what finally became de Gutes's first book, a set of linked essays—spare, ironic, chastened, wise—about the breakup of her marriage. De Gutes did not receive an advance, but Ovenbird allowed her to keep 100 percent of the proceeds in return for a voluntary donation back to the press.

It was this book, *Objects in Mirror Are Closer Than They Appear*, that was nominated for an Oregon Book Award. It won, and won a Lambda Literary Award, to boot. De Gutes's career took off. Agents started calling from New York. The *Washington Post* wrote a profile. De Gutes appeared on *Fresh Air*. Actually, I'm joking. What really happened is this: the book received a modest bump in sales, and de Gutes was able to get some teaching gigs at writing workshops, where she met a lot of agents, though at the time we spoke, she hadn't signed with any. By that point, *Objects* had sold about two thousand copies, the same total as the second novel by the Simon & Schuster author I mentioned in the first half of this chapter, which received an advance of $90,000.

De Gutes had also cut back on her business writing, with a corresponding hit to her income, to put in ten to fifteen hours a week preparing for the publication of her second book, *The Authenticity Experiment*.

The book was coming out with another small press, which meant that she had to do the marketing almost entirely herself. She was sending out dozens of copies to media outlets, each with a different letter; creating "shelf talkers," those little descriptive index cards you find in front of books at indie bookstores; reaching out to residencies she had done to get in their newsletters; submitting for the booklist pages of LGBT magazines; setting up a tour; and conducting an online campaign on Facebook and her blog.

One of the lessons that de Gutes had learned from Judith Kitchen had to do with the way she ended her essays. "I used to want to tie everything up," she told me. "But the reality is, that doesn't happen in life."

VISUAL ART

Visual art—meaning, for now, the art of the "art world," of galleries, museums, auction houses, and the rest—is subject to a radically different set of economic circumstances than the other arts. The reason is simple: music, writing, and video can all be digitized and thus demonetized. The art world is, by and large, a realm of unique physical objects. If anything—at a time when a single work can sell for nearly half a billion dollars (as did Leonardo's *Salvator Mundi* in 2017)—the problem in the art world is not too little money, but far too much.

It wasn't always like this. In the decades after World War II, when American art emerged as a force on the international stage, the scene was small and, with exceptions, financially modest. In the 1940s, the number of galleries that specialized in contemporary American art was no more than twenty; the number of collectors, about a dozen. As Ben Davis writes in *9.5 Theses on Art and Class*, "the entire New York art world [could] fit in one room." For another twenty years, this remained the case, even if the room got bigger. In the 1950s, there were about two hundred artists working in the city. By the late 1960s, the total was perhaps five hundred, dealers and collectors included. As Roger White, the painter and critic, quotes a witness to the era in *The Contemporaries*, "If somebody had a party at a loft, mostly everyone was there."

Prices, by the standards of today, were microscopic. Writing in 1965, the critic Harold Rosenberg marveled over sums of "$135,000 for a Wyeth, more than $100,000 for a Pollock, $70,000 for a de Kooning,

$30,000 for a Johns"—figures that, even with inflation, represent a tiny fraction of the prices commanded by today's most expensive living artists ($110 million for a Johns; $100 million for a Richter; $91.1 million for a Koons). Through the 1970s, as rents remained cheap and the city decayed, depopulated, and deindustrialized, the New York art scene, centered by then in SoHo, retained its bohemian character: alternative, artist-run spaces; countercultural values; and ideological preferences that abjured the creation of salable objects like paintings and sculptures in favor of conceptualism, performance, installation, and video.

All that changed, like so much else, in the 1980s. Money came in and transformed the art world, just as it transformed the city: Wall Street money, tax-cut money, inequality money. Once the finance guys got bored with doing blow, they looked around to see what else there was to spend their bonuses on. Whereas before an artist wouldn't even think about showing for the first ten years of a career, now the galleries began recruiting straight out of art school, at least if you were making stuff that they could sell. Young, in the art world, once meant under forty. Now the stars were figures like Julian Schnabel, David Salle, and Jean-Michel Basquiat—all of them painters, and all of them famous before they were thirty.

The era set the pattern for the cycles to come, as the art world climbed aboard the roller coaster of finance capitalism. The market cooled (and painting fell out of favor) with the recession of the early 1990s, but within a decade, auction prices started soaring (and painting made a comeback) once again, surpassing 1980s benchmarks by 2005. From 2002 to 2007, global art sales roughly doubled, to $65 billion, increasing 55 percent, in a speculative frenzy, in 2007 alone. The Great Recession proved to be a hiccup, so fast were the rich getting richer, with sales returning to pre-crash levels by 2011. A study from 2009 revealed a direct correlation between the run-up in prices and the growing concentration of wealth, consistent with the behavior of markets in other luxury goods like high-end real estate. "A one percentage point increase in the share of total income earned by the top 0.1 percent," the researchers discovered, "triggers an increase in art prices of about 14 percent."

The new money is hedge-fund money, oligarch money, Asian-billionaire money. More than half of the global art market, by aggregate value, consists of sales of $1 million or more. Art collecting at that level is an affair of "ultra-high-net-worth individuals," people with liquid

assets of $30 million or more—though one insider told me that the bar is more like $250 million. Other than a horse, a house, or a wife, a work of art is one of the few unique objects that a wealthy man can buy. But whereas older generations of plutocrats were apt to collect in a spirit of cultural stewardship, carefully amassing collections with the intention of eventually bequeathing them to institutions, the new crowd treats art as another investment, a way to diversify their portfolios. Art is now an "asset class," subject to cornering, flipping, and dumping, to hot tips and quick sales. The Modernist, Impressionist, and postwar stalwarts have been displaced, as the focus of collecting fashion, by contemporary artists, who "play the role," Ben Davis writes, "of highly speculative stocks." So-called emerging artists, in particular, are treated like promising start-ups, vested with the hope of fast returns—a practice that gives new meaning to the phrase "art appreciation." Art is used to launder money, expatriate wealth, evade taxes, and collateralize debt. Much of it ends up in private museums or luxury storage facilities—the latter now a billion-dollar business.

<p style="text-align:center">* * *</p>

The influx of money into the art world over the last four decades has acted like an infusion of growth hormone. By 1989, there were 150 galleries in SoHo. By 2008, 300 in Chelsea, which had become the new center. By 2016, the number of galleries across the city had passed 1,100. From the late 1990s to the early 2010s, I was told by Hrag Vartanian, editor of the online arts journal *Hyperallergic*, the art world grew by a factor of four or five.

But growth, as throughout the economy, has arrived with consolidation. There may be eleven hundred galleries in New York, but most are small, are struggling, and don't stick around for very long. Many of the ones that do are vanity projects for people with trust funds or tax shelters set up to run at a loss. One study found that 60 percent of galleries lose money or barely break even. In particular, the years since 2008 have seen a large-scale contraction in the crucial middle tier—the kinds of places that discover and nurture young artists, as well as carrying work by, and providing a major source of income for, the middle range of practitioners, that large bulk of established professionals who operate below the level of the "stars." A lot of mid-tier galleries were wiped out in the crash. Many more have since

fallen victim to soaring rents. The middle tier has also lost a significant share of its customer base, who are also in the middle: upper-middle-class collectors who buy at price points (roughly $1,000 to $50,000) to which the wealthy wouldn't stoop—or at least, who used to, before they too were hit by the crash. Instead, the gallery world has consolidated around a handful of behemoths, not just in New York but globally. Before the 2000s, it was almost unheard of for dealers to operate in more than one location. Now, David Zwirner has five galleries in three countries; Hauser & Wirth has eight in four countries; Pace has nine in five countries; and Gagosian, the goliath, has sixteen in seven countries, including five in New York.

The other major factor affecting the fortunes of galleries today, and the biggest new trend in collecting over the last twenty years, is the rise of the art fair. Like every form of cultural "experience," these have multiplied in recent years at all scales and around the world. In 2018, there were eighty "international" events alone. The largest are vast, gilded, multiday extravaganzas for the jet set. Art Basel, the leading European fair, opened satellite events in Miami Beach in 2003 and Hong Kong in 2008. As of 2015, all three featured more than two hundred galleries and attracted more than seventy thousand visitors.

For collectors, fairs are fun, sexy social events replete with parties, openings, entertainment, lots of free booze, and none of the icy intimidation of walking into a gallery. For dealers, though, especially the smaller ones, they have become a huge financial burden. Booths can run $20,000 for minor fairs, $100,000 for big ones. Shipping and other costs add another $10,000 to $20,000. And sales at fairs don't supplement those in a gallery's home location; they largely replace them. At many brick-and-mortar spaces, I was told by William Powhida, the artist and art-world gadfly, foot traffic has dwindled to a trickle. Ben Davis reports that for some dealers, on-location sales have fallen to as low as 5 percent of their total.

Roger White believes that fairs are good for galleries in secondary cities, at least, places like Milwaukee or Dublin, because they bring them into contact with the international art world and provide enough sales to enable them to exist in the first place. But according to Troy Richards, who has taught at the University of Delaware and the Cleveland Institute of Art (he is now the dean of the School of Art and Design at New York's Fashion Institute of Technology), regional gallery scenes are contracting, as well, because of competition from the fairs and the economic decline

of local elites. Mid-tier galleries in places like Cleveland, he told me, are being replaced by artist-run nonprofits, which typically survive no more than a couple of years. And whether in New York, Cleveland, or elsewhere, most galleries exist on the financial edge. A bad month, or a bad fair, Powhida said, can put them out of business. "And every time there's a bad three months on Wall Street," said White, a *lot* of them go out of business.

* * *

For artists, especially young ones, the frothy markets of the new Gilded Age have created a correspondingly inflated set of expectations. Enticed by images of wealth and glamour—achieved, what is more, at a very young age—aspiring artists have flooded the schools, where programs have multiplied. "In the 2000s," Davis writes, "the MFA was pitched as a Golden Ticket, with an ever more youth-oriented art market generating rumors of dealers snapping up artists right out of school." Roger White remarked that "when you go to art school" now, "your dream is not to be Andy Warhol; it's to be Julian Schnabel."

But it's not enough to go to any art school. Only a few programs really count in terms of gaining access to the market. In 2016, Davis and a collaborator, Caroline Elbaor, crunched the numbers and found that of the five hundred top-selling American artists aged fifty or younger (as measured by sales at auction), 53 percent have MFAs, and 61 percent of those attended one of ten schools. Another 35 percent have BFAs, where the study discovered a comparable bias. And judging by admissions numbers, everybody gets this. Acceptance rates to master's programs climb precipitously once you get beyond the top few institutions. In the teens or single digits at perennial bastions like Yale, RISD, CalArts, and the School of the Art Institute of Chicago, as well as at "hot" schools like Columbia, Hunter, and Rutgers, they rise near 50 percent or higher before you leave the top 20. There are back doors into the art world, I was told by Coco Fusco, the interdisciplinary artist who has taught at many institutions—she mentioned Skowhegan and the Studio Museum's Artist-in-Residence program—but in general, she said, "it's a very closed society."

This is not to say that everyone who goes to art school, even to one of the fancy ones, aspires to be rich and famous. But the false expectations

of recent decades also take a broader, even more pernicious form: the belief that a traditional artistic career—making paintings or other unique objects and selling them through galleries—represents a viable path not, as in the postwar years, for the bohemian few, but for the middle-class many. As the visual artist and essayist Martha Rosler, a senior figure in the field, has written, "Artists in large numbers want to have partners, get married, have children, live in warm and tidy circumstances . . . have pricy life-event celebrations . . . send their kids to good schools, drive decent cars, be nice people, and stay healthy." Lead the lives, in other words, of upper-middle-class professionals.

The numbers belie that ambition. Studies by the activist group BFAMFAPhD revealed that only 10 percent of the two million arts graduates in the United States make their primary living as artists, that 85 percent of artists in New York City have day jobs unrelated to the arts, and that the other 15 percent have median incomes of $25,000. Like everything else, the market for art is a winner-takes-all. In 2018, just twenty individuals accounted for 64 percent of total sales by living artists. (Ponder that one for a moment.) In fact, what struck me the most about Davis and Elbaor's list of the top 500 is that the person at the bottom—the 500th best-selling artist under fifty in the United States, someone well within the top 1 percent of individuals in that category—had lifetime sales at auction of only a little more than $13,000.

For a "staggeringly huge percentage of artists," writes Roger White, their "work will never appreciate one red cent beyond its initial purchase price, if it sells at all." Students in art schools, he told me, are rolling the dice, often consciously so. "You're so expendable as a young artist," he said. "Talk about overproduction: we've produced a *lot* of artists, [and] the structure just isn't big enough to support them. Every two years there's going to be one or two people that are courted and sought by the art market, and the red carpet will be rolled out, and they will be given the means to continue."

For the few who are given their turn—fed, that is, into the maw of a speculative economy—the result is often a rapid climb succeeded by an even faster fall. Another boomlet occurred from 2013 to 2015 around a group of young artists who became known (the term was not intended kindly) as "zombie formalists." The works of one, Lucien Smith, were selling for as much as $389,000 when Smith was still just twenty-four. Two years later, some of his canvases were having trouble finding buyers at

one-twentieth that price. It's "a good exercise," one painter told me, "to look back on Whitney Biennial catalogs even from five years ago, much less fifteen, twenty. The number of people you've heard of is minuscule."

* * *

The whole system can feel arbitrary in a brutal way. You can hit the market during a downturn, and by the time it has recovered you've already packed your bags and moved back home. Or the kind of work you do might simply not be suited to the current fashion. "If you're an artist, you're one kind of thing," White said. "If I make, you know, thick orange circle paintings, and when I get out of school, everybody wants thin blue triangle paintings, I can't just turn around and retool myself."

But why do artists feel the need to make it so quickly these days, if people didn't even used to try to show their work until they had taken some years to explore and develop? Not just because they can, but because, increasingly, they have to. On top of soaring rents for space to live and work is the cost of getting through school in the first place—which means, effectively, of paying off your student loans. Of the ten most expensive colleges in terms of actual cost—not "sticker-price" tuition, but tuition less financial aid—seven are art schools. And that's before you do an MFA, which can add another $100,000 or more. "It's a question of how long can you afford—either literally or given the tremendous emotional-psychological investment in the project that you have to give to it—to kick around New York before you're discouraged," White said. "It's a real bitch to get beyond your first or second show."

The system *is* arbitrary, in a way that isn't even true of the other arts. Writers make more or less than one another because they sell more or fewer books, not because the market puts wildly different prices on the books they sell. Even with other luxury goods—sports cars, cigars—prices usually bear some relation to the underlying cost of production. But in the art market, they seem to have long ago lost any meaningful connection to intrinsic value, or to the prices of anything else. Is a $20 million painting really worth a thousand times as much as a $20,000 one? Are all $20,000 paintings really worth the same? Was a Lucien Smith in 2015 really worth only 5 percent as much as it was in 2013?

Value in art—that is, market value, perceived value, the thing that gets translated into price—is largely a conjuring trick or at best, as the

artist David Humphrey writes, a "consensual fiction." It is the product of a complicated interplay among a set of factors that are each enormously subjective: art world discourse (the cloud of language that critics, curators, and academics secrete around an artist or piece), cultural capital (the school an artist went to, the dealer they are represented by, the museums that have shown their work), and the transient whims of collectors. "Cynics say, with some justification," Humphrey remarks, "that it is not what you show but where you show it that matters." Another artist told me that the point is not how many people like your work but making sure the right ones do.

What is really demoralizing, though, is that prices are always and intrinsically relative. The art market is a closed system; the only thing that determines the cost of a work is the cost of other works. The existence of a $20 million painting depends on the existence of a host of paintings that sell for $20,000, and an even vaster host that sell for $200, or not at all. Which means, as Lise Soskolne of W.A.G.E., the activist group, has pointed out, the success of the few—the insane, obscene success of the very few—depends upon the failure of the many. You aren't just poor while others are rich; you're poor so that they can be.

* * *

Gallery careers, however unlikely, remain achievable, of course. One artist in her early forties (I will call her Phoebe Wilcox), who maintains a studio in Brooklyn, explained the basic setup. Wilcox has dealers in New York, Los Angeles, and London. She tries to do a show a year, one every three years at each of the three galleries. The idea, she explained, is for your prices *not* to have a sudden rise, precisely because they can crash, but rather for your dealers to increase them slowly as your work receives exposure through venues like group shows, exhibitions, and biennials. Auctions can be dangerous for just that reason. At the time we spoke, Wilcox's works on paper (19" x 24") were selling for around $6,000; her largest paintings (12' x 6'), for $45,000. Dealers take 50 percent. Prices are based on size, not judgments of quality, because you don't want to influence buyers' opinions. Smaller works are cheaper, but more expensive per square inch (kind of like real estate). Large paintings are easier to sell in Los Angeles than London or New York, because the houses are bigger.

Relationships are crucial in the art world, Wilcox told me, and so

is your ability to talk about your work—factors that favor the socially poised and expensively educated. When someone asks you about one of your paintings, she said, it's not "charming to be, like, 'I don't know, it's art.'" The studio visit, where collectors come to peruse your work, is an important ritual. Visitors might be referred by your gallery, or you might have met them at a social event. Sometimes it is wonderful to have a dialogue about your work, she said, and sometimes the visit is comic in exactly the way one might imagine, as in, "Can you make a blue one like that?" Rubbing elbows—at openings, benefits, art fairs, and the like—is de rigueur, and also good and bad. It can be invigorating, especially after spending all day alone in a white cube. But the art world, Wilcox said, "is a lot like a high school," and some of it can be "a repugnant, simplistic, and embarrassing quagmire of bullshit."

Even for gallery artists, sales almost never constitute the entirety of your income. For many, the biggest other piece is academic teaching. If you want to stay in New York or another center, that almost invariably means low-wage adjunct labor, often with a long commute thrown in. One artist I spoke with was driving back and forth from Brooklyn to Cornell, a distance of four hours (though the pay was substantially better than usual, probably precisely for that reason). Tenured jobs, as rare as unicorns in any case, mean exile. Kathy Liao, a painter with an MFA from Boston University, was adjuncting in Seattle when she landed a tenure-track job at Missouri Western, a small public university about an hour outside Kansas City. When I spoke to her three years later, she was still doing shows (she had remained with her gallery in Seattle) but was having trouble finding time to paint with all her teaching duties. And while Liao had been pleasantly surprised by the Kansas City art scene—it gave her a community of fellow artists with whom to share and talk about each other's work, which, she had come to realize, was an essential part of what she wanted out of her career—she was already looking for other jobs because she felt cut off from the art world and wanted to return to a coast. What's more, not a lot of students at Missouri Western, an open-enrollment institution, want to study art, and those who do want something practical, like animation or graphic design. You can't tell them that painting is a good career option, she said, because it's not.

* * *

Are galleries even necessary at this point? Can't you just go it alone? As in publishing and music, there seems to be a widespread feeling that the old system isn't working anymore and maybe was never too great in the first place. Relations between artists and dealers are frequently strained, as they tend to be in situations where the power is all on one side. Contracts are sometimes unfair; payments are frequently delayed. Most galleries today, writes the painter Peter Drake, do not have the resources "to engage in real career development." Dealers might represent a couple of dozen individuals but only focus on the one or two who are selling the best at the moment. Artists, I heard repeatedly, need to take control of their careers and not allow themselves to be "infantiliz[ed]," as the gallerist Ed Winkleman has put it. After quitting his gallery in Chelsea, Noah Fischer, the person who initiated Occupy Museums, went so far as to perform a ceremonial incineration of his contract right there on the street. He made the break, he told me, "to create space in my life to create a new relationship to art." His larger goal, he said, "is to create a different way of seeing what the art career is in relationship to society."

That is also Sharon Louden's mission in her ongoing series of books, which I mentioned in chapter 2, of which two have been published so far, *Living and Sustaining a Creative Life* and *The Artist as Culture Producer*. Each includes essays by forty working artists describing the particulars of their career. In her writings and copious public appearances, Louden insists that artists need to move beyond the image of the solitary genius to embrace a wider, more active, and more varied engagement with the world. But while the essays in her volumes are informative and sometimes inspiring, the books as a whole do not articulate a new blueprint for the artistic career so much as reveal the one that's long existed. The solitary-genius model—the hero alone in a studio, emerging at long intervals to astonish the masses—has been unachievable, not just recently but for many years, by all but the extremely few. Louden's artists piece together their professional lives, and their incomes, from the wide variety of sources upon which visual artists have long relied.

One is institutional support, of which there is undoubtedly more available in the art world than in any other creative field. Look at the CV of any veteran working artist, and you are likely to find a long list of grants, awards, residencies, fellowships, commissions, visiting appointments, guest lectureships, and so forth. Indeed, for certain sorts of artists—those whose

work is more experimental or conceptual, and therefore less salable—such support might represent the only income that their art produces. Another kind of income source involves the many ancillary roles that enable the art world to function. One of Louden's artists, Richard Klein, provides an "abridged listing of all the things I have done in the art world," including, in addition to making (of several kinds) and teaching (in many settings): working at a gallery, working as a conservator/restorer, writing, consulting for both institutions and collectors, serving on nonprofit boards, cofounding a nonprofit, lecturing, working as a visiting critic at art schools and residency programs, working at museums as both a curator and administrator, acting as a juror for public arts programs, acting as a nominator or reference for granting agencies, and consulting on artist housing projects.

A third kind of income source is new, and very much reflective of the times: branded art. The term refers to projects artists do for corporations to enhance the latter's brand identity, a kind of art-as-advertising. Branded art is not completely new—it goes back to Warhol, at least—but as in music and elsewhere, it is, if only of necessity, increasingly common.

I spoke with Andrea Hill and Samantha Culp, art-world veterans who founded the creative agency Paloma Powers, as Culp explained, to help bring artists and brands together in a more concerted and mindful way. One of their projects, for Airbnb, took place in conjunction with Art Basel Hong Kong in 2015. The company (whose founders met at RISD) was looking to enhance its appeal in the Asian market, where the notion of letting strangers stay in your home was encountering a lot of cultural resistance. The idea of the project was to reflect on the concept of hospitality as a way of linking Asian values to the values of the company. When Hill and Culp reached out to artists to participate, most of them said yes (to the pair's surprise)—the artists were intrigued by the opportunity, and they were happy to receive exposure to new audiences. One, for example, Amalia Ulman, an Argentinian-born artist who was twenty-six at the time, created "Rescue," a sleepover for fifteen volunteers (plus her) in a single large room with video projections on the walls—no cell phones, no belongings, no leaving the space—the conceit being that the group was stuck together in a snowstorm and was forced to make the best of it.

Branded art raises uncomfortable issues, to say the least, especially in a field that regards itself as a bastion of radical social critique. Hill and

Culp were cagey about this—even, it seemed, uneasy. Hill stressed that they started Paloma mainly as a way of putting money in artists' pockets by adding another leg to the funding stool. Philanthropic support is uncertain and scarce, she pointed out, the collector base is small, and museums are far from perfect. "Brands, in many cases, are treating artists far better than some of the most revered institutions," she said.

On the other hand, Hill acknowledged that branded art remains "a very loaded topic" in the art world—that it is still "taboo" to put the words "'brand' and 'art' in the same sentence." Is branded art defensible? Is branded art art? Both Hill and Culp displayed a tendency to dance around those questions. Hill invoked the Medicis: some of the greatest art in history was created to glorify the rich and powerful, yet we continue to love it as art. The artists they work with, Culp remarked, do not necessarily make a distinction between their "real" work and their branded work. "Some of the most interesting artists working today, especially of a younger generation," she said, "see a lot of porosity, a lot of blurred lines," between those two categories, "and are just *fascinated* by corporations *as a material*, the same way that Richard Serra is fascinated by steel."

But shouldn't art be critical of corporations, instead of compromising with them? So much art is already compromised, Culp answered, her example being the inevitable Jeff Koons. For Hill, the question of whether branded art can ever be critical is "challenging" and "a fine line." Some brands *like* their artists to be critical, she said. Both Ulman and Airbnb thought that her project was successful, she added, but probably for very different reasons. From Ulman's perspective, Hill said, "I think she kind of perverted the notion of how to be a perfect guest, how to be a perfect host." Still, Hill insisted, that doesn't mean that Ulman was operating in bad faith. "I don't think that in order to be truly critical," she said, "there has to be a veiled, underhanded screw-you attitude." Regardless of what one thinks about these questions, branded art seems here to stay, an increasingly normalized part of what it means to be an artist in the twenty-first-century art world.

* * *

Unlike arts that can be digitized, the making and selling of unique objects has not been transformed by the arrival of the Internet. But there is a vast field of visual creation that lies beyond the art world: illustration,

animation, comics and cartooning, graphic design, the world of crafts. These, as we'll see in the second half of this chapter, have clearly been transformed. Digitizable visual art like illustration, cartooning, and graphic design are subject to many of the same economic forces as digitizable music and writing, and the people who make them are victims of essentially the same predicament as musicians and writers. As for the crafts, creative objects that aren't digitizable but also aren't unique (in the sense that paintings or sculptures are), these, too, have been transformed, mainly by the emergence of online marketplace platforms like Etsy. The question for all of these creative forms, however—and it is a question, as we'll see, that a number of the people whom I interviewed were wrestling with—is whether they are art.

As for the art of the art world, the irreducible fact is that the creation of unique aesthetic objects will always be extremely labor intensive, which means that they will always be expensive, which means that (failing a truly epic increase in public support) we will always need the rich to buy or otherwise support them. Such labor will also always be highly skilled, cognitively if not manually, which means that it will always call for many years of training. Galleries may be closing, but the gallery system is not going away. Without a dealer, Phoebe Wilcox told me, she would have no access to collectors and no visibility or legitimacy within the art world. Without a dealer in New York, I was told by William Powhida, the art-world gadfly, "an artist's career can fade out of sight very quickly."

MFA programs, with their regal tuitions, are not going anywhere either. The "alternative art schools" that have been popping up of late are rarely actual schools, rather than short-term programs or smatterings of individual classes, and the ones that are aren't cheap. Besides, people go to fancy art schools, like they go to fancy colleges, less for education than credentials and connections. I came across a few people who expressed the belief that it might be possible to just make work and hang around New York and network your way into the art world, but I didn't come across anyone who had actually had the nerve to try it.

There is one respect, however, in which the creation of unique aesthetic objects resembles the rest of the arts today: many more people are trying to do it. Not too many—that's been true for decades—but way too many. When Roger White remarked that the structures can't support the number of artists that the schools have been producing, he meant

nonprofit structures, too: the institutions that, by awarding the grants and fellowships, and hiring the professors and instructors, make it possible to have a career outside of the gallery system. "As an artist whose professional life has unfolded through various institutional affiliations," he writes of a colleague at RISD, "he was uncomfortably aware that he exemplified the promise of a certain kind of success that still attracts many students to the MFA, in a very different professional climate than the one he witnessed."

Noah Fischer's desire to create a new relationship to art, a new relationship between art and society, is one (or so is my sense) that's widely shared. Young artists are often intensely idealistic, motivated not only by devotion to their calling but also by a sense of social mission, one that typically runs directly counter to the values of the market. For every person who wants to be Julian Schnabel, there's another who wants to be Banksy, the celebrated pseudonymous political street artist. The question is, how? As hard as it is to sustain a career by selling your work, it's even harder to sustain one by not selling it. Jen Delos Reyes, of the University of Illinois at Chicago, is one of the leading figures in the field of social practice, a form of art that is constituted not by the creation and exhibition of objects (salable or otherwise), but by direct relational engagement with audiences and communities for the sake of social change—a kind of art-as-social-work. Social practice, with its mission of political transformation, is a field of growing size and importance within the art world. It is also one, as Delos Reyes acknowledged, that lacks an economic model. I understand what it means to make *art* that way, I put it to her, but I don't understand what it means to make a *living* that way. Yes, she laughed, that's what we are trying to figure out.

SIX VISUAL ARTISTS

Jane Mount was thirty-six, and still struggling to break into the New York art world, when she lost her studio. This was in 2007. Mount, who had wanted to be an artist since the age of five, had started an MFA at Hunter back in the mid-1990s, when the program was beginning to generate some buzz, but had dropped out after a year. She wanted to paint, and at art school in the 1990s you weren't supposed to paint. Later, Mount had done some shows—large, figurative canvases and drawings—but they

always felt anticlimactic. You put in all that effort to make the work and mount the show and try to get people to come, she told me, and then it's just over. She also hated the schmoozing part; making the contacts to make it in the art world was not something she ever could or wanted to do. "It just didn't really feel like a viable business," she said. And then, when the building she worked in was sold, she lost her studio.

Mount was not hurting for money. At Hunter circa 1995, she had discovered the Internet in the basement computer room. She obtained an internship at one of the first ad-supported websites, learned HTML, became an early web designer, and cofounded a couple of Internet companies during the dot-com boom. Eventually, it got too hard to paint with ninety people reporting to her, so she quit her positions and sold part of her shares in one of the companies to focus on and finance her art.

But then, no studio, in addition to no traction and no contacts. Mount decided to work at her dining room table, which meant working small, and because she and her husband had just had some bookshelves installed, she started, just for practice, to draw their books. A friend of his came over. "Oh my God," he said, "what are those? I want to buy all four of those little drawings right now." She had never seen anyone "react so viscerally," she told me, to anything that she had made. It was almost like the way that you respond to music.

Mount knew that she was on to something. She started drawing her friends' books and selling the results on Etsy and other sites. After being trained to make art that *she* felt like making—"pure art," as she put it, where you're trying only to communicate your "message"—she thought, "What if I figured out a way to make things that people really wanted? That's when I started asking people to tell me their favorite books, the books that made them who they are, and painting those as sets"—"ideal bookshelves," as she called them. "And, I mean, people loved it. People love books. And the idea of taking that love of books and making it visual and personalized really struck a nerve."

The business grew steadily from there. Mount is not any more of a self-promoter online than she was in the art world—she is happy to have avoided "all of the soul-baring blog business"—but she is a demon merchandiser. In addition to the paintings, which sell for $350 to $1,000 and of which she does about two hundred a year, she now creates digital prints—assemblages of preexisting images, both custom ($100 to $300) and

non-custom ($35 to $40). She also sells notecards, mugs, wrapping paper, stationery, and enamel pins, mostly through the hundreds of bookstores that carry her work. In 2012, she did a volume of ideal bookshelves of cultural celebrities (Patti Smith, Judd Apatow, Alice Waters). When we spoke, she was finishing a second book, a "gifty" miscellany for book lovers, which was accompanied, upon publication, by a line of book-shaped ceramic vases. In 2016, she and her husband moved to Maui.

The work is meditative, Mount told me, not boring, though she'd be happy not to have to paint another *Catcher in the Rye* or *Pride and Prejudice*, but she doesn't want to do it forever. She was hoping to get back to the kind of painting she used to do—"where I just get to stand in front of a canvas and make pictures that I'm really into"—but not if she has to worry about selling it, because that's not the way, she said, to be an artist. Is she an artist now? She calls what she does illustration: creating work that's designed to appeal to other people. Art, for her, is something else. Yes, she said, "college-me" would have thought that what she's doing now is "cheesy," but that isn't how it feels, and while a piece of her is still college-her, "what keeps it at bay" are the responses she gets, especially from people who have given her work as gifts. "A few days after Christmas, I'll get a whole bunch of emails where people will say, 'Oh my God, I gave the painting to my mom, and she loved it so much she had happy tears.' That happens *a lot*," she said. "Happy tears to me are about the best feeling anyone can have ever. So if I can enable that feeling in other people, and help other people give that feeling to someone else, there's really not much better than that."

* * *

Lisa Congdon, one of the stars of the online illustration world, had never been interested in art. In fact, she had never even picked up an implement. Then, at thirty-two, she signed up for an art class that her brother had to take, just so she could spend some time with him. Suddenly, she caught the bug. Her sister had started a blog—this was in 2004—so Congdon did, too, posting her work there as well as on Flickr, an early image-sharing service.

People started noticing her stuff. People started asking to purchase her stuff. People started wanting to show her stuff in their shop. "Something inside of me was like, 'Huh,'" Congdon told me, "'I could potentially

make money from this.'" She started going part-time at her job, then, in 2007, at age thirty-nine, she made the leap to self-employment. It was "really scary," she said. "I would go to my computer every morning and just say a prayer [that] there would be *some* way for me to make some money" waiting there: a potential client, a possible collaborator.

Congdon worked frenetically—twelve hours a day, often seven days a week. The more material she put out, she figured, the better her chance to be seen, and any moment that she wasn't working was a moment wasted. In 2008, she got an illustration agent. In 2010, she landed her first book contract, her first gallery show, and her first regular illustration jobs. In 2011, she hit a "tipping point." The work was pouring in: publishing, licensing, teaching, speaking. Client work. Sales over Etsy. She was working on as many as fifteen projects at a time, saying yes to everything, and was back to making as much as she had at her job. At that point, she said, "I didn't have to say a prayer anymore."

The blog was key to her success. Congdon posted every weekday, not only images but long reflections on her art and life. She spoke candidly about her age, her sexuality, her struggles. Getting readers to become interested in you as a person, she told me, is essential to building your brand. People are looking for inspiration, she said, and her story, which she "got really good at telling," was very inspiring. The secret to online platforms, she also discovered, is shareability. Facebook's algorithms are criticized for rewarding engagement with increased visibility—the more people follow you, the easier it is for still more to discover you—but she decided early on to take advantage of that. She figured out who her audience was—mostly women, mostly thirty to sixty—and what kinds of questions they'd respond to, what kinds of keywords in a header. Some of her posts got tens of thousands of shares. Congdon incited conversations, replied to comments, issued calls to action ("It's Mother's Day—go get your mom a gift"), and was "unabashed," she said, "about directly promoting my work." As of November 2019, she had 102,000 followers on Facebook, 334,000 on Instagram.

At first, she told me, Congdon suffered from "incredible imposter syndrome." Real artists, she thought, were people who had MFAs; she had only gone, she said, to the "School of Lisa Congdon." But her first studio ("outside of my coffee table") was in a space she shared with lots of art school graduates, and despite her trepidations they embraced

her as an equal, even eventually asked her to critique their work. "They understood that there are many different ways to be an artist," she explained.

The other issue that Congdon has grappled with is whether she is, as she put it, a "sellout." What does it mean to make work that's decorative, not conceptual, "lowbrow as opposed to highbrow," she has asked herself. "What does it mean to be an artist who makes stuff for consumer goods, as opposed to making art for art's sake? What does that say about me or who I am or my talent?" By the time we spoke, Congdon had come to see those alternatives as simply representing different choices. Plus, around the time she started, figures like Shepard Fairey, the street artist and graphic designer who created the famous Obama poster ("HOPE"), were becoming models for a more commercial way of being a "respectable" artist. "Then I became a model for it for other people," she said.

In 2017, after ten years as a full-time artist, Congdon published a post on her blog, *Today Is Going to Be Awesome*, titled "On Self-Employment, Workaholism and Getting My Life Back." In it, she confessed some things that she had hidden—even from herself—for many years. By 2011, the year of her "tipping point," she wrote, she was already suffering from "chronic neck and back pain" as well as "almost constant anxiety." Her relationship with her girlfriend was also suffering. Yet despite the warning signs, Congdon had pressed on. "I told myself, *You can do this! You work fast! You don't need much sleep!*" Meanwhile, she explained to me, "I wanted to appear as though I had it all together. People looked at me from the outside and held me out as someone who managed to do all these things and do them with a smile on her face." But by 2016, she wrote, "I hit bottom. I was strung out, uninspired, anxious, and in chronic pain. I was *miserable*." She had finally had enough.

A year later, Congdon had managed to relearn how *not* to work: how to slow down, how to set boundaries, how to read more than a paragraph at a time, how to enjoy the things she used to love to do when she was younger, how to make art at something other than "daily Instagram speed." How to have a life. "It's not glamorous to be busy," she concluded her post. "It's just exhausting. And I am done being exhausted."

* * *

Lucy Bellwood, the cartoonist, walked me through the list of steps she takes whenever she completes a comic. She creates a preview graphic for the piece; posts a pdf on Patreon; posts it on Gumroad, a direct-to-consumer platform; posts the whole comic, cut up into individual panels for mobile readers, on Medium, making sure to link to all the places you can buy it, as well as to her Patreon page; adds it to the comics directory on her website, cross-linking to Medium and elsewhere; writes a blog post on her website; puts a link on Twitter; puts a link on her business's Facebook page; puts a link on her personal Facebook page; puts a link on Patreon; puts a preview image on Instagram; does a little Instagram live show-and-tell video; excerpts it on Tumblr; and announces it in her newsletter.

Comics aren't the only work that Bellwood does. She has also self-published three full-length books (with a Kickstarter for each), done freelance illustration for periodicals, accepted personal commissions (invitations, posters), done a little animation, dabbled in graphic design ("which," she said, "I felt singularly unqualified to do"), lectured, taught, and flogged her work at comic conventions all over the globe. When I asked her how much she works, she said eight to four, four to six days a week. Then she stopped herself. "No, that's not accurate, because I go back to work in the evenings." A part of her, she explained, defines work as the 90 percent of what she does that involves running her business, "and then the 10 percent that's actually drawing, I do when everyone else has gone to bed, or before everyone else has woken up, or when I'm on vacation." It was Bellwood who told me that she knows it's a holiday only when the traffic slows down, and who was trying to take her relationship with her boyfriend beyond mutual email triage and Post-it Note organization.

During the five years since she had graduated from college, Bellwood, who has avoided taking day jobs, had made about $25,000 a year. For the first four years, she'd been on food stamps. Becoming a full-time creative freelancer had been a loaded decision for her. Her parents are creative freelancers themselves: her mother a visual artist, her father a Hollywood screenwriter whose career, in a business that is feast or famine, has mostly been the latter. The family was often close to broke. When Bellwood filled out her FAFSA form for federal student aid, her expected contribution came to $6. She admired her parents, she told me, but she also wanted to build a more sustainable career than they had managed to.

Money, in fact, is something that Bellwood has thought about a lot. In 2016, at the XOXO conference for independent creators, she delivered an impassioned, emotionally naked talk in which she aired her tormented feelings on the subject: her guilt about accepting food stamps ("there's gotta be someone who needs this more than me"); her guilt about asking for money over Kickstarter and Patreon; her guilt about wanting anything at all for making art, let alone financial stability; her shame about negotiating for higher fees; her shame about not negotiating for higher fees; her terror at "the prospect of being an only child with two aging parents who I might not be able to support"; her self-flagellation about ever relaxing, or feeling good, or buying something nice; her fear of talking about all of this in public in the first place, and of what the Internet would do to her for daring to; and finally, her determination to confront these feelings, her insistence that creators need to challenge the taboos against discussing money, and against wanting it.

The Internet is something else that she has thought about a lot, especially since her life depends on it, spiritually as well as financially. "Everything I have done in the past six years now of being a cartoonist," Bellwood remarked in her talk, "has been made possible by my community"—on Kickstarter, Patreon, Twitter. She feels unspeakable gratitude for her supporters, but that support, she explained, is in some sense reciprocal. Seeing her enthusiasm for making art, she said, for living the dream of being a creator, inspires people to believe that they can "shave off some small piece of that for themselves, like flint for the fire of whatever passion ignites them." Her impression, Bellwood told me, is that people "like me as an entity almost more than the work"; what they want to support is her "continued existence as a human being."

Part of the reason for that, she believed, is that she's very good at coming across as vulnerable and genuine online—a product of her touchy-feely childhood in Ojai, California. But, she told me, she had "started to hit the upper limit" of her ability to "give my soul away on the Internet"—to always be, in every sense, available. At worst, she said, "it feels like there are thousands of tiny ants pecking away bits of your flesh, and you're getting carried off in small chunks in a million directions, and you're like, 'No, no, no, no, no come back, I need to be a whole person.'" Yet the Internet, especially for her, is awfully tough to get away from. It was also Bellwood who said this: "We are asked to extend the bounds of

what would usually be your most intimate friendships to strangers, and that connection is the glue that holds your fiscal life together. And that is both really magical to me and also totally terrifying."

* * *

As a child in small-town South Carolina, growing up poor and black in the 1970s, Paul Rucker watched his mother learn to play piano—by mail. How was that even possible, I asked him. He wasn't sure himself. But "she had a drive," he said, "and I got that drive." Around the same time (Rucker was in fourth grade), he began to teach himself the concert bass. No lessons, ever—which didn't prevent him, at age eighteen, from joining the South Carolina Philharmonic, as well as going on to play with half a dozen other orchestras around the state. "I don't feel limited," he told me, "by other people's perceived limitations of themselves."

Eventually, Rucker got bored with the concert repertoire. At thirty, he decamped for Seattle, because of its jazz scene, where he found a place in an illegal warehouse, sharing a bathroom and shower with fifteen other people, as well as a job as a janitor at the Seattle Art Museum. Whenever an artist moved out of the warehouse, Rucker would take their leftover supplies and experiment with them. One day, a woman who lived there, and who knew him as a musician, was surprised to see him gathering supplies. "Paul," she said, "you're not an artist." Rucker told me that he'd like to thank her someday, because she drove him to prove her wrong. "People don't want to see you being able to do more than one or two things," he said, "because they themselves feel like they can't be more than one or two things. That's a limitation that we put on ourselves really early."

"I start things with total naïveté," he explained. "If someone's making a film, I'll say 'You know what, I can do that.' If someone's painting, I'll say, 'I can do that, and I can do it just as well.'" Apparently, he can. In 2004, the Seattle Art Museum mounted a show by Christian Marclay, whose work combines music and visual art, which motivated Rucker to attempt the same. Two years later, he won a residency at the Rockefeller Foundation's prestigious Bellagio Center in northern Italy. When he returned, he decided to get up to speed as a visual artist by putting on a show every month for a year (remember that Phoebe Wilcox does one a year), along with continuing to gig as a musician and work a full-time job. Rucker told me that goes toward his fears. He was afraid of roller

coasters, so now he makes a point of going on them every chance he gets. He had a fear of spiders, "and I had a pet spider for fourteen years named Mendelssohn."

One fear that Rucker confronts throughout his work is that of racial violence. He has done projects about police shootings, mass incarceration, the murder of Emmett Till, the Birmingham church bombing, and lynchings "past, present, and any that are coming up." He collects branding irons that were used on slaves. In 2015, he created an installation that involved making dozens of multicolored Klan robes. ("I really want to have a Klan-off, Klan trivia, with an actual Klan member," he told me, "because I know more about the Klan than most Klansmen right now.")

A few years earlier, Rucker had received a grant from Creative Capital, a leading arts funder. He was one of forty-six winners that year out of over three thousand applicants. It was at one of the retreats that the organization holds for recipients, he told me, that he realized he needed "to figure out what kind of artist I want to be." He didn't want to be a commodity, or someone who makes commodities, who exploits the black struggle, or even appears to be doing so, by marketing the kind of art that enables white people to feel good about themselves. Yes, he sells some pieces, but only to continue making work. And while he's getting money from rich white people either way—sales, or the many grants and fellowships, including a Guggenheim, that Rucker has accumulated—he sees it as a form of reparations. Besides, he said, "our hands are dirty with every move we make every day. You can't help but be part of a broken system."

Rucker is not only a ferocious worker—he told me that he'll sometimes get exhausted just thinking about his art, so intensely does he do so—but also a meticulous planner. He draws up budgets at two-week intervals and formulates one-, three-, and five-year plans. In 2017, he became the first artist-in-residence at the National Museum of African American History and Culture in Washington, D.C. The same year, he began a residency at Virginia Commonwealth University, among the top-ranked visual arts programs in the country, where his Klan robe project was chosen as one of the inaugural installations at the institution's new museum.

When we spoke, Rucker was planning to market a food sauce that he had spent eight years perfecting. The business would employ ex-convicts,

and the labels would carry information about the penal system. Two years later, the product was already on shelves.

* * *

Nikki McClure may be the first person ever to sell her artwork through an online retailing platform—and she had no idea until I told her. McClure, who is fifty-two, lives with her husband and son in a house on a beach in Olympia, Washington. A quiet, meditative individual, McClure makes quiet, meditative art: paper-cut calendars and children's books that feature images of water, forest, mountains, creatures, wind. She likes to watch things, she told me. When we had our phone call, she was sitting on the beach. "There's these three mysterious sparrows walking right along the shoreline that I've never seen at my place before," she reported at one point. Then, a few minutes later, "a giant salmon just leapt out of the water, like, six feet from the shore."

McClure grew up in suburban Seattle without a lot of money. Her parents divorced when she was six, and her father didn't pay much child support. She remembers eating blocks of food-bank cheese and putting off the bill collectors when they showed up at the door. As a teenager, after her mother decided to move away, she lived in her grandmother's attic in order to attend a better school. She was a "feral" child, she told me, but very independent and responsible—no drugs, buses into Seattle on her own to go hear music.

College, at Evergreen State, took her to Olympia, where she found a supportive artistic community. After graduation, McClure did illustration for the college's ecology department ("I drew lots of ducks") and otherwise subsisted "outside of a normal economy"—bartering work with friends, sharing tools and space, and not stressing too much about money. K Records, the indie label, let her use its computer and flat file (a kind of cabinet for storing art). "If I just make a little bit of money every day," she thought, "I'll be fine." When she got down to her last hundred dollars, she'd do something like invest in rice and beans and sell burritos at the music festival across the street.

McClure started showing her work at local stores and selling it at Olympia's annual arts festival. It was only then, she told me, that she began to regard herself as an artist rather than an illustrator. An illustrator, she explained, creates work to serve someone else's specific needs.

But with art, "there's this other reason that isn't ever totally apparent until after it's made [and that] becomes apparent because of mystical reasons"—"because of someone else's story who you didn't know." You share your work, and then "there's this conversation with your work that the maker, the artist, isn't part of."

Paper cutting is slow, meticulous labor. McClure can make only about thirty to forty images a year, and selling them as unique objects was ultimately not sufficient for an adequate living. At one point she wrote on her wall, "less work, more money." One year, a coffee shop invited her to do a show, and since it was December, she produced a calendar, a project that appealed to her for its connection to the seasons. At the same time, a local coder and indie musician named Pat Castaldo was setting up a website so his friends could sell all the weird little DIY stuff they were making. This was 1999, six years before Etsy, and no one had done something like it before. Castaldo called the platform Buyolympia, and the first thing he decided to carry was McClure's calendar, in an edition of three hundred.

She thought the whole idea was ridiculous. "What, people are going to buy things they can't touch?" It turned out they are. The calendar sold out, and with every year's edition, McClure increased the run until, by 2007, she was printing fifteen thousand copies. She also started making children's books. (The first one was about gathering apples to bake a pie, a good metaphor for making art, and for making a living making art.) McClure's life changed pretty fast. She bought a little house, sent her son to a private middle school because the public one "felt like prison," and now, as she put it, eats goat cheese rather than block cheese.

But she still prioritizes other things than making money. McClure's ideal day consists of a long solitary walk, a few hours of work, another walk with her husband, and a couple of more hours of work. She insists on printing the calendar on high-quality paper at a union shop in Olympia—not, say, in China. "This is fine," she told me. "I don't need to go on *Good Morning America*." Her husband, whom she largely supports, is a carpenter and furniture maker who does a lot of free work in the community (he also built the house where the family now lives), and McClure sells her calendars in local stores, which produces income for the town. She also continues to barter her work—for fruits, vegetables, maple syrup—as well as donating it to places like the local food bank. "I have what I need," she said.

* * *

A lot of people move to New York to try to make it in the arts. Atiya Jones, the mixed media artist, moved away for the same reason. Jones grew up in a lower-income neighborhood in Brooklyn, but her mother pushed to get her into a school in a whiter, more middle-class part of the borough, where Jones took ceramics and photography. "My mother couldn't give us the world," she explained, "but she also never told us that we couldn't have it." Jones went on to the High School of Fashion Industries, a public magnet school, then to SUNY Purchase, a campus with a fine-arts focus. She wishes that she had majored in visual art, she told me, which is what she really loved, instead of studying new media, which seemed more practical. "I would feel better about the mountain of debt that I'm in," she said, "if I had just followed my actual dream instead of playing with this idea of, 'Well, I'll get a career doing something else.'" At graduation, Jones had $31,000 in outstanding loans; after paying $300 a month for six years, she was up to $38,000.

Jones spent most of her twenties back in Brooklyn (the hipster part), working in a restaurant—she actually loved the job—enjoying life, but making relatively little progress with her art. As she started to approach her thirtieth birthday, she decided to get serious. Residencies in Rochester and Grand Rapids (which she had to pay for) provided her first opportunities to do her art full-time—and in silence. "New York is so loud," she said—and distracting and expensive, she added. A third residency got her where she had decided to go: Pittsburgh, a city that she'd heard good things about but where she didn't know a soul. Moving there, she told me, meant "abandoning everything and everyone that I knew." She had established an identity in Brooklyn, and a presence (including a couple of murals in her neighborhood), but it was time for the next chapter.

The move was tough, at first—a "six-month depression slump," she said, to start with. Jones's rent went down by half (for a ton more space), but her income went down by almost as much (she found a job at the Ace Hotel), and her loan payments, of course, didn't budge. Nonetheless, she said, she had come "to try to find my tribe," and a year later, she had succeeded. "Everyone I know in Pittsburgh right now? They're all makers," she said. "We're all doers." And because the scene is so small, "everyone's pulling each other up the ladder. I didn't feel that in New

York." There's something happening artistically in Rust Belt cities like Detroit, Buffalo, and Rochester, she told me, "but I think that the way it's happening in Pittsburgh is really, really interesting."

There were some other things in Pittsburgh that she had not encountered in New York, like the absence of a young black middle class or the presence of unconscious bigotry of a particularly clueless kind, as in, "God, you are so *intelligent*." Jones's art focuses on issues of gentrification and its impact on African-American communities. It was she who talked about the importance of being "a good newcomer." When we spoke, she had recently mounted an exhibit of images that she had made on windows reclaimed from demolished homes, a project that she hoped would be "a conversation-starter in regards to the change that's happening in Pittsburgh, and who the new settlers are, and what we can do to not completely eradicate everyone who's ever been here."

Jones also wanted to make art that was more affordable, and therefore more accessible and approachable—prints, notecards, journals— which would have the added benefit of diversifying her income stream. In building an online business, she planned to draw on her marketing savvy. You create a website, she explained, but "the thing that makes the website relevant is Instagram. Instagram is just how you remind people that you exist, constantly. I don't need to post about my business. I just need to *post* something, and then people go, 'Oh yeah—Atiya,' and then they click my page. That's the nature of that addictive clicking thing that we're all doing. The website just exists, and then you just drive business there 'by accident.' You don't even talk about it. And then maybe like every fifth post, like, 'Oh, by the way, I'm selling this thing.'"

Committing to her art—to attempting "to become the artistic, creative person that I want to be"—was very intimidating. "I almost try not to envision a career," she told me, because it "puts me in a really vulnerable place." She was not afraid of poverty, she said, "because I've already been there," but the prospect of sacrificing her social life for the isolation of a studio was daunting, and even more, of owning the identity of "artist" as opposed to someone who simply makes art. Still, all that was better than the alternative, which was staying in the service industry forever. "I have to do it," she said. "I've been fighting a creative pursuit for a *really* long time, and now I've put myself in a position where it's the only way out."

FILM AND TELEVISION

Television is the great exception. Every other art either is starving for money, or has succumbed to a blockbuster model of winners and losers, or both. TV is rolling in cash, and the cash is relatively well distributed among creators. The reasons are obvious: we all continue to pay a lot of money for it (both directly, through subscription fees, and indirectly, in the form of advertising), and that money is being used to make more shows, and therefore employ more people, than ever. It's no coincidence that television, of all things—the "boob tube," the "vast wasteland"—is also blossoming artistically, alive with a sense of excitement and confidence, like no other art form today.

How did we get here? The best thing that cable and streaming have done for the medium over the last twenty years, both aesthetically and financially, is also one of the circumstances that is frequently lamented about the media landscape today: they have chopped up the audience into ever-smaller pieces. In the age of the networks, everybody watched the same few things, which meant that executives could only program shows that they thought would appeal to the entire country (and that would be acceptable to the corporations that were advertising to it). Yes, Americans shared a common frame of reference back when everyone was watching Walter Cronkite, but everyone was also watching *The Beverly Hillbillies*, the top-ranked show the year that Cronkite took the anchor's chair.

Cable—specifically, HBO—developed a different model. The

broadcast networks, it has been said, sell viewers to advertisers; the premium networks sell programs to viewers. Before it could pioneer a new kind of television, HBO pioneered a new kind of revenue stream: the paid subscription. Dispensing with advertising meant dispensing with concerns about ratings or "standards." A successful show was one that made people want to subscribe, whether or not it drew a lot of viewers. And since the network didn't have to care if companies that market things like cereal or diapers would want to be associated with its shows, or whether the FCC would censor them—since its programs could incorporate not only sex, nudity, cursing, and graphic violence, but also the kind of sophistication that becomes possible when you're no longer trying to appeal to the lowest common denominator—HBO produced a lot of successful shows. In consecutive years beginning in 1998, the network launched *Sex and the City*, *The Sopranos*, *Curb Your Enthusiasm*, *Six Feet Under*, and *The Wire*.

The floodgates had opened. HBO demonstrated that people were willing to pay for television—which was otherwise so bad that you had to give it away—as long as you offered them something that they thought was worth paying for. Showtime, FX, AMC, and others joined the fun, and the subscription model started feeding on itself. The better and more lucrative that TV got, the better and more lucrative it got. The streaming services, which entered scripted television in a significant way in 2013 with Netflix's *House of Cards*, haven't so much changed the model as, by infusing additional cash (a *lot* of additional cash), expanded it still more. In 2009, there were 210 scripted shows. By 2019, the number was 532.

More shows mean that executives are forced to take a lot of chances, if only to fill up their programming slots. They also mean that the audience for any given show no longer needs to be particularly large. *The Beverly Hillbillies*, the year of Cronkite's debut, had a rating of 36, which means that 36 percent of households with television sets were tuned in. *The Big Bang Theory*, the most popular series of the 2018–2019 season, clocked in at all of 10.6. Television has become like every other art, one whose range reflects the true breadth of society's tastes. Room exists now for the offbeat, the subtle, the tragic, the strange. *Girls* seldom cracked a million viewers (its highest-rated episode came in at 0.6), which didn't prevent it from running for six seasons. With more than sixty networks and streaming services, the television business is in the midst of what the *New*

York Times has called "a fierce arms race for content"—and therefore for talent. "If you're a creative person" in the industry, Ron Howard has remarked, "it's the greatest time ever. Because if you have a story that you care about, you can find the platform, you can find the place to make it."

* * *

In film, the mood is rather different—more like what it is in music, just with spandex. From the mid-1980s through the mid-2000s, the VHS and DVD had played the role for Hollywood that the LP and CD had had for the record labels, furnishing the industry with large and reliable sources of income. That era was also, not coincidentally, a golden age for the medium. Working especially through "mini-major" studios like Miramax, which specialized in smart, mid-budget pictures, the industry nurtured the work of a new generation of indie directors: Spike Lee, the Coen brothers, Quentin Tarantino, Lisa Cholodenko, and many, many others—artists who made films that seized the center of the culture.

Then came broadband: streaming, piracy, eventually Netflix. Instead of going to the theater or buying DVDs, people rented on-demand, paid a single monthly fee, or stole. Or, because of HBO et al., they just watched television. In the era of the DVD, profit margins in the movie business, as the veteran producer Lynda Obst reports in *Sleepless in Hollywood*, hovered around 10 percent. By 2012, they had fallen to the neighborhood of 6 percent.

That's a lot of missing money, but the problem isn't just the lack of money. It is also the uncertainty. Movies cost a lot to make and market. In order for a project to get budgeted correctly—and therefore approved in the first place ("greenlit," in the term we've all become familiar with)— its producers, Obst explains, need to formulate a "P&L," a statement of anticipated profit and loss. Doing so involves projecting the picture's likely earnings across a range of revenue streams: domestic and international box office, "DVD, TV, pay cable, Internet, airplane devices, VOD, handheld devices, etc." But DVDs, she continues, "used to be half of the entire P&L." Now the money isn't so much gone—though a lot of it is— as impossible to predict. The other major revenue source, the second pillar of the old P&L, was North American box office. There the situation is the same: less money now, who knows how much money in the future. "If you're a studio or a network or a production company," Ron Howard

has said, "and you're trying to figure out what . . . a movie should cost, it's a mind-bender—and how many movies should you make, and where they should play. All of that's driving them crazy." When I spoke with David Hinojosa, a producer at Killer Films, a leading independent production company, he told me that Killer no longer even has a budget line for DVDs, and that it puts down zeros on its P&Ls for North American box office.

That leaves one main source of revenue still standing: international box office. Fortunately (at least for the studios), the global market is exploding. When she started making movies in the late 1980s, Obst remarks, international sales accounted for about 20 percent of worldwide box office; by 2012, they were up to 70 percent and climbing. In the wake of *Titanic* (1997), the first global hit, Russia, she tells us, "went from nothing to one of the top five markets in five years." China was expected to be number one by 2020. But dramas made in English don't go over very well in Russia and China, and neither do comedies of any but the broadest kind (Obst mentions *Bridesmaids* and the *Hangover* movies). What do go over well are chases, explosions, and well-muscled people in tights. And since, with the fragmentation of promotional channels and the multiplication of overseas markets, publicity has gotten more and more expensive, the studios increasingly rely on "pre-awareness." Hence the turn to sequels and adaptations and away from original scripts. In 2008, Marvel launched the Marvel Cinematic Universe—*Iron Man*, *Thor*, *The Avengers*, etc., etc., etc.—which will be up to thirty films and counting as of 2022. In 2011, Obst reports, every one of the top ten movies by US box office was either a sequel or the first installment of a comic-book franchise—a situation that remains essentially unchanged to this day.

Blockbuster Video may have gone belly-up, but the blockbuster effect in Hollywood keeps getting more pronounced. The top five grossing films accounted for 16 percent of US box office in 2001; in 2018, they accounted for 23 percent. From 2006 to 2013, the number of pictures released by the major studios declined by 44 percent. Worse, during roughly the same time frame, the number released by their "art house" divisions—the mini-majors—declined by 63 percent, from eighty-two to thirty. The latter circumstance is hardly a surprise, given that so many of the mini-majors, including Miramax, have simply been eliminated. Mid-budget pictures, movies that cost between $5 million and $60 million,

which include the serious dramas and intelligent comedies that constitute the artistic lifeblood of the industry—films, in other words, for grown-ups—are getting all but impossible to make.

Here, too, we are losing the middle. The movie business, Obst explains, is now partitioned into "tentpoles and tadpoles": CGI extravaganzas and small-budget indies. Reeling off a list of pictures that could not get made today, she cites *The Graduate*, *The Big Chill*, *Moonstruck*, and *The Fisher King*. In a post from 2014 entitled "How the Death of Mid-Budget Cinema Left a Generation of Iconic Filmmakers MIA," Jason Bailey mentions John Waters, Spike Lee, David Lynch, and Francis Ford Coppola as directors who either had not made a movie since at least the middle of the previous decade or had not made one that was not essentially self-financed.

Two of those figures, of course, have since re-emerged. (A third, Waters, has essentially become an author.) After resorting to Kickstarter to finance his previous film (for all of $1.4 million), Lee got $15 million from Amazon Studios to make *Chi-Raq*, revived *She's Gotta Have It* as a Netflix series, and then went on to make *BlacKkKlansman*, which was nominated for six Academy Awards. Lynch has still not made a film since 2006, but in 2017 he returned to public notice with the final season of *Twin Peaks*, on Showtime. Taken together, Lee and Lynch's recent careers exemplify three fundamental facts about TV and movies today: TV is eating the movies, the line between the two is disappearing, and Netflix and Amazon increasingly dominate both.

As money migrates to television, so does talent: writing talent, acting talent, producing and directing talent. The old financial and creative hierarchies, where movies were king and television was a joke, have been reversed. As of 2012, as I noted in chapter 4, the television divisions of the five big media conglomerates were generating about nine times as much profit as their film divisions. Now it's Hollywood that's paralyzed with caution, TV that takes the risks. Ten years ago, I was told by Lisa Bacon, a producer with nearly thirty years' experience in the industry, it would have been unthinkable for someone at the level of Nicole Kidman to work in television. Now she stars in *Big Little Lies* on HBO. Lee Daniels produced seven films between 2001 and 2013, including *Monster's Ball*, *Precious*, and *The Butler*. Then, as he has told the story, his friend Whitney Cummings, who had her own show at the time, sat him down

for a talk. "Why are you poor?" she asked him. "You get these Oscars for people, but you're [poor]. I get a lot of money. I mean, *a lot* of money." Daniels said, "Really, what kind of money?" And then, he continued, "She told me what kind of money." That's when Daniels decided to do his next project as a television series. It is known as *Empire*, he is no longer poor, and he hasn't made another film to date.

Yet with the rise of Amazon and Netflix, as well as HBO and the other premium networks—with the rise, in short, of on-demand viewing—film and television are turning into different versions of the same thing. When the people at Killer develop a project, Hinojosa told me, they start with the topic—the "IP" or intellectual property (a novel, a news article)—and only then do they ask themselves how best to "crack" it: as an "ongoing," a limited series, or a feature. If they decide to do it as a feature, the question then becomes theatrical or digital: release it in the traditional way, or distribute it as what we still call "television" even though we are as apt to watch it on our laptops, tablets, or smartphones.

Killer has a production deal with Amazon, one of several the tech giant has signed with production companies to give itself credibility with talent as well as connections within the industry. But the biggest new player in the world of creatively ambitious film and television—the biggest player, period—is Netflix. That is, if nothing else, a matter of necessity. HBO is a subsidiary of Warner, which is a subsidiary of AT&T, which generates more than $170 billion in annual revenue. For Amazon, as Hinojosa remarked, video is almost certainly a loss leader, a way to sell Echos and memberships in Prime. But Netflix is only Netflix, a small fish swimming in a sea of killer whales, trying desperately to not get swallowed. Content is its only business, so it is with content that it lives or dies. In 2018, HBO spent about $2 billion on original programming, Amazon spent about $5 billion, but Netflix spent as much as $13 billion. By 2022, the final number is expected to increase to $22.5 billion.

* * *

This is not to say that everything is perfect in the film-and-television industry, even beyond the problems with the big screen. "There's a lot more work," according to Elizabeth Banks, who produces and directs as well as acts, "but it's a lot harder to make money on anything . . . For low-end workers, the people on the tail of those big productions, it's a

lot harder to get by. And that's true for middle-class actors and writers, too."

Still, for individual creators, especially ones who are looking for their foothold in the industry, the digital age offers several paths. One is the old one: move to LA, find an entry-level job (maybe starting with an internship in college), and hustle your way up the ladder. "There are still very traditional ways to get into the business," I was told by Jane Espenson, the producer who has worked on *Buffy the Vampire Slayer*, *Gilmore Girls*, *Battlestar Galactica*, and many other shows. "You write a spec pilot—a clever new take on the cop show—and you submit it to the Disney Writing Fellowship, get into the Fellowship, they introduce you to showrunners and agents, then one of those agents sends you to one of those showrunners, and you have a *great* meeting, and you're put in a writers room, and you spend twenty years jumping from room to room, from show to show, rising up through the ranks until a network hands you your *own* show to run." Which is pretty much the way she did it.

"Connections are everything," Bacon told me, especially when you're starting out. The biggest groups of people in the industry, she said, are those who attended a top undergraduate program (USC, UCLA, NYU, BU), those who grew up in LA, and, at least in comedy and film, Ivy Leaguers. But the key for everyone, at every stage, she said, aside from hustling, is "networking, constant networking."

Sean Olson, for example, the director of *F.R.E.D.I.*, the film about a friendly robot, grew up in Phoenix and earned a BFA in film and television production from the University of Arizona. After graduation, he was hired by a local morning news show, where he learned to edit, followed his director to a station in Denver, then headed to LA, where he got a job through a friend at the Lifetime network. Olson moved among programs for several years, operating freelance and short-term—which, both he and Bacon told me, is increasingly how editing and other gigs in television work—then landed a full-time position at *Extra*, the daily syndicated news show that covers the entertainment industry. The job would finish around 3:45 p.m., at which point he would start his other job: building up his reel, and making connections, by editing movies, thirty to forty hours a week, for indie directors he knew.

Eventually, still at *Extra*, Olson started working for a production company that makes the kinds of movies that go straight to DVD. After

editing a few, he persuaded them to let him direct one, a thriller starring Danny Trejo. Olson shot the whole thing in eleven days and brought it in significantly under budget. Later, he did a dog movie (featuring forty canines, a pig, and some chicks), then a Christmas movie with Denise Richards. He had learned to direct by editing, he told me, took every project seriously, even ones with talking animals, and used his paternity leaves (he has two kids) to get in extra freelance work. It was in 2015, fifteen years after moving to LA, that Olson was approached by a producer that he'd worked for to direct *F.R.E.D.I.*, an "Amblinesque," kids-on-bikes affair. The project represented a significant step up for him. When we spoke, Olson had just finished filming, was hoping for theatrical distribution, and had already lined up money for a sequel.

To hear the stories of individuals like Olson is to get a better picture, in this age of endless television, of the kinds of shows that people mainly get to work on as they try to make it in the business. The true breadth of society's tastes, if that's indeed what TV gives us now, does not often make for a pretty sight. There may be 532 scripted programs, but very few of them are *True Detective* or *Atlanta*. And beneath the scripted shows, an even vaster sump comes into view: reality shows, morning shows, tabloid shows, daytime talk shows; *Jerseylicious*, *Bad Girls Road Trip*, *18 Wheels of Justice*; E!, Bravo, TLC—programs and channels that emit the odor of bottom-feeding near failure that afflicts so much of the entertainment industry.

Sometimes the odor is literal. When James Lee, who grew up in Arcadia, east of Pasadena, got his start as a production assistant with Brillstein-Grey, a big production company, the first thing he was asked to do, when he got to the lot in Culver City, was take out the trash. The second thing was make coffee. Lee has worked as a PA, assistant producer, and post producer for twenty years, selling real estate on the side as needed to make ends meet, and has been trying on and off for nearly half that time to get his own movie, about an Asian American stuntman, made. He has worked on *Slamball*, *UFO Hunters*, and a show called *Clean House*, which literally involved cleaning houses: sometimes in summer, fourteen hours a day, for bad pay and no overtime. "I honestly felt like a field hand," he told me. One day, a garbage bag exploded on him. "If I can make it through this show," he thought, "I can handle anything." In the end, it was through *Clean House* that Lee met Lisa Bacon, who brought him on

to *Fashion Police*, a hit show that hired him full-time with good benefits and regular raises, and where he worked for over eleven years.

<p style="text-align:center">* * *</p>

But the new technologies provide a different route, as well, albeit one that's equally uncertain. Today you can demonstrate your chops by shooting a pilot or web series and putting it up online. In the best-case scenario (*Broad City*, *High Maintenance*), someone picks it up and lets you turn it into a show. Miracles like that are very rare, however. More realistically, Jane Espenson said—and this scenario, of course, is still unusual—it gets you a spot in a writers' room the way a spec script once did and still can. Indeed, according to Bacon, having such a project to show for yourself is becoming more or less expected. When she goes back to Harvard, her alma mater, to speak to students, she meets a lot of them who want to be directors (including, say, math majors). "Here's the one thing I'm going to tell you," she says. "No one wants to hear your excuse. If you say, 'I want to be a director,' they're like, 'Great, show me the short films you've directed.' Shoot your movie—on your iPhone. Cut it together. If you don't do that, *no* one is going to take you seriously. It might stink, but you have to show that you have a vision, you are going to execute it, and you have a different point of view. Or else don't bother coming [to LA]."

Hence the growing link between TV and independent film. For indie directors, more and more, the ultimate goal is to get into television, with their low- or micro-budget movies (shorts or features) offered as a calling card. The glory days of indie film are dead and gone. Independent filmmaking, like so many other artistic endeavors, is both increasingly popular and decreasingly profitable. From 2003 to 2012, the number of independent films essentially doubled. At the same time, their total market share declined from 31 percent to 24 percent, even as the movie business as a whole was entering a slump, which means the average revenue per film declined by something like 60 percent. More slices, smaller pie. Indie films face all the financial headwinds of studio pictures—piracy, falling DVD and ticket sales—without the benefit of global theatrical releases and mammoth marketing machines. Budgets are smaller, shooting schedules are tighter, pay is declining for all involved. Todd Solondz made two movies in the 1990s, *Happiness* and *Welcome to the Dollhouse*,

that each grossed over $5 million. Of the four he has made since 2004, none has earned as much as $750,000.

Indie moviemaking is a grueling proposition at the best of times. "Every independent film is an absolute horrific marathon," as the director Andrew Neel has put it. The first challenge (other than writing the screenplay, of course) is lining up a budget. Movies cost serious money to make, even in the age of digital everything. Equipment costs money, transportation costs money, post-production costs money, but what costs the most is talent, on both sides of the camera. "Micro-budget" can mean as much as $400,000; "low-budget," as much as $2 million. Crowdfunding, especially Kickstarter, has been a tremendous boon, but it also helps to know some people who are rich. Which means it helps to *be* rich. That is why the world of independent film, as I mentioned being told, has "a high level of trust-fundism." When he talks to young filmmakers, Mitchell Johnston, the director, urges them to go to graduate school in part because "you meet a lot of rich kids who want to make movies." Of the people he knows who came out of MFA programs and made a feature that went to Sundance or SXSW, most, he said, "knew a rich kid who wanted to pay for it—and I mean a *really* rich kid, someone who is willing to put hundreds of thousands of dollars into something."

Another young director told me that he'd made a point, while doing his MFA at an elite university, of taking a class at the business school, where he met a lot of people who talked about how they had wanted to go into film and how they planned to start producing once they'd made their pile. "There are increasing numbers of rich kids with checkbooks and Russians with pretty wives," writes Lynda Obst, "who want a small part in a movie in exchange for financing the picture." "Wealthy people want to be involved in the arts," Johnston said. "It's the same reason people buy a painting: because they want a piece of that identity." And while people who invest in indie films, Johnston told me, "would like to think that there's a chance of a return," in reality, he said, without name actors, "your chance of making money in this day and age, with the glut of films, is zero to none."

Funding for an independent film will typically assume the form, as Micah Van Hove, the indie director from Ojai, explained, of "a Frankenstein of financing," stitched together from a multiplicity of sources:

individual investors, production companies, tax incentives, in-kind dona-
tions, sales of foreign rights to overseas distributors. The last category is
crucial, just as it is for Hollywood, but, because of piracy—no one wants
to screen a film that people have already watched on their computers—
increasingly precarious. Indeed, distribution in general is the other great
challenge in making an independent film (aside from actually shooting
the thing). You can't just put it on the Internet: no one's going to find it,
and even if they do, no one's going to pay for it, which means you won't
be able to recoup your costs. You need to secure release through some
kind of recognized channel, theatrical or digital. In other words, you
need to appeal to the gatekeepers. And in the world of independent film,
the gatekeepers are the festivals.

* * *

Film festivals, like every other kind of arts event, have been proliferating
endlessly in recent years. One estimate from 2013 found about three
thousand then currently active around the world. Jarod Neece, senior
film programmer at SXSW, estimated that there are sixteen or seventeen
in Austin alone. But the vast majority of festivals are small and insignificant:
at best, places to network; at worst (since festivals charge submission
fees), outright scams. "There's a whole seedy underbelly of *shit* film fes-
tivals out there," Micah Van Hove explained, "that exist purely to just
take money from people who want the validation of having their movie
in a film festival, even if it's somebody's basement in Florida." In terms of
distribution, according to Neece, there are only four in North America that
really matter: Sundance, SXSW, Tribeca, and Toronto.

Selection is highly competitive, to say the least. SXSW, Neece told
me, receives about 8,000 submissions a year: 5,000 shorts, of which it
takes 110, and 3,000 features, of which it takes 130. Of the latter, 90 are
premiers, and 70 are by first-time directors. And while Neece and his
fellow organizers have come to insist on diversity and "are super-happy,"
he said, "to find unknown people," he acknowledged that connections
definitely "don't hurt," if only by getting a movie on their radar screen. In
practice, I was told by the filmmaker Hannah Fidell, the successful young
directors in her cohort almost invariably went to film school, and not just
any film school, but one of the "right" ones (she mentioned CalArts and
the North Carolina School of the Arts as well as the holy trinity of USC,

UCLA, and NYU). "There's a ton of filmmakers that we know," Neece told me, "who are making good work, who work with other people who are making good work, and it seems like they find each other. And only one person really has to come up, and then they bring a bunch of other people with them." Which would seem to prove Fidell's point. In the world of indie film, said Mitchell Johnston, the true outsider is "one in a million."

Getting your movie selected for something like SXSW is huge for all involved, but it isn't necessarily the coronation that people suppose. Just a few years after he arrived in Los Angeles, Sean Olson edited a movie for a friend, *How the Garcia Girls Spent Their Summer*, that starred America Ferrera and premiered at Sundance. "We all thought our lives were going to change overnight," he said. Needless to say, they did not. "If you get into Sundance," the Brooklyn-based director Tim Sutton told me, "then everybody approaches you—everybody." Nonetheless, the first film he took to the festival, an experimental picture called *Memphis* about a singer drifting through the city, was "too strange," he said, for anyone to end up signing him. The second time, with *Dark Night*, a feature based on the mass shooting at a movie theater in Aurora, Colorado, "every agency called me."

The goal, at a minimum, is to sign with an agent, the initial step in entering the industry. Even better is for the film itself to get a distribution deal. Digital is good, theatrical is better, but best of all is Netflix. The streaming service, with its bottomless pockets and "insatiable appetite for content," as the journalist Sean Fennessey writes, is now the dominant player in distribution. The company, which has largely stabilized the indie market, has been "a godsend," I was told by one director. Netflix and, to a lesser extent, Amazon, Fennessey writes, are the powerbrokers now at Sundance, replacing Miramax and Sony Pictures Classic. Sundance plus Netflix: that's pretty much the dream in indie film today.

There are some downsides to a Netflix deal. The company demands exclusive rights, since it releases content all at once around the world. That means no theatrical distribution, no DVDs, no foreign pre-sales. It also means, as Jarod Neece explained, that your movie gets pulled from the festival circuit. "What is that six-month festival run going to do for the filmmaker's career—contacts, travel, learning, meeting people? Versus getting a huge chunk of change and then maybe being able to use that to make more movies." There is also some concern, Fennessey writes,

about the independent movie business turning into a duopoly, with two colossi dictating tastes. Filmmakers report that Netflix and Amazon provide "astonishing freedom" and "full-blown creative control," and others have told me that the streaming services are willing to fund small projects that don't have obvious audiences, but will they continue to do so? Are they spending freely now, as Amazon has done in other sectors, only because they're choking off the competition? Netflix carried over sixty-seven hundred movies as of 2010; as of 2017, the tally was four thousand and falling.

The number of television shows it carried, though, had nearly tripled. Some directors, including Tim Sutton and Micah Van Hove, remain committed to the feature as an art form. But for most of those I spoke with, the ultimate goal is television. They hope to keep on making films, but they also know where the action is.

* * *

Film and television have a final advantage over arts like music or writing. Amateurs do not pose any threat, because no one is ever going to mistake what they do for the real thing. Despite the hype that swirled around the genre in the early days of YouTube, web series—cheaply produced shows that are parceled out in mini-episodes of several minutes each—have not emerged as a serious rival to television in the more traditional sense. They remain a niche, especially among younger fans (more on that in the second half of this chapter), but in retrospect they were eclipsed by Netflix and the other streaming services. Far from the Internet rendering television obsolete, TV has bent the Internet in its direction. Such is the inertia of our viewing habits—not to mention our attachment to professional storytelling, seasoned acting, and high production values—that the sixty-minute drama and the thirty-minute comedy have retained their artistic hegemony, and so have the kinds of people who have always made them. Tech has not displaced the creators of television; it has enriched them.

SEVEN CREATORS OF FILM AND TELEVISION

Hannah Fidell understood that if she was going to get her movie into Sundance, she would need to game the system. Fidell had grown up with privilege, but in the world of indie film she was still an outsider.

The daughter of a lawyer and a Pulitzer Prize–winning journalist, both of whom teach at Yale, Fidell discovered film in high school (she would watch *The Big Lebowski* every weekend at a friend's house), then obtained a Netflix account in college at Indiana University (it was still the red-envelope days). "I remember just like not leaving my house" as an undergraduate, she told me, "just watching movie after movie after movie." It never occurred to her to try to be a filmmaker, though, since the odds of success were so small. Her parents were professors, so she would be one, too.

The turning point arrived when Fidell discovered mumblecore, a movement in independent cinema in the mid-to-late 2000s that featured naturalistic dialogue, loose-jointed plots, nonprofessional actors, and low production values. For the first time, making movies seemed like something she could do. Plus, it was 2008, 2009. "The world felt like it was really going to shit," she thought. There were no jobs anyway, so if not now, when? Still, Fidell was nervous about the move. She gave herself until her twenty-seventh birthday—an anxious person's thirty—to make the film thing work.

Because she hadn't gone to film school, Fidell had neither know-how nor a network. She made connections by traveling to festivals and workshops and joined a screenwriting group in New York. "It was me and a bunch of kids who had just graduated from NYU," she said. "And they just knew *everything*. Hanging out with them was like a master class." She ended up learning "through trial and error," including a "secret first film" ("everyone I know has one") that she financed herself for $10,000— an absurdly low budget that she pulled off by hiring people whom she didn't have to pay.

The movie itself she did not pull off. "Everything went wrong that could've gone wrong," she told me. "I didn't hire the right people. You're only as good as the team you work with." But there were bigger problems, too: she didn't really have a network yet, and she wasn't thinking strategically. Now she started thinking very strategically. She was going to make a movie that would get into Sundance. Because she was up on the scene, she knew what hadn't been done before, so she decided to "take the ethos of mumblecore," she said, "but elevate the story" by heightening the drama. She also decided to work with individuals—a producer and a cinematographer—who had already taken movies to the festival.

And she broke "the cardinal rule of filmmaking," which is never to invest your own money. Her grandmother had left her a bequest, and she used $100,000 of it on the movie.

Meanwhile, Fidell had moved to Austin, where she spent a couple of years doing nothing, other than waiting tables, but writing the screenplay. When the movie, *A Teacher*, was finished—she shot it in the city—her producer, who had gone through the Sundance Labs (a training program), alerted people at the Sundance Institute, who handed it off to the festival's programmers. At the same time, Fidell was also gaming SXSW. She had moved to Austin because she knew SXSW like to program home-grown films, and it had already accepted one of her shorts through its Texas Shorts initiative.

By chance—Fidell had just turned twenty-seven—she heard from both festivals the same day. SXSW first, informing her that she had been selected. "I was already like, 'Oh my God, this is amazing, this is the best day ever.' And then I got a call like three hours later from Sundance, and my brain kind of exploded." Sundance liked that she was a woman, Fidell explained, and also that she wasn't part of any filmmaking scene. "It made them feel like they had plucked someone out of the twenty thousand," she said, "instead of out of the twenty that had gone through the Labs. They were just like, wait, who are you? Where did you come from?"

Of the two events, Sundance would happen first. "I did not know what I was in for, in terms of the insanity of premiering at a major film festival," Fidell told me. "People say that your wedding is the most stressful, wonderful time in your life, but this, I think, took the cake. It was like being thrown into the lion's den." She had to buy a new outfit, do press, work with a publicist on flyers and posters, see to it that everybody got their flights, and make sure that the film arrived at the festival in exactly the way that it needed to. And then what, I asked. The credits roll, the lights go up, and twenty guys in suits just rush at you? "It feels that way," she said.

Fidell had already signed with an agent, who helped her field offers. By the time we spoke, four years later, she had written and directed a film for the Duplass brothers, was working on a third, and was in the process of moving into television. And if *A Teacher* hadn't gotten into Sundance, would she still be making films? "I'm sure I would not be," she said.

* * *

When James Swirsky and Lisanne Pajot set out to make *Indie Game: The Movie*, their documentary about the world of independent video-game developers, they realized that they should take a page from their subjects and, as they told themselves, "think like a fan." As the developers do, they would build an audience for their project as they *worked* on their project, by giving fans the kinds of things that fans desire—in other words, "by being very open throughout the entire process."

This was in 2010. Kickstarter was new, and so was the idea of following an artist along their journey. But Swirsky and Pajot were used to embracing new opportunities. The pair, who are married and live in Winnipeg, had teamed up in 2004, shortly after the advent of software like Final Cut Pro, which allowed you, for the first time, to edit video on your computer. They did lots of "crappy" corporate projects, they told me (including one about the benefits of soy-protein isolates), supporting themselves as they learned the new tools. So they were ready when, in 2008, the next big innovation came along: the first high-definition digital video cameras. The technology "revolutionized independent filmmaking," Swirsky explained. "Everything all of a sudden almost overnight looked a thousand times more cinematic. We just gobbled up these cameras," and "it was that momentum that we took into *Indie Game*," one of the first documentaries to use them. "It really was an opportunity for us as, like, two people from Winnipeg," Pajot said, "to make a film that *looks* like a film."

Swirsky had passed a couple of dreadful years in Vancouver as a video-game tester, a job "that sucked the life" out of him, he said, but the experience meant that he knew the world of game development, knew that exciting things were happening there: one- and two-person shops (as opposed to monster operations like Nintendo), games that told personal stories (rather than gorefests like *Grand Theft Auto*), digital distribution. Most of all, the way that designers were engaging in "open development" rather than jealously guarding their secrets—blogging, interacting with fans, putting out early builds, "leaning into the community that they're creating." Even as they chronicled that world, he and Pajot took their cues from it, especially since developers and gamers would themselves

be their audience and would be eager to engage with them. Over thirty-three months, the filmmakers wrote 182 blog posts; sent out more than thirteen thousand tweets; "tried to respond," as they would later write, "to nearly every email, Facebook post or tweet the film received"; and "produced and published, usually from hotel rooms on the road, eighty-eight minutes of extra content"—all while shooting, cutting, promoting, and distributing their first movie. "Looking back at it," they wrote, "it was probably an insane amount of work for two people."

By the time the movie premiered in 2012—at Sundance, where it won an editing award—Swirsky and Pajot had collected $150,000 in preorders, received more than three thousand screening requests, and built a mailing list of over thirty thousand names. In other words, they had mobilized a community. The question then became how best to monetize it. The distribution deals that they were offered in the wake of Sundance would have involved, in exchange for surrendering their digital rights, a small, money-losing theatrical run. Instead, they decided to self-distribute directly to fans.

The filmmakers knew that they had to move fast. They wanted to "build on the buzz" from the festival, as they would write, and they needed to stay ahead of the inevitable pirates. They put the movie up on iTunes as well as their own site, and they also put it up on Steam, the biggest distribution platform for video games. "Every doc has a core audience," they explained, "and every core audience has a spot on the Internet."

But audiences also exist in physical space. All those screening requests inspired the filmmakers to organize an in-person tour: not for money, but for the community. "There were so many people that had been following what we were doing," Pajot said, "and that felt that this was an opportunity to validate what they found meaningful in their lives." The tour was exhausting—twenty straight weeks on the road, over sixty Q&As—but the screenings, she said, would draw "tons of people on a Tuesday night to some random theater to come see this film and talk about it and feel closer to what they love." There were "lineups around the block," and meet-ups and parties afterward. And in the end, in part because the filmmakers signed a sponsorship deal with Adobe, the tour was also highly profitable.

The success of *Indie Game* has enabled the couple to be a lot more selective about the projects they do. (They also have a child now, a boy

who was two when we spoke.) Five years on, they had yet to commit to a second feature, and in the meantime they knew that the landscape had changed. Although they'd still attempt to build an audience while making any future documentary, they wouldn't self-distribute, since people don't buy movies anymore. Instead, they'd try to get a streaming deal. Now, they explained, it is all about Netflix.

* * *

Helen Simon makes movies of uncompromising frankness. Simon (not her real name) grew up in Cleveland with cultural but not financial privilege. After her parents divorced (her father, a PhD, ended up leading a marginal existence), Simon's mother, a writer and college professor, moved the family from New York City to find a cheaper place to live. Simon's movies chronicle the private lives of people in her Rust Belt town: a shy younger son growing up in a clan of factory workers, a mother struggling with a developmentally disabled child in the absence of adequate public support, a gifted teenage athlete whose dreams of escape are extinguished by injury. "All of my work," Simon told me, "deals with class."

Simon has always worked herself: starting as a babysitter at the age of eight; in restaurants, in bars, at a golf club; as a production assistant and production coordinator. For six months, she worked as a nanny. For a year, she lived off unemployment. For two years, she subsisted on grants. "There's always been this hustle," she told me. "I'll have five things going. I'll have five ways I think I can make money. I mean I'm talking about, really, like the last one being selling my gold."

Simon has wanted to be a filmmaker since the age of twelve. After high school, she went to Rutgers, then found a rent-controlled apartment in New York. When she was twenty-four, her father died and left her $20,000, all the money he possessed, which she used to make her first movie, a feature-length documentary. The film was shown on PBS—Simon was thirty by then—and she leveraged that credential to win admission to a leading film school. The latter was a wonderful experience. "The teachers were amazing," she told me. "I learned so much about articulating what I want to say. It formed who I was." Simon completed two shorts, one of which got into Sundance and garnered her a range of other accolades. She also graduated with $150,000 in student

debt, which four years later, at the time we spoke, had grown to $225,000. "I pretend it doesn't exist," she told me. "I pay my $59 a month and am really thankful for the education I got."

After graduation, Simon got a lectureship at Rutgers. Teaching had always been part of the plan; in film school, she had watched her teachers teach even as she took in their instruction. But within three years, she had given the position up. It was a wrenching choice. Simon loved the work, and she had a steady income for the first time in her life, but, she said, "it was crushing me": the teaching load, the long commute from Brooklyn. She had been working on a script for six years—it was going to be her first full-length fiction film—and she couldn't find the time to get it done.

So at the age of thirty-six, Simon returned to Cleveland, her first time living there since high school. And that's when things got really tough. Cleveland, she found, is not like New York: you cannot do the five-things hustle there, because there just are not that many things to do. She became poor, she said, "in a different way than I ha[d] been." She started babysitting again ("it's like, holy shit"). She borrowed a little money from her mother ("it just made me feel horrible—she can't afford it"). When some former students came to visit, she borrowed $50 to go out to dinner, because she couldn't let them see that she was broke. "It's just been a really, really, really, really challenging and scary time," she told me when we spoke about a year after the move. The writing had been going slowly, too. "I have a lot of issues with the Patti Smith narrative of the struggling artist," she said, "because I think it's bullshit. For those of us who struggle with anxiety no matter what, it's really hard to make work if you don't know how you're going to pay for food."

Simon's plan was to finish her script and send it to producers she had met through Sundance, then go back to Rutgers, where her job was still available. Longer-term, she hoped to secure an agent, work in television, and continue to teach—that is, if she could get her movie made. She had fielded some lucrative offers to direct commercials, and she had tried to make herself accept them, but in the end, she realized, "I just can't do it." She believed too strongly in living "a life that is the type of life I feel proud of." And how does she persist? "In the darkest times this year, I was like, there's nothing else I want to do. There's *nothing* else I want to do. It's just not a question. If it was a question, I wouldn't be where I am. But there's something really comforting and beautiful about just being

like, no matter what—no matter if I get the success that I want or if the rest of life is a struggle—this is all I want."

* * *

In 2006, a teenage girl who called herself Bree, and whose username was lonelygirl15, started posting a video diary on YouTube, which was then in its infancy. The diary quickly went viral.

In Los Angeles, a reality TV producer named Jenni Powell was shown the videos by a friend who was concerned about the girl. Powell immediately sensed that the videos were fake, and she thought that the whole thing was brilliant. Soon, her hunch was confirmed: *lonelygirl15*, a hoax designed to be exposed, turned out to be the first-ever scripted web series. As would become the norm within the genre, it quickly started generating contributions from its audience as fans began creating content of their own based on the show's proliferating cast and plot. But Powell wanted to be more than just a fan; she wanted to be part of the production team. So she created a parallel series to showcase her skills: *lonelyJewfifteen*, a parody of *The Diary of Anne Frank*.

The gambit, however tasteless, worked. Amanda Goodfried, one of *lonelygirl15*'s creators, reached out to Powell—because Goodfried wanted to be on *Powell's* show. Powell, in turn, was hired onto *lonelygirl15*. The move involved a significant pay cut, but Powell was repulsed by the work that she had been doing, on a reality show about a psychic (whom Powell could see was a fraud), and she was excited to tell stories in the new format, "where," she told me, "you're really, really close to your fan base."

Web series, Powell explained, are "hyper-interactive." With *lonelygirl15*, the creators posted five episodes a week but only stayed a week ahead in production, so they would have an opportunity, she said, "to integrate the fan stuff." What kind of fan stuff? "The audience was really good at picking out potential holes in our story," she said. "You're talking about a group of people—they love puzzles, they love picking things apart, people who will sit and watch your video, like, twenty-seven times, and be able to be like, 'at frame 27 at the two-minute mark she says *this*, and what does *that* mean?'"

Powell, who had worked on many other series by the time we spoke, regards her shows as games, her audience as players. She means,

specifically, video games, in which the users shape the story even as they experience it; more specifically, she means the subset of games known as MMORPGs, massively multiplayer online role-playing games, where many people play the game at once and do so in the guise of fictional personae. Like MMORPGs, web series trade on fanhood's ultimate fantasy: to step through the screen, in something like the way that Powell did herself with *lonelygirl15*, and enter the story.

For creators, the pace of production dictates constant work. Powell, who puts in twelve-to-fifteen-hour days, tries "to take some weekend time off now, because I'm getting older," but back in the day, she said, "it was go, go, go all the time. There were times I would just sleep at Felicia's [a fellow creator's] house for like, a week, because there was too much to do." And this went on for years. "You couldn't make it in digital if you didn't" work like that, she said. "The one drawback to this type of content is that it has to be coming out constantly, or you lose your fan base."

In 2011, Powell was approached by Hank Green, a prominent figure in the world of online video (and the brother of John Green, the young-adult novelist). Green intended to begin creating series based on classic books, and he wanted Powell to produce them. They began with *Pride and Prejudice*—which meant plotting out, to start with, the entire "story world" (the "universe," in movie terms) of which the initial series, *The Lizzie Bennet Diaries*, would only form a piece. Later installments centered on Lydia Bennet, Georgiana ("Gigi") Darcy, and, joining from *Emma*, Emma Woodhouse. All of the stories were transposed, *Clueless*-style, to Southern California; all of them were told as video diaries or vlogs (which made them easier to shoot); all of them, at Powell's insistence, used real actors, not YouTube personalities (a move that never works, she told me); and all of them encouraged copious and constant fan engagement. Lizzie Bennet would go on Twitter to complain about the paper she'd been stressing over in the latest episode. "Hang in there, Lizzie," people would respond.

How do you monetize a web series? "Ah," Powell replied, "the age-old question." The answer is: as many ways as you can think of. Merch (T-shirts, mugs), sometimes with lines from the show that the audience had turned into catchphrases. Ads. Brand integration. The Jane Bennet character was a fashion designer, so the producers partnered with a clothing company to make her outfits, which fans could click on pieces of and

buy. A DVD set, which was very popular, even though the content was free to watch online (people like to have a trophy). A pair of novels based on the show (which, of course, was based on a novel to start with). Each revenue stream, however, necessitates active management, so ideally, your team includes a dedicated salesperson. Powell makes money, she told me, but just enough to live in Los Angeles.

By the time we spoke, Powell was already moving on to other kinds of projects. Web series were the last thing. "Something else is going to come along that's going to be the next thing," she said, and she wanted to be part of *that*. At the time, she was "trying to crack the nut of Snapchat"—the company was beginning to develop original content—trying to figure out how to tell stories in one-minute segments. "I'm always looking to the future," she said. "What other tools am I going to have to play with?"

* * *

Brad Bell was also early to Internet video, but he had bigger things in mind. This was in 2008, when Bell was twenty-two. It was the era of Paris Hilton, he told me, and he realized that the most valuable commodity in the twenty-first century, as he put it, was eyes. "If you have enough people watching you," he said, "then you can really create an opportunity for anything." Bell, who grew up gay in Dallas, had escaped to Los Angeles after high school—a move he'd started plotting at the age of twelve—to make it big in showbiz. He'd always been a natural performer; now he thought, "I'm like a really interesting dip, and all I need are chips to deliver the dip to the people."

So Bell did something very few were doing yet. He created a persona—he called him Cheeks—and started posting videos on YouTube: sketch-like, satirical takes on politics and popular culture. "The goal was to build an audience," he said, "so that when I went somewhere and said, 'I want to do this thing—oh, and look, I have this audience built in, if you attach me to the project,' it would give me more leverage." Today, I observed, that's conventional wisdom. "That's the story of my life," he replied. "I spend five years banging my head against a wall, trying to get people to understand. And then it happens, and everyone goes, 'well *duh*, that's conventional wisdom.'"

Cheeks took off, but Bell's goal was not to be a YouTube star, as others were beginning to become. For one thing, the job involves a lot of

brand endorsement, which he didn't feel comfortable with. "You gotta drink the cola that is paying you," he said—have to shill for companies, in other words. "Which is ultimately how all entertainment works, I suppose, but there's something more personal about it when I'm the one having to hold a bottle." For another, the format favors quantity over quality, and Bell was interested in quality, and in gathering an audience that would appreciate it. "I want the respect and the admiration of people that I would want to hang out with," he said. "I don't chase the adoration of fools."

The year after Cheeks got his start, Miss California, Carrie Prejean, gave her famous "opposite marriage" answer at the Miss USA pageant. It was Cheeks's riff on the incident that drew the attention, via Twitter, of Jane Espenson, the big TV producer. ("I was like, this kid can write. This kid's making jokes that sound like my jokes.") So Espenson reached out to him. Both of them, Bell told me, were interested in doing something where they wouldn't have to deal with network interference or endure a long development process, so they decided to create a web series. The project they came up with was, as Bell described it, "gay *I Love Lucy*": a zany newlywed sitcom, but with two gay men, called *Husbands*.

Espenson financed production, Bell said, with "leftover *Battlestar* money." They made eleven single-scene episodes that were designed to also work together as a twenty-two-minute pilot. The idea was to have a proof of concept, something they could take to networks. *Husbands* quickly garnered critical attention, becoming the first new media program to be taken seriously as a television show: the first to be reviewed (favorably) by the *New Yorker*, the first to be included in the archives of the Paley Center, the former Museum of Television and Radio. It also developed a fan base. When the creators launched a Kickstarter to fund another pair of twenty-two-minute episodes, they raised the money in no time.

Before long, Bell and Espenson received an offer to develop the show for a network—exactly what they had been hoping for—but, Bell said, it "got sort of screwed up by our agents." Another network also made an offer, eight episodes with a total budget of $1 million, but the creators felt that that was simply not sufficient money for a decent job. (A single episode of *Modern Family*, Bell noted, costs about $3–4 million.) "We were high on success and momentum," he said, "so we thought, 'well this is a great offer, thanks guys, but we're just going to have to go somewhere

else for more money.' So we went around town with our show under our arm—and there was just no interest. At that point, the project is considered dead." As Espenson put it, "There's a universe in which that show was a massive hit and got picked up by Netflix, and [Brad] would now be running a big, established show." But that universe is not this one.

"It was really difficult," Bell told me. "I was really depressed, actually, for a couple of years. I mean real, real depression, not being able to get out of bed some days, just because I thought I had a good thing, and suddenly, nobody wanted it, and I just didn't know what to make of that or why or what to do next." Four years later, the outcome still haunted him. "Who knows," he said, "maybe I'll become Hollywood's It Boy in three or four years, and maybe I'll pitch it again."

* * *

Teresa Jusino was almost thirty when she decided that she'd had enough of trying to make it as an actor in New York. Jusino had grown up lower middle class in Queens and Long Island, became a theater geek in junior high, and went to NYU. The drama program there, she said, was pretty brutal. They "break you down to build you up again," she told me, plus "a lot of the teachers are also working actors, some of them working more than others, [and] you can tell when things aren't going well for them," because they're extra tough. After college, Jusino stuck it out for seven years, working mainly as an assistant for a theatrical publicist, who let her miss work for auditions. So many auditions. "I'm not a very castable type," she told me. "I am Latina. I'm fat." At one audition for *Twelfth Night*, she was up against "a tall, alabaster-skinned redhead" who thought the stage direction "*exeunt*" was part of the dialogue. The redhead got the part.

By 2009, Jusino was done with the stage. It was the early days of YouTube, and she and some friends decided to try to create their own content—a move that has become ubiquitous for actors, who understand that if they want to get a part, the smartest course is often just to write one. Each of the friends came up with a script, and the group selected Jusino's to produce. She had always loved to write, but this was "the first time I'd ever heard actors reading my words," she told me. "It was so amazing. Just seeing it on camera and watching the actors wrestle with it." So she threw herself into her writing, producing spec scripts and

publishing pop-culture criticism on a range of sites that would eventually include *Teen Vogue*, *Jezebel*, and *Slate*. Before long, Jusino decamped for LA, where she got a series of day jobs and couch surfed for the first two years.

By then, though, she was thirty-two. "Am I too old?" she asked a producer she met. "Is it too late for me? Should I go home?" No, was the reply, "but the second you know this is what you want to do, you have to just do it. And stick with it." Jusino set about making connections and gathering mentors—showrunners, writers—who looked at her scripts and helped her apply for fellowships. How did she meet these people? Through her journalism, through existing connections, sometimes just by going up to them. "I approach people who have something I want," she told me, "and that I have something in common with." At GeekGirlCon, she introduced herself to Javier Grillo-Marxuach, a writer and producer who has worked on *Lost* and other shows. "Hi!" she said, "I'm a huge fan of *Lost*, and also, I'm Puerto Rican. So how can I join the Puerto Rican writer mafia?" In LA, she said, you need to be direct. "People expect it, and they respect it."

At a networking party for women in the entertainment industry, Jusino met Celia Aurora de Blas, who had made a short film called *Incredible Girl* about an innocent young woman who ventures into the sexually charged environment of a dance club. Jusino asked to see the film and loved it, and the two of them agreed to try to turn it into something bigger. Picking up on a vibe in the short, Jusino contributed a "kink element," as she put it, of BDSM, something with which she'd had experience. She and de Blas began to do research, visiting dungeons around LA. The goal was to depict that world without stigmatizing or sensationalizing it.

The creators wrote a pilot script, outlined a full season, found a director, and launched a $50,000 crowdfunding campaign to shoot the pilot. In the end, they only raised a fifth of that amount. "The idea of kink was too much for a lot of people," Jusino said. Others who were part of that community did not want to be out in public. As for the networks and streaming services, she believed, once there's one show like hers, "there will be twelve, [but] nobody wants to be the first person to say yes."

Jusino and de Blas remained committed to the project, but by the time we spoke, Jusino had shifted her focus to other priorities. Her goal

was to finish two pilots and two spec scripts over the course of that year, so she could pursue representation with a body of work to show. She was also hoping to be hired for a writing staff; only now, five years after getting to LA, did she have enough contacts to make that prospect realistic, and she'd already had an interview for *SMILF*, a series with a Puerto Rican character. But Jusino was in it, she said, for the long haul. The people who don't make it, she'd been told repeatedly, are the people who stop. "I love telling stories," she said, "and I want to tell them for the rest of my life, and if I have to wait a little bit longer to get to a place where I can wake up every day and do that, that's what I'm going to do."

PART IV

WHAT IS ART BECOMING?

ART HISTORY

A rt may be eternal, but our ideas about it are not. What art is, what it's for—and therefore who the artist is—all these have changed. Art does not exist outside of time, and it does not exist outside of economics, either. Art is shaped by money, by the material arrangements under which it is produced—in plainer language, by the ways that artists get paid. When those shift, art shifts.

"Art" is not eternal: Art with a capital A, the notion of art as a distinctive form of activity—superior to other kinds of making, uniquely expressive of human truths, independent of established authorities and their official beliefs. Neither is the corollary notion of the "Artist": the creator as genius, as prophet, as hero, as rebel—speaking truth to power, dwelling with courageous freedom on the social margins. These notions—central, still, to the way that we think about art—arose at a specific time and place. That means that they can also end.

"Art as we have generally understood it is a European invention barely two hundred years old," writes Larry Shiner in *The Invention of Art*. When we speak of artifacts from other times and places—ancient Egypt, pre-Columbian Peru, medieval France—as art in our sense, he continues, we are engaging in a form of intellectual imperialism and/or presentism. What we now call art belonged, for most of human history, within the domain of religion, for it was religion that constituted the horizon of meaning, the limits of acceptable (or even thinkable) conviction.

Art expressed what people already believed, and they believed what religious authorities told them to.

Artists were considered artisans and served apprenticeships like any other craftsmen. They worked at the behest of other people, and they did what they were paid or supported to do. Patronage was not a gift; it was a quid pro quo. "Artist," "artisan": the words, by no coincidence, are virtually the same and were, before a certain point, synonymous. "Art" itself derives from a root that means "to make" or "craft"—a sense that survives in phrases like "the art of war" or words like "artful," in the sense of "crafty." We may think of Bach as a genius, but he thought of himself as an artisan. Shakespeare wasn't an "artist," he was a "poet," a denotation that is rooted in another word for "make." He was also a "playwright," a term worth pausing over. A playwright isn't someone who "writes" plays; he is someone who fashions them, like a wheelwright or shipwright.

The Renaissance began to modify the traditional pattern without fundamentally altering it. Art ceased to be exclusively religious. Artists ceased to be anonymous, and the best could even be lionized, as, most famously, in Giorgio Vasari's *Lives of the Artists* from 1550. But Vasari's artists—even Michelangelo—were not yet Artists. Creativity was still regarded as a power that belonged exclusively to the divine (hence the invocation of the Muse). As it had since Aristotle, "imitation"—the faithful copying of nature—remained the essential criterion of art. Art itself was not a unitary concept yet: there were "arts" but no "art." Indeed, Vasari doesn't even call his artists "artists"; his title, properly translated, is *The Lives of the Most Excellent Painters, Sculptors, and Architects*.

As for the meanings that writers, composers, and visual artists expressed, they remained, by and large, the established ones. Patronage was still in place, and so were traditional religious and political beliefs, not to mention traditional structures of power. Artists glorified God or flattered the monarch, nobleman, or wealthy merchant who was paying them. The commonplace that claims that "throughout history the artist has pointed out the injustices of society," as the writer Jonathan Taplin has put it, is simply misinformed. For most of history, artists did not engage in social critique, nor would it have occurred to them to do so. Those who railed against injustice, who sought to awaken society's slumbering conscience, were typically religious figures—prophets, visionaries,

heretics, reformers—for religion, again, was the framework of meaning, so it was within the realm of faith that moral and spiritual battles were fought.

* * *

Slowly, during the later seventeenth century, then rapidly across the eighteenth, a new paradigm emerged. It was then that the arts disentangled themselves from the crafts, the artist from the artisan. The term "fine arts," "those which appeal to the mind and the imagination," was first recorded in 1767. Art became a unitary concept, incorporating music, theater, and literature as well as the visual arts, a distinct realm of social activity not subordinate to any other. It became, what's more, a kind of higher entity or essence—"Art"—that made itself available for philosophical speculation and cultural veneration. As orthodox belief gave way before the skeptical critique of the Enlightenment, art emerged, for the educated or progressive class, as a sort of secular religion. Instead of looking in the Bible, you read Dostoyevsky, or listened to Wagner, or went to see an Ibsen play. Libraries, theaters, museums, and concert halls became the new cathedrals, places where you went to court the old emotions of catharsis, transcendence, redemption, and joy.

As art arose to its zenith of spiritual prestige, the artist arose along with it. For the first time, the idea of creativity began to be associated with human activity—specifically, with art—and imitation gave way, as art's defining concept, to expression. "Original" had meant "existing from the origin"—i.e., always, as in "original sin." Now it meant "new," and "originality" (a new word), the power of creating something new, became a central value in the arts. He in whom that faculty was most conspicuous, who possessed not merely talent but an extra spark of inspiration or creative force, was distinguished for the first time with the appellation "genius." In the new faith, the artist was prophet and preacher at once: solitary, like a holy man; inspired, like a seer; in touch with the unseen, his consciousness bulging into the future.

The new paradigm first emerged in full in the Romantic age, the late eighteenth and early nineteenth centuries, the period of Goethe, Beethoven, and Wordsworth. It reached its acme a century later in the age of modernism, the period of Picasso, Schoenberg, Nijinsky, and Proust. The

latter was the age of the artist as hero: defying conventions, demolishing taboos, imagining humanity forward into a new world. It was the age of the avant-garde, of art as revolution and of revolutionary art, the age of movements and of manifestos. For the philosopher Henri Bergson, creativity became humanity's highest good; for Nietzsche, who loomed above the time, art was "the essential metaphysical activity of man."

These developments did not take place within a vacuum. The emergence of Art and the Artist were components of the transformation that we call modernity. With them came the intellectual, another new type, not just a thinker but a thinker with a social mission. Came politics in the contemporary sense, not the struggle of princes and popes but a continuous debate, across society, as to the distribution and uses of power. Came revolution, the highest expression and inaugural condition of politics, beginning with the ones in America and France. Came democracy, with its new protagonist, the citizen. Came liberty of thought, expression, and belief.

Came, above all, the modern person: empowered, individual, free. The old structures, mental and social, had been broken open. Now you had the chance, and therefore the duty, to make your own life. You searched for values, struggled to develop your beliefs, worked your way toward mental independence. Personhood itself became a project. You didn't "find" yourself; you *formed* yourself. And you did so, preeminently, through art—a process that the Germans called "aesthetic education." "Privacy," the physical space to fashion interior space, was another new word: the modern person encountered themselves by encountering art, through silent reading and aesthetic contemplation, in the solitude of their own mind.

* * *

One more feature of modernity was inseparable from the emergence of Art: capitalism, which had become by then a fully fledged, world-conquering economic system. On the one hand, Art was born in principled rejection of the market. Art was above commerce and its vulgar considerations. In a world where everything was valued by its price and judged by its utility—where everything, in short, was a commodity—art was priceless and, in the best sense, useless (an idea captured in the slogan "art for art's sake"). Artists were above money and its compro-

mising entanglements. In a world that was coming to be dominated by yet another new type, the bourgeois—conventional, materialistic, "philistine" (a word that entered the language in 1827)—the artist was evolving into still another, his antagonist and opposite: the bohemian.

Yet it was capitalism itself that had enabled Art to emerge in the first place. Art could free itself from ideological control, could speak its own meanings, because artists were able to free themselves from economic control, to dispense with patronage by selling their work directly to the public—which meant, in practice, to the rising middle class, that progressive, educated audience that would make a religion of Art.

A key moment came in 1710 with the introduction in Britain of copyright. For the first time, authors were given the right to control the publication of their work, and thus a real chance to profit from it. And once anyone could make a living as a writer, many people tried. The eighteenth century saw an explosion of literary activity, and with it the debut of a new figure, the "hack writer" or writer-for-hire, whose characteristic milieu, named after the thoroughfare where London's publishers were concentrated, became known as Grub Street. It was the great Samuel Johnson, who had passed through Grub Street in his youth, who sketched a portrait of the new type in his *Life of Mr Richard Savage*, a memorial to his friend and companion in literary poverty. Johnson's Savage is a brilliant, neglected, drunken, tormented, disreputable vagabond poet, wandering the streets of the metropolis by night. Today we'd call him a bohemian.

Grub Street set the pattern for the economic life of artists under the new paradigm. The market, unlike the guilds and academies, welcomes all comers. With the emergence of the Romantics around the turn of the nineteenth century, being an artist—inspired, unconventional, free—acquired its enduring glamour. Everyone wanted to give it a shot, which meant the market was perpetually flooded. Too many artists, too little interest. Now, and only now, did the association of art and poverty begin, the "starving artist" become a stereotype. The word "Bohemian" appeared in our sense in English in 1848, not long before the Grub Street model spread to the visual arts, as the monopolies held by the French Royal Academy and comparable institutions were broken by figures like the Impressionists. Would-be geniuses of every species hastened to secure their garrets.

All this sheds a different light on the Artist's contempt for the market.

For many, the stance (or pose) was reactive or at best proleptic: you rejected the market because, or before, it rejected you. For others, it was simply the need to appeal to the public—the hated philistines, the masses—that rankled. Many of the leading Romantics and modernists were liberated for their great experiments by the possession of an independent income. Others perfected the art of sponging, cultivating patrons sometimes in the form of aristocrats or merchants of the more advanced variety (who were only too thrilled to be associated with the likes of Rilke or Yeats), sometimes in the form of publishers or dealers.

Still, these were just happy expedients. A paradox lay at the heart, and start, of Art. It couldn't live with capitalism, and it couldn't live without it. The market freed artists from Church and lord, but only by throwing them into the market.

* * *

The complex of ideas and attitudes associated with the second paradigm—art as higher truth, artist as sacred calling, genius, originality, bohemian authenticity—continue to exert their influence, albeit with attenuated force, to this day. As a practical matter, however, as early as the period between the world wars, with modernism still in full swing, a third paradigm began to take shape. After World War II, it came to the fore.

This was the age of the "culture boom." We built museums, theaters, and concert halls, founded orchestras, opera companies, and ballet troupes, all in unprecedented numbers. Foundations, residencies, organizations, councils—an entire bureaucratic apparatus arose to support the creation of art. The postwar prosperity was also raising up the world's first mass middle class, with leisure time, disposable income, and aspirations toward "improvement." Leonard Bernstein went on television to tell us about Mozart. Clifton Fadiman peddled the Lifetime Reading Plan.

Art increasingly became a public good. The National Endowment for the Arts was founded in 1965. The State Department funded cultural exchanges. Arts education diffused through the grade schools and high schools: music, "creative writing," "arts and crafts." Great Books courses multiplied in college curricula. The MFA had been invented in the 1920s. From 1940 to 1980, the number of institutions awarding grad-

uate degrees in studio art increased from 11 to 147. The University of Iowa had launched its famous Writers' Workshop, the first of its kind, in 1936. By 1945, there were eight such programs; by 1984, 150.

Art, in short, was institutionalized. And so the artist became a product and denizen of institutions—in other words, a professional. Now you didn't go to Paris to produce your masterpiece, then wait for the world to catch up with you. Like a doctor or lawyer, you went to university. You didn't burst from obscurity to celebrity with a single astonishing work. You slowly climbed the ranks. You accumulated credentials, sat on the boards and committees, collected your prizes and fellowships—built a résumé.

And you didn't only *go* to university; more and more, you made your living there. Higher ed was also booming: from 1949 to 1979, the number of professors nearly tripled, the number of students more than quadrupled, and colleges were opening at the rate of almost one a week. Already by the 1930s, the philosopher Irwin Edman was warning writers not to enter the academy. After the war, academic teaching became the norm among poets and novelists, as it would among painters and sculptors. Saul Bellow went to Paris in 1948, where he began his early masterpiece *The Adventures of Augie March*, but he went on a Guggenheim, and he came from an assistant professorship.

On the for-profit side, professionalization was less formal but no less unmistakable. The culture industry was booming, too: record labels and radio stations, publishing houses and magazines, galleries and theaters. Artists formed unions and professional associations, held conferences, and gave each other prizes, which are ways to certify not only the winners but also the organizations doing the giving. To the Oscars (1929) were added the Tonys (1947), the Emmys (1949), the National Book Awards (1950), and the Grammys (1959). The whole structure of professional intermediaries and handlers—agents, managers, publicists, bookers—assembled itself. So did the apparatus of official taste: critics, review sections, more prizes. The culture industry was not only burgeoning, it was also relatively stable, which meant that artists were able to enter into relatively stable relationships with their respective outlets. Being an artist became a career, with a variety of fairly well-defined career paths.

* * *

None of this, again, occurred in isolation. Across society, a general professionalization was taking hold. Intellectuals were becoming professionals (i.e., professors); scientists were becoming professionals (not the freelance amateurs of the eighteenth and nineteenth centuries, figures like Franklin and Darwin); businessmen were becoming professionals (or "managers"); athletes, journalists, cops. Universities were busy opening professional schools and thinking up degrees to offer. In 1956, Harold Rosenberg, the great mid-century art critic and wide-spectrum thinker, wrote an essay that made exactly this point. He called it "Everyman a Professional."

Professionalism is a kind of compromise. A profession is halfway between a sacred calling (a "vocation") and a job. Being a professional is halfway between abstaining from the market and being completely immersed in it. Institutions shield you from financial forces: it is the gallery, not you, that worries about profit and loss; it is the university, not you, that has to keep the donors happy. Nonprofit institutions hold open a space for noncommercial values—for the difficult, experimental, and foreign, for older traditions and genres, for the learned or highbrow. Entire forms retain their presence in the culture thanks to institutionalization: poetry, contemporary orchestral (or "classical") music, conceptual and other types of nonsalable art. Forced to pay their way, they'd largely disappear.

But institutionalization has its vices, no less than does commercialism. Going to art school, says the critic Dave Hickey, teaches you to be a student: a docile, obedient subject of psychological aggression. Working at a university, you learn to be an academic, to get along by going along. And while the profit motive is corrupting, protection from the market breeds its own, less obvious, corruption. The world of nonprofits is, as often as not, a realm of back-scratching, insiderism, petty territoriality, and unearned authority dishonestly exercised. Talent isn't necessarily rewarded any more than in the market. Instead of trying to entice the masses, you seek to please the boards, the councils—the committees. When disciplines are shielded from the judgments of popular taste, they tend to turn inward, encasing themselves in theory and jargon. Poetry, orchestral music, and high visual art: another thing they have in common

is that they all became abstruse, self-referential, and isolated from the public. You've needed, as it were, a PhD to understand them.

One of the purposes of professionalization is to limit access to a field, and thus to raise the earning power of practitioners by restricting their supply. You can't just call yourself a doctor; you have to go to medical school and pass a licensing exam. The arts have never worked that way, exactly, but the certifying mechanisms of the third, professional paradigm—the MFA programs, the publishers and gallerists, the fellowships and honors; in short, the gatekeepers—did, effectively, play such a role. There was never any shortage of artists who starved, but those who did achieve a modicum of success, who got through the gate, did better than before. The "middle class" of artists lived middle-class lives, with middle-class status.

Not surprisingly, they also drifted toward middle-class values. The avant-garde, notes the sociologist Diana Crane, became a "moyen garde," a middle guard, "with a well-defined niche in middle-class society." Artists were treated, precisely, like professionals. Indeed, writes the historian Howard Singerman, as professional training in the visual arts established itself in American universities, the figure of the bohemian was explicitly cast out, derided as "the artist of the scraggly beard" and "the half-mad Greenwich Village type."

Art became domesticated: for all of its pretensions, well behaved. Revolutionary rhetoric persisted in the arts (talk, after all, is cheap), but the age of revolution in the West was over. It had begun in 1775 at Lexington and Concord, and it ended in 1945 with the defeat of the revolutionary regimes of fascist Germany and Italy. In art, the age of revolution coincided with Romanticism, modernism, and the decades in between. But now, the basic form of government was settled. The avant-garde— the term derives from military use—was dead, because there were no longer any revolutionary movements, in or out of art, to be the vanguard of. (For today's professional artist, "Vanguard" is more likely to denote a mutual fund.)

Just as socialism was co-opted, in the postwar order, as social democracy, the "mixed economy" of regulated capitalism (which traveled in the United States under the names of the New Deal and the Great Society), so were the insurgent energies of modernism co-opted as good-for-society art, a kind of spiritual tonic for the body politic. Art, the cultural bureaucrats

liked to explain, was meant to "educate" us, to "enlighten" us, at most, to "challenge" us or challenge "the status quo"—but always within the established framework of liberal democracy and its consensus values. Hence the spectacle, in the public funding of "radical" artists and projects, of officially sanctioned dissent. Art became a member of the civic family, even if its role remained to play the wayward child.

Artists do not like to hear this kind of talk. "Professional" is a dirty word in much of the arts, and so, in many contexts, is "career." That certain arts are now the wards of universities is considered impolite to mention—even, or especially, at universities. Artists like to think they're still bohemians. Just as the second paradigm entailed a disavowal of the market, so does the third entail a disavowal of professionalization. Second-paradigm concepts and images—the artist as genius, hero, rebel, prophet—have persisted into the third, not as an anachronism, but as a necessary fiction. For artists, believing that you're not a professional is part of being a professional. Which doesn't mean that you're not a professional.

* * *

Artisan, bohemian, professional: three paradigms for the artist, rooted in three systems of economic support. Each entailed its own forms of training, types of audience, modes of exhibition, publication, and performance—its own understandings of art and of its role within society. There were overlaps, of course, between the different paradigms: long transitions, mixed and marginal cases, anticipations and survivals. But we have entered, unmistakably, the next transition. The professional model is on the wane, as the institutions that have undergirded it, nonprofit and for-profit, contract or disappear. A new paradigm is emerging. Its economic contours were the subject of the second and third parts of this book. Its implications for the nature of art and the artist are the subject of the next chapter.

THE FOURTH PARADIGM

I do not like to speak about the future, because I cannot see it. It's hard enough to speak about the present, let alone the past. Predictions are almost invariably wrong—in the realm of culture and society, embarrassingly wrong. What art will look like in the future, who can really say? What I offer in this chapter is a set of observations, necessarily provisional, about the characteristics that art and the artist appear to be assuming in our time—the new configuration that appears to be assembling itself. At the end, I attempt to give this paradigm a name.

The central fact about the situation of the artist now, as everything I've talked about thus far has shown, is that there's nothing left to shield you from the market. Whether or not you are "of" it (to return to a distinction that I used in chapter 2), you are definitely "in" it—all the way in it. Institutions won't protect you, as they did the professional. The bohemian option—abstaining from the market, at least where your art is concerned, and getting by in decent poverty on part-time work—is, in this age of rent and debt, no longer viable. Yes, artists have always had to worry about money, but they haven't always had to worry about the market per se: about operating within it, about becoming fluent in its terms and turns. That is what it means to say, after all, that artists now are one-man bands, that managing your career is like running a small business.

Operating in the market inculcates a market personality. In the digital age, the artist is unfailingly genial, cheerful, relatable. Think of Lisa Congdon, forever upbeat on her blog—*Today Is Going to Be Awesome*—even

as she spiraled into misery and burnout. Think of Lucy Bellwood, the cartoonist, perpetually vulnerable online, even as she feels like she is being picked apart by ants. Artists today are familiar, humble—regular folks. They need to engage their audience, so they are engaging. Their supporters look to them for inspiration, so they are encouraging. They are ingratiating and earnest, with no anger and no edge. And what is that personality—that stay-positive, self-effacing, smile-and-a-shoeshine personality—if not a commercial one? It is the shop clerk's smile, the salesman's hearty handshake, because the audience now is a customer base, and the customer is always right.

The market, as it has been altered by the Internet, has also accelerated the traditional pace of artistic production. Across the first three paradigms, artists were understood as needing to take their time—to work without interruption; to cultivate an inner stillness or focus or self-forgetfulness; to give themselves as long as it took to discover their voice, develop their craft, and refine their vision. The Internet, as we have seen, no longer makes that possible at any scale: not in the day-to-day, not in the larger sweep of your career.

And in a climate of instantaneity, where virality is king, everything must pop the moment it's released. There are few slow builds anymore, few sleeper hits. In Hollywood, writes Lynda Obst in *Sleepless in Hollywood*, "the opening number" (the first-weekend box office gross) "instantly brands the movie as a hit or flop." The typical book, I was told by Peter Hildick-Smith, a publishing-industry analyst, used to peak in its fourth or fifth week; now, with preorders, the bulk of sales is front-loaded into the first. "It was already clear, twenty-four hours in," writes John Seabrook in *The Song Machine*, "that 'American Girl' was not going to make Bonnie McKee a popstar." On the Internet, it's always now or never.

We can imagine the effect of such a climate on artists' nerves, not to mention their morale. The effect on art is also clear. Irony, complexity, and subtlety are out; the game is won by the brief, the bright, the loud, and the easily grasped. In music, for instance, I was told by Jeff Tayler, the guy who dissolved his emerging band because their label wanted "a reality show," technical proficiency or craft, whether of songwriting or of musicianship, is much less important today, in putting over an album or track, than concept or gesture or hook.

The question is not whether intricate, subtle, highly crafted art is better than art that only seeks to make a quick impression. Of course I think it is—but of course I would. I came of age with a certain set of aesthetic standards, ones that derived from the modernists. But good and bad in art are moving targets. A different generation, raised with a different set of standards and models, a different set of expectations, a different nervous system—raised with the art of the digital age—will have a different sense of good and bad. Subtle will be "boring." Long will be "verbose." Complex will be "jumps all over the place." Irony will be "I didn't get it." When I paraphrased Tayler's point to Jesse Cohen of Tanlines, the indie rock duo, he responded like this: "I don't care about music being technically accomplished. The thing I like about music is the feeling it makes me feel. Maybe you're getting more things that are hitting you on a more visceral level, like EDM—like, pummeling you—or more pop music, but that doesn't bother me."

* * *

The Internet, needless to say, did not give birth to the kind of art that solicits a more purely visceral response, or appeals to the lowest common denominator, or is only built to last a day—in short, to entertainment. But it did force everything onto the same playing field to compete on the same terms, which heavily favor such work. Before the Internet arrived, we read novels in books and stories in magazines, listened to music on the stereo or radio, watched movies in theaters and shows on television sets, and looked at images in museums, galleries, or art books. Each form had its separate formats, and moving from one to another was a relatively time-consuming (as well as brain-adjusting) process. Now we take in all the forms in a single place, and we can switch among them in the time it takes to tap a finger.

The Darwinian attention derby happens, not just between the different arts, but also within them. The jazz recording competes with the pop song, the *New Yorker* story with the listicle, the indie movie with the YouTube video. Before the Internet, someone who was reading the *Paris Review* was unlikely to suddenly stop and pick up a copy of the *National Enquirer*. They didn't have one, and they probably had never even opened one. But now the equivalent move, as the Internet tugs forever at our sleeve, is always an imminent possibility.

Not only must everything compete with everything else, everything must compete, full stop. One of the principal ways, as we have seen, that the culture industry supported more subtle or thoughtful or artistically ambitious work was through the practice known as cross-subsidization. The entertainment paid for the art: the thriller supported the poetry, the pop star supported the girl-with-guitar, the blockbuster floated the art-house division. Magazines and newspapers were themselves a form of cross-subsidization, with the fashion features or the sports reporting making possible the fiction or the deep investigative piece. So were albums: the "single" up front, for the radio play, the "deep cuts" for the art and soul. But now it's every tub on its own bottom. Everything has been "unbundled"; every song, every story, every unit must pay for itself. No more deep cuts.

When the market is everything, everything gets sucked into the market—a process for which the Internet has proved a ruthlessly efficient engine. Jessa Crispin founded *Bookslut*, the literary site, in 2002. The Web was different in the early days, she told me, but "it became corporate very fast. Now we're in this place of constantly auditioning for work. And it's very insidious. It keeps happening. Everything that is original and interesting and new is immediately taken over by this kind of job-interview feeling." Crispin mentioned Tiny Letters (a newsletter service that began in 2010), which are, she said, "the new blogs. Except the first person who got a book deal from their fucking Tiny Letter, *immediately* after that, you saw everybody reposition their Tiny Letter as a book proposal. It just became professionalized in a second." The result, she explained, is that "there's no literary underground anymore. Everything is just responding to the mainstream."

We can go further. Not only are works of art increasingly commercialized, of necessity, in their own right, they also increasingly function—as loss leaders, marketing platforms, branding devices—as merely one component of a larger commercial endeavor, a cog in the commerce machine. The phenomenon begins with artists themselves and their one-man-band small businesses. The music critic Jon Pareles has remarked that for contemporary pop stars, continuously active as they are on every available channel, music is "just one part of a pool of cultural content: aural, visual, textual, entrepreneurial." But the observation is valid not only for pop stars, as we have seen. For the ordinary artist, working a miniature version

of the same hustle, the situation is comparable. Around your comics or stories or songs, you fashion a portfolio of goods and services that you can actually charge some money for, plus a cloud of images and audio and text to draw and keep your fans. You build up a persona and a narrative. All of which changes how art is positioned, what it is and means. The pool-of-content thing, Pareles remarks, has eroded "the idea that a song is a thought-out, carefully distilled utterance"—something that is meant to stand alone and apart, to exist for itself, to make its own statement and create its own context—rather than another item, precisely, of "content." The work of art has been subsumed within the operations of The Artist, Inc., the Brand Called You.

And these larger commercial endeavors also get a good deal larger. We've looked at branded art in three different contexts: in music (rappers rhyming for Red Bull), in writing (Wattpad authors teaming up with Hollywood), and in visual art (Amalia Ulman and Airbnb). Branded art is different from commercial work (artists making extra money, for example, shooting videos or writing copy for a business—work they do not put their names on) as well as from sponsorship deals (corporations paying for the right to associate themselves with something you've already done). With branded art, your name is definitely on it, but the context is the corporation and its marketing campaign, which shapes, if not determines, the nature of the work you do.

Artists, perhaps inevitably, are increasingly at home with such arrangements. When practices change, norms change, not the other way around. Remember that Ashleigh Gardner at Wattpad, Samantha Culp at Paloma Powers, the creative agency, and Jane Friedman, the publishing consultant, all remarked that young creators do not have a problem now with branded art. In just the dozen years or so that he had been involved in music, Jesse Cohen said, he'd seen how attitudes had shifted. It was okay now to think about money; to think about marketing; to get into licensing, branding, and sponsorship.

You can be "in" the market without being "of" it, but can you be completely in it? J. P. Reuer founded the program in Applied Craft and Design at the Pacific Northwest College of Art, which integrates entrepreneurship with creative practice. Reuer worries, he told me, that artists are starting to think about the audience, think about how people might respond, too early in the process of creation—far earlier than they used

to, and far earlier than they should—a circumstance, he said, that inhibits their ability to make truly original work. Austin Kleon, the author of *Steal Like an Artist* and *Show Your Work!*, put the matter like this: "Being an artist and being a salesman, they are at odds with each other. Once you start doing the selling, when you sit down to actually make the work, there's some little bit of you that thinks about selling." Marketing, he went on, "wraps around your brainstem. You start thinking in terms of calls to action and, you know, what's the value prop." Still, he concluded, "Every artist is doomed to his time. You've got to work with what you've got."

* * *

Reuer called attention to the audience, and the audience is key to what's been happening in art. A great audience, Fran Lebowitz once remarked, is more important for the creation of great art than even great artists are. Great audiences create great artists, she explained, by giving people the freedom to take chances. "When people take movies seriously," the screenwriter and director Paul Schrader (*Taxi Driver*, *Raging Bull*) has said, "it's very easy to make serious movies."

If the central fact about the artist now is their immersion in the market, the central fact about the audience is the emergence of the fan. A fan is not simply a reader, listener, or viewer. As the origin of the word implies ("fan" is short for "fanatic"), a fan is a ferocious devotee. Fans have existed for as long as celebrities have—each implies the other—which means since the early days of mass media at the beginning of the nineteenth century. (The first celebrity, it's sometimes said, was Byron, who burst upon the scene in 1812.) But fandom used to be a relatively disempowered state. Think of the iconic images of Beatles fans, weeping and screaming in helpless thrall to their idols. It also used to be a relatively passive one. There just was not that much that you could *do*. *Star Wars* came out when I was thirteen, and everyone was crazy for it, but your only options, as a fan, were to go to the theater and see it again, talk about it with your friends at school, or get the action figures.

The Internet, of course, has changed all that. No longer is the rock star up there on the stage, the movie up there on the screen, remote and unreachable. Now you can talk to them, instantaneously and in public, and, what is more, they're talking back. In fact, they and every other artist

and production now are constantly imploring you: to like, tweet, rate, follow, comment, share, subscribe, preorder, buy the merch, visit the website, join the mailing list, become a patron—to pay attention, for God's sake, and if possible help out. Fandom now is active, even hyperactive; the fan's as busy as the artist is. And now the fans are in the driver's seat; now it is the artists who are weeping and screaming with need.

Fandom—how to stimulate it, how to tend it, how to monetize it—is at the center of the conversation in the arts today. The idea, always, is interactivity. With *Orphan Black*, BBC America invited fans to create art for the marketing campaign, as part of the marketing campaign. Shows and movies set up "second-screen experiences"—things to do on your laptop or phone while or after you watch. As Jenni Powell, the web series person, remarked, the viewer has become a player, a logic that extends to every form of fan engagement and to every work or artist that seeks to invite it—which means that the work of art, with all the online structures that typically surround it now and constitute its presence on the Internet, has become a kind of game, an environment to be navigated rather than an object to be contemplated.

No better illustration may exist of this logic at work than the museum selfie—museumgoers snapping pictures of themselves with famous works of art—which institutions now encourage. The viewer, quite literally, enters the frame, reframes the work around themselves, inverting the traditional hierarchy of reception. Now the *Mona Lisa*, say, exists in relation to you, not the other way around. Instead of seeking to be overwhelmed by a transformative aesthetic experience, the Romantic/modernist ideal, you retain control—as in a game. Then the image gets posted online, where the game continues.

In truth, fans do not need artists or corporations to organize them. Fandom is so powerful today because it is, with all of the tools that the Internet has put at its disposal, self-organizing: hashtags, fansites, Facebook groups, conventions; blogs and podcasts; fan-initiated house shows and reading series. When Jenni Powell and her collaborators were creating *The Lizzie Bennet Diaries*, they planned to reach out to the Jane Austen community, but the latter got wind of the series and deluged them with interest (and opinions) before they even had a chance. When the creators of *lonelygirl15* put up a tenth-anniversary episode, eight years after the series ended, with no advance notice and no publicity, it got nearly

two million views in twenty-four hours. Fandom is belonging and mean-
ing, in a world increasingly short on both, with the book, band, film, or
show no more, at times, than a point of departure.

* * *

To say that the audience for art in the digital age is organized into fan
communities, taste communities, is equivalent to saying, in business
terms, that it's divided into niches. Niche, of course, is the first com-
mandment of Internet marketing: thou shalt have a niche. "Everyone's
niched out now," Chris Rock remarked a few years ago: everyone is
reaching one specific audience on one specific set of channels by deliver-
ing one specific kind of art. Which means—the second commandment—
that everybody has to have a brand. The concept of a personal brand,
the "brand called you," arose in direct response to the emergence of the
Web, having first been enunciated in 1997. The brand is the corollary of
the niche. The audience is the niche; the artist is the brand. You reach
the first by having the second.

The hallmarks of a brand are consistency and recognizability. What
makes Coke a brand is not just its logo and name, but the fact that every
time you open a can, you know exactly what you're going to get. Once
you find a niche, you're expected to stay in your niche. That is one of the
reasons that the rise of the fan—the empowered, self-organized fan—is
so significant. Fans are customers, but customers who are especially well
positioned to make demands. Give them what they want—stay in your
niche, be true to your brand—or see your "business" disappear. That
circumstance becomes not less the case but more so if you've carved out
your own micro-niche by aggregating your thousand true fans, because it
means that the line between you and your customers is unusually direct—
you're constantly soliciting their continued approval, and they're con-
stantly telling you what they think—and because you can't afford to lose
too many of them.

Not every artist whom I talked with felt this kind of pressure, I should
say. Marian Call, who built her brand as a singer of upbeat songs about
geeks and geek culture, told me that her fans have been willing to follow
her as her material has gotten darker. But most of the artists who spoke to
the issue did feel so confined. And even when they shifted or expanded
their work, they did so under the rubric of niche. Sammus, the former

"nerdcore" rapper, was attempting to rebrand herself as "Afro-futurist." Lucy Bellwood, who became known for drawing comics set on sailing ships ("boats are kind of my brand"), was now referring to herself more broadly as an "adventure cartoonist." The suits used to package you; the Internet expects you to arrive self-packaged.

Branding is the way that businesses work, but it's pretty much the opposite of the way that artists were long thought to work. The artists of the second, Romantic/modernist, paradigm (and the idea persisted into the third) were meant to explore, to evolve, to avoid becoming stale or descending into self-parody by continually reinventing themselves— throwing everything out every once in a while and beginning from scratch. (Think of Picasso or David Bowie.) The artist-as-rebel was supposed to rebel, periodically, against themselves, as well—against the things they thought they'd learned, the artist they'd become.

They were also meant to rebel against the very elements that constitute a niche: genres, formulas, conventions, expectations. The most interesting art (but here are my biases at work again) has always been done between genres, against genres, with blithe indifference to genres. Any art that's worth its salt is too individuated, too much a genre of one, to be tucked inside a niche. "Literary fiction," for example, is not a genre so much as a name for the absence of one. Pick a "literary novel" at random, and—unlike with a detective novel or a horror story—you have no idea what you're going to get. Nor if you love, say, Don DeLillo or Jesmyn Ward, can any algorithm tell you whom else you might love. The indie director Jeff Baena (*Life After Beth*, *The Little Hours*), who makes odd, generically hybrid, tonally complex little films, has remarked that he tries to avoid putting labels on his work (e.g., "comedy"), because they invariably create the wrong expectations. But it's tough, he said, because "everything is marketing" today, "and so everything is labeling, everything is compartmentalizing."

Niche is also antithetical to the way that audiences used to conceive of themselves, and that art was conceived in relation to them. Niche compartmentalizes *us*, as well. It teaches us to think of our response to art in narrow terms: I'm into Celtic heavy-metal; I'm into debut fiction by young women writers. Even if you inhabit a variety of niches or move among them in succession, the terms are still narrow, because each niche is narrow, each one speaks to only a slice of your selfhood. Richard Nash,

the digital media strategist and former head of Soft Skull Press, has spoken of "tribe surfing" as a way that people engage with books today, and "tribe" is all too apt. Niche segments us into teams, into affinity groups and identity groups. Back when there were only twelve television channels, according to Chris Rock, "everybody had to appeal to everybody." In loftier terms, the concept of Art, as it arose in the eighteenth century and persisted across the nineteenth and most of the twentieth, was understood to constitute a universal language, speaking not to our differences but to our commonalities.

Those ideas—universality, common humanity—have been attacked, more recently, as concealing a predictable set of biases. "Universal," until a few decades ago, meant "Western," or "white male," or "heterosexual white Protestant male." But it doesn't have to. If anything, during the age of Art, artists from marginalized groups insisted on asserting their right to stake their own claim to universality: to speak *from* their particular experience but *to* us all. Rock's examples of those everybodies who appealed to everybody—and by "everybody," he did not mean white people, he meant everybody—included Richard Pryor, Redd Foxx, and James Brown. "Who the fuck's blacker than James Brown?" he said. "Nobody's blacker than James Brown."

But now the tribe, the group. Hence the importance of that fact that so much of our experience of art today is shared, and shared, precisely, with a group and in a group: at the art walk and the film festival, on Goodreads and Instagram, through the museum selfie and the book club. Art that is aimed at a group, at individuals self-constituted as a group— art whose reception is shaped by group dynamics, whether online or in person, that drive toward consensus—will affirm the value and the rightness and the glory of the group. Art directed at a tribe becomes, inevitably, tribal art.

Jessa Crispin, the founder of *Bookslut*, is also the author of *Why I Am Not a Feminist: A Feminist Manifesto*. Not long before we spoke, she had written a negative review of a book by a female novelist. The novelist wrote to complain—nothing new for Crispin there—but not in the usual terms (i.e., as Crispin put it, "you're an idiot and you don't know what you're talking about"). This time, Crispin told me, "It was an accusation of betrayal. That I had betrayed her, and the sisterhood. And she thought I was an ally, etc., etc." That kind of attitude, Crispin remarked, is

increasingly common. "The genuine work of art," wrote the critic Harold Rosenberg in 1948, "takes away from its audience its sense of knowing where it stands in relation to what has happened to it"—takes away, that is, the accepted versions of history, the official accounts of identity. "'[A]rt' means 'breaking up the crowd,'" he added, "not 'reflecting' its experience." Philip Roth was attacked in the 1950s and '60s for depicting Jewish characters in a sometimes-unflattering light—for making it more difficult for the Jewish community to see itself as it preferred to. But he wasn't attacked by other novelists.

Given the fact that a lot of niches do indeed bear the names of identity groups (e.g., "LGBT Muslim science fiction," Orna Ross's example of the kind of micro-genre that younger readers are interested in), the suspicion arises that the latter are the product of the former—that niche precedes identity—as much as the reverse. In other words, that the reason we find ourselves divided today into a myriad of micro-identities (or one of the reasons, at least) is that that is the way we are marketed to. If there are riches in niches, as the business gurus like to say, there's a lot of money in identity. Whereas there isn't much money at all anymore in trying to appeal to everybody. So people make art for identity groups, identity niches—which reinforces the importance, the existence, of identity groups. We learn to think of ourselves in those terms—as members of a team, of a little "us" against a great big "them"—because the culture is telling us to, and the culture is telling us to because the market is telling *it* to. "Politics is downstream of culture," as Andrew Breitbart, the conservative publisher, infamously said, but culture is downstream of the market.

"Breaking up the crowd": art, meant Rosenberg, speaks to each of us as individuals. "Along this rocky road to the actual," he said, to a truer relationship to reality, "it is only possible to go . . . one at a time." To adapt a formulation of James Baldwin's, art is meant to tell you, not *what* you are but *who* you are. Or so, again, we used to believe. The art of modernity—of the second paradigm, and to a lesser extent of the third—was created for the modern self. It was a self that was predicated on, and jealous of, its separateness and uniqueness, that defined itself, with a stubborn insistence, against the group. The word that captured such a self was, precisely, "individual," a term that was coined, in its modern sense, by Rousseau, perhaps the original modern individual, in

the 1760s. But the modern self, it seems, is passing from the scene. The new self—let's call it the digital self—defines itself through affinity with the group. It is networked, not solitary; public, not inward. It wants to know who it's like, and who likes it.

* * *

The power of the Internet-enabled audience is nowhere clearer than within the realm of criticism. One of the most conspicuous aspects of art in the digital age is the eclipse of expert opinion and the rise of populist alternatives: blogs, ratings, comment threads, audience reviews; Twitter, Facebook, YouTube. The professional critic—that elitist, that gatekeeper—embodies everything that is felt to have been wrong with the old system.

As a professional critic myself, I won't pretend to be impartial here, of all places. By the same token, I have a decent sense of what professional criticism has to offer. Critics have certainly sometimes been elitist in all the wrong ways, reinforcing social biases by ignoring artists from marginalized groups. They have also certainly sometimes been hidebound, failing to recognize original talent. But the most important thing to understand about the professional critic is that, if they are any good, their opinions are not just personal preferences or instantaneous reactions. They are, as people say, informed—which means that they have *been* formed—by a knowledge of the art: of its history, its methods, its possibilities, its peaks. (That is why some of the best criticism has been written by artists themselves.) The professional critic is a lot less likely, say, to anoint the latest literary sensation as the next Tolstoy, because they've read Tolstoy. Critics speak for themselves, but they also speak, or try to speak, for something larger than themselves: for the values and ideals, the past and the future, of the art itself.

Which is why the best professional critics, far from smothering original talent, are often the first to acknowledge it, and often play a crucial role in promoting it—as Clement Greenberg did for Jackson Pollock, Arlene Croce for Mark Morris, Lewis Mumford (many years after the novelist's death) for Herman Melville. They can recognize the value of experimental work—work that mystifies or enrages the audience—because they discern its deeper continuities with older achievements. They trust their own judgment, which means that they're willing not only

to stake a bold claim but also to change their minds, to be surprised and educated by the new. Popular opinion tends to be conservative; revolutions in taste are almost invariably led by experts. "Critics with dazzling track records," Dave Hickey, the art critic, writes, "were willing to put their reputations on the line, take chances, and make public bets on the value and longevity of problematic artworks." Expert criticism constitutes a counterweight to market forces. Critics don't just discover original talent; they also often sustain it through years of audience neglect. "There are generations of artists," writes Hickey, "for whom a consensus of professional respect could carry them through times of no money better than money could carry them through times of no respect."

I am not suggesting that the public should bow down before the critics. Quite the opposite: without the balancing effect of popular taste, experts tend to drive the arts into dead ends of abstrusiosity, as has happened to those forms that have retreated (or been ousted) from the market—poetry, orchestral music, conceptual art. "Esteem," says Hickey—professional respect—needs to enter into contact with "desire." But desire—what the audience wants—should not be worshipped either. Amateur opinion, which rules the Internet, is not the pure, unsullied voice of Democratic Man. People tend to like what people like them like. They tend to follow their herd. (I am no exception, especially in arts I don't know very much about.) And in the age of mass communication, the herds tend to go where the marketers tell them to go. But since the marketers give us what they think we like, what we have already liked, what's been focus-grouped and audience-tested, feeding our preferences back to us, the herds tend to travel in circles.

This is all the more true in the digital age—the age, that is to say, of metrics. The Internet has given us the blog, the comments section, the listener review, and more—forums where amateur voices, sometimes quite insightful, really can get a hearing. But how many people are listening? By the hundredth Amazon review, or the five hundredth comment on YouTube, who is still paying attention? Whereas metrics count everyone, which is why it is to metrics—how many people are reading or viewing or listening to what, and which people, and for how long, and how many times are they sharing it, and how does all that correlate with other preferences—that the producers and distributors of culture are paying attention. Labels sign artists according to metrics. Presses are picking

up writers from Wattpad according to metrics. Netflix created its very first show, *House of Cards*, and has been canceling idiosyncratic artist-driven comedies like *Lady Dynamite*, because of the metrics. Metrics are a lethally efficient way of aggregating audience taste, and therefore of reinforcing it. You can't like something if you never see it; if you see it all the time, because the metrics tell Spotify or Amazon to serve it to you, your chances to like it go up. The viral becomes more viral; the popular becomes more popular. What would've been a minor swell turns into a tsunami.

I was struck by something I was told by Ashleigh Gardner, Wattpad's head of content. I had asked her why the platform doesn't just start its own publishing arm instead of connecting its popular writers to places like Simon & Schuster. "We're a tech company," she responded. In other words, Wattpad isn't in the business of trying to lead or shape or educate audience taste, the way an adventurous editor might, or even anticipate it, the way that a Hollywood studio might. It is in the business of measuring it, of providing a platform where the audience can talk to itself, and then of telling it "from a data perspective," as Gardner put it, what it is saying. ("I can look at what are the most popular horror stories being read by people under the age of sixteen in Ohio," she told me.) And since Wattpad's writers, who grasp what the task involves, are undoubtedly writing the kinds of stories that Wattpad's readers like—the kinds of stories that sound like Wattpad stories—amateur opinion and amateur creativity merge into a single seamless feedback loop.

Which is fine, if you think that quality is best determined by the plebiscite of popularity. I asked Mark Coker, the founder of Smashwords, whether people would really be content to do all their reading on Kindle Unlimited, Amazon's equivalent of Spotify for e-books, which contains about 1.3 million mostly self-published titles but excludes the catalogs of the major commercial presses. Coker acknowledged that "the vast majority of those million-plus books are probably crap," but, he said, the platform still enables readers to "discover amazing five-star authors." I used to be a college professor. "Five-star author" is about as impressive to me as "straight-A student." People instinctively grade on a curve; in any sample, some percentage of items will inevitably get the highest mark. A five-star author is merely an author who's better than most of the others. That's not the same as saying that they are actually any good.

People eat what's put in front of them. There are always ten movies in the top 10, and always one candidate who wins the race.

Or perhaps you think that quality is entirely subjective, and that any attempt to argue otherwise is necessarily elitist, a covert expression of prejudice. But diversity is not democracy. The fact that standards used to be biased against women and people of color, or still are, is not a reason to discard the very notion of standards. It just means we need better ones. Liberty Hardy, a blogger for Book Riot, one of the most popular sites for book enthusiasts, praised the Internet's democratizing effect on reading culture. Unlike the elderly librarians who formed her early tastes, she told me, the Internet says that "it's okay to love what you want to love. If you want to read romance novels, there's nothing wrong with that." Nor is there. But reading romance novels is not the same as believing that they are great literature. Hickey, not only a brilliant and versatile critic but the farthest thing possible from a snob, had this to say about himself: "I have probably spent roughly three times as many hours in front of old *Perry Mason* episodes as I have spent listening to Mozart and reading Shakespeare combined. This is not a happy statistic, but there it is." Hickey loves *Perry Mason*, but that doesn't mean that he thinks that it's better than Mozart or Shakespeare. He understands, as he puts it, that "some things are better than others."

He also understands that tastes are aspirational. "From a data perspective," Hickey likes *Perry Mason* three times as much as Mozart and Shakespeare combined. But he isn't looking at it from a data perspective. The flesh is weak. Sometimes—a lot of times—we just want to slump into the couch and look at *Perry Mason*. Yet we care about Mozart and Shakespeare, or whatever it is that we most esteem (not desire), infinitely more—care about its continued existence in the world, because we want it to be there when we're ready for it (and we want it to be there for others, as well). But that isn't the kind of preference that the Internet can see, or metrics count.

* * *

Yet the ultimate expression of the newfound power of the audience lies not in amateur opinion, amateur criticism, but in amateur creation itself: at participatory events like open mics, live storytelling, and improv comedy, all exploding in popularity; on platforms like TikTok, SoundCloud,

and so forth. Here the approach of fan to artist, their new intimacy and proximity, reaches its vanishing point. The fan becomes the artist. (Indeed, a lot of amateur creation takes the form, precisely, of fan art.) And amateurism, what is more, is not just practice now but ideology. One of the presiding commonplaces of our age, to deny which is to commit a kind of thought crime, is that everyone's an artist.

This is not an idea that would have occurred to many people during the age of the second paradigm, when artists were considered special souls. In fact, it would have seemed ridiculous. Nor would it have made a lot of sense (any more than saying that everyone is a doctor) within the context of the third, when being an artist was understood to involve, at least, a special form of training. (During the first, when artists were artisans, it would have been like saying everyone's a blacksmith.) That it seems no more than common sense today can be traced to a number of sources. One is the spirit of radical egalitarianism that took hold in the 1960s. Authorities were being challenged, hierarchies overturned, across society, and the arts were no exception. Artists took their work to the streets. Performers "broke the fourth wall." The distinction between "high" and "low" was discarded; the distance between artist and audience, abolished. The notion of the artist as a special kind of individual, even as a certain kind of professional, was rejected as elitist.

Like that decade's utopian impulses writ large, these developments left a deposit in the collective memory, as a set of ideas and aspirations, but otherwise largely faded over the ensuing years. It was left to a different group of radicals to create the tools that would give the era's egalitarian ideals lasting form—or so, at least, they believed. This was the circle of tinkerers and hobbyists who gathered around Stewart Brand, publisher of *The Whole Earth Catalog*, in Menlo Park, California, at the heart of the region that would soon become known as Silicon Valley. Some of them formed the Homebrew Computer Club, two of whose members were Steve Wozniak and Steve Jobs. It was from this milieu that the personal computer, conceived as an instrument of individual liberation, was born. The idea, as Brand would later say, contrasting Berkeley in the '60s to Stanford in the '60s, was not "power to the people" but "just power to people."

If that promised utopia—decentralized, egalitarian—has failed to materialize, that is due in part to the fact that bringing power to people

(as opposed to *the* people) turned out to be an incredibly lucrative business, one that has come to be dominated by a handful of mammoth corporations. And one of those corporations, the one that was founded by the two Steves, figured out that the best way to get us to buy its expensive machines was to convince us that we're all creative geniuses with something unique and wonderful to express. "Producerism," we can call this, by analogy with consumerism. Consumerism doesn't just mean buying stuff; it means constructing your identity around the stuff you buy. What we were now persuaded to buy, above all, were the means to produce, to create.

It isn't that we hadn't had tools to make art before Apple came along. It's that now it seemed easy, and the world was telling you that you could do it, and what's more, that you should. In Apple's mighty wake came the armada of little boats that comprise the "creativity" industry: the books, the coaches, the conferences, the workshops, the videos, the classes. The adage used to be that you shouldn't try to be an artist unless your life depended on it. Now it became, why not give it a shot? From 1991 to 2006, the number of bachelor's degrees conferred in visual and performing arts increased by 97 percent. (Over the previous fifteen years, it had increased by 0.1 percent.) The idea that everyone is an artist had originated as a revolutionary assertion. Now it became a marketing slogan.

* * *

So why shouldn't we believe that everyone's an artist? Because words matter. Everyone isn't an artist for the same reason that everyone isn't an athlete. We are all born with some degree of athletic ability, just as we are all born with some degree of creativity, but we aren't all born with very much, and we don't all put in the work to develop what we have. To claim that everyone's an athlete would be to insult the people who actually are: who have gotten up every day of their lives, and trained and sacrificed and suffered, to earn the name. But nobody would claim it, because the notion is absurd. Not so with artist, where everybody seems to feel entitled to the honor, as if by a kind of human right. "Everyone's a fucking artist," as the film director Mitchell Johnston put it. "Steve Jobs and Generation X weaponized that term. 'Think Different' and putting the fucking Beatles and Albert Einstein on those fucking billboards was a very canny way of letting us all think that we define our own reality. *My*

playlist and *my* point of view and *my* art." If anything, as we saw, actual artists (and Johnston is no exception) are typically reluctant to claim the title, because they respect it so much—and also, now, because it's been so cheapened.

Johnston acknowledged that rejecting universal artisthood can come off as elitist. But is it? Asserting that only certain kinds of people *can* be artists (certain genders or classes or races), or make better artists— that's elitist. Asserting that only certain people *are* artists—that's just facing facts. "Everybody is creative," I was told by Roberto Bedoya, the longtime arts administrator who is now Oakland's manager of cultural affairs, "but I'm for rigor. I'm for disciplinary knowledge. I'm for history." You may be a spoken word poet who is trying to give voice to your community, he said, "but giving voice to this comes out of a *long* line of giving voice to this, and where are you in that line? Do you understand that? So I believe in experts, and I believe in expertise." But that belief, Bedoya added, is "a threat to commercialism"—meaning to that "very sophisticated sales pitch," as Johnston put it, on the billboards.

Yet the everyone's-an-artist construct isn't just rejected by snobs like Johnston, or "old assholes" (as he put it) like Bedoya, or snobbish old assholes like me. It is also rejected by people who deeply love the practice of amateur creativity, and precisely because they do. For it wasn't enough for the creativity industry, and the tech industry, to convince us that we are all special and gifted, so they could sell us stuff. Then they convinced us that we should use our special gifts to make a buck, so they could sell us more stuff—more books, more workshops, more advice—or at least so they could get us to use their platforms. Turn your hobby into a business! Professional artists are told to work for free, but amateurs are told to do it for the money (in which case they're no longer amateurs). Use your leisure time to earn some cash, we're urged (in which case it's no longer leisure). We're back here to there's-never-been-a-better-time and just-put-your-stuff-out-there.

"It's always a great time to create from the heart," Dan Barrett, the musician and producer, told me. But "making money from it, that's such a different thing. It's like this idea that if your aunt makes great blueberry pie, all of a sudden [she's] entitled to a bakery. She should be a baking star." Instead, he said, "have a very rich life, and a very deep community, and enrich your family and your friends and your community with

your beautiful blueberry pies, or your incredible songs. This very media-driven and fantasy-driven idea that more people should be stars of some sort—it disserves this beautiful, spiritual force in people. This idea that it should be monetized—it hurts my heart."

And what if your songs are not incredible? Real talent is rare—a lot rarer than the pieties of progressive education, or the you-can-do-it boosterism of a consumption-driven culture, or our own vanity would have us believe. We assume that the more art, the better, but is that really true, especially if the vast majority of it isn't very good, and almost no one sees it anyway? Amateur creativity can no doubt be very fulfilling, but how often does it actually make life better for anybody else? By all means, enrich the world with your incredible songs, if incredible they be, but before you start littering the Internet with mediocre art, here's a list of things that you can do with your leisure instead. Spend more time with the people in your life. Volunteer in your community. Work for a cause. Read seriously what's been written seriously, so you can make yourself better informed. Grow your own food. Make your own clothing or furniture. Take the money that you would've spent on your art hobby and spend it on art that was made by professionals. Any of those things would make the world a better place, much more so than doing your art. None of them are going to make you rich or famous, but neither is doing your art.

* * *

Whatever you might think of that advice, the larger point is that the world is not just telling you to make your art; it's telling you to sell it—telling you, indeed, that the second is the logical conclusion of the first. And here we start to glimpse another idea, one that may be in the process of abolishing the very notion of art itself—certainly, of Art itself. For at the same time that Apple was preaching the gospel of universal artisthood, a new way of thinking about the economy was beginning to emerge. In the decades after World War II, the age of the professional not only in the arts but everywhere, the engine of productivity and growth was understood to be knowledge: not just technical and scientific, but also social-scientific, managerial, vocational, and so forth. (That is why we had a boom in higher education, with college enrollments increasing more than ninefold from 1939 to 1989.) Professionals—people who

possessed, worked with, and produced knowledge—were understood as "knowledge workers," a phrase that was coined by Peter Drucker, the father of the modern business school, in 1959.

But by the turn of the millennium, a new rubric had arisen. "Knowledge" was giving way to "creativity": as the force that drove the economy forward; as the capacity that governments needed to foster, businesses to leverage, workers to possess, and students to develop. In 2002, Richard Florida published *The Rise of the Creative Class* (a book that we looked at in chapter 6), which was instrumental in propagating this way of thinking. "Human creativity," Florida announced, "is the ultimate economic resource" and has become "the key factor in our economy and society." And while his creative class was not actually that different, in terms of its membership, from the class of knowledge workers, their activity was understood in different terms. "The Creative Class," Florida wrote, "consists of people who add economic value through their creativity." Its core included "people who work in science and engineering, computers and mathematics, education and the arts, design and entertainment."

The arts, design, and entertainment. Something momentous is happening here. Artists are being subsumed, without distinction, within the creative class, which means that art is being subsumed, without distinction, within the larger class of "creativity." The emergence of "Art," as I mentioned in chapter 12, involved a unification of previously disparate categories—poetry, music, drama, painting, sculpture—as they were recognized as sharing certain fundamental qualities that were not shared by other human activities, including other kinds of what we now call creativity, specifically the "crafts." (Other forms—fiction, dance, photography, film—later also won acceptance as arts.) The crafts appealed to our sense of beauty, but the "fine arts" also appealed to "the mind and the imagination." The crafts involved the creation of useful objects. The arts served no utilitarian ends; they were an end unto themselves.

But "creativity," in the terms that Florida and other writers have promulgated, abolishes those distinctions as well as many others. Art, that unitary concept, doesn't so much dissolve back into its separate categories as become submerged within a vastly larger one, one that includes not only the crafts but all the forms of endeavor engaged in by the creative class. Science is creative, and engineering is creative, and teaching is creative, and so, Florida tells us, are law and medicine, finance and

business, journalism and scholarship. The technicians who operate x-ray equipment, he notes, employ creativity in their work, and so do the ones "who repair and maintain copying machines."

Art becomes another form of "creativity," and creativity itself—this is the other momentous implication of Florida's book—becomes a business concept. Florida does not define the creative class, after all, as people who do creative things; he defines it as "people who add economic value through their creativity." In Florida's conception, creativity does not count—literally, is not counted—until it enters the market. Creativity, in this view, is a commodity, something with a measurable economic value, something to be bought and sold. Indeed, it is the ultimate commodity, the secret to producing all other commodities, the yeast that makes the dough rise.

Companies were not slow to pick up on this way of thinking. "Creativity" became, and remains, the mantra of the corporate world. A parade of business sages expounded the new wisdom. Corporations hired chief creative officers. "Design thinking" came into vogue, touted by IDEO, the Palo Alto–based global consultancy, as well as by Stanford's "d.school," which launched in 2005. Daniel Pink, author of *A Whole New Mind: Why Right-Brainers Will Rule the Future*, declared that "the MFA is the new MBA." In an interview with the *New York Times*—to cite one of a million examples that show how automatic this kind of language has become—the chairman of Dentons, a giant international law firm, confided that "the people who become leaders are not just creative themselves, but they create circumstances for others to be creative."

The conflation of art and creativity, together with the redefinition of creativity in business terms, allowed the "entrepreneur," another newly sexy word, to appropriate the glamour of the artist—their aura of imaginative daring and countercultural rebellion. Steve Jobs, with his black turtleneck, beard, and bohemian backstory, became the poster boy for the CEO as artiste. Suddenly every third executive was an "innovator" or a "disrupter" or an innovative disruptor who "thinks outside the box." The writer Jonah Lehrer likened the creators of the Swiffer and the Post-it Note to Auden and Dylan; *Powers of Two*, another modish business book, paired Jobs and Wozniak with Lennon and McCartney; and the *Atlantic* ran a cover story on "Case Studies in Eureka Moments," a list that started with Hemingway and ended with Taco Bell.

As for the people who work for all of these awesomely creative disruptors, the new way of thinking has come to permeate the way we talk about them, too. "Creative," as an employment category—that is, as a noun—originated in the 1930s in the advertising business, but it is now applied promiscuously to a wide array of job descriptions in a wide array of industries. Talk of "creative careers," I was told by Sean Blanda, the former director of 99U, began in the early 2000s, with all the other creativity language, but "creative," in the context of corporate work, is basically a form of propaganda, a way to make people feel better about their jobs—or, in the case of the "independent contractors" who increasingly perform this kind of work, their lack of jobs. "Creativity," writes Astra Taylor in *The People's Platform*, "is invoked time and again to justify low wages and job insecurity." Hey, you're treated like shit, but on the plus side—you're creative!

Art as "creativity," "creativity" as economic concept: another sector that was quick to pick up on this kind of talk was higher education. Persuading someone to drop six figures on an art degree is a tough sell, and it became even tougher after the financial crash. Meanwhile, the institutions had been overbuilt: too many schools and departments, relative to the number of arts graduates the economy could absorb, too many programs and facilities. The deans needed ways to put asses in seats, and now they had a brand-new sales pitch. Forget about getting an art degree to actually make art. Businesses want creativity? Well, we have the secret sauce, and we're going to teach you the recipe. More facilities were built, more programs launched. The emphasis shifted from art to design, which is much more business-friendly. Arts divisions started snuggling up to the engineers on campus, hoping for collaboration and the credibility it would bring. Academic arts administrators tried to sneak an extra letter into "STEM," the most prestigious term in education, flogging the notion of "STEAM." Taking the hint from Daniel Pink, schools created dual MBA/MFA degrees.

From all this strenuous rebranding in both the business and the academic worlds, a trendy new buzz phrase emerged: "creative entrepreneur." No one was sure what it meant—or rather, it meant whatever people wanted it to mean—but boy, did it sound great. Creative! Entrepreneur! You're not an artist anymore; you're a creative entrepreneur.

In a single phrase, art is rewritten in the language of commerce, and the disappearance of art inside the market is complete.

But some of the individuals who are most involved with these developments recognize what's lost in such maneuvers. Amy Whitaker, the writer and educator who works at the intersection of art and business, makes a point distinguishing between design thinking and, as she calls it in the title of her book, "art thinking." Design thinking, Whitaker says, is about getting from point A to point B, figuring out how to realize a predetermined goal. Art thinking is an open-ended, exploratory process in the course of which, she says, you "invent point B," discovering your goal through the act of trying to reach it.

So too Austin Kleon, the author of *Steal Like an Artist* and *Show Your Work!* and one of the stars of the world of creative self-help. Kleon is the one who told me that he doesn't "give a shit about 'creativity,'" because what he really cares about is art. "Everything," he went on to lament, "has to be pitched in market terms now," his example being *The Doodle Revolution*, a book (and TED talk, and consultancy, and self-described "global movement") about using doodling as a business tool. Doodling, Kleon said, "is an escape mechanism. It's a way to drop out of the situation, not to, like, 'optimize' it. Doodling on the back of my notebook in sixth grade was something that kept me sane, and now you're up there peddling doodling as something that middle managers should encourage their people to do. And the whole idea of using the word 'revolution,' you know? I mean, this is really where we are with this."

Still, the best-intentioned people can fall prey to the commercial logic that is taking over the way that we think about what artists do. Several years ago, Ruby Lerner, the founder of Creative Capital, a key arts funder, delivered a hypothetical commencement address at a gathering of academic arts administrators—the things she'd want to say to fledgling artists if she had a chance. In it, Lerner counseled the imaginary graduates that "gratitude, generosity, and joy" are "important drivers of our creative economy." Lerner meant the sentiment to be inspiring, but to me it's deeply chilling. Gratitude, generosity, and joy: we are being told to monetize the most intimate parts of our being. The industrial economy laid claim to our bodies. The knowledge economy laid claim to our minds. Now the creative economy is laying claim to our souls. Like the farmer

with the proverbial pig, we use everything except the squeal. The squeal is when we realize what's happening to us.

* * *

So what shall we call this new paradigm? What is the artist today, in this economy in which, as the poet David Gorin has remarked, "the market has no outside"? I am not the first to ask this question—not the first to recognize that something fundamental is changing for the artist, and to feel that a new terminology is needed to describe their relation to the economy, their position within society. In fact, as we have seen thus far in glimpses, a kind of covert struggle is taking place over the terms in which the artist will be henceforth understood.

On one side, as we just saw, the word that's being urged on us is "entrepreneur," as in "creative entrepreneur." It is a word whose prominence and resonance we owe to Silicon Valley, with its glamorized start-up culture, and that aligns the artist's interests with the interests of capital. It is also, in this context, as we've said, a scam. A self-employed artist—a self-employed anyone—is not an entrepreneur. They are simply a person without a job, living on their wits from check to check. "Entrepreneur" is a means of mystifying that condition, sugar for the turd of gig work. Over the last couple of decades, people on the left have taken to speaking about the "precariat," a word that combines "precarious" and "proletariat." The precariat is the new class of workers who lack traditional employment and the security and stability that it provides. More recently, Silvio Lorusso, a multidisciplinary artist based in the Netherlands, has gone one better, combining "precariat" with "entrepreneur" to produce "entreprecariat," a term that seeks to capture the way that entrepreneurialism is being sold to the precariat as a myth of empowerment. As Lorusso puts it, "Everyone is an entrepreneur. Nobody is safe."

On the other side—the side, precisely, of the left—is "worker," someone at the opposite end from the capitalist, from the entrepreneur, of the relationship of capital to labor. "Worker" is the word you often hear from artist-activists like Lise Soskolne, the cofounder of W.A.G.E.—and, indeed, in names like W.A.G.E., which stands, remember, for Working Artists in the Greater Economy. (Soskolne is the one who ridiculed "this creative entrepreneurship bullshit.") And artists, as they move from gig to gig and project to project, stacking up their little checks, are indeed

often workers, not self-employed but actually (if only temporarily) employed: as teachers, lecturers, performers, independent contractors, and so forth. Still, artists are not *only* workers. They are, as I explained in chapter 2, also often capitalists, if only on the smallest of scales, people who are, precisely, *self*-employed: who make use of capital—the capital represented by their tools, by the money they've invested in their education, by advances and grants—to employ a single worker, themselves.

So if "worker" won't do, and neither will "entrepreneur," what name can we find? It will help to turn away for a few moments from the idea of the artist in the marketplace. For certainly there are still many artists who resist their definition by the market, who do their best to find a place to stand outside the market, if only within the shelter of institutional support. And how do they speak about what they do? Not the way that the modernists did, though they also rejected the market. Not in terms of art for art's sake: art as its own purpose and end, its own independent realm of value, obedient to its own logic and devoted to its own development. Such language is essentially extinct. Not in terms of aesthetic education: art as secularized spirituality, a tool to shape the soul. Such ideas survive, but like the academic humanities, at least insofar as they are meant to embody and transmit them, just barely and probably not for long.

No, when people aren't talking about art in terms of "creativity," or turning your hobby into a business, or art as a driver of local development—when they aren't talking about art and money at all—they talk about "relevance," about "social engagement" and "social impact," about what art can do for the "community." Such notions are conspicuous in social practice art, one of the most energetic movements in the art world today, where art becomes, as I mentioned in chapter 11, a form of social work. They are implicit in the fact that the arts institutions most characteristic of our time—McSweeney's, the publishing house, is one; the Moth, the live-storytelling organization, is another—understand themselves, at the broadest level, in terms of social improvement, so that both, for example, run educational programs for disadvantaged youth. They are ubiquitous in schools and departments of music, dance, theater, and visual art. Go to any gathering of academic arts administrators, and when they aren't talking about entrepreneurship, or STEAM, they're talking about relevance, engagement, and impact. As Jen Delos Reyes, one of the leading figures in the social practice movement, writes, "for

many . . . socially engaged artists today . . . it is not about the next new thing in art; it is about a change that reaches far outside of" art. "Curator Nato Thompson has pointed out," she goes on, "that the question has changed from 'is this art?'"—the characteristic question of modernism, of art as experiment and shock and mental revolution—"to 'is it useful?'"

And here is where the commercial and the noncommercial, even the anti-commercial, meet. For usefulness, of course—"utility"—is one of the market's essential concepts. Things have value in the market insofar as they are useful. For both art-as-"creativity" (something that produces economic benefit) and art-as-"impact" (something that produces social benefit), the value of art lies not in art itself, but in some other sphere of activity, in reference to some other set of purposes. Instead of art for art's sake, art for something else's, almost anything else's, sake: art for the sake of the local economy, art for the sake of the bottom line, art for the sake of the tribe or identity group, art for the sake of social justice. What becomes then of Art with a capital A, art as an autonomous realm of expression, not subordinate to anyone or any thing? If art is serving other ends, it must perforce be speaking others' truths.

Sharon Louden, the editor of that ongoing series of collections of autobiographical essays by visual artists, is also engaged in the project of finding new language, a new self-conception, for artists today. Her second book, remember, is called *The Artist as Culture Producer*. Louden's overriding objective, as I mentioned in chapter 11, is to demolish the idea of the artist as heroic, solitary genius—someone who creates value, in other words, just by working alone in their studio. In her preface, she writes of the practitioner "who reaches outside of the studio to extend creative energies and pursuits into his or her community." Artists, she goes on, like "the mechanic who services your car, the real estate agent who finds you a house, or the head of your bank down the street . . . provide a service to society . . . creating economic value and contributing to the well-being of others." The most striking thing for me about this passage is how seamlessly it welds together economic value with the social kind, "creativity" with "impact," so that the two are scarcely any longer separate, much less antithetical.

And that's why Louden, I believe, has hit upon the perfect word to christen our new paradigm. It is the word proposed in her title: "producer." "Producer," like "useful," is a quintessential market term. But

it is also a word that relieves us of the need to choose between the poles of labor and capital, "worker" and "entrepreneur." A producer can be either, or neither, or somehow both at once, exactly as the artist is today. And not only the artist. For it is one of my points, in proposing this four-part historical scheme, that in any given age, artists do not represent a special kind of economic actor. Rather, they belong to one of the categories that is already broadly available. They are what many others are, as well: artisans when artisans were common, professionals in the age of professionals, bohemians at a time when bohemianism flourished. So it is in the twenty-first century. We live in an age of economic atomization, a time when more and more of us are not professionals, durably attached to institutions, not workers, durably attached to employers, and, God knows, not entrepreneurs but, simply, producers: free particles in the marketplace, finding what work we can for what money we can, and exposed without protection to the market's whims. The artist as producer, then: the fourth paradigm.

PART V

WHAT IS
TO BE DONE?

ART SCHOOL

History does not move backward. The artist as producer, I believe, is here to stay. That doesn't mean there's nothing we can do about the situation. If artists are going to live in this world, they need to be prepared for this world, and they, and the rest of us, need to do what we can to improve the circumstances under which they make their work. Those challenges are the subject of the final part of this book.

Before we talk, in this chapter, about the ways that art schools need to change, let's ask a more basic question. Each year in this country, some ninety-five thousand individuals receive bachelor's degrees in the arts, some twenty thousand receive master's degrees, and nearly eighteen hundred receive doctorates. Are they making the right choice?

The answer will differ from student to student, but opinions about art school, pro and con, tend to run pretty strong. On the negative side is the conviction that being a student is antithetical to being an artist. Like Dave Hickey, the art critic, David Mamet believes, as he put it, that "the lessons that you learn in school are lessons of subservience. You say, let me please the teacher." Jason Alexander (*Seinfeld*'s George Costanza), who studied theater at Boston University, has remarked that he doesn't "believe that the best training for anyone in the arts is at a college," though not for the reasons of Hickey and Mamet. "The very nature of a college program—they're on a schedule," he explained, "and artists learn a craft in the time it takes them to learn it. But the college needs you to

go on to the next thing. So you find that you are burning through ideas before you really grok them."

Then there is the familiar idea that arts programs, especially graduate programs, tend to impose a uniform aesthetic, tearing you down to build you back up in the faculty's image. Recall that Jane Mount dropped out of her MFA program at Hunter in 1995 because she wanted to paint, and in 1995 you weren't allowed to paint. In the world of fiction writing, people have long complained about "MFA style" or "Iowa style"—polished, flattened, cold. In *Should I Go to Grad School?*, a useful collection, the poet Kenneth Goldsmith, who studied sculpture as an undergraduate at RISD, writes that the MFA industry "has resulted in deadly dull and overly cautious artistic practices" in both poetry and visual art. Hickey describes being conducted through the architecture studio at Cornell in 1992 and witnessing a "long row of students hunched over their boards lining out pale, pure modern architecture, straight up, no olives, no onion, no twist." "Oh yes," his "academic minder" tells him, "we like to wipe the slate clean here."

But many of the artists whom I spoke with, and not a few of the contributors in *Should I Go to Grad School?*, adored the experience. Helen Simon, remember, found her time in film school indispensable, cost be damned, because she learned how to say what she wanted to say. David Busis, a graduate of the Iowa Writers' Workshop, told me that MFA style is a myth. "MFAs allow less talented people to publish through hard work," he said, "and if you're not inspired, but you are lucky enough to get your ten thousand hours in, then your prose is just going to come out kind of flat. But the inspired people who go to MFAs are still writing inspired fiction." Brad Bell, the co-creator of the web series *Husbands*, studied cinema and television production at Los Angeles City College, a community college that, he told me, produces more graduates who work in the industry than any other school. The program, he said, "was fantastic. It's very blue-collar: here's how you walk on to a set and get a job. This is how you use a camera." At a fancier, four-year school, he explained, you might not get to touch a camera for two years. "At LACC, they put a camera in your hand day one." Bell went on to study improv at the Second City, another kind of formal training. Comedy has rules, he told me. "If you're really serious about succeeding in comedy," he said, "you need to study it."

"I believe that the educational process is invaluable," I was told by Nancy Blum, the visual and public artist, who did an MFA at the Cranbrook Academy and has taught at many institutions. "The opportunity to have a good process at the right point in the development of your art," she said, "makes all the difference between maybe making something average and potentially becoming good." I asked her why. First of all, she told me, rigor. "MFA programs are built on the idea of basically breaking down what you're doing to *see* what you're doing. And to be able to both articulate and defend what you're doing. Which is a terrible process in some ways for sensitive people, but it's also invaluable, because you have to be thoughtful about it." Second, teachers. "If you have a good teacher," she said, "they have a depth and breadth of both perception and exposure that—it's just a magnificent thing to get the chance to work with that person, especially if they have a generosity of spirit." Which, she said, a lot of teachers do. "I know a lot of schmucks," she said, "but I know a lot of people who are smart, devoted teachers and put in a lot more time with their students than they get paid for."

Third, time. "Whenever you get the luxury of having a time of intense focus to develop, you are going to progress much more rapidly," she said. And in art school, she added, "you're not just allowed to be repetitious, which is what a lot of people do when they're on their own." Finally— and this is something that I heard from many people—community, both now and in the future. "Go to a place where you can have enough of a peer group that you guys will encounter the same challenges as you grow and develop through the decades," Blum counsels young artists. "If you go through an MFA program," she told me, "you develop intellectually, and conceptually, and aesthetically—together. Even if you are all doing different things. It's a little bit like having a home base, like a family, for better and for worse."

There are also harder-headed reasons to pursue an MFA. MFA programs, as Blum suggested, are the place where you begin to build your professional network. The degree has also become indispensable for academic employment in the visual arts as well as in creative writing. In both fields, too, graduating from a leading program is, if not essential, then nearly so in gaining access to the top commercial outlets: New York galleries, New York publishers. In the 1980s, Kenneth Goldsmith writes, "only losers went to grad school. Everyone else went to New York and

clawed their way into the art world." But now, he goes on, "you need an advanced degree from a good school to even get galleries interested in your work." Gerald Howard, executive editor at Doubleday, has compared the world of writing programs to the NCAA. Both include a lot of schools, but only "a limited number of top drawer competitive programs where the truly talented gravitate." Instead of a draft, as in basketball or football, he explains, there is "a system of recommendations whereby the marquee writing instructors pass along their most promising students to their agents." These days, he says, there are "about as many uncredentialed walk-ons in our literary fiction as there are walk-ons in major league baseball."

* * *

Of course, the vast majority of art students do not attend a leading program. And many of those who don't (and indeed of those who do) find themselves encountering environments that are beset with all of the evils that plague academia in general today. The first is adjunctification: the shift from full-time, long-term faculty to instructors who are transient and, in the words of Linda Essig, who spent many years at Arizona State University's Herberger Institute for Design and the Arts, "grossly underpaid." As bad as this is for the teachers, it is just as bad for students. Especially inexcusable, Essig told me, is the use of part-time instructors in required undergraduate courses. Equally indefensible, she added, is their use in MFA programs. With respect to the latter, she said, "you want a student to have a three-year trajectory of working with really significant faculty. They should not be taught by adjuncts." And schools that don't show loyalty to their employees can expect none in return. When we spoke, Essig had just had a teacher quit a class—it was, in fact, a required course—in the middle of the semester.

When institutions hire term to term, they're also often not all that particular about the people they are hiring, if they're even paying attention. A painter who teaches at a well-known New York–area art school told me that he had recently taken over a course, again in the middle of the semester, because the students had gotten so disgusted with the abysmal level of their instructor's pedagogy that they had driven him out of the class. The school itself was not providing any oversight. As for the few full-time professors who remain—sometimes only one or two in

an entire department—they are often overwhelmed by the situation, the painter told me, since it falls to them to hire and supervise these "endless adjuncts." Nor are the alternatives to adjunctification today necessarily much better. Another artist told me of a friend who was thrilled to have secured a tenure-track position at a community college. The job required her to carry five courses a term—four is considered onerous—some of which she wasn't qualified to teach.

But the shift to adjunct labor is only the most conspicuous aspect of the larger phenomenon of academic corporatization. American universities, their arts divisions very much included, are increasingly run like corporations, and on behalf of corporations. Shared governance, the principle that schools should be overseen by their faculty, who have an intimate knowledge both of their students and of their fields, has given way to dominance by a separate stratum of managerial careerists—deans, deanlets, directors, deputy provosts—who often have no understanding of, appreciation for, or interest in the academy's traditional purposes: scholarship, mentorship, thinking, making, history, critique—the arts and the liberal arts. With these overcompensated mediocrities (excuse me, "leaders") comes the business blather of "accountability," "metrics," and "outcomes," along with "assessment" regimes that measure everything except what matters in teaching and learning, which can't be measured in the first place.

The mantra, inevitably, is "innovation"—better yet, "disruptive innovation"—which is code for treating colleges and universities like commercial entities, with departments reconceived as "profit centers." Adjunctification, after all, is a cost-cutting measure, but it is far from the only one. Some schools are reducing the length of their MFA programs. Others are shrinking studio space or eliminating it entirely. Programs are judged by their ability to generate "return on investment"—a standard by which the arts in general do not fare well, and traditional disciplines like painting, sculpture, and the crafts fare even worse. Coco Fusco, the interdisciplinary artist who has taught at many schools, has written about "post-studio curricula" and "the de-skilling of art education for institutional profit"—the retreat from the training of hand, eye, and mind.

Instead, novel product lines are rolled out in the form, as Fusco put it, of "dozens of newfangled degrees," which invariably try to catch the wave of market trends. As of the mid-1990s, for example, the School

of Visual Arts in New York had four master's programs. Today, it has twenty-one, including twelve MFAs ("Visual Narrative," "Illustration as Visual Essay," "Interaction Design," "Branding"). Schools expand too fast, take on too much debt, and are forced to hike enrollment with no commensurate increase in facilities or faculty. Rather than providing the kind of education students need, they increasingly see themselves as being in the business of producing the kind of graduates employers want.

Then, of course, there is the issue of cost—of tuition and debt. Of the ten most expensive colleges in the country, as I mentioned in chapter 11, seven are art schools. Art programs cost a lot to run, in part because space costs a lot, and art schools do not typically have large endowments, because they don't produce a lot of rich alumni. As for MFAs, universities treat them, like most other master's degrees, as cash cows, which means financial aid is generally not available. "Graduate art students," Dave Hickey writes of the explosion of programs that started in the 1980s, "were reduced to bagmen. They borrowed a quarter-million bucks from the government, gave it to the university to build the dean a house, and then worked in an Apple store to pay the bill."

Things have only gotten worse, at both the bachelor's and master's levels, since the financial crash in 2008. Not only do tuition and debt continue to rise, but application numbers have started to plummet—at some programs, by half or more—which means admission standards have, as well. Beyond the top few schools, acceptance rates are typically well above 50 percent. "They take anyone," Nancy Blum remarked, "and it is ugly." Students often go to art school for the wrong reasons: to delay decisions about the future, because learning issues or social issues prevented them from doing well in high school, because they want to fight for social justice but don't have a talent for art, Blum said, and should be doing something like law or journalism instead.

"The tragedy of student debt," she explained, "is that these are people who shouldn't have gone to art school in the first place. Give me an hour to scream. I know very average, decent young people who are strapped with terrible debt they're never going to get out of. It's immoral and corrupt." And this is not even to speak of the for-profit art schools, many of which, as with for-profit colleges in general, are little more than grift mills, preying on naïveté and ignorance to harvest dollars from the federal student loan system: places like the Art Institutes, which has many

locations and has been the target of many legal actions, or San Francisco's Academy of Art University, the largest private art school in the country, 35 percent of whose students take classes exclusively online (yes, at an art school) and only 7 percent of whom manage to graduate in four years.

Blum believes that BFA programs in general are often rather poor, with little quality control compared to regular BAs. Some are excellent, she said, but it's not uncommon to get through a BFA having learned almost nothing at all. Better for artists in college, she believes, to study the liberal arts, as she did, so they at least know how to think, talk, and write. For Coco Fusco (who also majored in the liberal arts), getting an MFA can actually be self-defeating, precisely because of the debt. You need to either get a job, which leaves no time to make your art, or produce work that sells, which prevents you from exploring and developing. If you have to take on debt to go to art school, her advice is: don't. Which, these days, is easier said than done.

* * *

Whether or not you take out loans to go to school, and whether you get a BFA, an MFA, or both (or a BM, MMus, or other comparable degree), the question when you graduate is how you are going to make a living with the things you've learned. Which means that the question *before* you graduate is how—or rather whether—your school is going to prepare you to. This is not a question many people in the world of art schools like to think about.

The problem starts with students themselves, whose attitudes can polarize, people told me, in one of two directions. Many are still "in a bubble" about career issues, Sharon Louden said—"trapped," said Coco Fusco, "in a very antiquated Romantic idea of the artist in a studio and being discovered and so on and so forth." Only once they graduate, Fusco explained, does "reality kick them in the face." Linda Essig, who studied stage and screen design, told me that she didn't get it herself until she had graduated from NYU and found herself working at Chicken and Burger World. Fusco's students at the University of Florida, where she has taught since 2016, are no different in this respect, she remarked, from the ones she taught at Columbia and Parsons. When she tells them about their chances of getting a full-time academic job, "their jaws drop," she said. And yet, when she goes on to talk about the need to consider

other professional options—K–12, after-school programs, community art centers, art therapy—"their eyes glaze over. They're not ready to hear that yet."

Other students are so consumed by their financial prospects that they prevent themselves from being students, from immersing themselves in the process of figuring out who they are and what they can and want to do. Sean Blanda told me that the students he meets when he speaks at design schools all "seem to be just terrified, absolutely terrified" about their future. Troy Richards, then the chair of the Department of Art & Design at the University of Delaware, remarked that all the talk of "disruption," in and out of academia, terrifies them even further. So students tend to head for the safest alternatives, which is not exactly what you want to witness in a budding artist. "Our students are becoming a lot less weird than they used to be," I was told by Rebekah Modrak, who has taught at the University of Michigan's School of Art & Design since 2003. "Very rarely now is there a student that presents an unusual thought or an action that is surprising to me and that stuns me in an interesting way." The feeling appears to be common; I have quoted Modrak's words during talks at more than one conference of academic arts administrators, and both times they were met with sounds of recognition.

Modrak went on to tell me about a course she was teaching for sophomores that was designed to enable them to explore ideas in a free-ranging way so as to begin to discover their artistic identities. When they'd gone around and introduced themselves the first day, all but two had announced that they planned to be some kind of designer—a product designer, an industrial designer, a graphic artist—that is, something very specific and practical. Yet when she'd told them that they were going to have three months to work on whatever they wanted, none of them had opted for anything related to design. One created a graphic novel; another made wearable art. "I'm really curious about this," Modrak said. "Whatever pressures our students have, either in terms of parental pressures or from the economy or student loans—I think it's bigger than that. I think it has something to do with their understanding of themselves as unique humans in the world and their capacity to say something very particular. I feel like they have given up on that."

Illusion on the one hand, panic on the other. Roger White, the painter, quotes a fellow RISD teacher as remarking that young artists need to

make decisions "based on something other than fantasy and paranoia." But they aren't, from what I gather, getting a lot of help with that from their professors. Many of the latter do not see their students' career prospects as their job to worry about. Others simply don't know how to help; they came of age at a very different time and are as clueless as their students are about contemporary conditions. Still others engage in the same kind of magical thinking their students do: if your work is good, they tell them, people will discover you. And finally come those who recognize that things must change, that they are preparing students for a world that no longer exists, but, as Coco Fusco said, "they're lazy." They've been teaching the same courses, in the same ways, for twenty or thirty years, and they don't want to put in the effort to do something different.

The biggest obstacle, however, seems to be that professors buy in, as much anybody else, to the Romantic myth of purity, of the starving, solitary artist-genius (which they can afford to do, since they have jobs). In fact, professors may be the ones who are most responsible, at this point, for propagating that myth, for producing generations of young artists who don't know how to think about money, because they've been told that they shouldn't. It's no surprise that 63 percent of undergraduate art students, according to one study, leave college feeling unequipped to support themselves.

* * *

This is not an easy problem to solve—not practically, and not philosophically. Indeed, it raises the central question that is raised by this book as a whole: how to keep your soul intact and still make a living as an artist. Because for many art schools, the answer to the problem of equipping their graduates to support themselves as artists is to discard the first or final elements of that equation: to help them make a living, but not necessarily with their souls intact or not necessarily as artists.

By the former alternative—not with their souls intact—I mean surrender to the market, turning arts education into a form of glorified (or not even all that glorified) vocational training. There's nothing wrong with becoming a product designer or a graphic artist—the world needs plenty of both—nor are you necessarily selling your soul if you do. There *is* something wrong when students are made to feel as if they don't have any other options. "Not all students are meant to be radicals or risk takers,

people who change the world," Rebekah Modrak said, "but you should be given at least somewhat of an opportunity to imagine yourself in that role." It is when institutions fail to provide that opportunity, when they treat their students like widgets to be fitted into preexisting market slots, that they produce young artists who have given up on understanding themselves as unique human beings with something particular to say, who are too afraid to be interesting or weird—who won't allow themselves to act like artists.

Then there is the second approach to preparing students in the arts to earn a living after graduation: dispensing with the part where they do so as artists. Arts degrees, on this account, are "anything" degrees, programs of study that prepare you broadly for anything and everything you might pursue—for success in career and fulfillment in life. I am sympathetic to this idea (it is also one of the best arguments for a liberal arts degree). Arts programs, I was told by Stephen Pullen, dean of the School of Arts at Utah Valley University, a large public institution, instill you with a wide array of soft skills. "And there's plenty of literature to support that," he said. "Creativity, imagination, collaboration, project management, entrepreneurial thinking: those are things that are built into the kinds of projects that art students do for four years. They are rehearsing and putting on plays or concerts or recitals. They're doing exhibitions." So they acquire those skills, he said, "without even realizing it."

Soft skills are powerful because they are transferable, and because they're needed everywhere. Linda Essig told me about running into an old student from her days at the University of Wisconsin who is now a product manager for a large manufacturing firm. "She didn't go to business school," Essig said. "She doesn't need to have gone to business school. She has a *theater* degree: she knows how to manage a project from beginning to end, how to work with people, how to communicate." The students his school is preparing, Pullen said, might go on to professional careers in the arts or arts education, "or maybe they're going to get a great art degree and then go to law school or to business school, and that's great, too." It certainly is, especially since there are already too many struggling artists in the world. But it doesn't solve the problem that concerns us here. It explains how art school graduates can make a living, but that's an issue only for art schools, which need to justify their existence. It doesn't explain how artists can.

Threading that needle—preparing students to function in the arts economy as it actually exists, without turning art school into trade school—is the great challenge. Meeting it can start with something as simple as the professional-practice course developed by Kathy Liao, the painter who teaches at Missouri Western, to convey the nuts and bolts of being a visual artist: how to write an artist statement, how to price your work, how to reach out to galleries in a way that might actually get them to take you seriously—the kinds of things that she had had to figure out on her own, once she found herself, after graduating from the University of Washington, "bumping my head into the wall" for lack of professional knowledge. The more hands-on this kind of learning is, the better. At the Oregon College of Art and Craft (a fine little school that was recently forced to close), the BFAs were expected to mount their graduation show from start to finish: to locate an off-campus venue, draw up and stick to a budget, handle publicity, and manage the opening.

More broadly, institutions need to take their programs out of the silos into which arts education is typically partitioned. Artists make a living, as we know, by wearing many different hats. You don't just act in theater as a theater actor; you write, you direct, you produce, you act in film and television, do voice work and commercials. So the graduate writing program at the Otis College of Art and Design, for example, takes cognizance of the fact that writers tend to work in multiple forms today—not solely poetry or fiction or nonfiction—by running multi-genre seminars, but it also recognizes that very few people will actually be able to make a living doing any or all of those things. Its goal, instead, is to help its students put together a sustainable career in the literary world writ large: editing, translating, publishing, teaching, and so forth, as well as writing. To that end, the school runs its own press, involving students, as Peter Gadol, the program chair, has explained, "in every part of a book's production, from manuscript selection, to editing/copy editing, to printing, to working with distributors, etc."

In 2015, in a similar vein, Bard College launched the Orchestra Now, a graduate conservatory program that seeks to rescue students from the classical musician's all-too-common fate—slowly dying inside as you crank out the same old repertory season after season for a failing orchestra—by modeling careers that are creatively varied. Students undergo the traditional rigors of training, rehearsal, and concert-hall performance,

but they also put on pop-up shows, in smaller groups, in places like coffee shops and schools, "bringing music," as Lynne Meloccaro, the program's founding director, told me, "to where people are." The degree culminates in an independent project that may involve, as the program's materials put it, "forming and managing a performing ensemble, curating a program of solo and chamber works to explore a topic of social importance . . . or working with community members to explore and express their life experience in words and music." The idea is to recontextualize the classical tradition within a wider frame of reference, as something with a life in cultural history and the social present. "Instead of looking at notes on a page," Meloccaro said, "you think about why the audience needs to hear this."

For the many students who have already gravitated toward the more practical disciplines, the job is to give them permission to let their hair down. With *her* sophomores, I was told by Kate Bingaman-Burt, who has helped to build the graphic design program at Portland State University into one of the top thirty-five in the country (out of more than seven hundred), "it's about breaking open what their expectations of graphic design are, because a lot of them do approach it with this very one-dimensional view." She shows them that it isn't just about creating logos, but more than that, she "help[s] them turn their hoses on full," as she put it. "Let's make piles of work," she says. "Don't overthink what it is that you want to do." When we spoke, Bingaman-Burt was also developing a major that would integrate design and art—which are typically treated as opposites or even enemies—and that would "reflect what's happening in the current landscape," so that "students are equipped with grant-writing skills, with self-promotional skills," with theoretical knowledge and research skills, with skills in speaking and writing, and are "able to figure out the landscape, the work that they want to be doing, and start doing that type of work before they leave school," she said. "I want our students to be able to support themselves doing the things they love to do, you know? And if they don't have the basic skills [to do that], then I think fundamentally we're failing them."

It was that same philosophy that motivated Linda Essig to launch the Pave Program in Arts Entrepreneurship at Arizona State. "I think it's unethical to teach young people to be artists," she told me, "without teaching them how to be artists in the world." But a lot of the push

came from students themselves. Arizona State, unlike expensive private schools, enrolls a lot of students who are older and/or come from lower-income backgrounds. "They know they have to make their way in the world," Essig said, "because they've been doing it their whole lives." The proliferation of arts programs since the 1980s, she explained, has "increase[d] access to arts education for people who would not have traditionally been able to study at Yale or NYU or the School of the Art Institute of Chicago." As a result, she went on, students like hers are increasingly the norm. For them, the traditional model—high school to conservatory to professional career—is simply irrelevant. At Arizona State, she explained, "we're teaching them to be artists in their communities, artists in their location, artists in their state, artists in the world—making their own place."

This is where the concept of arts entrepreneurship comes in, of which Essig is the leading national exponent. The idea, she explained, can mean anything from being entrepreneurial about your practice ("proactive, resilient, persistent," as she put it) to actually trying to be an entrepreneur; from basic career management (balancing a checkbook, sending out a press release) to something closer to a small business (where you incorporate as an LLC, apply for commissions, and hire employees) to the kinds of ventures that Pave provides money and support to incubate (an iPad app for stage managers, a theater project that creates immersive environments out of classic literature).

"Entrepreneurship" starts to veer close to "creativity," a danger of which Essig is mindful. That is why she insists on speaking about "arts entrepreneurship," not "creative entrepreneurship," and about art, not design. Design is like engineering, she said, whereas art is like science, an open-ended process of discovering the truth. "I'm not talking about an industrial designer who's going to build a company around some great product," she said. "I'm talking about an artist communicating some truth about what it means to be human in the world." Whether others share that way of thinking is an open question. Programs in arts entrepreneurship, which scarcely existed before 2000, began to multiply in the new century and exploded after 2008, precisely because of concerns about employability. By 2016, there were 372 offerings at 168 institutions. Essig acknowledged that their quality is variable, to say the least. The bad ones, she said, just *talk* about entrepreneurship. The good ones—but this

requires time and money and know-how—actually have students interact with the public, to experience it in action. "The only way to really *learn* entrepreneurship," she said, "is to *do* entrepreneurship."

Meanwhile, unaware of these developments, a professor of theater at the California Institute of the Arts—CalArts, the prestigious private art school near Los Angeles—was working out her own ideas. Susan Solt had come from Hollywood (her first job was on *Sophie's Choice*, coaching Meryl Streep with her Polish dialect), and she hoped to use her experience as a producer to help her students have careers. She thought she was going to be teaching them business and management. But when she began to offer what turned out to be the very first course in arts entrepreneurship (it was Solt, in fact, who coined the term), she found that she needed to start much further back, by leading her students through, as she put it, "a really deep personal self-investigation, a sort of self-authoring." In other words, why were they doing this in the first place? "To ask students what they wanted," Solt told me, "what they felt, what they thought, to write about their art-making, was incredibly daunting to them. It was also incredibly exciting to them. And it was also incredibly emotional to them. It was tapping into something so deep inside about a sense of purpose and what I want from my life, and so many fears about whether there was a place for what they did."

One might think that that would be the normal starting point of an arts education, asking students to reflect about their motives and desires. In fact, as in education as a whole, it almost never happens. "Sometimes through their work," Rebekah Modrak of the University of Michigan remarked about her students, "you really have no sense of who they are. I've been on reviews where a faculty member will say, 'What do you care about?' and the student will just start crying." So that's where Solt began. Introspection, for her students—getting in touch with themselves—led organically to "taking ownership of their careers and their lives." Then the students went to work developing specific, concrete strategies for launching those careers. The point, for Solt, was not to funnel them toward particular choices, but to help them figure out how to identify their audience, their market, whether in the commercial world or the world of nonprofits—the people who would care about the work they wanted to do—and then to help them reach it.

When she first started teaching the course, she told me, Solt encoun-

tered "an enormous amount of resistance—just an *enormous* amount of resistance." Students were afraid that she was going to try to turn them into businesspeople. By the time she finished twelve years later, they were breaking down the doors. She was teaching it twice a semester, to students from across the institution, and was still turning people away. When I spoke with Katrina Frye, the artists' consultant, who spends a lot of her time coaching art school graduates who had not been equipped to support themselves, she mentioned a CalArts alumna who had neglected to take Solt's course because she hadn't understood why it was necessary. She would've changed her mind, Frye told me she said, if it had been called "Survival Guide: You Will Fail."

PIRACY, COPYRIGHT, AND THE HYDRA OF TECH

I n 2005, Ellen Seidler was approached by a friend for help with a video project. Seidler is a freelance editor and cinematographer who was living at the time in the Bay Area. The friend, Megan Siler, a writer and director, wanted to create a short, lesbian-themed spoof of the hit indie movie *Run Lola Run*.

Once the two got going on the project, though, it gradually evolved into a full-blown production. They signed a SAG-AFTRA Ultra Low Budget Agreement, which enabled them to hire union actors; created an LLC to obtain the requisite insurance; and took out permits ("paying through the nose," Seidler told me) to shoot on location. San Francisco, where they chose to film, didn't have the kind of acting talent they were looking for, so they held auditions in Los Angeles, including targeted ones, which are more expensive. "It's easier for a gay actress to play straight than it is for a straight actress to play gay," Seidler explained. "Not every actress is capable of having that sort of swagger, if you know what I mean." On a typical day, there were about twenty-five people on set, and all of them were paid. "It takes a village to make a film," she said.

Their lead was doing a play in LA, so the filmmakers had to work around her schedule and pay her airfare back and forth. The shoot turned out to coincide with Fleet Week, which meant noise from flyovers by the Blue Angels, so they needed to bring people back to do some reshoots nine months later. They paid to license music, including a couple of commissioned tracks. They paid for animation sequences. Plus, Seidler

explained, every frame takes effort, and money, in post-production: color correction, where you adjust for differences in lighting to give the film a consistent appearance; "sweetening the audio," where you put in sounds like footsteps and sighs. One day, one of their actors showed up with a zit, and it ended up costing them $600 for a digital patch.

"We were doing it bare-bones as much as we could," Seidler said, "but you get to the point where you put so much investment and time and money into something" that you do what you have to to make it look good. Their initial budget of $100,000 turned into more like $250,000. The film was pretty much self-financed—Seidler tapped into her retirement and took out a second mortgage—but the filmmakers, who didn't pay themselves a cent, had done their homework, and they were confident that they could make their money back through sales of DVDs. After screening the movie, which they called *And Then Came Lola*, at over a hundred gay and lesbian film festivals, they arranged for distribution through Wolfe Video, the largest exclusive distributor of LGBT films in North America.

The day the DVD came out, Blockbuster Video went bankrupt. "There were literally pallets with DVDs of our film sitting on the loading docks that weren't going to go anywhere," Seidler said. But then she discovered something unexpected. Within twenty-four hours, a copy of the movie had appeared online. That wasn't the unexpected part; Seidler already knew about file sharing and piracy. What was unexpected was what she found out, as she put it, "once I started to drill down and look at what was happening."

Piracy, Seidler learned, "wasn't about sharing in the slightest. It wasn't about people saying, 'Oh, I want you to see this great movie, let me share it with you.' It's a moneymaking endeavor. It's a black-market business model." Pirated films (and songs), she explained, "are carrots to attract users to websites"—piracy sites. Content is pirated wholesale, indiscriminately, and the traffic—the eyeballs, the clicks—is monetized mainly through ads, which are brokered, like everywhere else on the Web, by Google. The pirate sites make money; Google makes money; the payment processors (Visa, MasterCard, etc.) make money. The people who created the films and songs, of course, do not make any money whatsoever.

And so-called cyberlocker sites—the first and biggest at the time

was Megaupload, which was founded by someone who calls himself Kim Dotcom—go even further. In order to obtain more uploads, and therefore generate more advertising dollars, they offer incentives: a bonus for uploading lots of files, a cut of the revenue from downloads of your uploads. So Kim Dotcom, Seidler said, "had this little army of mini-pirates that would upload all this stuff." (At its height, according to Jonathan Taplin in *Move Fast and Break Things*, "Megaupload hosted twelve billion unique files," including "almost every music and movie file in existence," and accounted for 4 percent of global Internet traffic.) The arrangement leads to, as she put it, "viral spread": "one person rips the DVD, and all these pirates rip off the initial pirate, and they take that same file, and they spread it far and wide, because they want to earn their money [from the cyberlocker sites]. So you start seeing that same file spread across the Web within hours." Within a few months of her film's release, Seidler documented sixty thousand download links.

How and why she did so is the next part of the story. "Here I am seeing my film on my computer screen, in HD glory, next to a Google-sponsored ad," she told me. "Google's making money off my film, and I'm not making a dime, and I'm in debt. It just didn't sit well. So the journalist in me came out." Seidler had started in TV news; now she was teaching at a community college, which meant she had the summer off. She spent hours a day, for weeks at a time, combing the Web for copies of her film. Under the Digital Millennium Copyright Act (DMCA)—which was passed in 1998, has never been amended, and is, as Seidler put it, "woefully out of date"—creators who discover that their copyright has been infringed are allowed to file a "takedown notice" to have the offending link removed. But they need to do this separately, one at a time, for every instance of infringement.

"There's a specific email address you have to send a takedown notice to," Seidler explained. "You have to copy the links that you want removed, there's specific verbiage you use, and then you send them off. If you're lucky, you get to send them via email," so you can cut and paste. But "some places—like Google—have these onerous web forms" that require you to fill out every single line: name, address, and so forth. Google, she said, "puts as many roadblocks into the process as possible." Seidler filed takedown notices by the thousands. But takedown doesn't

mean stay down. "Some sites, like Megaupload, eventually implemented trusted user accounts, where you could go in and delete the links en masse, but yeah, they removed the link, but they didn't remove the file, and they generated a new link within hours." The takedown system is an analog remedy for a digital affliction. "It's like standing under Niagara Falls holding an umbrella," Seidler said.

But wait, there's more. Google, through Google Drive, enables users to set up blog sites—some of which are themselves used for piracy (a site for gay and lesbian films, for example). The DMCA includes a "repeat infringer" clause, but as Seidler discovered, hosting links on your blog site to, say, thirty-five gay and lesbian films does not constitute repeat infringement. A creator has to file three different notices, each separated by at least forty-eight hours, to establish a site as violating the clause. At the time we spoke, Seidler had recently come across a Google Drive site with nearly a thousand films. She had sent the notices to Google, waiting the appropriate amounts of time between each, but several weeks later, the site was still up. Google, of course, is not only the leading abettor of piracy, it is its largest beneficiary, especially since it also owns YouTube. "Google does what Google wants to do," she said.

That's for sure. The company has become the biggest corporate lobbyist in Washington. As part of its efforts to control legislation and influence public opinion, it also engages, like other tech giants, in massive funding of supposedly independent policy institutes, including the Electronic Frontier Foundation (EFF), a think tank that was founded, in part, by individuals from the tech industry. In 2001, the EFF and others established the Chilling Effects archive to document the allegedly negative impact on free speech of copyright enforcement. (Now called Lumen, the archive is hosted at the Berkman Klein Center for Internet & Society at Harvard.) Chilling Effects took off in 2002 when Google started forwarding its DMCA notices for posting on the site—notices, of course, that include the offending links that were supposed to have been taken down. That's right: when Seidler filed her notices with Google, it may have taken down the links, but then it sent them to Harvard, where they went right back up again. So she filed a takedown notice with Chilling Effects itself, but Harvard filed a counternotice, which anyone can do on any pretext. Her only recourse, at that point, was the extremely expensive option of initiating a federal lawsuit.

* * *

Piracy isn't a victimless crime. The claim that people only pirate content that they wouldn't have paid for in any case, a common argument, has no verifiable basis. Academic studies of the loss of film sales due to piracy, as I mentioned in chapter 4, put the figure between 14 percent and 34 percent. We know what happened to music with the advent of Napster; if piracy had not been leaching revenue, the industry wouldn't have crashed. After Seidler's summer of scrubbing, she told me, her distributor documented a noticeable bump in sales. And independent movies—as well as independent artists or, in other words, artists—operate on narrow margins at the best of times. Even if piracy represents a loss of only 5 percent, Seidler said (though she believes that it's a great deal more), that is the difference, for her and Siler, between breaking even and losing money. Seven years after their film came out, the two were still about $30,000 short of covering their costs—which is to say, of making their first dollar from the movie that they worked on for three or four years.

Piracy *is* an invisible crime. The movies that are most affected are the ones that don't get made. If you lose money on your film, you're much less likely to make the next one. If you *know* you're going to lose money, you're not going to make one at all. Remember how movies are financed: with forecasts of profit and loss. When piracy cannibalizes not only sales of DVDs but also revenue from streaming, a movie that cannot secure a large theatrical release is a movie that has much more difficulty getting funded. "It's the little indie films like ours," Seidler said, "where we're totally dependent on the back end, that are most vulnerable." And since the world of indie films, she's pointed out, is much more representative than Hollywood, piracy also hurts diversity.

Piracy hits Hollywood as well, of course. It is one of the reasons that the industry continues to drift in the direction of blockbusters, movies that can still sell lots of tickets—ideally during gargantuan opening weekends, heralded by saturation publicity, in thousands of theaters simultaneously around the world—before the pirates have a chance to go to work. Piracy is one of the reasons that studios make fewer films, that arthouse divisions have closed, and that mid-budget movies are so difficult to do. Yes, Seidler has said, there's still a *Moonlight* every now and then,

but how many *Moonlight*s will we never get to see? Defenders of piracy like to say that Hollywood needs to adapt to the new world. Well, it has.

And when Hollywood is hurt, everyone who works for it is hurt. The industry is, precisely, an industry. For each executive and every movie star, there are hundreds of ordinary people supporting themselves and their families on middle-class and working-class incomes: carpenters, makeup artists, production assistants, sound technicians, regular workaday actors, and on and on—the folks who populate the village that it takes to make a film. That is why, in 2014, a coalition of individuals, entertainment companies, and labor unions founded CreativeFuture, an advocacy group designed to push back against the tech industry and its fellow travelers at places like the EFF by raising awareness about issues of piracy and copyright. The group comprises entities and individuals—studios and screenwriters, for example—who are often inevitably at odds, as labor and management always are, but they recognize a common enemy in the industry that robs them of much of the money that they'd like to return to fighting over.

Since its founding, CreativeFuture has expanded to other copyright-dependent industries. (As of this writing, the alliance includes some 550 companies and organizations and 220,000 individuals.) Because piracy, of course, is not just a problem in film. It affects TV, as well: *Game of Thrones*, like many hit series, was heavily pirated, which means less money for HBO to develop new shows; *Hannibal*, which ran on NBC from 2013 to 2015, appears to have been pirated out of existence. Piracy continues to exert a devastating effect on music, services like Spotify notwithstanding. CreativeFuture estimates that about $7 billion worth of music is pirated each year in the United States, as compared to about $10 billion that's actually paid for. With e-books and print-on-demand, piracy is now a growing problem for large commercial presses and self-published authors alike (as is the related problem of the online sale of counterfeit print books). Also vulnerable, and also affected, are designers, photographers, and anyone else whose livelihood depends on putting images online. Defenders of piracy invariably characterize the artists it hurts as rich rock stars (or, more recently, rich pop stars) who can afford to take the hit—a group whose number, within the universe of people whom it actually hurts, would not even show up as a rounding error. As of 2015, according to CreativeFuture, core copyright industries

employed about 5.5 million people in the United States alone. You've met dozens of them in the pages of this book.

* * *

There are a lot of arguments against copyright and in defense of piracy, and all of them stink. To wit:

"Piracy is free speech." No, piracy is theft. Ripping a music file and posting it online is no more an act of free speech than stealing a stack of magazines and handing them out on the corner.

"I don't want to pay for something until I know it's good." That isn't how it works with any other product or service: a bicycle, a yoga class, an apple. Besides, if it does turn out to be good—the song, the movie—do you pay for it then? I didn't think so.

"Labels rip off artists." So that means that you can, too?

"Intellectual property isn't really property." This isn't so much an argument as it is a confession of ignorance. Property does not have to be a thing. In fact, it isn't a thing; it's the right to do things with a thing. As Lewis Hyde puts it, quoting an old definition, it is "a right of action." My car is my property because I get to say what happens with it. Copyright is the right, precisely, to make a copy. When you infringe that right, you aren't stealing the copy, you're stealing the opportunity to profit from that right.

"Digital copies cost nothing to make, so I'm not depriving anyone of anything." We just went over this.

"Piracy is not a loss but a 'lesser gain'" (that one's from Chris Anderson in *Free*). A lesser gain *is* a loss, especially when sales are needed to recoup expenses (as they usually are).

"Copyright inhibits innovation" (a favorite of Silicon Valley's). Has there been a dearth of innovation since the institution of copyright (and its scientific sibling, patent) over the last two or three centuries? Quite the opposite.

"For most of human history, ideas were free." We saw this in chapter 3. Yes, ideas were free, because the people who created ideas, or made art, were supported by patronage. And in part as a result, the pace of innovation was glacial.

"Copyright is too expensive to enforce" (another favorite of Silicon Valley's). Too expensive for the tech industry? Please. That's what they say about privacy. It isn't too expensive; they just don't want to do it.

"Information wants to be free." Ah, the old chestnut. Stewart Brand said this in 1984, and the techies have been waving it around like holy writ ever since. But there are two problems with the idea, at least as typically deployed. First, information doesn't "want" anything. The statement is a classic example of the tendency to naturalize social arrangements: to treat as eternal and inevitable that which has been created, temporarily and contingently, by human beings. Markets are not naturally occurring phenomena, despite what the free marketeers like to think. They are structured by state regulation, which is itself the evolving product of competing interests within society. Which brings us to the second problem. What Brand actually said was this: "On the one hand, information wants to be expensive, because it's so valuable . . . On the other hand, information wants to be free, because the cost of getting it out is getting lower and lower all the time. So you have these two fighting against each other." Exactly: fighting against each other, and government needs to intervene to ensure the fight is fair—and it has gotten a lot less fair since 1984—as well as conducted for the benefit of society as a whole.

"It's better to work for free." We also saw this one in chapter 3: making art is like giving blood, amateurs are superior to professionals, yada yada yada. The example that's invariably cited is the open-source-software movement, where programmers voluntarily write and share code. Open-source is admirable. It's also only possible because the people who participate already make a lot of money at their day jobs. It's easy to be an amateur, when you're a professional.

"Art is a gift." Lewis Hyde's famous formulation, which faces in two directions: art is something that artists give to others without expectation of reward, and art is something that is given to artists from mysterious sources. Art does not come *from* you, the latter idea would have it, it comes *through* you. Maybe so—the notion is a survival of the old belief in divine inspiration—but there's another way to turn it. Art comes *through* you, but it also comes through *you*. It doesn't come through anybody else. You're the one who's in the room; you're the one who did the work to make yourself receptive. As for the other sense in which art is a gift: yes, and a gift is something that is freely given. Piracy is not a "gift." If artists want to give their work away, it should be *their* choice, not the Internet's.

One final argument, my favorite. "Nothing is original. Everything is

a remix." This is a banality that grew up to become a stupidity. That new creations build upon existing ones—that nothing is ever completely original—has long been a cliché, the proof texts predictably being Newton's statement that he "stood on the shoulders of giants" and T. S. Eliot's dictum (though this is not quite what he said) that "all poets borrow." But the tech philosophers have gotten hold of it and stretched it to mean that nothing is *ever* original, that creation means, and only means, the rearrangement of existing parts. Which makes you wonder how we ever managed to progress from the first painting in the first cave. Assisting them in these arguments is the concept of the "meme," the idea that elements of culture propagate themselves from mind to mind, just as genes do from body to body. But the meme hypothesis (if you can even call it that) fails to recognize that minds, unlike bodies, are capable of intentionally altering their contents: are capable, in other words, of thought. We don't just passively transmit ideas and images; we evaluate them, modify them, and generate new ones. Or, at least, we can.

In any case, the same example of artistic borrowing is inevitably adduced in this connection: Shakespeare's appropriation of Plutarch's description, as translated by Sir Thomas North, of Cleopatra's arrival for her first encounter with Mark Antony. It is always the example, because it is the best example, at least in Shakespeare, and because the people who cite it clearly never bother to actually look at it. You might say that it's a meme, propagating itself from brain to brain without the intervention of thought. Even Lewis Hyde, who should really know better, remarks that "Shakespeare's description [is] copied nearly verbatim." So let's compare the two. This is the start of the passage in North:

> . . . a barge with gilded poop, its sails spread purple, its rowers urging it on with silver oars to the sound of the flute blended with pipes and lutes.

And here it is in Shakespeare:

> The barge she sat in, like a burnish'd throne,
> Burn'd on the water: the poop was beaten gold;
> Purple the sails, and so perfumed that

The winds were love-sick with them; the oars were silver,
Which to the tune of flutes kept stroke, and made
The water which they beat to follow faster,
As amorous of their strokes.

See if you can spot the difference. The surface details come from Plutarch. The meter, the similes and metaphors, the perfume, the sexplay (the water says, "hit me again"), the governing conceit (nature dizzy with desire)—all these come from Shakespeare. Plutarch reported it; Shakespeare imagined it. And that's the best example that the remixologists can find in him. So much for "borrowing." Here's what Eliot really said: "mature poets steal . . . and . . . the good poet welds his theft into a whole of feeling which is unique, utterly different from that from which it was torn." Unique. Utterly different. Original.

The arguments that I have just enumerated all have several things in common. First, none of them existed before Napster. In other words, it did not occur to anyone that it was acceptable to rip off people's work until it was easy to do so. Arguments against copyright are ex post facto rationalizations of a system of organized theft. Second, they are generally conducted in bad faith. The tech industry rails against copyright, but extend the same logic to the intellectual property that *it* produces and owns—computer code, patents—and see how fast it does a back flip. As for individual users, Ellen Seidler documented what occurred when Instagram announced, three months after Facebook had bought the platform, that it was going to change its user agreement to enable it to monetize the pictures people post: everyone freaked out. "My photos will not sell without my knowledge and compensation," one individual wrote. Finally, somebody gets it. Everyone's a communist, with other people's property. The same may be said of academics who write hymns to piracy from the safety of a tenured position. Ditto those who are happy to give their work away for free (many of whom are also academics) because no one would pay for it anyway.

Finally, these arguments—undertaken as they are, by and large, by legal scholars, tech-friendly journalists, techies, and laypeople—are conducted in blithe ignorance of the actual conditions under which actual artists actually make their work. That is why the only artists who appear

in them are rich pop stars like Justin Bieber. Musicians work for love, writers will write for free, amateurs make better art: all of this is baby talk, make-believe. People who think piracy is fine, whether they are advocates or simply users, are like little kids who think that food just magically appears on their plate, without their parents having to work for it. It's time they grew up.

* * *

The basic argument for copyright remains the same as always. It's not that it's fair for individuals to benefit from the things they create (though it is). It's that we all benefit. Copyright incentivizes innovation by enabling creators to reap the rewards of their labor. That is why the right is right there in the Constitution. "Congress shall have power," the document states, "to promote the progress of science and useful arts, by securing for limited times to authors and inventors the exclusive right to their respective writings and discoveries." Abolish copyright, and you abolish the ability of creators to receive a return on their investment, whether that investment is the billions of dollars that HBO spends on original programming, the money Ellen Seidler put into her film, or the years that a novelist devotes to a manuscript.

Copyright also entails "moral rights," the right to protect the integrity of your work in both senses of the word. Daniel Defoe, the author of *Robinson Crusoe* and the first great champion of copyright, opposed the pirating of printed works, in part, because the resulting copies were often corrupt (that is, full of errors), just as pirated content is today. As for integrity in the other sense, without the moral rights that copyright protects, you could not stop Donald Trump from playing your songs at his rallies, or Walmart from using them in its commercials. Pete Seeger copyrighted "We Shall Overcome" for exactly such reasons.

Copyright can certainly be abused, especially by entertainment companies with lots of lawyers on their payroll. Lawrence Lessig documents a number of cases in *Remix*, a book that inveighs against copyright law as it currently exists, as does Lewis Hyde in *Common as Air*, his own book on the subject (and the one that I've been quoting in this chapter). It may well be that the term of copyright should not have been extended from the life of the author plus twenty-eight years to life plus seventy years; that corporations have been overzealous in pursuing infringement

by ordinary individuals, especially in cases of informal creative use (the kinds of things that people like to throw up on the Internet); that heirs and estates have unfairly blocked the use of work by great dead artists; and that companies are trying to privatize ever-greater portions of our collective cultural heritage (Hyde's particular concern). We can debate these issues, and amend the law as needed.

But the important point for us, in this book, is that they are utterly irrelevant to our concerns. Pirates do not sample or remix; they copy the whole thing. Pirates do not target the works of the past, or the dead. They target the new and the living. In fact, both Lessig and Hyde affirm the basic principles of copyright. "Copyright is . . . critically important to a healthy culture," Lessig writes. "If it takes me ten years to write my novel," says Hyde, "it is right and proper for the law to help me earn my rewards." Hyde is seeking, quite properly, to protect the cultural "commons," the accumulated body of art and thought that sustains our minds and souls, our societies, and that belongs to us all. But there can be no surer way to devastate those commons than by choking off their replenishment by fresh acts of imagination. Just as there is no future, in culture, without a past, neither is there a past without a future. And the pastures of culture—whether we like it or not—are watered by money.

That was true before the age of copyright, as well, which brings us to the final reason to support it. We came across this circumstance in chapter 12: prior to copyright, the wealth that funded culture came from patrons, who therefore had a veto over art and thought they didn't like. By allowing authors to pursue their living in the marketplace, copyright emancipated them from those restrictions. The very term "freelance" ("free lance") is rooted in the idea of freedom from feudal subordination. Copyright gave legal form to the recognition that authors were, in fact, "authors," the sole originators of their work, and thus entitled to control it.

And authorship itself, as the concept was emerging at the time, embodied a momentous—ultimately, a revolutionary—new idea: that individuals themselves, using nothing but the power of their own minds, could bring new meanings into the world. That we no longer needed to rely on—to trust, to obey—established authorities. That we could authorize our own thoughts and actions, including our thoughts about the proper constitution of government and the actions we should take to

form it. Copyright was a component of the matrix of ideas and institutions that liberated society from church and crown. Ending it would not increase our freedom—not really, not practically. It would only ensure that culture fell under the scepter of the great contemporary power in society, the power of concentrated wealth. Art would be made either by the rich or for them.

* * *

It is the power of concentrated wealth, of course—the power of Silicon Valley—that is at the root of much of what I've been discussing in this book. There's still a lot of money in the arts economy; it just isn't going to artists. The issues go way beyond piracy, way beyond copyright. Silicon Valley in general, and the tech giants in particular—above all, Google, Facebook, and Amazon—have engineered a vast and ongoing transfer of wealth from creators to distributors, from artists to themselves. The cheaper the content, the better for them, because they're metering the flow—counting our clicks and selling the resulting data—and they want that flow to be as frictionless as possible. This didn't all just happen by itself.

Google, to begin with, doesn't just enable piracy by hobbling the takedown process. As Jonathan Taplin reports in *Move Fast and Break Things*, YouTube, one of Google's most valuable subsidiaries, was built on piracy, in conscious, even gleeful violation of the DMCA. One of the statute's key components is its "safe harbor" provision. Platforms aren't considered liable for the presence of infringing material as long as they are not aware of it and do not profit from it. But from the beginning, YouTube's founders knew perfectly well that people were posting stolen content. In fact, they counted on it. It was the professional stuff—pirated Hollywood movies, not amateur videos—that would generate traffic, that enabled the company to outcompete Yahoo! and others, and that led to its acquisition by Google, less than two years after its founding, for $1.65 billion. That is some serious profit indeed.

Facebook also benefits from piracy. A 2015 study found that of its 1,000 most popular videos, 725 had been posted illegally. So does Amazon, where those counterfeit books are a growing presence. But for Silicon Valley, piracy's greatest benefit may be its indirect one. As we saw in chapter 8, the standing threat of piracy—the threat that content can be

priced at zero—enables the distributors to price it at pretty much what-ever they want. Piracy is the reason that labels and musicians are willing to accept the fractional pennies of streaming—indeed, to remain in the dark as to what the streaming rates actually are. And remember that as low as the rates appear to be on Spotify (0.44 cents) and Pandora (0.13 cents), they are lowest of all on good old YouTube, a larcenous, insulting 0.07 cents, or $700 for a million streams.

Both YouTube and Facebook could screen for piracy, just as they do for pornography. Google could effectively destroy the pirate sites, Taplin notes, by "disappearing" them from search results, just as it was forced to do (after paying a $500 million fine) for sites that illegally market phar-maceuticals. It could certainly implement user-friendly takedown tools, as Ellen Seidler said. But none of these companies are going to do any of those things until they are compelled by something stronger than the occasional measly nine-figure fine. Piracy is just too lucrative for them. As of 2019, YouTube generated an estimated $30 billion in annual revenue, making it worth as much as $300 billion.

More broadly, the sheer market power of the tech goliaths lets them dictate terms. We already saw this with Amazon with respect to both publishing companies and self-published authors. With Facebook, it takes the form of stealing your traffic, then charging you for access to your audience (as anyone who's been invited to "boost your post" is aware). Bands once maintained their own sites, for example. Once every-body's eyes were glued to Facebook, they had no choice but to move their pages to the platform. Google's image search is likewise designed to siphon traffic away from photographers' own sites. As David Lowery has put it, disintermediation, the Web's great promise of direct access to fans, has become "re-intermediation."

The vast reserves of wealth at Silicon Valley's disposal also enable it to undersell and undermine the competition. Again, we saw this with Ama-zon, which treats both books and video content as loss leaders, ways to sell Echos and subscriptions to Prime. But a lot of the wealth in question does not belong to the tech companies themselves; it belongs to the ven-ture capital firms that have played a crucial role in the industry's growth and dominance. VC funding is what has allowed corporations like Ama-zon and Spotify (or, most obviously, Uber) to run at a loss for years on end. The model, invariably, is this: aggressively build market share with

subsidized products or services (Uber still loses money on every ride); kill off rivals, including those in the existing industry that you're "disrupting" (books, music, taxis); secure a monopoly. Once you've done that— once you are Facebook or Amazon—you can do whatever you want.

Venture capital, I was told by Steve Greenberg, the producer, has created "a big distortion in the market for content" over the last couple of decades. Greenberg likes to say that there are three kinds of "free," three ways that content is available at no cost to the consumer: piracy free, ad-supported free, and what he calls "Internet free"—free "because somebody's pumping billions of dollars into a company to keep it afloat until it gets enough critical mass" (that is, until it becomes a monopoly). Together with piracy, Greenberg said, venture funding has created the feeling that content will and should be free, a feeling that has proved so damaging to the arts. "It gave the public the false impression that things could actually be had for free in a sustained fashion," he said. Information, in other words, *looks* like it wants to be free, but only because it's backed by hidden funders or is generating hidden profits.

Finally, Silicon Valley uses its immense power and wealth to control the policy debate on issues of copyright, piracy, intellectual property, and the virtues of "free." The Electronic Frontier Foundation is only the tip of this particular iceberg. "Many of the most prominent organizations advocating for the free culture agenda," writes Astra Taylor in *The People's Platform*, "take funding from firms such as Google." A 2017 investigation by the *Wall Street Journal* found that "over the past decade, Google has helped finance hundreds of research papers to defend against regulatory challenges of its market dominance, paying $5,000 to $400,000 for the work." The strategy, an example of "intellectual capture," is reminiscent of comparable campaigns by the tobacco industry, the fossil fuel industry, and others to discredit inconvenient scholarship.

And with its image as the good guys (one that's justly dead at last), Silicon Valley has long been adept at mobilizing public support. In 2012, Congress was poised to pass legislation designed to curb the pirate sites, bills known as SOPA and PIPA. In a matter of weeks, using its unrivaled access to the public, the industry orchestrated a massive online protest that destroyed the legislation. Very few of the millions of people who signed those petitions, it is fair to say, had any clear idea of what they

were doing. I know, because I was one of them. No one understood what SOPA and PIPA actually were; we just knew that they were bad. After all, the Internet had told us so.

* * *

Silicon Valley and its academic allies like to portray the battle over free content as one that pits individual users against Big Media. It is more accurately described as one that pits individual artists against Giant Tech—or, to be precise, individual artists plus Big Media against Giant Tech. The media companies are indeed big. As of this writing, the total market value of Big Media's Big Five—Disney, AT&T, Comcast, ViacomCBS, and News Corp—was $772 billion. But the total value of the Big Five in tech—Microsoft, Apple, Amazon, Alphabet (the parent company of Google), and Facebook—was $5.5 trillion, more than seven times as much (and larger than the GDPs of all but two countries). Those are five of the six largest corporations in the world, and the first four are each larger than all of Big Media combined. Their size, moreover, knows no theoretical limit. The corporations of old, by and large, sought to dominate individual industries. NBC did not go into retail, and Macy's did not compete with Ford. But tech wants to dominate everything: communications, media, retail, transportation, even (in the form of Facebook's cryptocurrency, Libra) money itself.

In the arts, however, tech does not eliminate existing producers—creation can't be automated—it exploits and immiserates them. Jonathan Taplin estimates that between 2004 and 2015, about $50 billion in annual revenue "moved from the creators of content to the owners of monopoly platforms." For that, finally, is the central issue here. Free content, as Ellen Seidler discovered, is incredibly lucrative. Content has been demonetized, but only at the point of sale. For those who are counting the clicks, it's a gold mine.

The question is, is there anything that can be done about it—about the baleful behavior of Big Tech, and about the crisis in the arts economy more broadly? That question is the subject of my final chapter.

DON'T MOURN,
ORGANIZE

There is no single answer to the problems of the arts economy. There are only lots of partial, little ones. To the extent that there are larger answers, they lie outside the arts entirely. To fix the arts economy, in other words, we need to fix the whole economy. Which means, since the only effective response to the power of concentrated wealth is the power of coordinated action, we need to organize.

But to start with—because the smaller answers matter, too—artists need to organize. Fortunately, some already have. Here's a rundown of the more important efforts that I came across in researching this book. A few we have already touched upon. Ellen Seidler became an anti-piracy activist, speaking widely and blogging at voxindie.org. The Authors Guild, the oldest and largest writers' organization in the country, spent ten years suing Google over the epic act of copyright infringement entailed in the creation of Google Books. CreativeFuture, the advocacy group for television, film, and other industries, also works to combat content theft—in part by educating legislators, in part by working with advertising agencies to remove the latter's clients from the pirate sites. If you go to those places today, Seidler told me, all you see are ads for porn, games, and malware.

The goal of the Artist Rights Alliance, the musicians' group formerly known as the Content Creators Coalition, is "making sure the artist's voice is heard in [the policy] process," I was told by Melvin Gibbs, then the organization's president. The first time he spoke at the federal Copyright Office in Washington, he said, "I was literally the only artist in the

room"—a room that was otherwise full of lawyers from the labels and the tech industry. "There were a lot of people *saying* they were speaking for the artist, but there was no one who was actually speaking for the artist." At the same time, Gibbs makes no apologies for working, when necessary, *with* the labels. "We're standing next to people because that is the only way we're going to actually be able to make this thing work," he said. The ARA and its allies scored an important victory in 2018 with the passage of the Music Modernization Act, which improves the way that songwriters are paid by streaming services; establishes a uniform copyright for recordings made before 1972; and ensures that a portion of royalties goes to producers, engineers, and others involved in the creative process.

W.A.G.E. (Working Artists in the Greater Economy), Lise Soskolne's group, decided that the way to make a difference was to choose a relatively narrow goal and work at it relentlessly. They opted to focus on a crucial but neglected aspect of the art world: the relationship between artists and the museums, art spaces, and other nonprofits that exhibit their work. W.A.G.E.'s key insight was that artists provide these institutions with an enormous amount of labor in the form of educational programming. They give talks, presentations, and readings; participate in discussions and workshops; stage performances; hold screenings; and furnish texts for publication—and typically, this work is paid haphazardly and arbitrarily, when it is paid at all. Participating in an exhibition also takes work, as well as arriving with out-of-pocket costs—and typically, ditto.

W.A.G.E.'s response was to set up a system of fees. The group created a table of minimum rates for use by smaller institutions—$1,000 for a solo exhibition, $100 for a talk, and so forth—plus a formula for calculating rates for larger ones. Then it established a program of certification in which institutions agree to abide by the formulas. As of this writing, fifty-eight institutions, mostly smaller ones, have agreed to join. The program also includes a parallel certification for artists, one that recognizes their role as employers of labor, as well—specifically, of studio assistants, a job that's infamously underpaid. W.A.G.E. sets an hourly rate of $25 for studio assistants in New York—remember that the rate can be as low as $11—with downward adjustments, based on cost of living, for other locations. W.A.G.E.'s goal, Soskolne has said, is to ensure

that everyone involved in the circulation of art gets "our fair share of the obscene amount of money" that that traffic involves. And by everyone she means not only artists and assistants but also handlers, guards, carpenters, janitors, waiters, and more.

Persuading artists to organize is not always easy. To be a worker, Soskolne has said, is to be the same as everybody else, whereas much of the value of being an artist, psychologically, lies precisely in feeling exceptional. (It was an effort by the motion picture industry "to stave off . . . unionization" during "the early days of Hollywood," Ben Davis writes in *9.5 Theses on Art and Class*, that led to the convention of referring to actors as "artists.") When artists who had previously supported W.A.G.E. begin to reach a certain level of success, Soskolne has noticed, they tend to distance themselves from the group. "Everybody thinks they have a right to [their] position, that they have earned it," she told me, "and they fight tooth and nail to stay there."

Artists also often fail to recognize their common interests. The field is inherently competitive, plus it is highly dispersed. The work, as Susan Orlean, the journalist and author, has noted in reference to writing, is also neither uniform nor standard, and no one knows what anybody else is getting. To address the latter problem, several websites, including whopayswriters.com and contently.net, have crowdsourced freelance rates and other information. But in an age when writers are essentially in business for themselves even when they have a regular position at a publication, competing with the people sitting next to them for clicks, organizing, I was told by Tammy Kim, the labor journalist, becomes that much more difficult. Still, staff have been voting to unionize at a growing number of media organizations both "old" and "new," including the *Chicago Tribune*, the *Los Angeles Times*, the *New Yorker*, *HuffPost*, *Vox Media*, *Vice Media*, *Slate*, *Mic*, and *Fast Company*.

The biggest obstacle to organizing may simply be the sense that "this is just the way things are," a sentiment I heard from many younger artists, especially musicians. Most people, I was told by Melvin Gibbs, don't think about the big picture. "They just kind of put their heads down and start running," he said. "This is the thing about organizing: it takes people to get to that pain point where they're like, 'Okay, this really hurts.'"

* * *

But artists, as I have explained, are not just workers. They are also miniature capitalists: people who produce and sell their work on the open market. Here, too, they are organizing. More than one plan is afoot, for instance, to develop a blockchain registry (the same technology that's used in cryptocurrencies like Bitcoin) to redress a long-standing, and especially galling, injustice: the absence of a resale royalty for art. When someone buys a work of yours, then sells it ten years later, say, for five times as much, you don't see a dime of that, even though it is usually your own continued productivity—the value of the work that you did in the interim—that is responsible for that appreciation. A registry would enable artists to retain an equity stake in their work (that is, a fractional ownership share), the usual figure proposed being 15 percent. One version is being developed by Amy Whitaker, the writer and educator, in collaboration with others, a second one by W.A.G.E. The latter would also include a set of moral rights: the right to have input into how the work is shown, to get it back for a couple of months every year, to block its use as a financial instrument. The point is to establish the principle that a work of art is not merely another commodity.

A number of organizations are simply trying to enable artists to operate in the market free from subservience to the likes of Facebook and Amazon. One is CASH Music (the name stands for Coalition of Artists and Stakeholders). CASH, a nonprofit, creates free, open-source digital tools. "Anything an artist needs," explained Maggie Vail, the organization's executive director, "to connect directly with their audience on their own website": a shopping cart, tour-date management, email-list management, etc. "The music industry loves to build up middlemen," she said. The goal of CASH is to clear them out by pushing fans to an artist's own site—undoing, in other words, what David Lowery called re-intermediation. And that way, crucially, the artist also owns the data. It's theirs to do with as they wish, and it can't disappear if the middlemen do.

Because the tools are open-source, musicians can adapt them any way they want (or get CASH to help them do so), and because they're free, the organization doesn't even need to know that you're using them. Its most successful client has been Run the Jewels, the hip-hop duo, which has built an email list that, at the time I spoke with Vail, ran to seven hundred thousand names. "That's one of the largest ones in the music industry," she said. "You can build a career on that sort of thing." Run the

Jewels, it should be said, began to build its list through Topspin, a for-profit version of the same concept that was later bought by Beats, sold a month after that to a private equity group (a month before Beats itself was bought by Apple), and is now, Vail told me, essentially shuttered. Which is often the way things go in the for-profit world.

Often, but not always. Smashwords was not the first free self-publishing platform, I was told by its founder, Mark Coker, but it was the first not built around selling services to authors. It also doesn't sell its data, nor does it sell ads. "Ads create friction," he said. "They annoy people. They get in the way of people doing stuff that they want to do. I really wanted to force us to build a business around selling books." So Coker borrowed what was best, he said, in traditional publishing and monetizes only through commissions, a percentage on each book sold. The site is also honest with potential authors. You probably won't sell a lot of books, it says, because there's too much competition.

Developing the platform, said Coker, who has a background in Silicon Valley, cost tens of millions of dollars. Self-published e-books, he explained, are "dynamic, living creatures," not "static objects" like printed books. The price can change, the text can change, the cover, the title, etc., all as often as the author wants. So Coker needed to construct a system that could manage that "chaos," as he put it, as well as creating an efficient, instantaneous interface between a myriad of books and a multiplicity of sellers—Apple, Sony, Barnes & Noble, and more. Coker funded the development himself. Two years in, growth was rapid and profitability was within sight, but, he said, "I had used up all of my life savings. I had maxed out the line of credit on my home. And so I did what any self-respecting adult would do. I called my mom." His mother declined to invest, but she did provide a loan against a rental property he owned. Coker refused to accept venture capital, he told me, because "VCs are vultures." Every conversation he has had with one (and he's had a great many) "has left me," he said, "with just a horrible taste in my mouth." VCs would have pushed him in the direction of "selling expensive, overpriced services to authors," he explained. "I wanted to be different."

Jen Bekman's approach is also different. Bekman founded 20x200, an online store for high-quality art prints. The name comes from her main initial product line: editions of 200, sized at 8" x 10" and priced

at $20 each. (There are also larger, more expensive formats.) This isn't "wall decor," Bekman explained, the kind of thing you'd pick up at West Elm to match the sofa. This is art: museum-quality prints, in exclusive editions, created by contemporary artists and accompanied by both an artist statement and a signed certificate of authenticity. In galleries, they'd sell for many times as much. The company's motto is "Art for Everyone." Bekman's goal, she said, is to enable ordinary people to collect—people who never thought they could, who don't know how, who are intimidated by galleries, who feel insecure about their opinions about art or don't believe they have a right to have them.

Bekman also wants to be of benefit to artists. "Artists make work, make a life as an artist, at incredible personal expense," she said. At the same time, "there's all this amazing art out there that doesn't have an audience." The art world, she explained, "has subsisted on scarcity for its entire existence, [but] more than ever, that scarcity is a myth. It's manufactured." To struggling galleries that are nervous about letting their artists participate in 20x200 because they're afraid that she is trying to take their business, Bekman says, "I don't want your pie. I want to make the pie bigger." Yes, artists today have an unprecedented opportunity to build an audience and sell to it directly, she said, "but if the only art that's getting seen is being made by people who are good at marketing, that's really problematic. In a perfect world, I take all that shit off their hands, so that they can spend more time making art. Because *that's* the thing that they can do that nobody else can do."

* * *

Caroline Woolard wants to make it possible for artists to step outside the market altogether. Woolard is a visual artist, organizer, and educator. Some years ago, she found herself wondering why she couldn't get her favorite band to play in her studio by some means other than paying them. She ended up trading a performance for a work of art, plus a day of spackling and sanding. The exchange evolved into OurGoods, "an online barter network for artists, designers" and others, founded by Woolard, three other artists, and a computer programmer. By matching "haves" with "needs"—e.g., "I can help you write a grant if you make my costumes"—the platform not only enables creators to exit the cash economy, Woolard has said, "It helps us honor and value our work. It

draws the creative community together into mutually supportive relation-
ships . . . It replaces the zero-sum funding game with a game of 'the more
you get, the more I get.'"

In 2010, OurGoods publicized itself with a pop-up space on the
Lower East Side called Trade School, where people bartered for knowl-
edge. Trade School, in turn, developed a life of its own and now exists
as dozens of independent local cooperatives around the world. Each is
an attempt to envision what education might look like if it weren't being
run on a pay-for-play basis. Each is also an example, Woolard said, of the
kind of "informal network where we actually learn how to show up for
one another when no one asks us to, except each other."

Showing up for one another is also the idea behind the XOXO festi-
val, an annual event for independent creators in Portland, Oregon. The
name means exactly what it does at the end of a text. The point, said
Andy McMillan, one of the festival's founders, is to create a "loving, sup-
portive community"—a place to "talk about the difficulties of working
as an independent, creative person on the Internet. It's a whole bunch
of people who work by themselves, but when we're together, we are a
community of people living similar experiences. It's become a support
group that we all get to go to once a year, and it makes it easier to get
through the rest of the year."

McMillan grew up in Belfast and became a freelance web designer
back when that was something new. Web designers had their own events,
and he was there, he told me, when the money arrived and ruined them:
"sponsored speaking slots, very aggressive marketing, tote bags full of
garbage. Our attention was being sold off to the highest bidder." So at
XOXO, he and his partner, Andy Baio, decided to try something differ-
ent. Companies are "patrons," not sponsors. There is a limit of ten. The
organizers choose ones in the community that they already like and invite
them to provide things, McMillan said, that make the festival "more wel-
coming or inclusive": childcare, a nonalcoholic bar, live transcripts of
the talks. Acknowledgment is subtle and low-key. There is no recruit-
ment, no marketing materials, no logos stamped all over everything, no
swag. "Doing something generous quietly," McMillan told me, is "much
more valuable"—for the companies, too—than "doing something boring
loudly."

Organizing also takes the form of books or films, specifically when

they are used as platforms for public conversations. Sharon Louden's collections of essays by working artists—*Living and Sustaining a Creative Life*, *The Artist as Culture Producer*, and other volumes still to come—are inseparable from the events that she organizes around them. The tour for *Living* had 62 stops; the one for *The Artist*, 102. The occasions—which are panels, not readings, Louden plus a group of local artists—are as much about building community as they are about raising awareness. Louden is a force of nature, with a voice like a bear hug. "Artists helping artists—that's what it's about," she began the event I went to by declaring. "How many people in the audience are artists?" Lots of hands went up. "Yes," she said, "I love all of you." Later, she urged the assembled to ask themselves what they need and what they want, then stand up and tell the rest of us. "What happens on this tour, when artists do that," she explained, is that "somebody in this audience may be able to answer that question"—supply a need or want that someone else articulates. People, she went on, have gotten jobs, exhibition opportunities, press coverage. "It's been extraordinary," she said, "but it's not surprising, because when we as a collective support one another, things happen."

Rain Perry, the DIY singer-songwriter, has organized something comparable to Louden's tours, building a "community screening campaign" around *The Shopkeeper*, her film about the Austin producer Mark Hallman and, by extension, the financial plight of music and musicians in the age of streaming. Perry described the film as "an epitaph for the way it used to be." She made it, she told me, for two reasons. First, to "allow people who are from the old model to understand that it's really over," so they are able to properly grieve. Second, "to snap people out of it," so they can start to think about what needs to happen next.

Scott Timberg, the journalist who published *Culture Crash: The Killing of the Creative Class* in 2015, told me that his tour events would often prompt a similar catharsis. "For people who had the ground pulled out from under them," he said, who lost their writing job or their gallery, "what I often heard from them was, 'You helped explain to me what happened. You gave me the sense that it wasn't my fault, that it was part of a larger process.'" That they weren't a failure, in other words, and that they weren't alone. Which, needless to say, is part of the purpose of this book, as well.

* * *

Can we, the audience, do anything? One proposed solution that I came across repeatedly involved the idea of moral persuasion. The analogy, invariably, was to the food movement. People are willing to pay more for local or organic or artisanal food because they understand that it's better not only for them but for the world. So too should they pay for music and other forms of content (including journalism). There is much to be said for this idea. One of the conspicuous developments of our time has been the move toward more responsible consumption, which begins with raised awareness. If we knew more about the way things worked online, as Maggie Vail, the head of CASH music, has said, "we would start to make very different choices about our online behaviors." Indeed, that is another purpose of this book. Just as there are animals and farmers at the other end of the food supply, so are there human beings—not corporations—at the other end of the art supply. I've been told that fans will "find a way" to support the artists they love, but you don't need to "find" a way, because it's already right there in front of you. Just pay for their goddamn stuff.

Still, I'm skeptical that an "art movement" would ever get the traction of the food movement. With food, you're getting a better product. With art, you would be paying more (or paying at all) for the exact same thing. (In fact, people are often already willing to pay at least a little bit—e.g., get a Spotify subscription—for a better alternative to inconvenient, corrupt, and possibly malware-infected pirate files.) And food, because it is purchased in public, provides extensive opportunities for virtue signaling and conspicuous consumption. Shopping at your local farmers market is, among other things, a display of moral and social status. But nobody knows if you paid for that download or not.

One thing I will say, however: as hard as it may be to convince individual users, especially young ones, not to take things for free, it is long past time that we established the principle that it is absolutely unacceptable to ask people to *work* for free. If you run a website that's looking for writers, or a venue that's looking for performers, or a groovy little company that is looking for designers, you need to pay them. If you can't, you shouldn't be in business in the first place. You may think that you're making the world a better place, but you're actually making it shittier. If your business

model depends on not paying people, it isn't a business model; it's a criminal conspiracy.

<div align="center">* * *</div>

The efforts and proposals I have documented thus far in this chapter are admirable. They are also, even taken together, plainly incommensurate with the scale of the overall problem. That is not the fault of those who undertake or propose them, nor does it mean that they're not worth doing. But the problem, as I've said, begins with Giant Tech—with the demonetization of content and the ongoing transfer of wealth from creators to distributors. Any real solution needs to start there, too.

Virtually everyone I spoke with on the matter advocates an overhaul of the Digital Millennium Copyright Act, the DMCA, which was designed to bring copyright law up to date for the digital age. (It was the DMCA that allowed Ellen Seidler to file her thousands of takedown notices, one at a time, against illegal download links for her movie.) When the law was passed in 1998, Google was five weeks old, YouTube did not yet exist, Mark Zuckerberg was starting high school—and Napster was a year away from being launched. It was not designed to deal with piracy at the scale that was about to erupt.

"Takedown" must become "stay down," so files cannot go right back up again. A small claims court should be established for copyright infringement, so individual artists, not just media conglomerates, can afford to sue for damages. "Fair use," the provision in copyright law that allows for limited exemptions (like citation for scholarly purposes or sampling for purposes of satire), which Google and others have relentlessly been seeking to expand, needs to be kept within traditional bounds. In 2019, the European Union passed a landmark law, as the *New York Times* explained, "that requires platforms to sign licensing agreements with musicians, authors," and others before posting content—in effect, to remove infringing material proactively. A comparable rule should be enacted in the United States.

But those measures deal only with copyright. The larger issue is the wildly disproportionate advantage that monopoly platforms possess in the struggle over pricing. To begin with, that pricing is often mysterious. We don't know what the platforms are paying, in many cases, because they aren't required to tell us. That is why those music-streaming rates

(0.44 cents on Spotify, 0.07 cents on YouTube) are just a guess, as is the per-page rate that Amazon pays through Kindle Unlimited (its Spotify for e-books). Artists even lack the information upon which to negotiate, namely, how much money the services are taking in. What is YouTube's annual revenue? We don't know, because it's part of Google. How much does Kindle Unlimited generate? Amazon's not talking. And if we had that information, it's unlikely that the platforms even would negotiate. What really bothers her, Ellen Seidler told me, "is that no one's willing to come to the table" from the other side. Instead, she said, "artists have been vilified in a fairly orchestrated way. Our voices have been quashed. It's David versus Goliath."

What's less clear is what can be done about this: what can be done, in other words, to create a more equitable distribution of the many billions of dollars that "demonetized" content continues to generate, to claw back the money that the tech monopolies have clawed away. Workers are allowed to organize for higher wages. When producers cooperate to set prices—even imagining that such a thing were possible here, given how incredibly dispersed the production of content now is—it's called collusion, and as the name implies it is illegal. The government cannot fix prices either, needless to say.

But one thing the government can do—and as people have increasingly begun to realize of late, must (for a host of reasons, many unrelated to the arts) absolutely do. It must break up these monopolies. Already there are moves in that direction. In 2019, the federal government initiated antitrust investigations into four of the Big Five, with the Justice Department looking into Google and Apple and the Federal Trade Commission taking responsibility for Amazon and Facebook. The House Judiciary Committee also announced plans for a probe. That same year, the Supreme Court, in a decision on a lawsuit over Apple's App Store, signaled a willingness to revisit its approach to antitrust law, a move that was long overdue. Such efforts to rein in "the apex predators of tech," in the journalist Kara Swisher's phrase, must not be derailed. All the powers of the tech monopolies that we looked at in the previous chapter—to flout the law, to dictate terms, to smother competition, to control debate, to shape legislation, to determine price—flow directly from their size, wealth, and market dominance. They are too big, too rich, and too strong. And we need to get this done before it is too late.

* * *

Yet even that would not be enough. To fix the arts economy, again, we need to fix the whole economy.

The arts, it's often said, are ecosystems. That means many things. It means that major talents, with their lasting, transformational achievements, do not fall out of the sky, that their emergence depends upon a host of other individuals: childhood teachers, early mentors, lifelong rivals and collaborators, all of whom must have a way to earn their keep, as well. It means that institutions (the local club, the ninety-nine-seat theater, the indie label, the independent press) can only survive with a critical mass of artists to serve—who rely, in turn, upon the institutions. It means that even small or mediocre projects have their value, because they give creators experience, and they also give them a paycheck, so they can stick around and work another day. It means that artists cannot do their work if others can't, as well: the lighting technician, the copy editor, the person who keeps the books or checks the coats or sells the beer. It means that artists coexist in networks, helping each other find jobs, cheap rooms, opportunities—but only as long as they're able to stay in the arts. "One of the principles of having a healthy ecosystem," Melvin Gibbs explained, "is that every level of the ecosystem has to be operating at maximum efficiency. The plankton have to be healthy for the blue whales to survive."

Another way to understand this idea, that the arts are ecosystems, is to recognize that money circulates within artistic communities. I saw this again and again. When you give artists money, they not only use it to make more art, they use it to help others make art. When she gets a little money in her PayPal account, Sammus told me, she'll turn around and buy an album. Many of their supporters on Patreon, both Lucy Bellwood and Monica Byrne remarked, are fellow struggling artists. The principle applies at larger scales, as well. Ani DiFranco created a label, Righteous Babe, to release her own recordings, but she went on to release the work of many other artists, too. Robert Rauschenberg and Andy Warhol both established foundations that support the arts. Mikhail Baryshnikov and Mark Morris both established arts centers.

But if there isn't money, there isn't anything to circulate. The music business now, Gibbs said—and this is true, of course, of other arts, as

well—"is based on *starving* the plankton so that the whales can survive."
Righteous Babe no longer carries other artists; in the age of piracy and
streaming, DiFranco's own recordings do not generate sufficient profit.
"I'm from the generation before hip-hop was even called hip-hop,"
Gibbs told me. "Wasn't no *industry* putting no money in there. There
was no 'industry.' We *made* the industry." But "the way the music busi-
ness is situated now," he said, "hip-hop wouldn't have happened. The
way people were making money then, it would be impossible, because of
the platforms." The only thriving scenes he sees are corporate ones like
K-pop, since that's where all the money is.

Reviving the arts economy means restoring those ecosystems. But
they don't exist in isolation, either. What I've just been saying about
the arts—indeed, much of what I've said throughout this book—should
sound familiar to those who have nothing to do with the arts. All com-
munities are ecosystems, and so is the economy writ large. In the broader
economic ecosystem, too, the whales are getting fatter by starving the
plankton. Consolidation toward monopoly is now affecting nearly every
sector, and it is the major cause of falling wages. The trend toward poorly
compensated contract work—gig work, piecework, temporary work—is
virtually ubiquitous. As institutions tremble and crumble, profession-
als across the board are losing their autonomy, their dignity, their place.
Wealth is moving upward everywhere, and everywhere the middle class
is disappearing.

Some of the people I spoke with believe that the solution for the arts
is better public funding. Others think we need a universal basic income.
These may both be good ideas, but I don't think they would solve the
problem, either. We definitely need to do a better job—a much better
job—of funding the arts in this country. A number of musicians told me
that they're able to survive at all only because of fees from performing
in Europe—specifically, at events that exist thanks to public support.
Everybody knows that funding for the arts is higher there than it is over
here, but I'm not sure they understand quite how much higher. As of
2017, average public arts support across the European Union came to 0.4
percent of GDP—more than sixty times the level in the United States. At
that rate, we would spend about $86 billion.

Yet to rely exclusively or even largely on public support, as I suggested
in chapter 12, would only be to introduce a different form of corruption.

Somebody decides who gets that money: panels decide, functionaries decide—a situation that rewards the well connected. Besides, you want the public to have a vote—which means, in practice, the market to have a vote. (In fact, you want the public to have most of the votes.) I go back to the critic Dave Hickey, his belief in the virtue of joining "esteem" to "desire," the acclaim of experts to the instincts of the audience. Markets, when they function properly, are mechanisms for transmitting the signals of desire—in plainer language, for telling us what we want. What we don't want is for art to be cut off from that, cut off from popular taste, for bureaucrats to tell us what to want.

But markets must, precisely, function properly. Universal basic income strikes me as the wrong answer to the right question. Yes, we need to put money in people's pockets, but better to do it organically, not simply by fiat—better to do it, in other words, by restoring the entire eco-system, by rebuilding the middle class. That would mean undoing much of what we did to get here: breaking up monopolies; raising the mini-mum wage; reversing decades of tax cuts; reinstituting free or low-cost higher education; empowering workers, once again, to organize, rather than persistently obstructing them. It would also mean updating laws and regulations fashioned for a bygone economy to reflect the one that actually exists: most obviously, by extending the kinds of safeguards that full-time employees enjoy—health and other benefits, protections against discrimination and harassment, the right to engage in collective bargain-ing—to the growing army of gig and contract workers. You shouldn't have to be a winner not to be a loser.

It's no surprise to me that this book has ended up exactly where my last one did. The devastation of the arts economy, like the degradation of the college experience, is rooted in the great besetting sin of contem-porary American society: extreme and growing inequality. To be middle class is, more or less by definition, to have some disposable income. And when people get a little extra money, one of the things that they spend it on is art. Money circulates within communities, but only if it's present in the first place. We do not need the government to pay for art, or the rich with their philanthropy. We only need each other.

NOTES

CHAPTER ONE: Introduction

11 **"The Creative Apocalypse That Wasn't":** Steven Johnson, "The Creative Apocalypse That Wasn't," *New York Times Magazine*, August 19, 2015.

11 **"reflect the complexity of the landscape":** Kevin Erickson, "The Data Journalism That Wasn't," futureofmusic.org, August 21, 2015.

CHAPTER TWO: Art and Money

14 **"subject matter, size, pigment":** Alison Gerber, *The Work of Art: Value in Creative Careers* (Stanford, Calif.: Stanford University Press, 2017), 14.

15 **"indie code":** See, e.g., Matt LeMay, "Nina Nastasia," *Pitchfork*, April 1, 2008.

16 **Hyde believes that science is a gift economy:** Lewis Hyde, *The Gift: Creativity and the Artist in the Modern World*, 2nd ed. (New York: Vintage, 2007), 100–101.

17 **"It is important to create the illusion that it's not a business":** Paper Monument, ed., *I Like Your Work* (New York: Paper Monument, 2009), 9.

17 **"By being ironic about what lies at the core of the arts":** Hans Abbing, *Why Are Artists Poor?: The Exceptional Economy of the Arts* (Amsterdam: Amsterdam University Press, 2002), 49.

17 **"secret money":** Hannah Hurr, "Sarah Nicole Prickett," *Mask Magazine*, November 2015.

17 **"the heir to a mammoth fortune":** Ann Bauer, "'Sponsored' by My Husband," *Salon*, January 25, 2015.

18 **"It is often commercial to be a-commercial":** Abbing, *Why Are Artists Poor?*, 48.

19 **"the stability of a reasonable income":** Lucy Bellwood, [untitled talk], XOXO Festival, November 23, 2016, Portland, Oregon, https://www.youtube.com/watch?v=pLveriJBHeU, 11:30.

19 **"Too fat, too thin; too tall, too short":** Ibid., 22:00.

20 **"People wonder when you're allowed to call yourself a writer":** Nina MacLaughlin, "With Compliments," in Manjula Martin, ed., *Scratch: Writers, Money, and the Art of Making a Living* (New York: Simon & Schuster, 2017), 13.

21 **"the remuneration of cultural value":** "Womanifesto," http://www.wageforwork.com/about/womanifesto#top.

21 **"Not talking about money":** Molly Crabapple, "Filthy Lucre," *Vice*, June 5, 2013.

23 **"When I teach business to artists":** Amy Whitaker, *Art Thinking: How to Carve Out Creative Space in a World of Schedules, Budgets, and Bosses* (New York: HarperCollins, 2016), 81.

24 **"a capitalist to my bones":** Emily Bazelon, "Elizabeth Warren Is Completely Serious," *New York Times Magazine*, June 17, 2019.

25 **"It has been the implication":** Hyde, *The Gift*, 356–57.

CHAPTER THREE: Never-Been-a-Better-Time

27 **"It has never been easier":** Johnson, "The Creative Apocalypse That Wasn't."

28 **the humorist who broke on Twitter:** Jesse Lichtenstein, "A Whimsical Wordsmith Charts a Course Beyond Twitter," *New York Times Magazine*, June 15, 2017.

28 **the poet who blew up on Instagram:** Shannon Carlin, "Meet Rupi Kaur, Queen of the 'Insta-poets,'" *Rolling Stone*, December 21, 2017.

28 **the singer who makes six figures:** Audie Cornish, "A Cappella Singer Defends Proliferation of Music Online," npr.org, August 8, 2016.

29 **Yochai Benkler:** See Astra Taylor, *The People's Platform: Taking Back Power and Culture in the Digital Age* (New York: Metropolitan Books, 2014), 47.

29 **Clay Shirky:** See ibid.

29 **"creative paradigms for a new age":** The phrase is Astra Taylor's, ibid., 53.

29 **"wiped off the face of the earth":** Matthew Yglesias, "Amazon Is Doing the World a Favor by Crushing Book Publishers," *Vox*, October 22, 2014.

29 **Nicholas Negroponte:** M. G. Siegler, "Nicholas Negroponte: The Physical Book Is Dead in Five Years," *TechCrunch*, August 6, 2010.

29 **"fully confident that copyright":** Jon Pareles, "David Bowie, 21st-Century Entrepreneur," *New York Times*, June 9, 2002.

29 **"Predictions are for suckers":** 0s&1s, *The Art of Commerce*, episode 3, "'Predictions Are for Suckers,'" February 25, 2015, http://www.0s-1s.com/the-art-of-commerce-iii.

30 **legions of part-time amateurs:** Chris Anderson, *Free: How Today's Smartest Businesses Profit by Giving Something for Nothing* (New York: Hyperion, 2009), 235.

30 **think with greater rigor and integrity:** Lawrence Lessig, *Remix: Making Art and Commerce Thrive in the Hybrid Economy* (New York: Penguin, 2008), 62, 92–93.

30 **"Monopolies aren't what they used to be":** Anderson, *Free,* 74–75.

30 **"I can take my business elsewhere":** Lessig, *Remix*, 136.

30 **"invisible hand":** Ibid., 49.

30 **"the audience that will figure out":** Steve Albini, "Steve Albini on the Surprisingly Sturdy State of the Music Industry—in Full," *Guardian*, November 16, 2014.

31 **"Make good art":** Neil Gaiman, "Neil Gaiman: Keynote Address 2012," uarts.edu, May 17, 2012.

31 **"All the grad students who are listening":** Terry Gross, "Samantha Bee on Trump's Win: 'I Could Feel This Seismic Shift,'" npr.org, March 6, 2017.

32 **Martin says in his promo:** Steve Martin, "Steve Martin Teaches Comedy, Official Trailer, Master-Class," https://www.youtube.com/watch?v=ZwcDvw70-n0, 1:31.

32 **"Winning does not scale":** Crabapple, "Filthy Lucre."

32 **Bradley Whitford:** *WTF* #909, April 23, 2018, 41:45.

32 **"those people probably have a safety net":** Jace Clayton, *Uproot: Travels in 21st-Century Music and Digital Culture* (New York: Farrar, Straus and Giroux, 2016), 266.

32 **"continue to deceive themselves":** Abbing, *Why Are Artists Poor?*, 120.

CHAPTER FOUR: The New Conditions

41 **median rent is up some 42 percent:** "Median Asking Rent: U.S. Housing Units," Economagic.com, http://www.economagic.com/em-cgi/data.exe/cenHVS/table11c01; and Jessica Guerin, "Median Rent Reaches All-Time High," *HousingWire*, April 26, 2019. Comparison is Q1 2000 to Q1 2019; inflation calculated at https://data.bls.gov/cgi-bin/cpicalc.pl.

42 **an average of 30 percent:** "The Wages of Writing: 2015 Author Income Survey," September 15, 2015, https://www.authorsguild.org/industry-advocacy/the-wages-of-writing/, 5.

42 **musicians dropped by 24 percent:** Kristin Thomson, "How Many Musicians Are There?," futureofmusic.org, June 15, 2012; and "Occupational Employment and Wages, May 2018, 27–2042 Musicians and Singers," https://www.bls.gov/oes/current/oes272042.htm.

42 **"a good retail job":** quoted in Taylor, *The People's Platform*, 29.

42 **47 percent . . . 67 percent:** "The Wages of Writing: 2015 Author Income Survey," 9.

43 **$39 billion in global revenue:** Bill Hochberg, "The Record Business Is Partying Again, But Not Like It's 1999," *Forbes*, April 11, 2019.

43 **had fallen to $15 billion:** "Music Industry Revenue Worldwide from 2002 to 2014," statista .com, April 14, 2015.

43 **loss of film sales due to piracy:** "Impacts of Digital Video Piracy on the U.S. Economy," June 2019, https://www.theglobalipcenter.com/wp-content/uploads/2019/06/Digital-Video-Piracy .pdf, ii.

44 **Tim Kreider:** Tim Kreider, "Slaves of the Internet, Unite!," *New York Times*, October 26, 2013.

44 **Jessica Hische:** Jessica Hische, "Should I Work for Free?," http://shouldiworkforfree.com.

44 **global fashion brands:** See, e.g., Michal Addady, "12 Artists Are Accusing Zara of Stealing Their Designs," *Fortune*, July 20, 2016.

45 **"'it's Spotify'":** Clayton, *Uproot*, 75.

47 **TV generated some $22 billion:** Lynda Obst, *Sleepless in Hollywood: Tales from the New Abnormal in the Movie Business* (New York: Simon & Schuster, 2013), 235–36.

47 **"street-level":** Richard Florida, *The Rise of the Creative Class: And How It's Transforming Work, Leisure, Community and Everyday Life* (New York: Basic Books, 2002), 182.

47 **From 2003 to 2013:** "National Arts Index: An Annual Measure of the Vitality of Arts and Culture in the United States 2016," https://www.americansforthearts.org/by-program/reports -and-data/legislation-policy/naappd/national-arts-index-an-annual-measure-of-the-vitality-of -arts-and-culture-in-the-united-states-2016, 2.

47 **earned more of their money:** Michael Cooper, "It's Official: Many Orchestras Are Now Charities," *New York Times*, November 16, 2016.

48 **at least sixteen:** Ibid.; Michael Cooper, "Chicago Symphony Musicians Walk Out to Preserve Their Pension Benefits," *New York Times*, March 12, 2019; Michael Cooper, "Lockout Mutes Symphony in City Under Strain," *New York Times*, July 2, 2019.

48 **financial troubles across the sector:** Daniel Grant, "How Do Museums Pay for Themselves These Days?," *HuffPost*, November 7, 2012.

48 **flagship institutions:** Robin Pogrebin, "Ambitions for Met Museum Lead to Stumbles," *New York Times*, February 5, 2017; Larry Kaplan, "LA's Museum of Contemporary Art Comes Back from the Brink," *Nonprofit Quarterly*, January 8, 2014; Heather Gillers et al., "Chicago Museums Reeling after Building Sprees," *Chicago Tribune*, March 13, 2013.

48 **local philanthropic largesse:** Cooper, "Lockout Mutes Symphony in City Under Strain."

48 **National Endowment for the Arts:** "National Endowment for the Arts Appropriations History," https://www.arts.gov/open-government/national-endowment-arts-appropriations-history.

48 **what the military spends on bands:** Jessica T. Mathews, "America's Indefensible Defense Budget," *New York Review of Books*, July 18, 2019.

48 **$1.38 billion:** "Government Funding to Arts Agencies Federal, State, and Local: 1999–2019," https://www.americansforthearts.org/sites/default/files/3.%202019%20Government%20 Funding%20for%20the%20Arts%20%2820%20Years%29.pdf.

49 **programs have been multiplying:** Mark McGurl, *The Program Era: Postwar Fiction and the Rise of Creative Writing* (Cambridge, Mass.: Harvard University Press, 2009), 25; Amy Brady, "MFA by the Numbers, on the Eve of AWP," *Literary Hub*, February 8, 2017; Brian Boucher, "After a Decade of Growth, MFA Enrollment Is Dropping," *artnet news*, October 18, 2016.

49 **less than 30 percent:** Martin J. Finkelstein et al., "Taking the Measure of Faculty Diversity," *Advancing Higher Education*, April 2016, 2.

49 **more like 6 percent:** Coco Fusco, personal communication.

49 **"various institutional affiliations":** Roger White, *The Contemporaries: Travels in the 21st-Century Art World* (New York: Bloomsbury, 2015), 46.

49 **"Over the course of my career":** Alexander Chee, "The Wizard," in Martin, ed., *Scratch*, 63.

52 **$140 million a year:** "Patreon Creators Statistics," https://graphtreon.com/patreon-stats.

52 **only 2 percent:** Brent Knepper, "No One Makes a Living on Patreon," *Outline*, December 7, 2017.

57 **ten million artists:** Tim Wenger, "SoundCloud, Will It Survive?," *Crossfadr*, October 9, 2017.

57 **the Kindle Store:** Peter Hildick-Smith, personal communication.

57 **About fifty thousand films:** Micah Van Hove, personal communication.

57 **now over six million:** https://en.wikipedia.org/wiki/Kindle_Store.

57 **fewer than two copies a month:** http://authorearnings.com/report/may-2016-report/ [this resource is no longer available].

57 **fewer than two thousand:** Ibid.

57 **less than 3 percent:** "How Many Films in an Average Film Career?," https://stephenfollows .com/many-films-average-film-career/.

58 **over 95 percent of streams:** "What Are the Total Number of Artists on Spotify?," https://www .quora.com/What-are-the-total-number-of-artists-on-Spotify.

58 **roughly fifty million songs:** https://en.wikipedia.org/wiki/Spotify.

58 **20 percent have never been streamed:** Justin Wm. Moyer, "Five Problems with Taylor Swift's Wall Street Journal Op-ed," *Washington Post*, July 8, 2014.

59 **"Most submissions":** Chris Parris-Lamb and Jonathan Lee, "The Art of Agenting: An Interview with Chris Parris-Lamb," in Travis Kurowski et al., eds., *Literary Publishing in the Twenty-First Century* (Minneapolis: Milkweed Editions, 2016), 176, 182.

60 **"big sucks the traffic":** Quoted in Taylor, *The People's Platform*, 122.

61 **"the bigger [would] get smaller":** Ibid., 123.

61 **In the age of Thriller . . . top 1 percent:** Jonathan Taplin, *Move Fast and Break Things: How Facebook, Google, and Amazon Cornered Culture and Undermined Democracy* (New York: Little, Brown, 2017), 44.

62 **Matthew Yglesias:** Yglesias, "Amazon Is Doing the World a Favor."

63 **Jaron Lanier:** Jaron Lanier, *Who Owns the Future* (New York: Simon & Schuster, 2014), 186–87.

63 **the average video:** Harper's Index, *Harper's Magazine*, June 2018.

66 **arts funding in K–12:** https://static1.squarespace.com/static/57630b716b8f5b87e314c6d1/t /5a5c2fc6e2c483cd41a29c7e/1515991006751/LoudenBookTour_Description.pdf, 4.

66 **Hourly wages for studio assistants:** William Powhida, personal communication.

66 **When staff at the New Yorker:** Noreen Malone, "The *New Yorker* Staff Has Unionized," *New York*, June 6, 2018.

CHAPTER FIVE: Doing It Yourself

70 **in excess of a hundred people:** White, *The Contemporaries*, 80.

70 **"the experience of arising":** Dave Hickey, *Air Guitar: Essays on Art & Democracy* (Los Angeles: Art Issues Press, 1997), 161.

72 **"authors who have had their novels":** Sam Sacks, "Professional Fictions," *New Republic*, December 7, 2015.

72 **Steven Kotler:** "Episode 108: Steven Kotler—Your Flow State: What Is It? How to Get There . . . ," *The Learning Leader*, 1:01:15.

72 **59 percent from 2009 to 2015:** "The Wages of Writing: 2015 Author Income Survey," 8.

79 **"An American writer fights his way":** James Baldwin, *Nobody Knows My Name* (New York: Vintage, 1961), 7.

79 **Meredith Graves:** Meredith Graves, "The Career of Being Myself," *WATT*, June 2, 2016.

81 **"25/8 not 24/7":** Thomas Kilpper in Sharon Louden, ed., *Living and Sustaining a Creative Life: Essays by 40 Working Artists* (Bristol, UK: Intellect, 2013), 181.

82 **large-scale longitudinal survey:** Quoctrung Bui, "Who Had Richer Parents, Doctors or Artists?," npr.org, March 18, 2014.

83 **43 percent of artists lacked insurance:** Renata Marinaro, "Health Insurance Is Still a Work-in-Progress for Artists and Performers," in Center for Cultural Innovation, *Creativity Connects: Trends and Conditions Affecting U.S. Artists* (National Endowment for the Arts, 2016), 48.

84 **Amy Whitaker:** Whitaker, *Art Thinking*, 44.

CHAPTER SIX: Space and Time

86 **As of May 2019:** Crystal Chen, "Zumper National Rent Report: May 2019," *The Zumper Blog*, April 30, 2019.

87 **rents increasing 19 percent . . . fourth-most-expensive:** "Zumper National Rent Report: December 2015," *The Zumper Blog*. As of May 2019, it had fallen to sixth.

88 **"[A] formal studio":** John Chiaverina, "Does the Cost of Living in New York Spell the End of Its Artistic Life?," *New York Times*, September 11, 2018.

88 **"I am entirely dependent":** David Humphrey in Louden, ed., *Living and Sustaining a Creative Life*, 56.

89 **sales of electric guitars:** Paul Resnikoff, "Electric Guitar Sales Have Plunged 23% Since 2008," *Digital Music News*, May 10, 2018.

90 **Galapagos Arts Space:** Colin Moynihan, "Born in Brooklyn, Now Making a Motown Move," *New York Times*, December 8, 2014.

90 **"nightlife mayor":** Anna Codrea-Rado, "Notes from 'Night Mayors' Abroad," *New York Times*, August 31, 2017.

90 **where musicians are getting priced out:** Ibid.

90 **"You can't be the live music capital":** Michel Martin, "South by Southwest Adds a 'Super Bowl' to Austin's Economy Each Year," npr.org, March 18, 2017.

90 **70 percent of the city's artists:** Caille Millner, "San Francisco Is Losing Its Artists," *Hyperallergic*, September 30, 2015.

90 **"It seems like New York":** Ryan Steadman, "How I Get By: The Lives of Five American Artists," *Observer*, April 13, 2016.

92 **"It's the big fish in a small pond":** Pete Cottell, "Summer Cannibals' Jessica Boudreaux Wants to Burst the Portland Bubble," *Willamette Week*, January 10, 2017.

95 **"didn't have a career to speak of":** Graves, "The Career of Being Myself."

97 **"Human creativity":** Florida, *The Rise of the Creative Class*, xiii, 68.

98 **"Bohemian Index":** Ibid., 260, 297.

98 **"If Mark sells the Congress House":** Rain Perry, dir., *The Shopkeeper* (2016), 1:22:05.

99 **"preferred tenants":** Nate Freeman, "Mom & Popped: In a Market Contraction, the Middle-Class Gallery Is Getting Squeezed," *artnet news*, November 29, 2016.

101 **where local activists have mounted:** Carolina A. Miranda, "The Art Gallery Exodus from Boyle Heights and Why More Anti-Gentrification Battles Loom on the Horizon," *Los Angeles Times*, August 8, 2018.

102 **murders dropped some 70 percent:** https://en.wikipedia.org/wiki/Crime_in_New_York _City#Murders_by_year.

102 **the population grew by over 9 percent:** https://en.wikipedia.org/wiki/Demographics_of_New _York_City#Population.

102 **"a cultural district":** Lise Soskolne, "Who Owns a Vacant Lot," *Shifter* 21: Other Spaces (2012).

103 **"The identity right now is money":** WTF #858, October 26, 2017, 77:00.

103 **"People who keep themselves busy":** Mihaly Csikszentmihalyi, *Creativity: Flow and the Psychology of Discovery and Invention* (New York: HarperCollins, 1976), 99.

103 **"a utopia of experimental fuckaroundery":** White, *The Contemporaries*, 50–51.

CHAPTER SEVEN: The Life Cycle

107 **"I don't remember":** Quoted in Whitaker, *Art Thinking*, vii.

110 **"I often want to write":** WTF #878, January 4, 2018, 18:35, 19:05.

112 **Lewis Hyde:** "The Artist as Entrepreneur," *Full Bleed*, May 4, 2017.

113 **Jill Soloway:** Terry Gross, "'Transparent' Creator Jill Soloway Seeks to Upend Television with 'I Love Dick,'" npr.org, May 10, 2017.

114 **"other broke artists":** Lucy Bellwood, [untitled talk], 17:00, 17:14.

116 **"Threw the towel in":** WTF #793, March 13, 2017, 40:22.

119 **"For those who are not writers":** Alexander Chee, "The Wizard," in Martin, ed., *Scratch*, 61.

119 **"The phrase 'made it'":** Jack Conte, "Pomplamoose 2014 Tour Profits," medium.com, November 24, 2014.

119 **"hype machine":** Lucy Bellwood, [untitled talk], 23:06.

120 **"A decade ago":** WTF #872, December 14, 2017, 2:21.

121 **"dreamed upon lifestyle":** Neda Ulaby, "In Pricey Cities, Being a Bohemian Starving Artist Gets Old Fast," npr.org, May 15, 2014.

121 **"Most writers I know":** J. Robert Lennon, "Write to Suffer, Publish to Starve," in Martin, ed., *Scratch*, 105.

122 **it takes about twenty years:** WTF #725, July 18, 2016, 23:00.

CHAPTER EIGHT: Music

129 **"$39 billion in global revenue":** Hochberg, "The Record Business Is Partying Again."

129 **From 2000 to 2002 . . . another 46 percent:** John Seabrook, *The Song Machine: Inside the Hit Factory* (New York: Norton, 2015), 119, 134.

130 **some four hundred million iPods:** Jeff Dunn, "The Rise and Fall of Apple's iPod, in One Chart," *Business Insider*, July 28, 2017.

130 **began to get traction in 2012:** Felix Richter, "Spotify Boasts 140M Active Users, 50M Premium Subs," statista.com, January 14, 2015.

130 **displaced the digital downloads:** Perry, dir., *The Shopkeeper*, 1:07:50.

130 **streaming accounted for three-quarters:** Patricia Hernandez, "Streaming Now Accounts for 75 Percent of Music Industry Revenue," *Verge*, September 20, 2018.

130 **stood at $19 billion:** "IFPI Global Music Report 2019," April 2, 2019, https://www.ifpi.org /news/IFPI-GLOBAL-MUSIC-REPORT-2019.

130 **38 percent of listeners:** Matt Binder, "YouTube Accounts for 47 Percent of Music Streaming, Study Claims," *Mashable*, October 10, 2018.

131 **In 2010, Live Nation:** Ben Sisario and Graham Bowley, "Roster of Stars Lets Live Nation Flex Ticket Muscles, Rivals Say," *New York Times*, April 2, 2018.

131 **more than 850 stations:** https://www.iheartmedia.com/iheartmedia/stations.

131 **"showola":** Deborah Speer, "Radio's New 'Showola,'" *Pollstar*, September 25, 2014.

131 **a good set of estimates:** https://informationisbeautiful.net/visualizations/spotify-apple-music -tidal-music-streaming-services-royalty-rates-compared/.

132 **nearly half of all listening online:** Binder, "YouTube Accounts for 47 Percent of Music Streaming."

132 **Zoë Keating:** Zoë Keating, "The Sharps and Flats of the Music Business," *Los Angeles Times*, September 1, 2013.

132 **Rosanne Cash:** Seabrook, *The Song Machine*, 296.

132 **Rain Perry:** Perry, dir., *The Shopkeeper*, 1:14:15.

132 **"Our band's only record":** Graves, "The Career of Being Myself."

132 **"90 percent of your subscription fee":** Seabrook, *The Song Machine*, 296.

132 **Alan B. Krueger:** Alan B. Krueger, "The Economics of Rihanna's Superstardom," *New York Times*, June 2, 2019.

132 **"If the type of music I make":** Marc Ribot, "If Streaming Is the Future, You Can Kiss Jazz and Other Genres Goodbye," *New York Times*, November 7, 2014.

133 **from $1 billion in North America:** "2016 Year End Special Features," *Pollstar*, January 6, 2017.

133 **"heritage acts":** Chris Ruen, *Freeloading: How Our Insatiable Appetite for Free Content Starves Creativity* (Melbourne: Scribe, 2012), 60.

133 **by 2017, the number was 60 percent:** Krueger, "The Economics of Rihanna's Superstardom."

133 **80 percent of the money:** "Copyright—Tift Merritt, Marc Ribot and Chris Ruen Conversation," OnCopyright 2014 conference, April 2, 2014, New York, https://www.youtube.com/watch?v =gpyTlqfa6Zk&t=193s, 15:22.

133 **"You see every artist and his dog":** Perry, dir., *The Shopkeeper*, 1:19:25.

133 **"To earn a living":** Suzanne Vega, "Today the Road Is a Musician's Best Friend," *New York Times*, November 6, 2014.

134 **"recording vocals late at night":** Seabrook, *The Song Machine*, 214.

134 **"Touring is artistic death":** Hutch Harris, "Why I Won't Tour Anymore," *WATT*, October 4, 2016.

135 **"the ultimate merch":** "Copyright—Tift Merritt, Marc Ribot and Chris Ruen Conversation," 15:55.

135 **number of full-time songwriters:** Nate Rau, "Musical Middle Class Collapses," *Tennessean*, January 3, 2015.

135 **David Remnick:** *WTF* #830, July 20, 2017, 19:05.

135 **"people just think":** *WTF*, #902, March 29, 2018, 59:20.

136 **"how far we'd traveled":** Clayton, *Uproot*, 117.

137 **"playlist plugging":** Liz Pelly, "The Secret Lives of Playlists," *WATT*, June 21, 2017.

138 **Patreon has started to play:** Jack Conte, "We Messed Up. We're Sorry, and We're Not Rolling Out the Fees Change," *Patreon Blog*, December 13, 2017.

138 **SoundCloud:** Jenna Wortham, "If SoundCloud Disappears, What Happens to Its Music Culture?," *New York Times Magazine*, August 6, 2017.

138 **"Meet the New Boss":** David Lowery, "Meet the New Boss, Worse Than the Old Boss?," *Trichordist*, April 15, 2012.

140 **"that's most of us":** *Real Time with Bill Maher*, season 14, episode 9, March 18, 2016.

140 **"write a blog post":** https://mariancall.com/i-want-to-be-marians-best-fan-ever-and-do-nice-things-for-her-where-do-i-start/#more-225.

141 **"a full-time artist deep in debt":** https://mariancall.com/category/f-a-q/.

150 **"tiny, dense snowglobes":** Erin Lyndal Martin, "Six Haunted Ladies of Folk Noir," *Bandcamp Daily*, November 18, 2016.

150 **"You're amazing and your voice":** "Nina Nastasia—Cry, Cry, Baby," https://www.youtube.com/watch?v=u_VNaThCRJc.

CHAPTER NINE: Writing

153 **Only about 350 literary titles:** Richard Nash, personal communication.

153 **By the early 1990s:** Richard Nash, "What Is the Business of Literature," in Kurowski et al., eds., *Literary Publishing in the Twenty-First Century*, 253–54.

154 **the company did not become profitable:** Nick Statt, "Amazon, Once a Big Spender, Is Now a Profit Machine," *Verge*, July 28, 2016.

154 **median income 50 percent higher . . . responsible for 60 percent:** Peter Hildick-Smith, personal communication.

154 **28 percent of the book market:** Peter Hildick-Smith, personal communication.

154 **sales of the format exploded:** Felix Richter, "U.S. eBook Sales to Surpass Printed Book Sales in 2017," statista.com, June 6, 2013.

154 **E-book sales have since plateaued:** Michael Kozlowski, "Ebook Sales Decrease by 4.5% in the First Quarter of 2019," *Good e-Reader*, June 17, 2019.

154 **By 2017, online sales:** Peter Hildick-Smith, personal communication.

154 **over 40 percent . . . over 80 percent:** Mike Shatzkin, "A Changing Book Business: It All Seems to Be Flowing Downhill to Amazon," The Idea Logical Company blog, January 22, 2018.

154 **From 1995 to 2000 . . . about a quarter of the lost ground:** Paddy Hirsch, "Why the Number of Independent Bookstores Increased During the 'Retail Apocalypse,'" npr.org, March 29, 2018. "About a quarter" is my calculation.

155 **But the brick-and-mortar book business . . . down by 39 percent:** David Streitfeld, "Bookstore Chain Succumbs, as E-Commerce Devours Retailing," *New York Times*, December 29, 2017; and https://en.wikipedia.org/wiki/Borders_Group.

155 **only 5 percent will cite an online seller:** Peter Hildick-Smith, personal communication.

157 **Amazon is squeezing those publishers:** Franklin Foer, *World Without Mind: The Existential Threat of Big Tech* (New York: Penguin Press, 2017), 105.

157 **from $65 billion to $19 billion:** Douglas McLennan and Jack Miles, "A Once Unimaginable Scenario: No More Newspapers," *Washington Post*, March 21, 2018.

157 **some twenty-one hundred of them:** Douglas A. McIntyre, "Over 2000 American Newspapers Have Closed in Past 15 Years," *24/7 WallSt*, July 23, 2019.

157 **more than 240,000 jobs, 57 percent of their workforce:** "Employment Trends in Newspaper Publishing and Other Media, 1990–2016," https://www.bls.gov/opub/ted/2016/employment-trends-in-newspaper-publishing-and-other-media-1990-2016.htm.

158 **he was paying $150:** Foer, *World Without Mind*, 169.

158 **Vice, Vox, BuzzFeed, and others:** Derek Thompson, "The Media's Post-Advertising Future Is Also Its Past," *Atlantic*, December 31, 2018; and Benjamin Mullin and Amol Sharma, "Vox Media on Pace to Miss Revenue Target as Digital Advertising Disappoints," *Wall Street Journal*, September 23, 2018.

158 **"I thought you could just drink":** 0s&1s, *The Art of Commerce*, episode 54: "'I Was Young and Full of a Billion Ideas but Had No Clue How to Execute Them,'" March 2, 2016, http://www.0s-1s.com/the-art-of-commerce-liv.

160 **"unspool[ing] myself for cash":** Sarah Nicole Prickett, "The Best Time I Dropped Out of College (Twice)," *Hairpin*, November 24, 2014.

160 **"go beyond the book . . . 'fucking figure it out'":** Jane Friedman, "An Interview with Richard Nash: The Future of Publishing," janefriedman.com, September 22, 2015.

161 **"more social and economic actors":** Nash, "What Is the Business of Literature," in Kurowski et al., eds., *Literary Publishing in the Twenty-First Century,* 269.

162 **A lot of his students "are realists":** WTF #984, January 10, 2019, 1:29:35, 1:30:35.

163 **about eighty-five thousand new titles:** Valerie Bonk, "Howard County Authors Make the Leap into Self-Publishing," *Baltimore Sun,* April 6, 2016.

163 **over a million:** "New Record: More Than 1 Million Books Self-Published in 2017," bowker.com, October 10, 2018.

163 **22 percent by dollar amount:** http://authorearnings.com/report/january-2018-report-us-online -book-sales-q2-q4-2017/ [this resource is no longer available].

164 **seven million books have been self-published:** "Self-Publishing in the United States 2008– 2013: Print vs. Ebook," bowker.com; "Self-Publishing in the United States 2011–2016: Print vs. Ebook," bowker.com; and "New Record: More than 1 Million Books Self-Published in 2017," bowker.com. I'm extrapolating a minimum of one million a year from the start of 2018 to the middle of 2020.

165 **Pottermore was capturing:** http://authorearnings.com/report/january-2018-report-us-online -book-sales-q2-q4-2017/ [this resource is no longer available].

166 **eighty million readers . . . 665 million uploads:** https://company.wattpad.com/press/.

166 **six million writers:** Ben Sobiek, personal communication.

166 **fifty languages:** Ashleigh Gardner, personal communication.

166 **45 percent are thirteen to eighteen; 45 percent are eighteen to thirty; 70 percent are female:** Ibid.

166 **90 percent are reading on mobile devices:** Ben Sobiek, personal communication.

167 **1.3 million books:** Dan Price, "5 Reasons a Kindle Unlimited Subscription Isn't Worth Your Money," *MakeUseOf,* January 7, 2019.

167 **rate was about 0.48 cents per page:** Chris McMullen, "The Kindle Unlimited Per-Page Rate Holds Steady in October, 2018," chrismcmullen.com, November 15, 2018.

169 **seven hundred assignments . . . over 527,000 words:** Nicole Dieker, "How One Freelance Writer Made $87,000 in 2016," *Write Life,* January 16, 2017.

170 **"calculating":** Nicole Dieker, "This Week in Self-Publishing: Let's Get Serious About Sales and Money," hello-the-future.tumblr.com, February 3, 2017.

170 **"strategic":** Nicole Dieker, "This Week in Self-Publishing: I Love Pronoun," hello-the-future .tumblr.com, January 27, 2017.

170 **"just fling words into the sky":** Dieker, "This Week in Self-Publishing: Let's Get Serious About Sales and Money."

170 **"a couple of lovely Amazon reviews":** Nicole Dieker, "This Week in Self-Publishing: Publica- tion Week," medium.com, May 26, 2017.

170 **"It's everything a debut author":** Ibid.

170 **"*just send your book*":** Nicole Dieker, "This Week in Self-Publishing: What Else Should I Be Doing Right Now?," medium.com, June 23, 2017.

171 **"nearly every free minute":** Nicole Dieker, "This Week in Self-Publishing: It's Time to Start Working on Volume 2," medium.com, July 28, 2017.

171 **"But the truth is":** Nicole Dieker, "On Revising My Novel While Reading Meg Howrey's 'The Wanderers,' or: Books Are Supposed to Make You Think and Feel, Right?," nicoledieker.com, September 16, 2017.

174 **Stephen Colbert:** *The Colbert Report,* June 23, 2014, http://www.cc.com/video-clips/07oysy /the-colbert-report-john-green, 3:00.

178 **"anti-resume":** Monica Byrne, "An Artist Compiled All Her Rejections in an 'Anti-Resume.' Here's What Can Be Learned from Failure," *Washington Post,* August 8, 2014.

CHAPTER TEN: Visual Art

182 **Leonardo's *Salvator Mundi*:** Eileen Kinsella, "The Last Known Painting by Leonardo da Vinci Just Sold for $450.3 Million," *artnet news,* November 15, 2017.

182 **In the 1940s:** Diana Crane, *The Transformation of the Avant-Garde: The New York Art World, 1940–1985* (Chicago: University of Chicago Press, 1987), 2.

182 **"the entire New York art world":** Ben Davis, *9.5 Theses on Art and Class* (Chicago: Haymarket Books, 2013), 76.

182 **two hundred artists working in the city:** Holland Cotter, "When Artists Ran the Show," *New York Times*, January 13, 2017.

182 **"If somebody had a party":** White, *The Contemporaries*, 210.

182 **"$135,000 for a Wyeth":** Harold Rosenberg, *Discovering the Present: Three Decades in Art, Culture, and Politics* (Chicago: University of Chicago Press, 1973), 110.

183 **today's most expensive living artists:** https://en.wikipedia.org/wiki/List_of_most_expensive _artworks_by_living_artists.

183 **Through the 1970s:** Martha Rosler, "School, Debt, Bohemia: On the Disciplining of Artists," artanddebt.org, March 4, 2015.

183 **wouldn't even think about showing:** Bill Carroll in Louden, ed., *Living and Sustaining a Creative Life*, 210.

183 **now the galleries began recruiting:** Rosler, "School, Debt, Bohemia."

183 **once meant under forty:** ibid.

183 **surpassing 1980s benchmarks:** White, *The Contemporaries*, 140.

183 **global art sales roughly doubled:** Davis, *9.5 Theses on Art and Class*, 78.

183 **increasing 55 percent:** https://wageforwork.com/files/w9U7v627VLmeWsRi.pdf, 6.

183 **sales returning to pre-crash levels:** S. Lock, "Global Art Market Value from 2007 to 2018 (in Billion U.S. Dollars)," statista.com, October 29, 2019.

183 **"A one percentage point increase":** Quoted in Davis, *9.5 Theses on Art and Class*, 79.

183 **More than half of the global art market:** Anna Louie Sussman, "Could Blockchain Put Money Back in Artists' Hands?," artsy.net, March 16, 2017.

184 **"highly speculative stocks":** Davis, *9.5 Theses on Art and Class*, 80.

184 **So-called emerging artists:** This sentence is informed by White, *The Contemporaries*, 140.

184 **Art is used . . . billion-dollar business:** Atossa Araxia Abrahamian, "The Lemming Market," *London Review of Books*, May 10, 2018.

184 **150 galleries in SoHo . . . 300 in Chelsea:** Carroll in Louden, ed., *Living and Sustaining a Creative Life*, 215.

184 **had passed 1,100:** Magnus Resch, "The Global Art Gallery Report 2016," phaidon.com.

184 **60 percent of galleries:** Cited by William Powhida in Sharon Louden, ed., *The Artist as Culture Producer: Living and Sustaining a Creative Life* (Bristol, UK: Intellect, 2017), 380.

185 **eighty "international" events:** Caroline Goldstein, "Attention, Art Collectors: Here Is the Definitive Calendar of International Art Fairs for 2018," *artnet news*, January 29, 2018.

185 **two hundred galleries . . . seventy thousand visitors:** https://en.wikipedia.org/wiki/Art_Basel.

185 **as low as 5 percent:** Davis, *9.5 Theses on Art and Class*, 84.

186 **"the MFA was pitched":** Ben Davis, "Is Getting an MFA Worth the Price?," *artnet news*, August 30, 2016.

186 **crunched the numbers:** Ibid.

187 **"Artists in large numbers":** Rosler, "School, Debt, Bohemia."

187 **only 10 percent:** BFAMFAPhD, "Artists Report Back: A National Study on the Lives of Arts Graduates and Working Artists," http://bfamfaphd.com, 2014.

187 **85 percent . . . 15 percent:** Quoted in Nicholas D. Hartlep et al., eds., *The Neoliberal Agenda and the Student Debt Crisis in U.S. Higher Education* (Abingdon, UK: Routledge, 2017), 95.

187 **just twenty individuals:** Allison Schrager, "Art Market Snubs the Merely Rich," *New York Times*, May 17, 2019.

187 **a little more than $13,000:** Davis, "Is Getting an MFA Worth the Price?"

187 **"staggeringly huge percentage":** White, *The Contemporaries*, 120.

187 **"zombie formalists":** Chris Wiley, "The Toxic Legacy of Zombie Formalism, Part 1: How an Unhinged Economy Spawned a New World of 'Debt Aesthetics,'" *artnet news*, July 26, 2018.

187 **as much as $389,000:** Christian Viveros-Faune, "At UES Show, Lucien Smith Leads the Charge of the Opportunist Brigade," *Village Voice*, June 4, 2014.

187 **Two years later:** Eileen Kinsella, "Has the Market for 'Zombie Formalists' Evaporated?," *artnet news*, October 6, 2015.

188 **seven are art schools:** U.S. Department of Education, College Affordability and Transparency List, report for which colleges have the highest and lowest tuition and net prices?, 4-year or above, private not-for-profit, highest net prices, https://collegecost.ed.gov/affordability.

189 **"consensual fiction":** Humphrey in Louden, ed., *Living and Sustaining a Creative Life*, 56.

189 **"Cynics say":** Ibid.

191 **"real career development":** Ibid., 156.

191 **"infantiliz[ed]":** Ibid., 213.

192 **"abridged listing":** Ibid., 166.

194 **"alternative art schools":** See, e.g., Isaac Kaplan, "MFAs Are Expensive—Here Are 8 Art School Alternatives," artsy.net, November 22, 2016.

195 **"As an artist whose professional life":** White, *The Contemporaries*, 46.

199 **"chronic neck . . . constant anxiety":** Lisa Congdon, "On Self-Employment, Workaholism and Getting My Life Back," lisacongdon.com.

201 **"there's gotta be someone":** Lucy Bellwood, [untitled talk], 6:57.

201 **"the prospect of being an only child":** Ibid., 27:15.

201 **"Everything I have done":** Ibid., 8:30.

201 **"shave off some small piece":** Ibid., 25:28.

CHAPTER ELEVEN: Film and Television

208 **the top-ranked show:** https://en.wikipedia.org/wiki/1962–63_United_States_network _television_schedule.

209 **the number was 532:** John Koblin, "Peak TV Hits a New Peak, with 532 Scripted Shows," *New York Times*, January 9, 2020.

209 **had a rating of 36:** https://en.wikipedia.org/wiki/1962–63_United_States_network_television _schedule.

209 **all of 10.6:** https://en.wikipedia.org/wiki/2018–19_United_States_network_television_schedule.

209 **seldom cracked a million viewers:** https://en.wikipedia.org/wiki/List_of_Girls_episodes.

209 **came in at 0.6:** "Sunday Cable Ratings: 'Real Housewives of Atlanta' Wins Night, 'True Detective,' 'Ax Men,' 'Shameless' & More," tvbythenumbers, January 14, 2014.

209 **more than sixty networks and streaming services:** Tad Friend, "Donald Glover Can't Save You," *New Yorker*, March 5, 2018.

210 **"a fierce arms race for content":** John Koblin, "Tech Firms Make Push Toward TV," *New York Times*, August 21, 2017.

210 **"If you're a creative person":** *WTF* #754, October 27, 2016, 98:30.

210 **10 percent . . . 6 percent:** Obst, *Sleepless in Hollywood*, 11.

210 **"DVD, TV, pay cable":** Ibid., 39.

210 **"used to be half":** Ibid., 40.

210 **less money now:** "Domestic Yearly Box Office," boxofficemojo.com.

210 **"If you're a studio":** *WTF* #754, October 27, 2016, 98:18.

211 **international sales:** Obst, *Sleepless in Hollywood*, 53–54.

211 **"went from nothing":** Ibid., 56–57.

211 **Marvel Cinematic Universe:** https://en.wikipedia.org/wiki/Marvel_Cinematic_Universe.

211 **every one of the top 10 movies:** Obst, *Sleepless in Hollywood*, 33.

211 **essentially unchanged:** "2019 Worldwide Box Office," boxofficemojo.com.

211 **top five grossing films:** "Domestic Yearly Box Office," boxofficemojo.com.

211 **From 2006 to 2013 . . . simply been eliminated:** Ruth Vitale and Tim League, "Guest Post: Here's How Piracy Hurts Indie Film," indiewire.com, July 11, 2014. The authors have 37 percent for the decline in the number of pictures released by the major studios, but their own figures indicate 44 percent.

212 **"tentpoles and tadpoles":** Obst, *Sleepless in Hollywood*, 41.

212 **Reeling off a list:** Ibid., 9–10.

212 **John Waters, Spike Lee:** Jason Bailey, "How the Death of Mid-Budget Cinema Left a Generation of Iconic Filmmakers MIA," flavorwire.com, December 9, 2014.

212 **After resorting to Kickstarter:** https://en.wikipedia.org/wiki/Da_Sweet_Blood_of_Jesus.

212 **Lee got $15 million:** https://en.wikipedia.org/wiki/Chi-Raq.

212 **nine times as much profit:** Obst, *Sleepless in Hollywood*, 235–36.

213 **"Why are you poor?":** *WTF* #847, September 18, 2017, 23:58.

213 **HBO:** Meg James, "HBO to Get Bigger Programming Budget, Says WarnerMedia Head John Stankey," *Los Angeles Times*, July 24, 2018.

213 **Amazon:** Alex Weprin, "Amazon Expected to Spend $5 Billion on Video Content This Year," mediapost.com, February 23, 2018.

213 **Netflix:** David Z. Morris, "Netflix Is Expected to Spend up to $13 Billion on Original Programming This Year," *Fortune*, July 8, 2018.

213 **"There's a lot more work":** Kyle Buchanan, "Elizabeth Banks: It's Getting Harder to Make Money in Hollywood," *New York Times*, June 24, 2019.

216 **the number of independent films . . . 31 percent to 24 percent:** Bailey, "How the Death of Mid-Budget Cinema Left a Generation of Iconic Filmmakers MIA."

216 **Todd Solondz . . . earned as much as $750,000:** Figures from the Wikipedia pages for the respective films. Clicking on the link for the box office number for *Dollhouse* shows that the figure is slightly over $5 million.

217 **"Every independent film":** Micah Van Hove, "How 'Goat' Director Andrew Neel Enabled Breakout Performances on a Tight Shooting Schedule," nofilmschool.com, February 2, 2016, 1:53.

217 **"Micro-budget":** Stephen Follows, "What's the Average Budget of a Low or Micro-Budget Film?," stephenfollows.com, September 22, 2014.

217 **"increasing numbers of rich kids":** Obst, *Sleepless in Hollywood*, 41.

218 **One estimate from 2013:** Stephen Follows, "How Many Film Festivals Are There in the World?," stephenfollows.com, August 19, 2013.

219 **"insatiable appetite for content":** Sean Fennessey, "The End of Independent Film as We Know It," theringer.com, April 10, 2017.

220 **Netflix carried over sixty-seven hundred movies . . . had nearly tripled:** Travis Clark, "New Data Shows Netflix's Number of Movies Has Gone Down by Thousands of Titles Since 2010—but Its TV Catalog Size Has Soared," *Business Insider*, February 20, 2018.

223 **"think like a fan":** James Swirsky and Lisanne Pajot, "Indie Game Case Study: Tech & Audience," indiegamethemovie.com, November 1, 2012.

223 **"by being very open":** Ibid.

224 **"tried to respond . . . two people":** Ibid.

224 **"build on the buzz":** James Swirsky and Lisanne Pajot, "Indie Game Case Study: Theatrical & Tour," indiegamethemovie.com, November 7, 2012.

224 **"Every doc has a core audience":** James Swirsky and Lisanne Pajot, "Indie Game Case Study: Digital," indiegamethemovie.com, November 19, 2012.

CHAPTER TWELVE: Art History

237 **"Art as we have generally understood it":** Larry Shiner, *The Invention of Art: A Cultural History* (Chicago: University of Chicago Press, 2001), 3.

238 **"Artist," "artisan":** Raymond Williams, *Keywords: A Vocabulary of Culture and Society* (New York: Oxford University Press, 1976), 41.

238 **Artists ceased to be anonymous:** Gerber, *The Work of Art*, 15.

238 **Creativity was still regarded:** Williams, *Keywords*, 82; and Shiner, *The Invention of Art*, 31.

238 **As it had since Aristotle:** Arthur C. Danto, *After the End of Art: Contemporary Art and the Pale of History* (Princeton, N.J.: Princeton University Press, 1997), 46.

238 **Art itself was not a unitary concept:** Williams, *Keywords*, 41.

238 **"throughout history":** Taplin, *Move Fast and Break Things*, 10.

239 **The term "fine arts":** https://www.etymonline.com/word/fine#etymonline_v_5954.

239 **As art arose to its zenith:** Information in this paragraph is mostly drawn from the relevant entries in Williams, *Keywords*.

240 **Henri Bergson:** Hannah Arendt, *Crises of the Republic* (New York: Harcourt Brace, 1972), 171.

240 **Nietzsche:** Friedrich Nietzsche, "A Critical Backward Glance," quoted in Wayne C. Booth, *Modern Dogma and the Rhetoric of Assent* (Chicago: University of Chicago Press, 1974), 98.

241 **the Grub Street model spread:** Abbing, *Why Are Artists Poor?*, 266.

243 **increased from 11 to 147:** Howard Singerman, *Art Subjects: Making Artists in the American University* (Berkeley: University of California Press, 1999), 6.

243 **University of Iowa . . . 150:** McGurl, *The Program Era*, 5, 24.

243 **from 1949 to 1979:** Jack H. Schuster and Martin J. Finkelstein, *The American Faculty: The Restructuring of Academic Work and Careers* (Baltimore: Johns Hopkins University Press, 2006), 39.

244 **subject of psychological aggression:** See Dave Hickey, "Nurturing Your Addictions," in *Pirates and Farmers* (London: Ridinghouse, 2013), 119–28.

245 **"moyen garde":** Crane, *The Transformation of the Avant-Garde*, 15.

245 **"the artist of the scraggly beard":** Singerman, *Art Subjects*, 23.

CHAPTER THIRTEEN: The Fourth Paradigm

248 **"the opening number":** Obst, *Sleepless in Hollywood*, 88.

248 **"It was already clear":** Seabrook, *The Song Machine*, 266.

250 **"just one part":** Jon Pareles, "The Era of Distraction," *New York Times*, December 30, 2018.

252 **"When people take movies seriously":** *The New Yorker Radio Hour*, May 25, 2018, 40:03.

253 **BBC America invited fans:** John Koblin, "Never Mind the Ratings," *New York Times*, August 11, 2017.

254 **"Everyone's niched out now":** *WTF* #224, November 3, 2011, 57:30.

254 **having first been enunciated:** Taylor, *The People's Platform*, 206.

255 **"boats are kind of my brand":** Lucy Bellwood, [untitled talk], 1:20.

255 **"everything is marketing":** *WTF* #826, July 6, 2017, 42:02.

256 **"tribe surfing":** 0s&1s, *The Art of Commerce*, episode 2, "'And We Oiled Each Other Up and Ran Naked in the Dust of Sparta,'" February 18, 2015, http://www.0s-1s.com/the-art-of-commerce-ii.

256 **"everybody had to appeal":** *WTF* #224, November 3, 2011, 56:30.

256 **"Who the fuck's blacker":** Ibid., 56:43.

257 **"The genuine work of art":** Rosenberg, *Discovering the Present*, 18–19.

257 **"Politics is downstream of culture":** Conor Friedersdorf, "How *Breitbart* Destroyed Andrew Breitbart's Legacy," *Atlantic*, November 14, 2017.

257 **"Along this rocky road":** Rosenberg, *Discovering the Present*, 18–19.

257 **a term that was coined:** Joshua Cohen, *Attention: Dispatches from a Land of Distraction* (New York: Random House, 2018), 184–85.

259 **"Critics with dazzling track records":** Hickey, *Pirates and Farmers*, 156–57.

259 **"There are generations of artists":** Ibid., 157.

259 **"Esteem" . . . "desire":** Hickey, *Air Guitar*, 106.

260 *House of Cards:* Greg Petraetis, "How Netflix Built a House of Cards with Big Data," idgin siderpro.com, July 13, 2017.

260 **has been canceling idiosyncratic:** Joseph Adalian, "Why Did Amazon, Netflix, and Hulu Kill a Bunch of Alternative Comedies?," vulture.com, January 18, 2018.

261 **"I have probably spent":** Hickey, *Air Guitar*, 138.

261 **"some things are better than others":** Hickey, *Pirates and Farmers*, 155.

262 **Like that decade's utopian impulses:** The source for most of this paragraph is Evgeny Morozov, "Making It," *New Yorker*, January 13, 2014.

263 **From 1991 to 2006 . . . 0.1 percent:** https://nces.ed.gov/programs/digest/d17/tables/dt17_322.10.asp.

265 **with college enrollments increasing:** Schuster and Finkelstein, *The American Faculty*, 39.

266 **"knowledge workers":** https://en.wikipedia.org/wiki/Peter_Drucker#Key_ideas.

266 **"Human creativity":** Florida, *The Rise of the Creative Class*, xiii, 4.

266 **"consists of people":** Ibid., 68.

266 **"people who work in science":** Ibid., 74.

267 **"who repair and maintain":** Ibid., 70.

267 **"the MFA is the new MBA":** Janet Rae-Dupree, "Let Computers Compute. It's the Age of the Right Brain," *New York Times*, April 6, 2008.

267 **"the people who become leaders":** Adam Bryant, "Share Your Ideas, Even the Crazy Ones," *New York Times*, June 25, 2017.

267 **Jonah Lehrer:** Scott Timberg, *Culture Crash: The Killing of the Creative Class* (New Haven, Conn.: Yale, University Press, 2015), 215.

267 **"Case Studies in Eureka Moments":** *Atlantic*, July/August 2014.

268 **originated in the 1930s:** "Can 'Creative' Be a Noun?," merriam-webster.com.

268 **"is invoked time and again":** Taylor, *The People's Platform*, 59.

269 **"invent point B":** Whitaker, *Art Thinking*, 8.

269 **"global movement":** http://sunnibrown.com/the-doodle-revolution/.

270 **"entreprecariat":** Silvio Lorusso, "What Is the Entreprecariat?," networkcultures.org, November 27, 2016.

270 **"Everyone is an entrepreneur":** http://networkcultures.org/entreprecariat/about/.

271 **"for many . . . socially engaged artists":** Jen Delos Reyes, *I'm Going to Live the Life I Sing About in My Song: How Artists Make and Live Lives of Meaning* (N.p: Open Engagement, 2016), 8.

272 **"who reaches outside of the studio":** Louden, ed., *The Artist as Culture Producer*, 9.

272 **"the mechanic who services your car":** Ibid., 10–11.

CHAPTER FOURTEEN: Art School

277 **Each year in this country:** Figures based on the most recent year for which statistics are available: https://nces.ed.gov/programs/digest/d18/tables/dt18_318.30.asp. Totals obtained by adding creative writing degrees (under English) to degrees in visual and performing arts.

277 **David Mamet:** *WTF* #889, March 15, 2018, 48:15.

277 **Jason Alexander:** *WTF* #904, April 5, 2018, 43:30.

278 **"MFA style":** See, e.g., Eric Bennett, "How Iowa Flattened Literature," *Chronicle of Higher Education*, February 10, 2014.

278 **"has resulted in deadly dull":** Jessica Loudis et al., eds., *Should I Go to Grad School?: 41 Answers to an Impossible Question* (New York: Bloomsbury, 2014), 122.

278 **"long row of students":** Hickey, *Pirates and Farmers*, 122–23.

279 **"only losers went to grad school":** Loudis et al., eds., *Should I Go to Grad School?*, 121.

280 **"in major league baseball":** Gerald Howard, "The Open Refrigerator," in Kurowski et al., eds., *Literary Publishing in the Twenty-First Century*, 198–99.

281 **"post-studio curricula":** Coco Fusco, "Debating an MFA? The Lowdown on Art School Risks and Returns," *HuffPost*, December 4, 2013.

281 **"dozens of newfangled degrees":** Ibid.

282 **had four master's programs:** Boucher, "After a Decade of Growth, MFA Enrollment Is Dropping."

282 **Today, it has twenty-one:** http://www.sva.edu/graduate.

282 **the kind of graduates employers want:** Other sources for the preceding two paragraphs include Nancy Popp, "Dismantling Art School," artanddebt.org, June 4, 2015; Lee Relvas, "MFA No MFA Lee Relvas: The Creative Time Summit," mfanomfa.tumblr.com, December 17, 2015; and Rosler, "School, Debt, Bohemia."

282 **"Graduate art students":** Hickey, *Pirates and Farmers*, 122.

282 **application numbers have started to plummet:** Boucher, "After a Decade of Growth, MFA Enrollment Is Dropping."

282 **Art Institutes:** https://en.wikipedia.org/wiki/The_Art_Institutes.

283 **35 percent of whose students:** Katia Savchuk, "Black Arts: The $800 Million Family Selling Art Degrees and False Hopes," *Forbes*, August 19, 2015.

283 **7 percent of whom:** https://en.wikipedia.org/wiki/Academy_of_Art_University.

285 **"based on something other":** White, *The Contemporaries*, 47.

285 **63 percent of undergraduate art students:** Katrina Frye, personal communication.

287 **"in every part of a book's production":** 0s&1s, *The Art of Commerce*, episode 32, "'Whose Canon Is It Anyway?,'" October 8, 2015, http://www.0s-1s.com/the-art-of-commerce-xxxii.

288 **"forming and managing":** https://www.bard.edu/theorchnow/program/.

289 **372 offerings at 168 institutions:** Linda Essig and Joanna Guevara, "A Landscape of Arts Entrepreneurship in US Higher Education," Pave Program in Arts Entrepreneurship, December 2016, 9.

CHAPTER FIFTEEN: Piracy, Copyright, and the Hydra of Tech

294 **"Megaupload hosted twelve billion unique files":** Taplin, *Move Fast and Break Things*, 177.

295 **the biggest corporate lobbyist:** Hamza Shaban, "Google for the First Time Outspent Every Other Company to Influence Washington in 2017," *Washington Post*, January 23, 2018.

295 **Chilling Effects took off:** https://en.wikipedia.org/wiki/Lumen_(website).

296 **loss of film sales due to piracy:** "Impacts of Digital Video Piracy on the U.S. Economy."

297 *Game of Thrones:* https://d31sjue3f6m1dv.cloudfront.net/wp-content/uploads/2018/01/30134404/CreativeFuture-The-Facts-1.30.18.pdf.

297 *Hannibal:* Matt Porter, "Hannibal Producer Thinks Piracy Contributed to Cancellation," ign.com, May 2, 2017.

297 **about $7 billion:** https://creativefuture.org/the-facts-illustrated/.

297 **about $10 billion:** "U.S. Recorded Music Revenues by Format 1973 to 2018, Format(s): All," https://www.riaa.com/u-s-sales-database/.

298 **about 5.5 million people:** "The Facts One-Pager," creativefuture.org (Resources—Facts & Figures).

298 **"I don't want to pay for something":** This comes from Ellen Seidler.

298 **"Labels rip off artists":** This comes from Brian Day, "Online Piracy . . . It's Different," thetrichordist.com (videos).

298 **"a right of action":** Lewis Hyde, *Common as Air: Revolution, Art, and Ownership* (New York: Farrar, Straus and Giroux, 2011), 24. My discussion here follows Hyde's.

298 **"Piracy is not a loss":** Anderson, *Free*, 71.

299 **"On the one hand":** https://en.wikipedia.org/wiki/Information_wants_to_be_free.

300 **"stood on the shoulders of giants":** His exact words were, "If I have seen further, it is by standing on the shoulders of giants."

300 **"copied nearly verbatim":** Hyde, *Common as Air*, 202.

300 **"a barge with gilded poop":** http://penelope.uchicago.edu/Thayer/E/Roman/Texts/Plutarch/Lives/Antony*.htm.

300 **"The barge she sat in":** *Antony and Cleopatra*, 2.2.192–98.

301 **"mature poets steal":** T. S. Eliot, "Philip Massinger," in *Selected Prose of T. S. Eliot* (London: Faber and Faber, 1975), 153.

301 **"My photos will not sell":** Ellen Seidler, "IP and Instagram–a Teaching Moment Perhaps?," voxindie.org, December 18, 2012.

302 **"Congress shall have power":** U.S. Constitution, article I, section 8, clause 8.

302 **Daniel Defoe:** David Wallace-Wells, "The Pirate's Prophet: On Lewis Hyde," *Nation*, October 27, 2010.

302 **Pete Seeger:** Hyde, *Common as Air*, 244.

303 **"Copyright is . . . critically important":** Lessig, *Remix*, xvi.

303 **"If it takes me ten years":** Hyde, *Common as Air*, 48–49.

304 **Google, to begin with:** The paragraph follows Taplin, *Move Fast and Break Things*, 100–101.

304 **725 had been posted illegally:** John Lanchester, "You Are the Product," *London Review of Books*, August 17, 2017.

305 **"disappearing":** Taplin, *Move Fast and Break Things*, 179.

305 **$30 billion . . . as much as $300 billion:** Daniel Strauss, "Here's Why One Analyst Thinks YouTube Could Be Worth $300 Billion as a Standalone Company, Making It More Valuable than AT&T, Exxon Mobil, and Bank of America (GOOGL)," businessinsider.com, October 29, 2019.

305 **Google's image search:** Cesar Fishman, CreativeFuture, personal communication.

305 **"re-intermediation":** Timberg, *Culture Crash*, 115.

306 **"Many of the most prominent":** Taylor, *The People's Platform*, 154.

306 **"Google has helped finance":** Jonathan Taplin, "Google's Disturbing Influence," *New York Times*, August 31, 2017.

307 **about $50 billion in annual revenue:** Taplin, *Move Fast and Break Things*, 6–7.

CHAPTER SIXTEEN: Don't Mourn, Organize

310 **"our fair share"**: Lise Soskolne, "Online Digital Artwork and the Status of the 'Based-In' Artist," supercommunity.e-flux.com, May 27, 2015.

310 **To be a worker:** https://wageforwork.com/files/w9U7v627VLmeWsRi.pdf, 8.

310 **"to stave off . . . unionization"**: Davis, *9.5 Theses on Art*, 16.

310 **Susan Orlean:** Susan Orlean and Manjula Martin, "Running the Widget Factory," in Martin, ed., *Scratch*, 56.

310 **staff have been voting to unionize:** Daniel Victor, "*New Yorker* Forms Union, Reflecting Media Trend," *New York Times*, June 7, 2018.

312 **Topspin:** Chris Cooke, "Beats Sells Most of Topspin, to Be Merged In with BandMerch/Cinder Block," completemusicupdate.com, April 4, 2014; and "Apple to Acquire Beats Music & Beats Electronics," press release, apple.com, May 28, 2014.

313 **By matching "haves" with "needs"**: Jenny Jaskey, "Interview with Caroline Woolard of Our-Goods," rhizome.org, January 20, 2010.

316 **"we would start to make very different choices"**: Maggie Vail, "Not All Art Scales, Not All Businesses Should," *WATT*, January 19, 2017.

317 **European Union:** Adam Satariano, "Law Bolsters Copyrights in Europe," *New York Times*, March 27, 2019.

318 **Already there are moves:** Jack Nicas and Karen Weise, "Smaller Rivals Aim Slingshots at Tech Giants," *New York Times*, June 11, 2019.

318 **"the apex predators of tech"**: Kara Swisher, "Taming the Apex Predators of Tech," *New York Times*, May 21, 2019.

318 **major cause of falling wages:** See Eric Posner and Glen Weyl, "The Real Villain Behind Our New Gilded Age," *New York Times*, May 1, 2018.

320 **The trend toward poorly compensated contract work:** See Yuki Noguchi, "Freelanced: The Rise of the Contract Workforce," npr.org, January 22, 2018.

320 **0.4 percent of GDP:** "Public Funding of Culture in Europe, 2004–2017," The Budapest Observatory, March 2019, 5.

BIBLIOGRAPHY

ART AND MONEY

Abbing, Hans. *Why Are Artists Poor?: The Exceptional Economy of the Arts*. Amsterdam: Amsterdam University Press, 2002.

Bauer, Ann. "'Sponsored' by My Husband: Why It's a Problem That Writers Never Talk about Where Their Money Comes From." *Salon*, January 25, 2015.

Crabapple, Molly. "Filthy Lucre." *Vice*, June 5, 2013.

Davis, Ben. *9.5 Theses on Art and Class*. Chicago: Haymarket Books, 2013.

Hyde, Lewis. *The Gift: Creativity and the Artist in the Modern World*. 2nd ed. New York: Vintage, 2007.

Lerner, Ben. *10:04*. New York: Farrar, Straus and Giroux, 2014.

Scott, A. O. "The Paradox of Art as Work." *New York Times*, May 9, 2014.

THE NEW CONDITIONS

"The Free and the Antifree." *n+1*, Fall 2014.

Hische, Jessica. "Should I Work for Free?" shouldiworkforfree.com. Flowchart.

Kreider, Tim. "Slaves of the Internet, Unite!" *New York Times*, October 26, 2013.

Lowery, David. "Meet the New Boss, Worse Than the Old Boss?" *Trichordist*, April 15, 2012.

The Shopkeeper. Dir. Rain Perry. 2016. Film.

Timberg, Scott. *Culture Crash: The Killing of the Creative Class*. New Haven, Conn.: Yale University Press, 2015.

ARTISTS ON MAKE A LIVING TODAY

Bellwood, Lucy. [Untitled talk]. XOXO Festival, November 23, 2016, Portland, Oregon. www.youtube.com/watch?v=pLveriJBHeU.

Louden, Sharon, ed. *Living and Sustaining a Creative Life: Essays by 40 Working Artists*. Bristol, UK: Intellect, 2013.

——, ed. *The Artist as Culture Producer: Living and Sustaining a Creative Life*. Bristol, UK: Intellect, 2017.

Martin, Manjula, ed. *Scratch: Writers, Money, and the Art of Making a Living*. New York: Simon & Schuster, 2017.

INDIVIDUAL ARTS

Abrahamian, Atossa Araxia. "The Lemming Market." *London Review of Books*, May 10, 2018.

Bailey, Jason. "How the Death of Mid-Budget Cinema Left a Generation of Iconic Filmmakers MIA." *Flavorwire*, December 9, 2014.

Clayton, Jace. *Uproot: Travels in 21st-Century Music and Digital Culture*. New York: Farrar, Straus and Giroux, 2016.

Harbach, Chad, ed. *MFA vs NYC: The Two Cultures of American Fiction*. New York: Farrar, Straus and Giroux, 2014.

Kurowski, Travis, et al., eds. *Literary Publishing in the Twenty-First Century*. Minneapolis: Milkweed Editions, 2016.

Obst, Lynda. *Sleepless in Hollywood: Tales from the New Abnormal in the Movie Business*. New York: Simon & Schuster, 2013.

Seabrook, John. *The Song Machine: Inside the Hit Factory*. New York: Norton, 2015.

White, Roger. *The Contemporaries: Travels in the 21st-Century Art World*. New York: Bloomsbury, 2015.

THE HISTORY OF "ART"

Danto, Arthur. *After the End of Art: Contemporary Art and the Pale of History*. Princeton, N.J.: Princeton University Press, 1997.

Shimer, Larry. *The Invention of Art: A Cultural History*. Chicago: University of Chicago Press, 2001.

Williams, Raymond. *Keywords: A Vocabulary of Culture and Society*. New York: Oxford University Press, 1976. "Art," "Creative," "Genius," "Originality."

CREATIVITY AND "CREATIVITY"

Csikszentmihalyi, Mihaly. *Creativity: Flow and the Psychology of Discovery and Invention*. New York: HarperCollins, 1976.

Florida, Richard. *The Rise of the Creative Class: And How It's Transforming Work, Leisure, Community and Everyday Life*. New York: Basic Books, 2002.

ART SCHOOLS

Fusco, Coco. "Debating an MFA? The Lowdown on Art School Risks and Returns." *HuffPost*, December 4, 2013.

Loudis, Jessica, et al., eds. *Should I Go to Grad School?: 41 Answers to an Impossible Question*. New York: Bloomsbury, 2014.

McGurl, Mark. *The Program Era: Postwar Fiction and the Rise of Creative Writing*. Cambridge, Mass.: Harvard University Press, 2009.

Popp, Nancy. "Dismantling Art School." artanddebt.org, June 4, 2015.

Rosler, Martha. "School, Debt, Bohemia: On the Disciplining of Artists." artanddebt.org, March 4, 2015.

Singerman, Howard. *Art Subjects: Making Artists in the American University*. Berkeley: University of California Press, 1999.

PIRACY, COPYRIGHT, AND BIG TECH

Anderson, Chris. *Free: How Today's Smartest Businesses Profit by Giving Something for Nothing.* New York: Hyperion, 2009.

Day, Brian. "Online Piracy . . . It's Different." thetrichordist.com. Animated video.

Foer, Franklin. *World Without Mind: The Existential Threat of Big Tech.* New York: Penguin Press, 2017.

Hyde, Lewis. *Common as Air: Revolution, Art, and Ownership.* New York: Farrar, Straus and Giroux, 2010.

Lanier, Jaron. *Who Owns the Future?* New York: Simon & Schuster, 2014.

Lessig, Lawrence. *Remix: Making Art and Commerce Thrive in the Hybrid Economy.* New York: Penguin, 2008.

Ruen, Chris. *Freeloading: How Our Insatiable Appetite for Free Content Starves Creativity.* Melbourne: Scribe, 2012.

Seidler, Ellen. voxindie.com. Site with posts and links.

Taplin, Jonathan. *Move Fast and Break Things: How Facebook, Google, and Amazon Cornered Culture and Undermined Democracy.* New York: Little, Brown, 2017.

Taylor, Astra. *The People's Platform: Taking Back Power and Culture in the Digital Age.* New York: Metropolitan Books, 2014.

Wallace-Wells, David. "The Pirate's Prophet: On Lewis Hyde." *Nation,* October 27, 2010.

ADDITIONAL SOURCES

Harris, Malcolm. *Kids These Days: Human Capital and the Making of Millennials.* New York: Little, Brown, 2017.

Hickey, Dave. *Air Guitar: Essays on Art & Democracy.* Los Angeles: Art Issues, 1997.

——. *Pirates and Farmers.* London: Ridinghouse, 2013.

Rosenberg, Harold. *The Tradition of the New.* Chicago: University of Chicago Press, 1959.

——. *Discovering the Present: Three Decades in Art, Culture, and Politics.* Chicago: University of Chicago Press, 1973.

Whitaker, Amy. *Art Thinking: How to Carve Out Creative Space in a World of Schedules, Budgets, and Bosses.* New York: HarperCollins, 2016.

ACKNOWLEDGMENTS

My first and highest gratitude goes to the many people who agreed to be interviewed for this project, and who were remarkably generous not only with their time but with their candor. Money is a topic that you're not supposed to talk about—still less, to ask about—yet my subjects responded with honesty and vulnerability. I am humbled by the trust these strangers placed in me.

For enriching conversation on the issues covered in this book, fond thanks to Tsilli Pines, Rebekah Modrak, Tammy Kim, Sharon Louden, JP Reuer, David Gorin, Amy Whitaker, Alana Newhouse, Liz Lerman, Mara Zepeda, Kate Bingaman-Burt, Pat Castaldo, Rachel Mannheimer, Chris Schlegel, Lexy Benaim, Velvy Appleton, Nathaniel Rich, Denise Mullen, Julie Goldstein, Padraic McConville, Keriann Murphy, Leslie Vigeant, Killeen Hanson, Joey Edwards, Conor Friedersdorf, Matt Strother, Pauls Toutonghi, Daniela Molnar, Monika Kanokova, Joe Thurston, Yael Manes, Andrea Warchaizer, and Sean Peters.

Interview subjects not cited by name in the book include Freddi Price, Ben Burke, Jordan Wolfson, Jon Deak, Jamon Jordan, Katie McGowan, Kevin Wommack, Brett Wallace, Won Cha, Don McCaw, Neil Bremer, Ed Hooks, and Julia Kaganskiy. My thanks to them for their insights and stories, which helped to deepen my understanding of the issues in question.

For service above and beyond the call of duty in providing me with contacts for potential interviews, thanks to Andrew Neel, Christine

Smallwood, Maggie Vail, Joel Friedlander, Jane Espenson, Paul Rucker, Andy McMillan, Lucy Bellwood, Richard Nash, Rain Perry, Casey Droege, and Steve Albini, as well as Tammy, Sharon, Lexy, Jordan, Mara, Amy, and Rebekah.

For additional research help, thanks to Steve Greenberg, Eugene Ashton-Gonzales, Caroline Woolard, Ellen Seidler, Lise Soskolne, Tsilli Pines, Blakey Vermeule, Terry Castle, Gina Goldblatt, Ruth Vitale and Cesar Fishman at CreativeFuture, Mary Rasenberger and Paul Morris at the Authors Guild, Ben Davidson at Americans for the Arts, Kevin Erickson at the Future of Music Coalition, Carmen Graciela Díaz and Steve Cline at Grantmakers in the Arts, Diantha Daniels and Jon Bergdoll at the Lilly Family School of Philanthropy at Indiana University, and Ted Kalo, Matthew Montfort, and Thomas Manzi at the Artist Rights Alliance.

For the chance to hash out some of my ideas in the form of public talks, thanks to Tsilli at both CreativeMornings Portland and Design Week Portland; JP at the (then) joint program in Applied Craft and Design of the Pacific Northwest College of Art and the Oregon College of Art and Craft; Denise at the late, lamented OCAC; Summer Killingsworth at Association Dinner Series; Sean Blanda at 99U; Alexandre Frenette at the 3 Million Stories Conference; the Executive Committee of the National Association of Schools of Art and Design; Karin Roffman at Public Humanities at Yale; Fred Antczak at Grand Valley State University; Paul Jaskunas at the Maryland Institute College of Art; and Brian Clack and Noelle Norton at the University of San Diego.

For the chance to hash them out in the form of written essays, thanks to Ann Hulbert at the *Atlantic*, Bob Wilson at the *American Scholar*, Susan Lehman at the *New York Times Sunday Review*, and Giles Harvey at *Harper's Magazine*.

My editor, Barbara Jones, has been a pleasure to work with; major thanks to her, Ruby Rose Lee, and the rest of the team at Henry Holt. As always, my agent, Elyse Cheney, has been a brick, a baller, a consummate pro; immense and ongoing thanks to her, Claire Gillespie, and everyone else at the Cheney Agency.

My deepest gratitude goes to Aleeza Jill Nussbaum, who crafts with me the beautiful cathedral of our life together.

INDEX

ABOUT THE AUTHOR

William Deresiewicz is an award-winning essayist and critic, a frequent speaker at colleges and other venues, and a former professor of English at Yale. His writing has appeared in the *Atlantic*, the *New York Times*, *Harper's Magazine*, the *Nation*, the *New Republic*, and many other publications. He is the recipient of a National Book Critics Circle award for excellence in reviewing and the *New York Times* bestselling author of *Excellent Sheep* and *A Jane Austen Education*.